Secularizing the Sacred

Brill's Series in Jewish Studies

Series Editor

Joshua Holo (*Hebrew Union College – Jewish Institute of Religion*)

VOLUME 65

The titles published in this series are listed at *brill.com/bsjs*

Secularizing the Sacred

Aspects of Israeli Visual Culture

By

Alec Mishory

BRILL

LEIDEN | BOSTON

Cover illustration: Ze'ev Raban, *Let Him Kiss Me with the Kisses of His Mouth….*, illustration in *The Song of Songs*, Jerusalem: Shulamit Publication, 1923. Courtesy Dafna Winter, The Artist's Estate, Jerusalem

Library of Congress Cataloging-in-Publication Data

Names: Mishory, Alec, author.
Title: Secularizing the sacred : aspects of Israeli visual culture / by Alec Mishory.
Description: Leiden ; Boston : Brill, [2019] | Series: Brill's series in Jewish studies ; volume 65 | Includes bibliographical references and index. |
Identifiers: LCCN 2019017957 (print) | LCCN 2019018684 (ebook) | ISBN 9789004405271 (E-book) | ISBN 9789004405264 (hardback : alk. paper)
Subjects: LCSH: Art, Israeli—History—20th century. | Art—Palestine—History—19th century. | Jewish art and symbolism—Israel. | Jewish art and symbolism—Palestine. | Zionism in art.
Classification: LCC N7277 (ebook) | LCC N7277 .M5685 2019 (print) | DDC 709.5694—dc23
LC record available at https://lccn.loc.gov/2019017957

Typeface for the Latin, Greek, and Cyrillic scripts: "Brill". See and download: brill.com/brill-typeface.

ISSN 0926-2261
ISBN 978-90-04-40526-4 (hardback)
ISBN 978-90-04-40527-1 (e-book)

Copyright 2019 by Koninklijke Brill NV, Leiden, The Netherlands.
Koninklijke Brill NV incorporates the imprints Brill, Brill Hes & De Graaf, Brill Nijhoff, Brill Rodopi, Brill Sense, Hotei Publishing, mentis Verlag, Verlag Ferdinand Schöningh and Wilhelm Fink Verlag.
All rights reserved. No part of this publication may be reproduced, translated, stored in a retrieval system, or transmitted in any form or by any means, electronic, mechanical, photocopying, recording or otherwise, without prior written permission from the publisher.
Authorization to photocopy items for internal or personal use is granted by Koninklijke Brill NV provided that the appropriate fees are paid directly to The Copyright Clearance Center, 222 Rosewood Drive, Suite 910, Danvers, MA 01923, USA. Fees are subject to change.

This book is printed on acid-free paper and produced in a sustainable manner.

Printed by Printforce, the Netherlands

Contents

Acknowledgement IX
List of Illustrations X
Note on Terms and Transliteration XXVII

Introduction 1

PART 1
Before Statehood

1 **The Clarion Call: E. M. Lilien and the Jewish Renaissance** 19
 1.1 Life, Heroism, and Beauty 21
 1.2 Lilien's Winged Figures 26
 1.3 Restrained Decadence: Jewish Angels 29
 1.4 Olympus and Golgotha in the Service of Zionism 30

2 **Boris Schatz's Pantheon of Zionist Cultural Heroes** 43
 2.1 A Day Dream 44
 2.2 A New Florence 47
 2.3 A Hebrew Pantheon: Individual Commemoration 50
 2.4 Collective Commemoration 59
 2.5 Schatz's Legacy: Models for a Sovereign State Heroes 61

3 **"The Garden of Love": Early Zionist Eroticism** 67
 3.1 The Garden of Love: a Remedial Institution for Nervous Atrophy 68
 3.2 In the Song of Songs Pavilion 70
 3.3 The New Jew: Intellect and Sensuality Combined 71
 3.4 Kisses and Embraces 77
 3.5 Orientalism and Symbolism in the Zionist-Biblical World 79
 3.6 The Secular Bride 81

4 **Zionist Revival and Rebirth on the Façade of the Municipal School in Tel Aviv** 83
 4.1 Past and Present Come Together 84
 4.2 Four Hebrew Cities 88

PART 2
Objects and Conceptions of Sovereignty

5 **Israel's Scroll of Independence** 103

6 **Hues of Heaven: the Israeli Flag** 116
 6.1 The Zionist Flag 117
 6.2 The *Magen David* (David's Shield) or the Jewish Star 118
 6.3 The Blue Stripes 122
 6.4 First Proposals for an Israeli Flag 125
 6.5 A Multitude of King David's Shields 131

7 **Menorah and Olive Branches on Israel's National Emblem** 137
 7.1 In Search of a National Emblem 139
 7.2 Archaeology and Socialism: Jewish Tradition versus Secularism 140
 7.3 The Shamir Brothers Studio's Proposal 146
 7.4 Prophet Zecharia's Vision: Harmony between State and Church 148
 7.5 A Visual Precedent from 1300 151
 7.6 Public Reactions to the Design of the National Emblem 152

8 **From Exile to Homeland: the Mythical Journey of the Temple Menorah** 159
 8.1 An Icon of Destruction 159
 8.2 The Arch of Titus: a Symbol of Destruction and Exile 160
 8.3 "Oh Titus, Titus, If You Could Only See!" 165
 8.4 The *Menorah* Returns Home 167
 8.5 A Miraculous Translocation 169
 8.6 A Gift from the Mother of Parliaments to the New Israeli Parliament 170
 8.7 Benno Elkan: a Self-Anointed Modern Bezalel 174
 8.7.1 *Links in a Chain: Candelabras in Milan Cathedral, Westminster Abbey and the Parliament of Israel* 176
 8.7.2 *A Modular Iconographic System* 179
 8.7.3 *Concise Rendering of Alleged Jewish History* 179
 8.8 The *Menorah*'s Penultimate Station on Its Way Home: Kssalon Settlement 183
 8.8.1 *The* Menorah's *Last Station?* 185
 8.9 Visual References to the Israeli *Menorah* Motif 186

CONTENTS

9 **Zionism Liberates the Captured Daughter of Zion** 189
 9.1 The *Judaea capta* Coin 189
 9.2 Jewish References to the Roman *Judaea capta* Coin 192
 9.3 From *Judaea capta* to Judaea liberata 196
 9.4 The *Judaea capta* Image on Official Israeli Publications 203
 9.5 A Late Israeli Daughter of Zion 206

10 **The Twelve Tribes of Israel: from Biblical Symbolism to Emblems of a Mythical Promised Land** 209
 10.1 The Twelve Tribes of Israel: Symbolizing the Unity and Diversity of the Jewish People 209
 10.2 Biblical and *Midrashim* Sources 210
 10.3 Verbal Turned Visual: Heraldic Emblems of the Twelve Tribes 211
 10.4 From Christian Bibles to Jewish Synagogue Decorations 218
 10.5 E. M. Lilien's Legacy 222
 10.6 Beyond Lilien's Legacy 227
 10.7 Symbols of Sovereignty 229
 10.8 Emblems of a Mythical Promised Land 239

11 **Old and New in Land of Israel Flora** 244
 11.1 Israeli Plants as Local Icons 244
 11.2 Familiar Biblical Plants: the Seven Kinds 245
 11.3 The Four Species 247
 11.4 Grapes, Figs, and Pomegranates as Symbols of Sovereignty 250
 11.5 The Spies Motif 251
 11.6 The New Jew as a Tiller of the Soil 254
 11.7 Herzl's Cypress Tree Myth 254
 11.8 Unfamiliar Wild Plants 259
 11.9 "A Very Lovely Cyclamen" 264
 11.10 "We Shall Return as Red Flowers" 268
 11.11 "Nobody Understands Cyclamens Anymore" 270
 11.12 Local Plants Revisited 274
 11.13 A Symbol Shared by Two Peoples: the Israeli Cactus 282

12 **Ancient Magic and Modern Transformation: the Unique Hebrew Alphabet** 286
 12.1 Hebrew Calligraphy 287
 12.2 Hebrew Typography 287
 12.3 Hebrew Typography in Israeli Design 300
 12.4 Uses of the Hebrew Alphabet in Non-textual Israeli Visual Media 301

PART 3
Sculptural Commemoration within the Israeli Public Space

13 From Pilgrimage Site to Military Marching Grounds: Theodor Herzl's Gravesite in Jerusalem 315
 13.1 Herzl's Coffin Brought to Tel Aviv 317
 13.2 Herzl's Burial Ceremony in Jerusalem 317
 13.3 International Competition for Herzl's Burial Site Design 320
 13.4 Winner of the Competition: Yosef Klarwein's Design 324
 13.5 Runner-up Prize: Danziger and Shalgi's Design 326
 13.6 The Committee for Herzl's Burial Site Doubts Its Own Decisions 328
 13.7 Herzl's Tomb Final Design and Unveiling 329

14 Natan Rapoport's Soviet Style of the Yad Mordechai and Negba Memorials 335
 14.1 Ghetto Heroism and Israeli Valor 335
 14.2 The Yad Mordechai Memorial 338
 14.3 The Negba Memorial 349

15 Holocaust and Resurrection in Yigal Tumarkin's Memorial in Tel Aviv 358
 15.1 Is It Possible to Render the Holocaust Visually? 359
 15.2 The International Committee, Auschwitz 360
 15.3 Israeli Holocaust Memorials at Yad Vashem 361
 15.4 The *Memorial to the Holocaust and the Resurrection of Israel* 364

16 In Conclusion: Secularizing the Sacred, Israeli Art, and Jewish Orthodox Laws 373
 16.1 The Hebrew Bible: a Spring Abundant with Narratives and Allegorical Figures 375
 16.2 A Visual Discourse with Jewish Artists from the Past 380
 16.3 Israeli "Graven Images" 382
 16.4 Hybrids 382
 16.5 Jewish Angels and Israeli Cherubs 384
 16.6 Taharah and Tum'ah (Purity and Impurity) 389

 General Index 401

Acknowledgement

This book would have not been published but for the encouragement of two great New Yorkers: Professor Steven Fine of Yeshiva University and the erudite Dr. Ilil Arbel. With Steven I spent hours exchanging ideas, views (and jokes) on Jewish and Israeli symbolism. In my fascinating conversations with Ilil we shared family history, both wondering and admiring our grandparents' strange, but beautiful decision to leave Siberia and immigrate to Palestine in 1920. I enjoyed listening to her great wells of Jewish mythology while sharing with her my knowledge of Israeli visual culture. Steven approached me once and jokingly scolded me: "Why do you insist on writing and publishing your ideas in a 4000 years old language? Isn't it time you publish in English?" Ilil's meticulous editing of my text made his advice come true.

Alec Mishory
Tel Aviv, May 2019

Illustrations

0.1	Three ancient mosaics on Ben Gurion airport wall, 2004	2
0.2	Osnat Eshel, *Israeli banknote of 20 new Israeli shekels with a portrait of Poet Rachel*, 2017. Photo courtesy The Bank of Israel	2
0.3	Osnat Eshel, *Israeli banknote of 100 new Israeli shekels with a portrait of Poet Leah Goldberg*, 2017. Photo courtesy The Bank of Israel	2
0.4	Busts of presidents of Israel at the Presidential Mansion in Jerusalem	9
0.5	Various shapes of *menorah* bases and branches	10
1.1	Ephraim Mose Lilien (1874–1925)	19
1.2	Ephraim Mose Lilien, *Angel Gabriel and Satan*, illustration for *Der Engel* (The Angel) in *Juda*, 1900	20
1.3	Ephraim Mose Lilien, *Expulsion from Eden*, illustration in *Bücher der Bibel* (Books of the Bible), 1908	27
1.4	Ephraim Mose Lilien, *Creation of Man*, illustration in *Lieder des Ghetto* (Poems of the Ghetto), 1903	27
1.5	Ephraim Mose Lilien, *Sabbath*, illustration in *Ost und West*, 1904	28
1.6	Ephraim Mose Lilien, *In Memoriam of the Kishinev Martyrs*, 1904, illustration in *Ost und West*, December 1904	29
1.7	Walter Crane, *Genius of Mechanical Invention Linking Agriculture and Commerce*, plaster frieze	31
1.8	Walter Crane, *Genius of Electricity Linking the Different Parts of the World*, plaster frieze	31
1.9	Ephraim Mose Lilien, *Title Page for Ost und West*, 1904	32
1.10	Ephraim Mose Lilien, *Personal Ex-Libris*, 1901, illustration in *Ost und West*, 1904	34
1.11	Ephraim Mose Lilien, *Isaiah*, illustration in *Juda*, 1900	34
1.11a	Ephraim Mose Lilien, *Isaiah* detail	35
1.12	*The Sacred Heart*, a popular poster	35
1.13	Ephraim Mose Lilien, *Dror* (Freedom), Design for a stained glass window for the 'Bnai Brith' Club in Hamburg, illustration in *Ost und West*, 1904	36
1.14	Theodor Herzl	37
1.15	Ephraim Mose Lilien, *Mose* (Moses), illustration in *Bücher der Bibel* (Books of the Bible), 1908	37
1.16	Ephraim Mose Lilien, *Heinatlos* (Without a Homeland), illustration in *Ost und West*, 1904	38
1.17	Ephraim Mose Lilien, *Portrait of Max Nordau*, illustration in *Ost und West*, 1904	38

1.18	Ephraim Mose Lilien, *Passover*, illustration in *Juda*, 1900 39
1.19	Ephraim Mose Lilien, *Der Judische Mai* (The Jewish Month of May), illustration in *Ost und West*, 1904 39
1.20	Ephraim Mose Lilien, *Von Ghetto nach Zion* (From the Ghetto to Zion), Illustration for a poster commemorating the 5th Zionist Congress, 1902, illustration in *Ost und West*, 1904 40
2.1	Boris Schatz 43
2.2	Ze'ev Raban, *Title page* of Boris Schatz's *Jerusalem Rebuilt, a Day Dream*, 1923 45
2.3	*Title Page* of William Morris' *News from Nowhere*, 1891 45
2.4	Yosef Minor (architect), *Katzman House*, Ahad Ha'am street, Tel Aviv (before it was torn down). Photo courtesy of Zvika Zelikowitch 48
2.5	*Katzman House*, details: (from left to right, top to bottom) *King David, Prophet Isaiah, Prophet Jeremiah, Prophet Elijah*. Photos courtesy of Zvika Zelikowitch 49
2.6	Boris Schatz, *Matathias* (whereabouts unknown). Photo courtesy Schatz Estate, Jerusalem 51
2.6a	Benvenuto Cellini, *Perseus and the Severed Head of Medusa*, 1545–1554, bronze, Florence, Loggia dei Lanzi. Photo courtesy Wikipedia By Paolo Villa—Own work, CC BY-SA 4.0 51
2.7	Death mask, last painting, palette and brushes of artist-teacher Shmuel Ben David put on display at the Bezalel courtyard, 1927. Photo courtesy Schatz Estate, Jerusalem 53
2.8	Boris Schatz, *Memorial Plaque for Eliezer Ben Yehuda*, 1923, plaster relief. Photo published in *Boris Schatz, his Life and Work, Monography*, Jerusalem, 1925 55
2.9	Boris Schatz, *Plaque in Honor of Otto Warburg*, plaster relief. Photo published in *Boris Schatz, his Life and Work, Monography*, Jerusalem, 1925 56
2.10	Boris Schatz, *Memorial Plaque for Theodor Herzl*, 1905, plaster relief. Photo published in *Boris Schatz, his Life and Work, Monography*, Jerusalem, 1925 57
2.11	Avraham Melnikov, *Memorial to the Heroes of Tel Chai*, 1934, stone. Photo courtesy Wikipedia By CC BY 2.5 59
2.12a	Shamir Brothers Studio and Ya'akov Zim, *Israeli half a pound note*, 1958. Photo courtesy The Bank of Israel 61
2.12b	Shamir Brothers Studio and Ya'akov Zim, *Israeli five-pound note*, 1958. Photo courtesy The Bank of Israel 61
2.12c	Shamir Brothers Studio and Ya'akov Zim, *Israeli ten-pound note*, 1958. Photo courtesy The Bank of Israel 61

2.13a	Zvi Narkis, *Israeli one hundred new shekels note* (with a portrait of President Yitzhak Ben Zvi), 1976. Photo courtesy The Bank of Israel	62
2.13b	Dutch artists, *Israeli fifty old shekels note* (with a portrait of Prime Minister David Ben Gurion), 1977. Photo courtesy The Bank of Israel	62
2.13c	Paul Kor and Adrian Sanger, *Israeli one new shekel note* (with a portrait of Sir Moses Montefiore), 1980. Photo courtesy The Bank of Israel	62
2.14a	*Israeli banknote of 100 new Israeli shekels* (with a portrait of President Yitzhak Ben Zvi), 1976. Photo courtesy The Bank of Israel	63
2.14b	*Israeli banknote of 100 new Israeli shekels*, detail	63
2.15a	*Israeli banknote of 50 new Israeli shekels* (with a portrait of poet Shaul Tchernichovsky), 2015. Photo courtesy The Bank of Israel	65
2.15b	*Israeli banknote of 100 new Israeli shekels* (with a portrait of poet Natan Alterman, 2015. Photo courtesy The Bank of Israel	65

Chapter 3 illustrations 3.1–3.9 courtesy of Dafna Winter, The Artist Estate

3.1	Ze'ev Raban, *Portrait of the Artist's Wife*, 1920s	72
3.2	Ze'ev Raban, *Title Page of The Song of Songs*, Jerusalem, Shulamit Publication, 1923	73
3.3	Ze'ev Raban, *You are Beautiful my Love....*, illustration in *The Song of Songs*, 1923	75
3.4	Ze'ev Raban, *Let him Kiss me with the Kisses of his Mouth....* illustration in *The Song of Songs*, 1923	76
3.5	Ze'ev Raban, *My love, Let us Go out to the Fields, ...*, illustration in *The Song of Songs*, 1923	77
3.6	Ze'ev Raban, *I Made you Swear, Daughters of Jerusalem, ...*, illustration in *The Song of Songs*, 1923	78
3.7	Ze'ev Raban, *As an Apple in the Orchard so is my Lover among Men....*, illustration in *The Song of Songs*, 1923	78
3.8	Ze'ev Raban, *Who is that Coming out of the Wilderness*, illustration in *The Song of Songs*, 1923	79
3.9	Ze'ev Raban, *I Wish You were as a Brother to me ...*, illustration in *The Song of Songs*, 1923	80
3.10	Actress Theda Bara in the silent film *Cleopatra*, 1917. Photo courtesy Wikipedia, public domain	81
4.1	The Municipal School, Ahad Ha'Am street, Tel Aviv (built 1924). Photo courtesy Avi Hay	84
4.2	*If I forget thee, O Jerusalem, May my Right Hand Forget her Cunning.* Ceramic tile decoration above the central doorway of The Municipal School. Photo by the author	85
4.3	David Friedlander, *Zecher laChurban (Al Naharot Bavel)* (Memorial to the Destruction of the Temple, or, On the Rivers of Babylon), 18th century,	

ILLUSTRATIONS XIII

	wall painting in the wooden Synagogue in Grojec, Poland (destroyed by the Nazis in World War II). Photo in George Lukomski, *Jewish Art in European Synagogues, from the Middle Ages to the Eighteenth Century*, London and New York: Hutchinson Publications, 1947 86
4.4	Bezalel Ceramic Workshops, *"I will Build you up Again and You will be Rebuilt, O Virgin Israel*, 1920s, ceramic tile decoration on the façade of a Tel Aviv building. Photo courtesy Zvika Zelikowitch 88
4.5	The official emblem of the Tel Aviv Municipality (designed in 1924) 88
4.6	Ze'ev Raban, *Jaffa*, 1923, from the series *10 Towns of The Land of Israel*. Photo courtesy Dafna Winter, The Artist's Estate, Jerusalem 89
4.7	Ze'ev Raban, *Tiberias*, 1923, from the series *10 Towns of The Land of Israel*. Photo courtesy Dafna Winter, The Artist's Estate, Jerusalem 90
4.8	Bezalel Ceramic Workshops, *Tiberias*, ceramic tile decoration on the façade of The Municipal School. Photo courtesy Avi Hay 91
4.8a	The *Nordau* boat, photograph from the 1920s 92
4.9	Bezalel Ceramic Workshops, *Haifa*, ceramic tile decoration on the façade of The Municipal School. Photo courtesy Avi Hay 93
4.10	Bezalel Ceramic Workshops, *Hebron*, ceramic tile decoration on the façade of The Municipal School. Photo courtesy Avi Hay 94
4.11	Bezalel Ceramic Workshops, *Jaffa*, ceramic tile decoration on the façade of The Municipal School. Photo courtesy Avi Hay 95
Plate 1	*Cover of Gan Gani, Sefer la'Em velaYeled* (Kindergarten, my kindergarten, a Book for Mothers and Children), edited and selected texts by Levin Kipnis and Yemima Tchernowitz, illustrations by Isa, Tel Aviv, Tversky Publication, 1949 100
5.1	The *Israeli Scroll of Independence*, 1949, pen and ink on vellum. Photo courtesy Wikipedia, public domain 104
5.2	*Leningrad Codex*, 1008, Russian National Library, St. Petersburg, detail. Photo courtesy Wikipedia By Shmuel ben Ya'akov 105
5.3	Ashkenazi script 106
5.4	Sephardic script 106
5.5	The *Israeli Scroll of Independence*, pen and ink on vellum, detail 107
5.5a	Walisch and Sidner's script 108
5.4a	Sephardic script 108
5.6	*Israel's Scroll of Independence* taken out of its container for a recent (2017) taking of a professional photograph at the Israel State Archive. Photo courtesy Israel State Archive 108
5.7a, b	David Gumbel. Container for *Israel's Scroll of Independence*, 1949, silver, Jerusalem, State Archive. Photo by the author 110

5.8	David Tartakover, *Plate 13* of the *Declaration of the Foundation of the State, 21 Plates on [Israel's] Scroll of Independence* series, 1988. Photo courtesy David Tartakover	112
5.9	David Tartakover, *Kama Medinat Israel, Tama haYeshiva haZot*, (The State of Israel is Founded, this Meeting is Adjourned), *Plate 19* of *The Declaration of the Foundation of the State, 21 Plates on [Israel's] Scroll of Independence* series, 1988. Photo courtesy David Tartakover	114
6.1	The dais during the proclamation of the founding of the State of Israel ceremony, 1948. Photo courtesy Wikipedia by Rudi Weissenstein—Israel Ministry of Foreign Affairs	116
6.2	The official proclamation of the Israeli flag, 1948	117
6.3	Variations of the six-pointed star design	119
6.4	Two triangles forming the shape of the six-pointed star. Illustration by the author	119
6.5	The six-pointed star as a magic symbol	120
6.6	The six-pointed star on an amulet	120
6.7	The Jewish Star on a printer's banner, 16th century	121
6.8	The Jewish Star on a printer's banner from Prague, 16th century	121
6.9	Flag of the Bnay Zion Association in Boston, 1891	125
6.10	Nissim Sabach, *Proposal for Israel's National Flag*, 1948, Israel State Archive, *Flag and Emblem File*	126
6.11	Herzl's proposal for a flag for the future Jewish State	126
6.12	Anonymous artist, *Five Variations for a Proposed Israeli Flag*, 1948, Israel State Archive, *Flag and Emblem File*	127
6.13	Mordechai Nimtza-Bi, *Proposals for the Israeli flag*, 1949 in *Hadegel* (The flag), 1948. Author's collection. Photo by the author	128
6.14	Oteh Walisch, *Proposal for the Israeli flag*, 1948. Israel State Archive, *Flag and Emblem File*	129
6.15	The *Yellow Badge*, a badge of shame for Jews made by Nazi Germany	130
6.16	Ohad Shaltiel, *Mishmeret 1* (Watch 1, literally, First watch), 1977, tar on canvas, mixed media, 180 × 60 × 15 cm. Photo courtesy Ohad Shaltiel	132
6.17	Eitan Busheri & Tomer Shemi, *Hamishim Shana liMdinat Yisrael* [Israel's 50th anniversary], 1998, poster, author's collection. Photo by the author	133
6.18	Logo of *El Al* National Israeli Airlines	135
6.19	Logo of *Israir* Israeli Airlines	135
7.1	Official declaration of Israel's National Emblem	137
7.2	Walisch and Strossky, *Proposal for Israel's National Emblem*, 1948	138
7.3	The *Temple Menorah* as depicted in relief on the *Triumphal arch of Titus* in Rome, illustration in *Schiyot haMikra* (Treasures of the Bible) Berlin, 1923	139

7.4a	Ismar David and Yerachmiel Schechter, *Proposal for Israel's National Emblem*, 1949 (first version) 141
7.4b	David and Schechter, *Proposal for Israel's National Emblem*, 1949 (second version) 141
7.5	Synagogue floor mosaic decoration, 6th century CE, Jericho 142
7.6	Seals unearthed in Palestine with the inscription "To the King," illustration in *Schiyot haMikra* (Treasures of the Bible) Berlin, 1923 142
7.7	Nachshon, *Proposal for Israel's National Emblem*, 1948 144
7.8	An unknown designer, *Proposal for Israel's National Emblem*, 1948 145
7.9	Dr. Solnik, *Proposal for Israel's National Emblem*, 1948 145
7.10	Unknown designer, *Proposal for Israel's National Emblem*, 1948 146
7.11	Unknown designer, *Proposal for Israel's National Emblem*, 1948 146
7.12	The Shamir Brothers Studio, *Proposal for Israel's National Emblem*, 1948 (first version) 147
7.12a	The Shamir Brothers Studio, *Proposal for Israel's National Emblem*, 1948 (second version) 148
7.13	The Shamir Brothers Studio, *Final version of a proposal for Israel's National Emblem*, 1949 149
7.14	Yosef haTzarfati, *Vision of Prophet Zacharia* (carpet page from *The Cervera Bible*), 1300, illuminated manuscript. Photo courtesy Wikipedia, By Samuel ben Abraham ibn Nathan 151
7.15	The Shamir Brothers Studio, *The official National Emblem of Israel*, 1949 155
7.16	A brochure issued by Israel's Foreign Ministry explaining the symbolism of the State's official emblem 156
7.17	*Column base frieze* in the Temple of Apollo at Didyma, 4th century BCE Photo Wikipedia 157
8.1	Luigi Ademollo, *Preparation of the Captives and the Spoils of War Taken during the Conquest of Jerusalem for Emperor Titus' Triumphal March in Rome*, ca. 1838, etching and aquatint, 68 × 50 cm. Rechovot, Chaim and Vera Weitzman House Collection. Photo by the author 161
8.2	Luigi Ademollo, *Emperor Titus' Triumphal March in Rome After the Destruction of Jerusalem*, ca. 1838, etching and aquatint, 50 × 68 cm. Rechovot, Chaim and Vera Weitzman House Collection. Photo by the author 162
8.2a	Luigi Ademollo, *Emperor Titus' Triumphal March in Rome after the Destruction of Jerusalem*, detail, *The Candelabrum Brought into the Temple of Peace* 162

8.2b	Luigi Ademollo, *Emperor Titus' Triumphal March in Rome after the Destruction of Jerusalem*, detail, *The Book of the Law and the Temple Curtain put in the Palatine Library* 163
8.3	Ze'ev Raban, *Tish'ah be'Av* (The ninth of Ab), illustration in *Chageynu* (Our Holidays), 1920s, New York, Miller Lynn Publications 164
8.4	*The Arch of Titus*, 1942, stamp from The *Diaspora* series, issued by the Jewish National Fund, 1942. Photo courtesy The Jewish National Fund Archive, Jerusalem 166
8.5	Arieh Allweil, *On the Way to Liberated Jerusalem*, 1949, illustration in a *Passover Haggadah*, tempera on paper, 62 × 50 cm. Photo courtesy Nava Rosenfeld, the Artist's Estate, Tel Aviv 168
8.6	Aba Fenichel, *The Temple Menorah Returns Home*, 1950, caricature in *Ha'aretz* daily paper 169
8.7	Benno Elkan, *The Knesset Menorah*, 1956, bronze, Jerusalem, garden of the *Knesset*. Photo by the author 171
8.8	Bernard Engel, *Sketch showing the proposed future installation of Elkan's Knesset Menorah*, 1954, in *The Menorah Fund Committee, British Gift to Israel*, brochure. Photo by the author 175
8.9	Sculptor Benno Elkan working on *The New Testament Candelabrum*, 1940, in The *Menorah Fund Committee, British Gift to Israel*, Brochure. Photo by the author 177
8.9a	Benno Elkan, A Sketch for *The Old Testament Candelabrum* in *The Menorah Fund Committee, British Gift to Israel*, Brochure. Photo by the author 177
8.10	*The Trivulzio Candelabrum*, c. 1200, with additions of the mid-sixteenth century, bronze with inlaid gemstones, approx. 5 by 4 m, St. Mary of the Wood Chapel, Milan Cathedral. Photo courtesy Wikipedia, by G.dallorto—Own work, CC BY-SA 2.5 it 177
8.11	Two types of the seven-branched candelabrum. Illustration by the author 178
8.12	Benno Elkan, *Sketch showing the various reliefs on The Knesset Menorah*, 1954 in *The Menorah Fund Committee, British Gift to Israel*, Brochure. Photo by the author 181
8.7a	Benno Elkan, *Ruth* and *Rachel*, reliefs on *The Knesset Menorah* 181
8.13	Natan Rapoport, *Megilat ha'Esh* (The Scroll of Fire), 1969, bronze monument, Forest of Martyrs, Kssalon Settlement. Photo courtesy Steven Fine 184
8.14	Natan Rapoport, *Memorial Reliefs*, 1980, New York, Park Avenue Synagogue 185
8.15	Michael Druks, *Menorah*, wax and wicks, exhibited and self-consumed in 1983 186

8.16	*Ministry of the Interior and of Happiness, Identity Card of Nachman from Uman*, plastic binder for an incantation, author's collection, photo by the author 187
9.1	The Roman *Judaea capta* coin, 81 CE, photo courtesy Wikipedia, by Classical Numismatic Group, Inc. 190
9.2	The *Judaea capta* coin, 71 CE 190
9.3	Medal commemorating the victory of Polish King Stefan Batori on Russian Czar Ivan the Terrible, 1583 192
9.4	E. M. Lilien, *By the Rivers of Babylon*, 1910, etching, published in *Ost und West*, 1904 193
9.5	*Leah, a student of the Evelyn de Rothschild Girls School in the role of The Weeping Daughter of Zion*, photograph published in *Ost und West*, May, 1907 195
9.6	Heiman Perlzweig, *Frontispiece for the musical score of the Redemption March*, London, 1922 197
9.7	New Year's greeting card from Germany, 1909 197
9.8	Ya'akov Ben Dov, *Frontispiece of The Liberated Judea film program*, 1918 198
9.9	Ze'ev Raban, Cover of an envelope containing a series of postcards dedicated to *The Jewish Battalions in Palestine*, 1918. Courtesy of Dafna Winter, the Artist's Estate, Jerusalem 199
9.10a	Bezalel Workshops, The *Judaea capta coin*, ceramic tile decoration on an entrance lobby column in Bialik's house, Tel Aviv. Photo courtesy Wikipedia, By Talmoryair—Own work, CC BY 3.0 199
9.10b	Bezalel Workshops, The *Judea Frees Herself Coin*, ceramic tile decoration on an entrance lobby column in Bialik's house, Tel Aviv. Photo courtesy Wikipedia, By Talmoryair—Own work, CC BY 3.0 199
9.11	New Year's greeting card, New York, early 20th century 200
9.12	Official flag of the *Beytar* Association in Dieburg, Germany; the inscription in Hebrew reads In blood and fire Judea fell—in blood and fire Judea will rise 201
9.13a	Michael Kara, *Judea Restituta* (sketch for a proposed medal), 1949, plaster relief (whereabouts unknown), photograph. Author's collection 202
9.13b	Michael Kara, *Judea Restituta* (sketch for a proposed medal), 1949, plaster relief, Boaz Kritchmer's collection. Photo courtesy Boaz Kritchmer, Kibbutz Tze'elim 202
9.14	*Envelope commemorating the country's first Independence Day*, 1949. Photo courtesy Israel Philatelic Authorities 203
9.15	Oteh Walisch, *Ten Years of Liberty (ISRAEL LIBERATA)*, 1958, gold medal, circumference: 2.7 cm 204

9.16a	Studio Roli (Rothchild and Lifman), sketches for *ISRAEL LIBERATED* 1948, 1958, plaster casts, Boaz Kritchmer's collection, Photo courtesy Boaz Kritchmer, Kibbutz Tze'elim 205
9.16b	Studio Roli (Rothschild and Lifman), *JUDEA CAPTIVE 70 CE ISRAEL LIBERATED* 1948, 1958, bronze medal, circumference: 60 mm 205
9.17	Ilan Molcho, *Yehuda haShvuya* (The Captured Judea), 1984, poster. Photo courtesy Ian Molcho 207
10.1	Illustration for "To Him who led his People in the Wilderness" in *The Florsheim Haggadah*, ca. 1503. North Italy, Zurich, Florsheim Collection 212
10.2	Jacob Judah Leon Templo, *Retrato del Tabernaculo de Moseh* (Description of Moses' Tabernacle), 1654, Amsterdam: Gillis Joosten, Leeds Collection 212
10.3	Frontispiece to a Geneva version of the *Bible*, London 1599, Lib., Bib. Eng. 1599e.3(1), first title page, Bodleian Library, Oxford 214
10.3a	Frontispiece to a Geneva version of the *Bible*, details 214
10.4	The Patriarchs banners as described in *Numbers Rabbah*. Reconstruction by the author. The pairs are (top to bottom, left to right) Reuben and Levi, Simeon and Judah, Issachar and Zebulun, Dan and Gad, Naphtali and Asher, Ephraim-Manasse and Benjamin 217
10.5	Jan Luyken Willem Goeree, *The Emblems of the Twelve Tribes of Israel*, illustration in a Dutch Bible, 1683 219
10.6	Artist unknown, *Emblem of the Tribe of Zebulun* (right) and *Emblem of the Tribe of Dan*, late 19th century, wall paintings on the Torah Ark, Synagogue in Cekiske, Lithuania. Photo: Vitalii Cerviakov courtesy of The Center for Jewish Art, The Hebrew University, Jerusalem 219
10.7, 10.8	Avraham Mendel Grünberg (Grinberg), *Banner of the Tribe of Judah, Banner of the Tribe of Zebulun*, wall paintings, ca. 1900–1920, The Great Synagogue in Harlau, Romania. Photo by Boris Khaimovitch, courtesy of The Center for Jewish Art, The Hebrew University, Jerusalem 220
10.9, 10.10	Avraham Mendel Grünberg (Grinberg), *Banner of the Tribe of Zebulun, Banner of the Tribe of Benjamin*, wall paintings, 1927–1928, Grain Merchants' Synagogue in Bacau, Romania. Photo by Boris Khaimovitch, courtesy of The Center for Jewish Art, The Hebrew University, Jerusalem 220
10.11	*The Essen Synagogue*, inaugurated 1913, destroyed during *Kristallnacht* 1938 and restored in 1994. Photo courtesy of Stadt Essen, Peter Prengel 221
10.12	Essen Synagogue bronze doors, 1913. Photos published in Edmund Körner, *Neue Synagoge Essen Ruhr* (Mit Text von Richard Klapheck), Berlin 1914, p. 55 (right door) p. 56 (left door) 221

10.13	Ephraim Mose Lilien, *Illustration for Das Wunderschiff* (The Ship of Wonders), in *Lieder des Ghetto* (Songs of the Ghetto) by Morris Rosenfeld, Berlin: Calvary Verlag, 1902 223
10.14	Ephraim Mose Lilien, *Frame for Die Bedruckung des Volkes* (Oppression of Nations), chapter in *Bücher des Bibel* (Books of the Bible), 1909 224
10.14a	Ephraim Mose Lilien, *Emblems of The Twelve Tribes of Israel*, details 224
10.15	Ephraim Mose Lilien's stamp collection album, The Israel Museum Library Collection. Photo by the author 225
10.15a	Jewish National Fund, *Twelve Tribes of Israel* stamps 225
10.16	Ephraim Mose Lilien, *Design for the Cover of the Jewish National Fund Golden Book*, ca. 1902 225
10.17	Emil Ranzenhofer (1864–1930), *Jewish National Fund Golden Book Certificate*, 1902 226
10.18	Lewin Epstein Bros. (publishers), Gameboard for *Entry of the Twelve Tribes into the Land of Israel*, Warsaw, 1920s, David Tartakover collection. Photo courtesy David Tartakover 226
10.19	*Banner of the Hebrew Gymnasium in Lodz*, after 1901, 135 × 180 cm, blue and white silk, blue and gold embroidery, Warsaw, Jewish Historical Institute Collection. Photo courtesy Jewish Historical Institute, Warsaw 227
10.20	Friedrich Adler, *The Twelve Tribes*, 1919, stained glass window, made of six parts, 53.5 × 81 cm each, Tel Aviv, Tel Aviv Museum of Art 228
10.21	*Nes haNassi*, the Israeli Presidential Standard 230
10.22	Czech Presidential standard (1918–1939), 1945–1960 231
10.23	French President Vincent Auriol's standard 1947–1954 231
10.24	Shalom (Siegfried) Seba, *The Twelve Tribes of Israel*, sketches for stained glass windows, watercolor on transparent paper, ca. 1953–1955, 37 × 12 cm, Joe Lipshitz collection. Photo courtesy Joe Lipshitz 232
10.24a	Shalom (Siegfried) Seba, *The Twelve Tribes of Israel*, detail, *Judah* 233
10.24b	Shalom (Siegfried) Seba, *The Twelve Tribes of Israel*, detail, *Benjamin* 234
10.24c	Shalom (Siegfried) Seba, *The Twelve Tribes of Israel*, detail, *Naphtali* 235
10.25	Oteh Walisch, *The Menorah Stamp*, 1952. Photo courtesy Israel Postal Services 237
10.25a	First-day issue envelope, 27.2.1952. Photo courtesy Israel Postal Services 237

10.26	George Hamori, *Twelve Tribes of Israel Stamps*, 1956. Photo courtesy Israel Postal Services 238
10.26a	*Map of the Twelve Tribes' Estates*, illustration on a first-day of issue envelope for the *Twelve Tribes of Israel* stamp series, 1956. Photo courtesy Israel Postal Services 238
10.27	Haifa's *Municipal Emblem* 240
10.28	Jerusalem's *Municipal Emblem* 240
10.29a, b, c, d	from left to right: *Mateh Yehuda* [Judah] Regional Council; *Mateh Binyamin* [Benjamin] Regional Council; *Bney Shim'on* [Simeon] Regional Council; *Mateh Asher* Regional Council 241
11.1	Zim, *Poster for Shavuot*. 1950s, published by The Elementary School and Kindergarten Teachers' Council for The Jewish National Fund of Israel. Author's collection. Photo by the author 249
11.2	Artist unknown, *Chag haShavu'ot—Chag haBikurim* (Festival of Shavuot—Festival of the First Fruits), 1950s, published by The Jewish National Fund of Israel. Author's collection. Photo by the author 249
11.3	Bezalel Ceramic Workshops, *Pomegranates, Grapevines*, detail of *The Seven Kinds* decorations, 1923, ceramic tiles, façade of the *Moshav Zkenim Synagogue*, Tel Aviv. Photo courtesy Zvika Zelikowitch 250
11.4	Hasmonean coins 251
11.5	Bar Kochva coin, 134–135 CE 251
11.6	Oteh Walisch, *Do'ar Ivri* (Hebrew Post) stamp, 1948. Photo courtesy Israel Postal Services 252
11.7	The *Pruta* series of Israeli coins, 1952. Photo courtesy Bank of Israel 252
11.8	Bezalel Ceramic Workshops, *Spies*, 1934, ceramic tile decorations on the fireplace in Bialik's House, Tel Aviv. Photo by the author 253
11.9	Avraham Soskin (photographer), *Daughters of Judea—Present Day* (Sisters Fira [left, the author's mother) and Ida Wissotzky, students at the *Herzliya* Gymnasium), 1920s, souvenir postcard. Author's collection. Photograph by the author 253
11.10, 11.11, 11.12	Shepherd, *'Those who sow with Tears,' 'Those who Reap with Joy'*, 1925, ceramic tile decorations on the Lederberg House, Allenby Street, Tel Aviv. Photo courtesy Zvika Zelikowitch 255
11.13	Herzl's cypress tree in *Motzah*, photograph from the 1920s 255
11.14	Moshe ben Itzchak Mizrachi, *Mizrach*, 1920s, poster. Photo courtesy Wikipedia, By www.pikiwiki.org.il, CC BY 2.5 257
11.15	Illustration for *Herzl's Cypress Tree*, in Y. Weingarten *Third Textbook, for Language and Spelling*, Tel Aviv and Warsaw, 1937 257

11.16	Bezalel Carpet Workshop, *Abraham Tamarisk Tree, Mount Sinai, Herzl's Cedar Tree*, ca. 1910, silk tapestry 258
11.17	Aharon Shaul Shur, *The Cornerstone of the Hebrew University in Jerusalem*, 1920s, oil on canvas, 25 × 35 cm, Vera and Chaim Weitzman's House collection, Rechovot. Photograph by the author 258
11.17a	Avraham Melavsky, *Laying the Cornerstone to the Hebrew University on Mount Scopus, 24.7.1918*. Photo courtesy The Jewish National Fund Archive 259
11.18	The *Viola tricolor* flower, called *Amnon veTamar* in Hebrew 260
11.19	*Chavatzelet*, Illustration in *Schiot haMikra* (Treasures of the Bible) 261
11.20	*Shoshana*, Illustration in *Schiot haMikra* (Treasures of the Bible) 262
11.21	Zvi Livni, *Nesher, Rakefet* (Vulture, Cyclamen), illustration in Smoli, *Yafa at Artzenu, Sipurim al ha'Chai vehaTzomeach* [You are Beautiful, our Country: Stories of Fauna and Flora], Yavne, Tel Aviv, 1951 263
11.22	Baruch Ur, *Illustration for haRakefet* (Cyclamen) in Levin Kipnis *Tzmacahi, Prachai* (My Plants, my Flowers) ca. 1950 265
11.23	Baruch Ur, *haNarkis* (Narcissus) in Levin Kipnis *Tzmacahi, Prachai* (My Plants, my Flowers) ca. 1950 265
11.24	Zvi Livni, *Saknai, Narkis* (Pelican, Narcissus), illustration in Smoli, *Yafa at Artzenu, Sipurim al ha'Chai vehaTzome'ach* [You are Beautiful, our Country: Stories of Fauna and Flora], Yavne, Tel Aviv, 1951 267
11.25	Oteh Walisch, *Independence Day Stamp*, 1952. Photo courtesy Israel Postal Services 269
11.26	Oteh Walisch, *Independence Day Stamp*, 1954. Photo courtesy Israel Postal Services 270
11.27	Zvi Narkis, *Independence Day Stamps*, 1959. Photo courtesy Israel Postal Services 271
11.28	Michael Gross, *Ish Aino Mevin Shuv Rakafot* [Nobody Understands Cyclamens Anymore], 1978, silkscreen print. Photo courtesy Tel Aviv Museum of Art, Tel Aviv 272
11.29	Moshe Gershuni, *Yom Aviv Yavo veRakafot Tifrachna* (A Spring day would Come and Cyclamens would Bloom), 1981, silkscreen print. Photo courtesy Moshe Gershuni Estate, Tel Aviv 273
11.30	David Tartakover, *Ke'ev* (or *Ke'av*) (Pain or as a father), 1989, poster. Photo courtesy of the artist 275
11.31	David Reeb, *Kalaniyot III* (Anemones III), 2013, oil on canvas. Photo courtesy of the artist 276
11.32	Uri Gershuni, *Aviv* (Spring), a series of color photographs, 90 × 120 cm, 30 × 40 cm. Photo courtesy of the artist 277

11.33	Eli Shamir, *Persephone*, 1992, oil on canvas, 183 × 121.5 cm. Photo courtesy of the artist 278
11.34	Michal Shamir, *Untitled*, 2000, candies and gumdrops on a metal armature. Photo courtesy of the artist 279
11.35	Ilan Averbuch, *Havtachot, Havtachot* (Promises, Promises), 1990s, rocks, wooden railway beams. Photo courtesy The Open Museum, Tefen 280
11.36	Larry Abramson, *Rose of Jericho III*, 2003, oil and acrylic on canvas, 38 × 38 cm, Photo courtesy of the artist 281
11.37	Assim Abu Shakra, *Untitled*, 1988, pencil and watercolor on paper, 14 × 14 cm. Photo courtesy of El-Sabach non-profit Organization, Um el Fahem 283
11.38	Micha Kirschner, *Abba Eban*, 1996, from the series *The Israelis*, published in the daily newspaper *Ma'ariv*. Photo courtesy of the photographer's estate 284
12.1	Ancient Hebrew script (left), Hebrew Aramaic script 288
12.2	Hebrew letters *reysh* and *mem* extended 289
12.3	The *Bomberg* typeface, ca. 1520 290
12.4	Christofal van Dijk, the *Amsterdam* typeface 290
12.5	The *Meruba* typeface 290
12.6ab.c	Cover of *Milgroim* (1922), *the Letter aleph, the word Yayin* (wine). Photo by the author 291
12.7	*Initial word in a Passover Haggadah*, Germany, 18th century 291
12.7a	Joseph Budko, *Initial Word in a Passover Haggadah*, 1914 291
12.8	Experiments with Hebrew letters by Bezalel students, published in *Ost und West*, 1904 292
12.9	Levin Kipnis and Ze'ev Raban, *Aleph Bet*, Berlin, *haSefer* Publication, 1923 292
12.9a	Kipnis and Raban, *Aleph Bet*, details 292
12.10	The *Frank-Rühl* typeface 293
12.11	*The Berthold Letter Casting Firm Catalog*, 1924 294
12.12	Hebrew initial letters in the *Berthold* catalog, 1924 295
12.13	The *Chaim* typeface 297
12.14	The *Aharoni* typeface 297
12.15a, 11.15b	An Israeli announcement, 1948; an Egyptian announcement, 1948 297
12.16	Ismar avid, the *David* typeface, 1954 298
12.17	Henry Friedlander, the *Hadassah* typeface, 1958 299
12.17a, b, c, d	from right to left: *aleph* in *Frank Rühl*, in *Hadassah*, in *Haaretz* newspaper logo, in *David* typeface 299

ILLUSTRATIONS XXIII

12.18	David Tartakover, *Poster for Claude Lantzman's film Shoah*, 1986. Photo courtesy of the artist 300
12.19	David Tartakover, *Logo for Shalom Achshav* (Peace Now) movement, 1978. Photo courtesy of the artist 301
12.20	Eliyahu Koren (Korngold), The *Koren* typeface 302
12.21	"A wife of noble character who can find?" (Proverbs 31, 10), 1995, poster, author's collection. Photo by the author 303
12.22	Michael Sgan-Cohen, *Kamatz Patach*, 1982, acrylic on canvas (diptych), 46 × 30 cm, private collection. Photo courtesy the artist's estate 304
12.23	Michael Sgan-Cohen, *Yod He Vav He* [Y, H, W, H], 1980, acrylic on canvas, four units, 7 × 12.5 cm each, David Tartakover collection. Photo courtesy the artist's estate 305
12.24	Drora Dominey, *Tub with Diacritical Vowels*, 1993, aluminum cast, 30 × 35 × 80 cm. Photo courtesy of the artist 306
12.25	Hila Lulu Lin, *Ptzatza Metaktekteket* (Tick-ticking Bomb), 2002, painted wooden box, silk-screen print, mirror. Photo courtesy of the artist 307
12.26	David Rakia, *Letters Hovering in the air*, oil on canvas 308
12.27	Sharon Shrem, *Ancient Hebrew Script Font for Use on the Computer*, 2001, brochures, author's collection. Photo by the author 309
13.1	Herzl's Funeral, photo in *Ost und West*, July 1904 316
13.2	Herzl's tomb in Vienna 316
13.3	Herzl's tomb in Jerusalem 316
13.4a, b	Herzl's coffin on a platform, Parliament Plaza, Tel Aviv, 1949. Photo courtesy Central Zionist Archive, Jerusalem 318
13.5	Yosef Klarwein's design for Herzl's burial ceremony in Jerusalem, 1949. Photo courtesy Central Zionist Archive, Jerusalem 319
13.6	Earth-bag carriers at Theodor Herzl's re-burial ceremony in Jerusalem, 1949. Photo courtesy Central Zionist Archive, Jerusalem 320
13.7a, b	Yosef Klarwein, *Proposal for Theodor Herzl's Burial Site*, 1949. Photo courtesy Central Zionist Archive, Jerusalem 325
13.7c	Yosef Klarwein, *Proposal for Theodor Herzl's burial site*, detail, the dome. Photo courtesy Central Zionist Archive, Jerusalem 325
13.8a	Yitzhak Danziger and Shalgi, *Proposal for Theodor Herzl's Burial Site*, 1949. Photograph from the archive of photographer Israel Zafrir. Photo courtesy of The Information Center for Israeli Art, The Israel Museum, Jerusalem 327
13.8b	Yitzhak Danziger and Shalgi, *Proposal for Theodor Herzl's Burial Site*, detail. Photograph from the archive of photographer Israel Zafrir. Photo courtesy of The Information Center for Israeli Art, The Israel Museum, Jerusalem 327
13.9a	A plaza in front of Herzl's tomb. Jerusalem, Mount Herzl, 1978 333

13.9b	Plaza in front of Herzl's tomb. Jerusalem, Mount Herzl, 2011. Photo courtesy Wikipedia, By www.pikiwiki.org.il, CC BY 2.5 333
14.1	Natan Rapoport's *Memorial for the Warsaw Ghetto Fighters*, ca. 1950, postcard issued by The Jewish National Fund. Author's collection. Photo by the author 336
14.2	Natan Rapoport, *Memorial for the Warsaw Ghetto Heroes*, 1949, bronze sculpture, Warsaw. Photo by the author 337
14.3	Natan Rapoport, *First Model for the Anilewizc Memorial* in Yad Mordechai 1949 (first version). Photo courtesy Kibbutz Yad Mordechai Archive 340
14.4	Vera Muchina, *Factory and Kolchoz Workers*, 1937, stainless-steel plates on an iron skeleton, Moscow. Photo by the author 340
14.5	Natan Rapoport, *Plaster model for the Memorial of the Fallen in Kibbutz Yad Mordechai*, 1949. Photo courtesy Kibbutz Yad Mordechai Archive 341
14.6a, b	Natan Rapoport, *Second model for the Anilewizc Memorial* in Yad Mordechai. Photo courtesy Kibbutz Yad Mordechai Archive 342
14.7	Natan Rapoport, *Memorial for Mordechai Anilewizc*, 1949–1951, bronze, Kibbutz Yad Mordechai. Photo by the author 343
14.8	Natan Rapoport, *Plaster model for Mordechai Anilewizc*, detail of fig. 14.6a 345
14.9	Mordechai Anilewizc (1919–1943), (photograph) 345
14.10	Nachum Gutman, *Man of Kibbutz Gat*, 1949, pen and ink drawing, from the artist's book *Chayot haNegev* (The Negev Beasts). Photo courtesy Nachum Gutman Museum of Art, Tel Aviv 348
14.11	Natan Rapoport, *Model for the Negba Memorial*, clay relief, Kibbutz Negba. Photo courtesy Kibbutz Yad Mordechai Archive 349
14.12	Natan Rapoport, *Model for the Negba Memorial*, plaster relief, Kibbutz Negba. Photo by the author 350
14.13a	Natan Rapoport, *Model for the Negba Memorial*, clay. Photo courtesy Kibbutz Yad Mordechai Archive 351
14.13b	Natan Rapoport, *Model for the Negba Memorial*, clay. Photo courtesy Kibbutz Yad Mordechai Archive 352
14.14	Joseph Torak, *Fraternity*, 1937, bronze, sculpture for the German Pavilion in the Paris International Exhibition 352
14.15	Yosef Friedman, *The Execution Committee*, illustration in a daily newspaper, 1948 353
14.16	Natan Rapoport, *The Negba Memorial*, 1953, bronze, Kibbutz Negba 354
14.16a	Natan Rapoport, *The Negba Memorial*, detail 355
15.1a	P. Casella, J. Jarnuskiewicz, J. Falka, F. Simoncini, *Final Plan for the Auschwitz Memorial*, 1964, model 361

ILLUSTRATIONS XXV

15.1b, c *The Auschwitz Memorial*, 1967, height: 7 meters 361

15.2 *Bergen Belzen Memorial* 362

15.3a, b Arieh Elchanani, Arieh Sharon, Binyamin Idelsohn, *Ohel Izkor* (Memorial Tent), 1961, Jerusalem, Yad Vashem compound. Photo courtesy Yad Vashem, Jerusalem 362

15.3c Bezalel Schatz, *Entrance Gate to Ohel Yizkor*, 1961, iron, Jerusalem, Yad Vashem compound. Photo courtesy Yad Vashem, Jerusalem 362

15.3d David Polombo, *Entrance Gate to Ohel Yizkor*, 1961, iron, Jerusalem, Yad Vashem compound. Photo courtesy Yad Vashem, Jerusalem 363

15.4 Yigal Tumarkin, *Sketch for The Holocaust and Resurrection of Israel Memorial*. Photo courtesy Tel Aviv Municipality Archive 368

15.5 Yigal Tumarkin, *The Holocaust and Resurrection of Israel Memorial*, 1975, steel, painted concrete, bronze relief, Tel Aviv, Rabin Square. Photo by the author 369

15.5a, b Yigal Tumarkin, *The Holocaust and Resurrection of Israel Memorial*, details. Photos by the author 370

15.5c Yigal Tumarkin, *The Ecological Pool* next to *The Holocaust and Resurrection of Israel Memorial*. Photo by the author 371

16.1 Ro'ee Rosen, *Gvarim beTarbut Israel (Mezukanim)* (Men in Israeli Culture [Bearded]), 2004, photograph, 150 × 120 cm. [standing from right to left]: Joshua Simon, Gil Shani, Roy Arad, Noam Yuran, Boaz Arad, Doron Solomons, Dan Shadur, Gabi ben Moshe; [seated, from right to left]: Aim Deuelle-Luski, Doron Rabina, Yair Garbuz, Adi Ofir, Moshe Zuckerman. Photo courtesy of the artist 374

16.2 Shalom (Siegfried) Seba, *Moses about to Break the Tablets of the Law*, 1947–1953, tempera and gouache on paper. Joe Lipshitz Collection. Photo courtesy Joe Lipshitz 377

16.3 Chaim Ma'or, *haKtonet Bincha Hee?* (Know now whether it be thy son's coat or no), 1978, photograph, text and shirt on plywood. Photo courtesy of the artist 378

16.4 Vered Aharonovitch, *Untitled*, 2011, polyester and marble dust, 40 × 50 × 90 cm. Photo courtesy of the artist 379

16.5 *Bird's Head Haggadah*, ca. 1330, south Germany. Photo courtesy Wikipedia Menahem Details of artist on Google Art Project 380

16.6 Michael Sgan-Cohen, *The Wandering Jew*, 1983, acrylic and pencil on cloth, diptych, 108 × 212 cm, the artist's estate. Photo courtesy the artist's estate 381

16.7 David Morris, *Chicago Bulls Kettle*, 1993, wood-fired clay, 47 × 14 × 10 cm. Photo courtesy of the artist 384

16.8	Miriam Gamburd, *Kruvim Me'urim Ze baZeh* (Cherubs Intertwined), 2002, pastel chalks on paper, 50 × 70 cm. Author's collection. Photo by the author	388
16.9	Printed page in Assi Meshulam's *Ro'achem*. Author's collection. Photo by the author	390
16.10	Assi Meshullam, *Ya'akov* (Jacob), 2011, mixed media. Photo courtesy of the artist	391
16.11	Assi Meshullam, *David*, 2011, mixed media. Photo courtesy of the artist	391
16.12	Yocheved Weinfeld, *Nida*, 1976, 8 photographs documenting a performance enacted at the Debel Gallery, Eyn Karem. Photo courtesy Wikipedia, By Yocheved Weinfeld—Yocheved Weinfeld, CC BY-SA 3.0	393
16.13	Michael Druks, *Hitbonenut laMizrach* (Looking towards the East), 1977, staged photograph, from the Collection of Mishkan, Museum of Art, Ein Charod, Israel. Photo courtesy Mishkan, Museum of Art, Ein Charod	394
16.14	Moshe Gershuni, *Le'Eyla ule'Eyla Min Kol Birkata* (Beyond any Blessing and Song), 1988, china plate decorated with ceramic glazing inscriptions and stains. Photo courtesy the artist's estate	395
16.15	Arnon ben David, *Jewish Art*, 1988, plastic toy gun, anti-rust paint, cloth and ink on plywood, David Tartakover collection, Tel Aviv, Photo courtesy of the collector	398

Note on Terms and Transliteration

Eretz Yisrael (The Land of Israel), Palestine and *Yishuv* are terms referring to the geographical area that was not a single official political entity during the period under Ottoman rule (until 1917) and the British Mandate period (1917–1948). Consequently, this book uses them in different contexts. The term Palestine is used in references made to this region's general historical period. The Hebrew word *Yishuv* (literally settlement) is the accepted term used when referring to the Jewish population of Palestine, prior to the establishment of the sovereign state of Israel in 1948. The Hebrew term *Eretz Yisrael* (Land of Israel) is used in two different contexts: it is the common term for the country, referred to in the Bible and in later historical periods leading to the destruction of Jerusalem in 70 CE. The other context of the term is its Jewish-Zionist usage as an equivalent of the universal term Palestine, in scholarly publications.

The transliteration of words in Hebrew, geared for the convenience of reading, marks the definite article (the letter *hey* in Hebrew—ה), prepositions and cases when a letter appears twice consecutively as a vowel and a consonant by an apostrophe, i.e., *ha'Aretz, Aachad ha'Am*. Hebrew consonants that do not exist in English are transliterated as follows: letters ח (as in *Pesach*) and כ ך, (as in *rach* [soft] = ch; the letters ס and שׂ (as in moss = s; the letter צ as in pizza = tz. Hebrew vowels are as follows: *a* as in father, *e* as in bed, *i* or *ee* as in beet, *o* as in hot, *u* as in book. Transliteration quoted throughout the text and bibliography are by the author except where an English version exists.

Introduction

How does one begin to describe the complex phenomenon of Israeli visual culture's link with Jewish tradition? Two mundane instances immediately come to mind: the way the country chooses to introduce itself to incoming visitors and the everyday use of its currency.

On the slanting pathway that leads to passport control at Ben Gurion airport, visitors encounter three ancient mosaics, fixed to a high wall (fig. 0.1). They were given to the Israeli Airport Authorities by the Israeli Antiquities Authorities in 2004, at the inauguration of the new airport terminal. The mosaics serve as something beyond a merely decorative function; they intend to tell visitors that they have arrived at a place which is both contemporary and ancient, a place where Jews lived in the past and have resettled themselves there through Zionism. The decision to greet visitors with ancient findings attests to local archeology as the source for the Zionist concept of an unbroken sequence during which Jewish presence at the particular geographical site never stopped.[1]

Recently, the Bank of Israel issued two new bank notes (December 2017); a twenty Israeli shekel bill (fig. 0.2) depicting a portrait of the poet Rachel, and a hundred Israeli shekel bill with the portrait of poet Leah Goldberg (fig. 0.3). The two female poets' bills were preceded by two others, depicting portraits of male poets Shaul Tchernichovsky and Natan Alterman (discussed in chapter 2).

Bank of Israel officials created a long sought after balance by including female cultural heroines on the newly issued banknotes. However, they did not expect to be criticized by a small section of Israeli society, let alone that the latter would physically violate the newly issued bills because they depict images of women. An extreme Jewish Orthodox group advised its male members to refrain from using the new female bills; some even went as far as disfiguring them with black ink.

Fortunately, this contemporary *iconoclasm* is indeed the act of a minority group in Israeli society. Nevertheless, due to political considerations of every government coalition with the clerical parties in Israel, the latter's views concerning visual images influence politicians and slowly penetrate every phase of Israeli culture. Accordingly, Israeli artists and designers' adherence or rejection of the Second Commandment that allegedly prohibits the depiction of human

1 Quite surprisingly the mosaics, taken from archeological sites at Caesaria, Beyt Sh'ean (Schitopolis) and a site near Nazareth do not exhibit any Jewish themes.

FIGURE 0.1 Three ancient mosaics on Ben Gurion airport wall, 2004

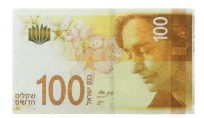 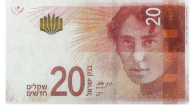

FIGURES 0.2, 0.3 Osnat Eshel, *Israeli banknote of 20 new Israeli shekels with a portrait of Poet Rachel*, 2017, *Israeli banknote of 100 new Israeli shekels with a portrait of Poet Leah Goldberg*, 2017

figures images, and the obsession with local archeology run like a golden thread throughout the discussions in this book.

As historical analyses of Diaspora Jewish visual culture blossom in quantity and sophistication, this book analyzes 19th–20th-century developments during Israel's pre-state period (up to 1948) and later the State of Israel. In the course of these approximately one hundred years, Zionist Israelis developed a visual corpus and artistic lexicon of Jewish-Israeli icons as an anchor for the emerging civil religion. Bridging internal tensions and even paradoxes, artists dynamically adopted, responded to, and adapted significant Diaspora influences for Jewish-Israeli purposes, as well as Jewish religious themes for secular goals, all in the name of creating a new state with its own paradoxes, simultaneously styled on the Enlightenment nation-state and Jewish peoplehood.

Next to Israeli canonical works of art, this book deals with emblems, banners, flags, coins, banknotes, stamps, posters, book illustrations, architectural decorations, New Years' greeting cards and other popular Israeli visual means of communication conveying Zionist messages. They express national awareness and are used as concise means of communication, endowed by great evocative powers for the spread of Zionist ideas, ideals, and dogmas, formerly expressed only in verbal sources such as literature, political essays, popular lyrics, and poetry. They became common knowledge and are taken for granted; nevertheless, their design process and the ideas that contributed to their formation make a significant part of this research. Formal, historical and iconographic analyses of these images reveal behind-the-scene phenomena involved in their creation process. All of them are based on Jewish and Israeli myths, epic stories, and legends in various forms. Themes expressed in visual terms are injected with symbolic elements, relevant to a particular historical period.

The fact that most artists living and creating in Israel are Jewish is taken for granted by those who document the history of Israeli art; they almost disregard the point as they aim to stress the reputation of Israeli artists as belonging to the contemporary international artistic circles. Only eight books dedicated to the general history of art, produced during the pre-state period and in Israel, even exist. A small number, considering the time span of more than a hundred years they cover. In comparison with the number of publications dedicated to Hebrew literature in Israel, such a number is bordering on the absurd and reflects a certain reality. The following are the general historical documentation of art created in pre-state and Israel:

> Karl Schwartz, *haOmanut haYehudit haChadasha be'Eretz Israel* (New Jewish Art in The Land of Israel), 1941;
>
> Chaim Gamzu, *Tziur vePisool be'Israel, Hayetzira haOmanutit be'Eretz Israel baChamishim haShanim ha'Achronot* (Painting and Sculpture in Israel, Artistic creation in the Land of Israel in the past fifty years), 1957;

Binyamin Tammuz (editor), Yona Fisher, Mira Friedman, Aviya Hashimshoni, John Chaney, *Omanut Israel* (The Art of Israel), 1963;
Ran Schechori, *Art in Israel*, 1974;
Binyamin Tamuz, Dorit Leviteh, Gideon Ofrat, *Sipura shel Omanut Israel, Mimey Bezalel be-1906 ve'ad Yameynu* (The Story of Israeli art from the Bezalel Days in 1906 to our Time), 1980;
Amnon Barzel, *Art in Israel*, 1987;
Gideon Ofrat, *100 Years of Art in Israel*, 1998;
Yigal Zalmona, *Me'ah Shnot Omanut Israelit* (One Hundred Years of Israeli art), 2013.

Two approaches characterize these books' historical documentation of the history of Israeli art: one that identifies it as a unique phenomenon and therefore calls it Israeli Art.[2] The other does not recognize in it specific stylistic traits (except, perhaps, its subject matter) and therefore labels it as Art in Israel.[3] The two approaches brought scholars to value judgment. The first approach refers to certain trends in local art as patriotic, movements whose aim is to seek specific, unique Israeli characteristics. Other trends are labeled universal.' The latter term is given a higher status than the patriotic approach because patriotism is commonly seen contemptuously as propaganda art serving the Zionist Establishment and therefore no art for art's sake.

Few attempts at current historical research were able to refute some of the pre-conceived notions that characterize this value judgment. The following publications deal with specific historical periods, styles and particular themes; their specificity sets them apart from the above mentioned general historical documentation books.

The retrospective exhibition of *Kvutzat haAassara* (The Group of Ten)[4] (and the articles included in the catalog accompanying it) held at the Ramat Gan Museum of Israeli Art (1992) is a relevant example. It deals with a group of Israeli artists who mutinied against the prevailing abstract trend in the Israeli art field of the 1950s and 1960s by proclaiming that they seek unique, local characteristics which they wish to convey. Gideon Ofrat's various publications made significant contributions to the research of Israeli art in general and specifically to its unique symbolism. In most of his scholarly publications, Ofrat deals with specific motifs, themes and various Zionist narratives presenting their visual expressions in contexts such as contemporary poetry and

2 So do Tamuz's book of 1980 and Zalmona's of 2013.
3 So do Schwartz's book of 1941, Gamzu's of 1957, Schechori's of 1974 and Barzel's of 1987.
4 A group of Israeli artists from the 1950s who claimed to create Israeli characteristics in their works of art.

INTRODUCTION

literature.[5] Other scholarly publications discuss mainly the Jewish symbolism of different periods of the *Bezalel* School of Arts and Crafts.[6] The *Lichiot eem haChalom* (Living with the Dream) exhibition, curated by Batya Doner at the Tel Aviv Museum of Art (1989) surveyed iconic Israeli images, such as soldiers, high officials, and Zionist-Israeli personifications and allegorical figures. David Tartakover curated several exhibitions in which he showed, among others, hallowed images of Zionist leader Theodor Herzl, and game boards of Zionist-Israeli children's games.[7] All of the above make significant contributions to the research of symbols and visual motifs in Israeli culture.

One of the reasons for the inadequate involvement with the visual manifestations of Zionist ideas stems from a fundamental Jewish concept still prevailing in Israeli culture: the high level in the hierarchy of artistic creativity given to the verbal as opposed to the visual. The lower social status of Boris Schatz, founder and director of Bezalel School of arts and crafts in Jerusalem to that of the national poet Chaim Nachman Bialik, makes a prime example. A Hebrew poet, enjoying a generous public's tremendous support and popular admiration bordering on a personality cult, as opposed to a Hebrew artist, shunned by most of his contemporaries. This unique hierarchy is backed by a common, popular, but erroneous assumption that Judaism abhors the visual. It is based on the biblical interpretation of the Second Commandment which forbids the making of graven images.

When it comes to visual images, none of the books mentioned above refer to the most significant and relevant components of Jewish traditional rabbinic attitude and commentaries of the biblical Second Commandment. But needless to say, it is impossible not to write a survey on Jewish artists' works, including Israeli artists, without referring to this matter.

The 1990s show a significant surge of research devoted to Judaism's attitude towards the visual; Richard. I. Cohen's *Jewish Icons, Art and Society in Modern Europe* (1998), Kalman P. Bland's *The Artless Jew, Medieval and Modern Affirmations of the Visual* (2001) and Vivian Mann's *Jewish Texts on the Visual Arts* (2000) stand out as most significant. The authors of these texts relate mainly to Diasporic Judaism (Cohen dedicates a short chapter to implementations of Jewish visual preoccupations in the Bezalel School of Arts and Crafts

5 *Eem haGav laYam, Dimuyey haMakom beOmanut Israel uveSifruta* (With one's Back to the Sea, Images of the Place in Israeli Art and its Literature), Omanut Israel, 1990.
6 Yigal Zalmona, Nurit Shilo Cohen, *Bezalel shel Schatz* (Schatz's Bezalel); Dalia Manor, *Art in Zion: The Genesis of Modern National Art in Jewish Palestine* (London: 2005) is the most comprehensive academic discussion of the Bezalel period during the *Yishuv* period art.
7 David Tartakover (curator), *Tiyul ba'Aretz, Mischakim meChanuto shel Barlewi* (A Trip Across the Country, Games from Barlewy's Store), Tel Aviv: Ha'Aretz Museum, 1990.

in Jerusalem). Following such distinguished publications, this book purports to discuss historical-cultural analyses of a similar phenomenon, or, rather its continuation that took place during Israel's pre-state years and later on the sovereign State of Israel.

Zionist-Israeli linkage with Jewish Diaspora is a combination of two polarized approaches: rejection and admiration. Zionist negation of the Diaspora was part of its all-encompassing aim of creating a new Jew in its old-present homeland, and this concept was acted upon by most Israeli artists during the 1950s by the trend of abstraction. Their abstract works had nothing to do with subject matter, let alone Jewish. It was only during the late 1960 and especially in the 1970s that Israeli artists showed interest in Jewish art by getting familiar with Jewish aesthetes and theoreticians' writings (especially from the United States) in which they voiced their deliberations in everything that concerns the existence of Jewish art. Becoming familiar with such publications by a certain number of Israeli artists allowed for similar deliberations concerning their own Jewish identity: Clement Greenberg's and Harold Rosenberg's publications especially, Robert Pincus Witten and Abraham Kampf.[8] All through the 1960s, the New York-based *Commentary* journal acquired a significant stance in Modern Jewish culture.

"Is there a Jewish art?," so Rosenberg begins one of his articles;[9] "First they build a Jewish Museum, and then they ask 'is there a Jewish art. Jews!' He then answers his own question in the affirmative and adds that when Jews are asked this question, they retort by what he claims as a Jewish trait by answering a question with a question: "What do you mean by Jewish art?"[10] Rosenberg then describes what is meant by the term Jewish art and offers four ways for its identification: Jewish artists create Jewish art; Jewish art is an art that depicts Jewish subjects; Jewish art is a craft of Jewish ritual objects, and Jewish art is an alleged metaphysical Judaica.[11]

Ten years after the publication of Rosenberg's article, preoccupation with the nature of, or even with the mere possible existence of Jewish art, was expressed in a grand exhibition held at the Jewish Museum in New York (1976). It was titled "The Jewish Experience in the Art of the 20th Century," and curated by art historian Abraham Kampf. The attempt to exhibit such a comprehensive subject was bound to raise public controversy both in the

8 Mark Godfrey, "That Old time Jewish Sect Called American Art Criticism," in *Action/Abstraction, Pollock, DeKooning and American Art, 1940–1976* (cat. exh.), New York, New Haven and London: The Jewish Museum and Yale University Press, 2008, 247.
9 Harold Rosenberg, "Is There a Jewish Art?" *Commentary*, July 1966, 67–70.
10 Godfrey, "That Old time Jewish Sect Called American Art Criticism," 248–249.
11 Rosenberg, "Is There a Jewish Art?", 67.

definition of Jewish art and in referring to the choice of works by the curator. Kampf attempted to exhibit seventy years of 20th-century Jewish creativity by European, American and Israeli artists. He focused on two aspects, mentioned beforehand by Rosenberg: Jewish art is an art created by Jews and Jewish art concerning itself with Jewish subjects. He called these phenomena Jewish experience; Rosenberg before him called it Deep Jewish expression.

A short while after the inauguration of the exhibit at the Jewish Museum, Robert Pincus Witten published a critical article "Jewish art—Six Assumptions" in *Arts Magazine*, in which he opposed Kampf's concepts. He contradicted the latter's conception of Jewish art (and that of Rosenberg's) by claiming that "Jewish art is abstract art." The recognition of such a simple fact requires disqualification of all two hundred and sixty items (except a small number of works) of Kampf's choice.[12] Kampf's selections, he claims, are based on Renaissance illusionism which is the polar negation of Judaism. Illusionism is typical of gentile art. A Jewish artist's work that is not abstract is consequently not Jewish.

One problem with Pincus-Witten's concept that he was aware of is the fact that the majority of artists who produce abstract art are not Jewish. He then tried to solve the issue by claiming that "In Israel, one can find the essence of Jewish abstract art." Rosenberg's definition of Jewish art as the product of Jews served Pincus-Witten in naming contemporary Jewish-Israeli artists; he seemed to forget that non-Jewish artists were also living and producing abstract art in Israel. They were held as canonic Israeli artists for their belated abstraction even in the 1970s, after such movements as Abstract Expressionism were highly criticized and consequently replaced by Pop art. He finally expresses a critical view of Israeli art by claiming that "False Cubism and Expressionism continue to be supported in Israel as wishful ..." Confronted by such trivialities that were supported in Israel, he found himself speechless. Two Israeli artists who manifest his theory are Ya'akov Agam (who, although born in Israel, is a French citizen living and working in Paris) and Moshe Kupfermann (1926–2003). The two, according to Pincus-Witten, "Embody more than any other artists the Jewish concept as I see it."

A time span of seventy years separates the first significant Exhibition of Jewish artists held in Berlin in 1907 and the Jewish Experience in the Art of the 20th Century in the Jewish Museum in New York. *Ausstellung Jüdischer Künstler* (Exhibition of Jewish artists) was organized by the German Society for the encouragement of Jewish art. Close to two hundred works were exhibited next to Jewish ritual objects, sent from various synagogues throughout Germany

12 Pincus-Witten's article was translated into Hebrew and published in *Mussag*, 10, 1976.

and the Jewish Museum in Vienna. Organizers of the show concluded that it was impossible to base a straightforward definition to the question "what is Jewish art?" on a single exhibition and therefore left the question open.[13]

During Israel's pre-state period, later to become Jewish Israeli artists were part of this Jewish preoccupation with the definitions of Jewish art. They saw themselves as New Jews, professionals who created local, secular versions of Jewish art produced in the Diaspora at the beginning of the 20th century. The Zionist-held concept claiming that Diasporic Jewish artists' works were old was, of course, completely erroneous, because of lack of knowledge or for deliberately ignoring and dismissing. The idea shows no knowledge of the Jewish renaissance phenomenon, practiced at the end of the 19th century and the beginning of the 20th, especially in Russia where Jewish artists created *avant-guard*, innovative and secular Jewish art that did not represent the old at all.[14] Another center for such activities was Berlin in which a tremendous undertaking of preservation and cataloging of Jewish visual culture took place. Hidden treasures of Jewish aesthetics from the Middle Ages and later historical periods were discovered through an attempt to adapt them to modern design.[15]

Jewish artists who left Eastern Europe and immigrated to Palestine were not familiar with or consciously ignored these contributions made by Jewish *avant-guard* renaissance in Russia that probably did not match their conservative artistic principles. At the beginning of the 20th century, most *yishuv* artists who came from Eastern Europe ignored their Diasporic colleagues' works, their attempts at creating Modern Jewish art, and their deliberations regarding their Jewish identity.

"Is there a Jewish art in Israel?" one may ask; the answer, partial and general, must demand a separation of two Israeli realms: Israeli public space and the private domain of individual artists. In other words, a great difference separates between linkage to Jewish art and tradition when dealing with three-dimensional works in the Israeli public space that are usually subordinated to alleged Jewish laws that the Israeli clerical establishment dictates to their

13 Bat Sheva Goldman Ida, *Bki'eem baMar'ah, Ta'aruchat Omanim Yehudin beBerlin 1907* (Fragmented Mirror, Jewish Artists' Exhibition in Berlin 1907), (exh. cat.), Tel Aviv: Tel Aviv Museum of Art, 2009. Goldman recreated the Berlin Exhibition by collecting several (not all of them) of the works exhibited.
14 Ruth Apter Gabriel (curator), *Bachazarah la'Ayara, An-sky vehaMishlachot haEtnografiyot haYehudiot 1912–1914, me'Osfey haMuzeum haMamlachti le'Etnografiya beSankt Peterburg* (Back to the Shtetl, An-sky and the Jewish Ethnographic Delegations 1912–1914, from the Collections of the National Ethnographic Museum in St. Petersburg), Jerusalem: The Israel Museum, 1994.
15 Especially relevant in this context was *Milgroim*, a magazine dedicated to Modern Jewish culture. It will be discussed in chapter 12.

INTRODUCTION 9

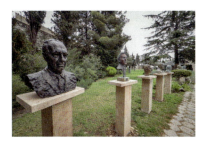

FIGURE 0.4
Busts of presidents of Israel at the Presidential Mansion in Jerusalem

creators. In contrast, works produced by artists in private spaces are free to express their views without limit. At the same time, when it comes to *exhibiting* these private works in public—in official museums, for example, it is possible that due to political pressure they would be rejected. The Herzl tomb project (discussed in chapter 13) and memorials for the Fallen (discussed in chapters 13 and 14) are prime examples for the first realm and its link to Jewish tradition. The refusal of the Tel Aviv Museum to hold an exhibition for David Tartakover's works (discussed in chapter 5) for its political aspects which were regarded by the museum directorship as subversive is another.

In their attempt to concretize a narrative or a national myth visually into a concise visual image, artists and designers are equipped with only three formal elements: line, shape, and color. The choice of a specific color plays a significant part in the design process of an image due to its psychologically suggestive powers. Red may suggest abstract qualities such as passion, love, or danger; green may suggest tranquility, spring, or abundance. Specific colors convey such ideas or concepts as purity, holiness, kingship or peace; others may express such themes as assault, war, or power. Color symbolism in Jewish culture is based primarily on the various references made to it in the Bible, especially those referring to the design of the Tabernacle in the wilderness and the colors of the High Priest's costumes. Some colors are endowed with holy connotations and are tied to God; they are linked with the national aspect of the People of Israel.

The most concise visual images that convey symbolic aspects are icons and symbols. An icon is a sign which bears a resemblance to the phenomenon it stands for, and its image echoes the essence of the object represented; i.e., the Jewish *menorah*, the seven-branched candelabrum of the Temple in Jerusalem. The *menorah* symbolizes the Temple, and indirectly, it stands for the link that binds God and the People of Israel (discussed in chapters 7, 8). Another icon that conveys this theme is the *shofar* (a ram's horn) since it stands for the biblical narrative of the Sacrifice of Isaac and indirectly refers to the covenant between God and the People of Israel (discussed in chapter 13). A symbol is

FIGURE 0.5 Various shapes of *menorah* bases and branches

an arbitrary sign that is not iconic and therefore does not bear a resemblance to the signified whether an object, animal or the like, i.e., the Jewish Star, a geometric shape of a six-pointed star which stands for the Jewish People or Zionism (discussed on chapter 5).

Common to the two visual types is the fact that they are agreed upon both by the designers and their public. They go through a process of codification through which they become conventionalized. Both icons and symbols may be depicted in different variations. The different versions for the portrayal of the Temple *menorah* make a prime example. Its primary image demands that it would comprise of six curved lines, three on each side of a central, vertical line. The differences in representing various types of *menorahs* may be discerned by their six curved lines and in the angle at which they stem from the central line (90-degree angle or rounded corners) and the shape of the base that the central line stems from. It may be presented as a tripod, a three-legged base, or shaped as steps or boxes (fig. 0.5).

Colors and signs, essential components of the visual language used by artists and designers in conveying a message may be juxtaposed with the portraying of a human figure. Such depictions produce a visual personification, a concise visual rendering of abstract ideas through an anonymous human figure, accompanied by objects that serve as its attributes. Peace may be represented by a female figure crowned with a wreath made of olive branches, holding a dove which alludes to the biblical story of Noah. Another commonly known visual personification is Liberty, a female figure, wearing a Roman toga and a headdress made of pointy light rays. She holds a torch in her right hand and a pair of stone tablets representing the American Constitution in her left; under her feet lie broken fetters.

Examples of such icons, emblems and Jewish, Zionist and Israeli personifications are referred to in the various chapters of this book wherever relevant. The book demonstrates references made by canonical Israeli artists to the Zionist ideas mentioned and describes how they refer to them in their attempt to comment about the particular myth they convey or to express through them entirely different messages.

The first part of the book, Before Statehood, discusses visual expressions of Zionist ideas created by individual artists who worked in a quasi-Zionist consensus during the years before the establishment of the state of Israel.

The first chapter, The Clarion Call: Ephraim Mose Lilien, points out the influence of Greek art on the artist's design process and mentions his transformation of non-Jewish attributes and visual metaphors in his striving to convey Zionist messages. His Zionist illustrations show a similar inclination to classical ideals of beauty, youthful spirit, strength, and vitality, also expressed in the early poems of Shaul Tshernichovsky.

The second chapter, Boris Schatz's Pantheon of Zionist Cultural Heroes, traces the works and legacy of sculptor Boris Schatz, founder and head of the Bezalel School of Arts and Crafts in Jerusalem. One of his most significant artistic creations was the series of commemorative portraits for what he regarded as the new Jewish-Hebrew Men of Renown. His plaster relief plaques make a first modern example of Jewish commemoration of cultural heroes in the visual arts. Although it was rejected by contemporary artistic and political establishments, Schatz's visual commemoration found expression some decades later on Israel's banknotes.

The third chapter, The Garden of Love: Early Zionist Eroticism, introduces Schatz's utopian novel *Jerusalem Rebuilt—a Day Dream*, in which he combined socialist ideals with Hebrew Eroticism by binding the Zionist present with the biblical era. One of the book's chapters describes The Garden of Love institution, a site filled with disguised eroticism. Artist Ze'ev Raban knew Schatz intimately; he published a series of illustrations for the biblical *Song of Songs* that constitute a visual rendition of Schatz's erotic ideas. The discussion analyses Raban's art and mentions the possible sources for his newly invented Hebrew style.

The fourth chapter, Zionist Revival and Rebirth on the Façade of the Municipal School in Tel Aviv, presents a series of visual images depicted on ceramic tiles. As Zionism regarded the modern era and its building enterprises as a symbolic realization of biblical prophecies, the designers of these decorations imported familiar visual motifs from Jewish Diasporic tradition as well as creating local ones. The discussion concludes with iconographical analyses of the Zionist messages they conveyed.

The second part of the book, Objects and Conceptions of Sovereignty, considers case studies following the establishment of the State of Israel, and the transformation of symbols and signs from the pre-state to the sovereign iconography.

Chapter 5, Israel's Scroll of Independence reviews the visual aspects of Israel's declaration of statehood, beginning with Oteh Walicsh's commission to write the text on a vellum scroll in a specially designed Hebrew calligraphy.

The Israeli scroll resides in a container made of silver. The discussion traces the scroll's calligraphic style and the silver container.

Chapter 6, Hues of Heaven: the Israeli Flag, analyses examples of proposals submitted to a government committee and concludes with the committee's final decision was to adopt, after all, the familiar Zionist flag as the national flag of the State of Israel.

Chapter 7, *Menorah* and Olive Branches on Israel's national Emblem, traces the design process of Israel's national emblem, beginning with examples of entries and iconographic analyses of their symbolic messages. After viewing more than 160 entries, the committee finally approved Maxim and Gavriel Shamir's design as the official State Emblem. The discussion concludes with documentation of the emblem's verbal and visual sources.

The eighth's chapter, From Exile to Homeland: the Journey of the Temple *Menorah* begins with a discussion of the Temple *Menorah* depicted in relief on the Arch of Titus in Rome as a visual record of the 70 CE destruction of the Jerusalem Temple. After World War II, the image of the arch's relief was metamorphosed into a myth, giving birth to various visual examples depicting the *Menorah Returns Home* motif.

Chapter 9, Zionism liberates the *Captured Daughter of Zion*, discusses the image of the Daughter of Zion as it evolved from the ancient Roman coin *Judea Capta* into several iterations that transformed the meaning of the original coined image. Examples of the different interpretations of this representation express its pliability as a source for Zionist and Israeli visual culture.

Chapter 10, The Twelve Tribes of Israel: from Biblical Symbolism to Emblems of a Mythical Promised Land, describes the development of imagery surrounding the twelve tribes of Israel and their function as symbols of unity and diversity of the People of Israel. It describes the historical development of the concept, followed by an analysis of the resultant imagery in Israel of the late 1960s.

Chapter 11, Old and New in Israeli Flora, discusses the role of plants in Zionist and Israeli visual culture. It describes the emergence of secular traditions regarding biblical plants and agricultural themes through various common representations such as book illustration, posters, and Israeli artists' use of these plants' iconic symbolism.

Chapter 12, Ancient Magic and Modern Transformation: The Unique Hebrew Alphabet, discusses Hebrew fonts and typefaces by following their development, with an emphasis on the modern era. The Hebrew scripts' sacred uses in religious contexts are juxtaposed with examples of secular models and explain the revolution and the full extent of the role of Modern Hebrew typefaces in complementing the process of secularizing the language itself.

The book's third part, Sculptural Commemoration within the Israeli Public Space discusses Israeli memorials in the country's public spaces.

Chapter 13, From Pilgrimage Site to Military Marching Grounds: Theodor Herzl's Gravesite in Jerusalem is centered on the design of the ceremonies and the eventual burial site of Theodor Herzl. It describes the processes of the secularization of the burial ceremony itself, aspects of the negation of figurative sculpture as expressed by architect Yosef Klarwein's design and the prophecy-derived proposal by Israeli sculptor Yitzhak Danziger. The chapter addresses aspects of secularizing the sacred typical of both winning designers and concludes with the site's actual appearance regarding its relation, or lack of it, to Judaism.

Chapter 14, Natan Rapaport's Soviet Style of the Yad Mordechai and Negba Memorials, describes the sculptor's commissions for memorials in two *kibbutzim*. It brings an account of their evolvement and design considerations, as well as discussing how this sculptor's artistic style was grounded in Soviet concepts.

Chapter 15, Holocaust and Resurrection in Yigal Tumarkin's Memorial in Tel Aviv, considers the possible models serving as precedents, and provides an alternative analysis of Tumarkin's work, based on the evolution of the Tel Aviv Municipality commission.

In conclusion: Secularizing the Sacred, Israeli Art and Jewish Orthodox laws sums up the various symbolic images discussed throughout the book and analyses contemporary Israeli artists' reactions to and appropriations in their works of biblical stories. The discussion focuses on artists' reactions and references to the Second Commandment, prohibiting the making of Graven Images; a few disregard its forbidding essence and create what is forbidden, so that some aspects of their visual discussions with Jewish Orthodox laws bring their art near to an expression of blasphemy.

Bibliography

Barzel, Amnon, *Art in Israel*, 1987.
Besancon, Alain, *The Forbidden Image, an Intellectual History of Iconoclasm*, Chicago and London: The University of Chicago Press, 1994.
Bland, Kalman P., *The Artless Jew, Medieval and Modern Affirmations and Denials of the Visual*, Princeton and Oxford: Princeton University Press, 2000.
Cohen, Richard, *Jewish Icons, Art and Society in Modern Europe*, Berkeley: University of California Press, 1998.

Gamzu, Chaim, *Tziur vePisool beYisrael, haYetzira haOmanutit beEretz Yisrael ba-Chamishim haShanim haAchronot* (Painting and Sculpture in Israel, Artistic Creation in the Land of Israel in the Past Fifty Years), 1957.

Godfrey, Mark, "That Old time Jewish Sect Called American Art Criticism," in *Action/Abstraction, Pollock, DeKooning and American Art, 1940–1976* (cat. exh.), New York, New Haven and London: The Jewish Museum and Yale University Press, 2008.

Hobsbawm, Eric, Ranger, Terence, (eds.), *The Invention of Tradition*, Cambridge: Cambridge University Press, 1983.

Kampf, Abraham, (curator), *Jewish Experience in the Art of the 20th Century*, New York: The Jewish Museum, 1976.

Mann, Vivian B., *Jewish Texts on the Visual Arts*, Cambridge: Cambridge University Press, 2000.

Manor, Dalia, *Art in Zion: The Genesis of Modern National Art in Jewish Palestine*, London: 2005.

Ofrat, Gideon, *100 Years of Art in Israel*, 1998.

Rosenberg, Harold, "Is There a Jewish Art?" *Commentary*, July 1966, 67–70.

Schechori, Ran, *Art in Israel*, 1974.

Schwartz, Karl, *haOmanut haYehudit haChadasha beEretz Yisrael* (New Jewish Art in The Land of Israel), 1941.

Tamuz, Binyamin, Leviteh, Dorit, Ofrat, Gideon, *Sipura shel Omanut Israel, Mimey Bezalel be-1906 ve'ad Yameynu* (The Story of Israeli art from the Bezalel days in 1906 to our time), 1980.

Tamuz, Binyamin, (editor), Fisher, Yona, Friedman, Mira, Hashimshoni, Aviya, Chaney, John, *Omanut Israel* (Art of Israel), 1963.

Zalmona, Yigal, *Me'ah Shnot Omanut Israelit* (One hundred years of Israeli art), 2013.

PART 1

Before Statehood

One of the aspirations of the Zionist dream was to create a new Jewish culture in which the visual arts would play a significant role. The creation of such a new aspect of Jewish culture was seen as a part of the amalgamation process of the new Jewish identity. Designers of that culture espoused a secular-spiritual resurrection based on the Nation's spiritual tradition. The cultural issue was dealt with at the 5th Zionist Congress held in Basle in 1901. Zionist leader Max Nordau conceived art as a propaganda vehicle. His idea was developed and extended by Martin Buber who claimed that art should be used as a tool for the creation of a new Jewish person, whole and ripe, as a stage in the realization of national purposes. Buber claimed that the Diaspora Jew is an incomplete, unproductive being when it comes to beauty that blooms outside of the Jewish Ghetto fence. The missing element in Jewish existence is the aesthetic one. Since he saw in Zionism the expression of the Jewish People's wish for self-fulfillment, art, for Buber was one of the factors that would make this fulfillment possible. Art would provide an aesthetic-expressive aspect and would make the intellectual component that is so characteristic of Judaism from its earliest existence complete.[1]

According to Buber, Jewish art was supposed to be aware of the cultural tradition of the Jewish People, to its language, its customs, to its naïve, folk art, to its ritual objects and its costumes.[2] Jewish art was meant to relate to all of the above as source material. Buber went further to claim that a National art is in need of earth and sky—national roots and ideals and that it would grow on Jewish soil. He saw Jewish art as a tool that enables a process of unification between the past and present of the Jewish People; a means linking the individual and the group, Jew and the complete man, creating a bond between feelings and aesthetics with the intellect. He saw Jewish art as a most significant vehicle for the realization of Zionism both in its metaphysical and cosmological meanings.[3]

Generally speaking, every renaissance phenomenon in the history of art looks back to the past for models. What were, then, the possibilities for the creation of a Jewish renaissance in the visual arts? To emphasize the spirit of rebirth, artists felt the need not only to depict Zionist themes but to express them through a unique style, whose basic characteristics would convey that particular spirit. Because of its aspiration for rebirth, the new Zionist art was

1 *Stenographisches Protokol der Vorhandlungen der V Zionisten Congress in Basel* (Minutes and Protocols of the Fifth Zionist Congress in Basle), 26–30, December, 1901, 157.
2 Ibid.
3 Ibid.

expected to turn to its ancient national models: to Jewish art created in the ancient Land of Israel or, perhaps to medieval or Renaissance Jewish art.

After the Russian revolution of 1917 Jewish artists became free persons: on the one hand, they were equal to their Russian colleagues. On the other hand, they were almost cut off from the Orthodox, Jewish traditional milieu. The artistic reaction of some Jewish artists was manifested—for only a short period—in a significant search for the creation of secular and national Jewish art. Their art was comprised of an amalgamation of *avant-guard* styles and Jewish contents through the use of Jewish folk motifs and their adaptation to modern needs.[4]

The person responsible for the documentation of Jewish culture at this period was Shlomo Zanwil Rapoport alias An-Sky (1863–1920). His ethnographic expeditions unearthed Jewish folk art motifs that appeared on various artifacts: tombstones, ritual objects—spice boxes, *menorahs*, synagogue ark curtains and ornaments for Torah scrolls, Synagogue wall paintings and more. An-Sky's findings were used by artists such as El Lissitzky, Nathan Altman, Issachar Ribak. Their use of traditional Jewish motifs was manifested in removing them from their original, religious context and transforming them into secular works of art.[5] These Jewish *avant-guard* artists succeeded in transferring the basic, familiar depictions of the Jewish *shtetl* both in contents and in style. They created a national Jewish art, infused with freshness and artistic quality. However, as early as the 1920s, these artists abandoned their primary approach and had turned to universal values.

These experiments, carried out by Russian-Jewish artists were short lived and not necessarily concerned with contemporary Zionism, let alone with the contemporary Jewish population of Palestine. The realization of the Zionist rebirth of Jewish art, as advocated by Martin Buber was based, in most cases, on non-Jewish models; the graphic work of German-Jewish artist Ephraim Mose Lilien (1874–1925) is one of its early expressions.

4 Ruth Apter Gavriel "In the Spirit of An-Sky: Jewish Folk Motifs in Russian Jewish Art" in Rivka Gonen (ed.), *Back to the Shtetl: An-Sky and the Jewish Ethnographic Expeditions, 1912–1914*, Jerusalem: The Israel Museum, 1994, 111.
5 Ibid., 112.

CHAPTER 1

The Clarion Call: E. M. Lilien and the Jewish Renaissance

FIGURE 1.1
Ephraim Mose Lilien (1874–1925)

Ephraim Mose Lilien was born in Drohowizc, Galicia, at the time an Austrian province. When he turned sixteen, he moved to Cracow, intending to continue his studies at the local art school. In 1892 he was admitted to the municipal art school in Vienna and finally settled in Munich. In 1896 Lilien won a prize at a photography competition organized by the weekly *avant-guard* magazine *Die Jugend* (The Youth). This achievement led to an engagement with the periodical, to which he began contributing his illustrations.[6] In 1900, he illustrated the highly successful book, *Juda*, by the German ballad poet Boris von Munchhausen.

The robust publicity for the book and the abundance of cultural and artistic Jewish activities that followed ushered in a new art movement, centered in Berlin and Vienna. In a review published in the Zionist organ *Die Welt* (The World) on December 14th, 1900, Martin Buber wrote about Lilien's artistic

6 Orna and Micha Bar'am, *Letzayer be'Or, haHebet haTzilumi bitzirat E. M Lilien* (Painting with Light, the Photographic Aspect in E. M. Lilien's Work), Tel Aviv: Tel Aviv Museum of Art, Dvir Publishing, 1990, 15.

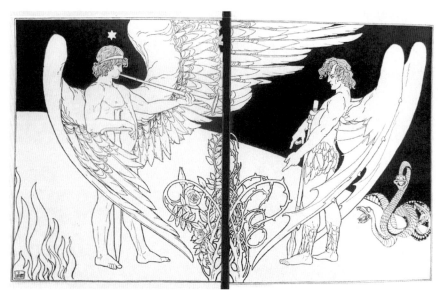

FIGURE 1.2 Ephraim Mose Lilien, *Angel Gabriel and Satan*, illustration for *Der Engel* (The Angel) in *Juda*, 1900

achievements. He interpreted the artist's illustrations for *Juda* as pointing to the eternal Jewish potential of renewal and youth.[7]

Buber approved of Lilien's art: "... Most renowned among our young artists, Ephraim Mose Lilien ..., penetrated the magical secrets of our People, he recognized the essence and values of our ancient motifs and adopted them. He experienced Zionism with his body and absorbed it inwardly...."[8] Buber's words reveal an interesting phenomenon. In Lilien's creations, he saw something that was not there at all—the illustrations show no trace of traditional Jewish ancient motifs. Apparently, Buber had projected the essence of his own expectations for a new Jewish art on Lilien's creations, when in fact, it is evident that the artist had used motifs whose origins were not Jewish at all. A short while later, Lilien began publishing his illustrations in *Die Welt* and the Jewish Zionist periodical *Ost und West* (East and West). He organized the first significant exhibition of Jewish artists at the Fifth Zionist Congress in 1901.[9]

7 Mark H. Gelber, "E. M. LIlien veTnu'at haRenaissance haYehudit" (E. M. LIlien and the Jewish Renaissance Movement) in *Lilien baMizrach haTichon, Tatzrivim, 1908–1925* (E. M. Lilien in the Middle East, Etchings, 1908–1925) (exh. cat.), Beer Sheva: Ben Gurion University Art Gallery, 1988 (unpaged).
8 A description of the speech and its complete contents were published in *Die Welt* No. 4, January 1904, as quoted by Bar'am *Letzayer be'Or*, 24.
9 Ibid.

Lilien's illustrations were geared to a Western European Jewish public or, more precisely, the German-Jewish one. He based his creative process on the assumption that Classical culture, suffused with elements of the Christian religion, was not foreign to his audience. Two significant aspects characterize his contributions to the newly formed Jewish-Zionist art: youthful spirit, achieved by a close link to ancient Greek art as a general approach in the depiction of human figures, and the creation of allegorical images as well as visual personifications for Zionist concepts.

Much had been written about Lilien's association with the contemporary style of *Jugendstil*, better known by the French term *Art nouveau*. Indeed, the artist spoke the language of the early 20th century, but his contribution to Zionist thought and his influence on Jewish artists and designers who followed him is his breakthrough of using symbolic elements that are not Jewish for the creation of Jewish-Zionist-Hebrew images.

Scholarly publications dealing with the components of his style mainly focus on the influence of several late nineteenth-century English artists on his art.[10] Most of the authors take Lilien's iconographic cross-breeding of Classical culture, Christian symbolism and Zionist ideas for granted. The artist's Zionist images are a result of a complicated creative process formed by a unique visual language.

1.1 Life, Heroism, and Beauty

The linear quality of Lilien's figures, their strength and virility, the rendering of their musculature and their stylized facial features, all point to models from ancient Greek art. Most of his figures are portrayed in the nude. Why would a Jewish-Zionist artist portray biblical, Zionist, and contemporary Jewish public dignitaries in the Greek style and, furthermore, in the nude? The idea itself is self-contradictory even today. At the end of the nineteenth century and the beginning of the twentieth, such a representation was bound to be regarded as blasphemous by traditional Jewish audiences. Orthodox Judaism views Greek and Roman art as pagan or idolatrous; they make a complete contradiction for the rendering of Jewish subjects and themes. Nevertheless, Lilien creates a fusion between the soul of the classical-pagan world and the spirit of the

10 See: Milly Heyd, "Lilien and Beardsley: 'To the Pure all Things are Pure'", *Journal of Jewish Art*, VII, 1980, 58–6; Michael Hasenclever, *M. Lilien, Zeichnungen* (E. M. Lilien, Drawings), München, 1996 (unpaged).

Jewish-Zionist Renaissance. His art manifests a meeting between seemingly polar concepts.

M. S. Levoussove wrote about this phenomenon at the beginning of the twentieth century:

> Aren't these two movements identical in principle, since in both the soul aspires for a greater Freedom and a more perfect expression? When a new spirit arises, it expresses itself in various ways. Why, then, wouldn't it be possible for a Jewish artist to combine the Hellenic with the Hebrew? Why shouldn't it be possible for the ancient, prophetic soul to be combined with the beautiful?[11]

Such admiration of the Hellenic and the Beautiful may suggest that Jewish art is an imitation of non-Jewish models and consequently that Lilien's Zionist art, rendered in a non-Jewish style, might constitute a contradiction to the very idea of Jewish rebirth.

Zionist scholar Achad ha'Am (1856–1927)[12] partially resolved this conflict. In an article entitled *Chikuy veHitbolelut* (Imitation and Assimilation) the author claimed that imitation of customs or cultural aspects of other peoples, when done by Jews, acquires a positive nature when the process acts as a competition. As a historical illustration of his claim, the author used the case of ancient Egyptian Jewry that was close to Greek culture:

> Egyptian Jews used their knowledge of Greek culture in their aspiration to discover their own Jewish spirit, to expose its Beauty to the whole world and to show how inferior it [Greek culture] is in comparison [with Jewish culture]. In other words, by imitation, its primal reason being self-deprecating from the power of the foreign spirit, they [Egyptian Jews] succeeded in acquiring the strength to move from self-deprecation to competition.[13]

11 M. S. Levoussove, *The New Art of an Ancient People, The Work of Ephraim Mose Lilien*, New York: B. H. Huebsch, 1906, 49.

12 Asher Zvi Hirsch Ginsberg, alias Achad ha'Am (one of the people) was a Hebrew essayist, and one of the foremost pre-state Zionist thinkers. He is known as the founder of cultural Zionism. With his secular vision of a Jewish spiritual center in Israel, he confronted Theodor Herzl. Unlike Herzl, the founder of political Zionism, Achad ha'am strived for a Jewish state and not merely a state of Jews.

13 Achad ha'Am's article was published in *Hapardes*, book II, Odessa, 1893, republished in *Kol Kitvei Ahad ha'Am* (The Complete Works of Achad ha'Am), Tel Aviv: Dvir Publishing and Jerusalem: Hotza'ah Ivrit, 1961, 86–88.

Ahad ha'Am further argued that throughout history, Jewish leaders always tried to distance their people from the spiritual life of other nations. In his opinion, distancing was in vain because

> ... The People of Israel has a tendency as well as a great talent in imitation; everything that the People of Israel imitates—it does so well. It acquires quickly this foreign spiritual power that led it, in the beginning, into self-deprecation. At this stage, the Jewish People's sages teach the people to direct this power to the purpose of discovering its own, individual spirit. Self-deprecation would then be over, and imitation would acquire a form of competition. Consequently, it would endow Hebrew entity with courage.[14]

According to Ahad ha'Am, imitating the culture of the Gentiles should be permitted, because when carried out in a spirit of competition, the process of imitation strengthens Jewish existence and enhances it.

In his early poems, Shaul Tchernichovsky (1875–1943) supported Ahad ha'Am's and Martin Buber's literary approach to the mingling of Jewish and non-Jewish cultures in pursuit of Beauty. He voiced his amity for a foreign culture differently than Ahad ha'Am; the Diaspora Jew was shown in his late 1890s poems as an old man, tired and decaying.

Tchernichovsky articulated the concept of the Jewish People's revival by communicating his admiration for beauty, youth, strength, and virility he found in classical culture. The search for these qualities, shunned by Judaism for generations, appears in two of his early poems: *Neta Zar at leAmech* (You are a Foreign Sapling among your People, 1898) and *Lenochach Pessel Apollo*: (In front of an Apollo Statue, 1899). In the first, the poet's soul—a living spirit that admires Beauty—is contrasted with the People of Israel's dead soul: "For you—you are Spring, they are pits of decay; they reek of graves, you are the joy of light."[15]

Tchernichovsky expresses his admiration for Classical culture even more vehemently and clearly in *In front of an Apollo Statue*. The poem marks his passage from his Odessa period to his move to Heidelberg. Tchernichovsky was exposed to contemporary ideas, conceiving ancient Greek culture as an expression of the harmony of body and soul, heart and mind. German poet Johan von Goethe (1749–1832) is mentioned as a potential influence on the

14 Ibid., 88.
15 Shaul Tchernichovsky, *Shirim* (Poems), Tel Aviv: Schocken Publishing, 1959, 57. (my translation).

poet's concepts. His *Urmensch*, the primal man, encountered solely in Homer's epics, is a man of Nature, whose addiction to the pleasure of his senses is tied to the love of art. Ancient Greek culture, according to Goethe's concept, was a perfect man who lived in a perfect environment, his perfection realized in Greek sculpture.[16]

The poem opens with these lines: "I come to you—do you recognize me? I am the Jew, your adversary of old!" In his yearning to break his ancient nation's "handcuffs of the soul" the poet reverts to a foreign culture:

> I would kneel, I would bow down
> To Goodness and to the Sublime,
> To that which is exalted throughout the world,
> To all things splendid throughout creation,
> Elevated within the mysteries of the Cosmos.
> I would bow down to Life, to Valor, and to Beauty,
> I would prostrate myself to all precious things—now robbed
> By human corpses and the rotten seed of Man
> Who rebels against Life bestowed by God, the Almighty—
> God of mysterious ineffable wilderness
> God of Men, who conquered Canaan in a storm—
> They bound Him with straps of their phylacteries …[17]

Lilien's artistic endeavors seem to be a visual version of Tchernichovsky's search for beauty, for a youthful spirit, light, and freedom. Yet in the visual arts, this search exhibited a conflict, typical of almost every contemporary Jewish artist; on the one hand, a search for beauty and admiration for the art of the Gentiles, on the other hand, its complete rejection by most strata of Jewish society. Lilien's contemporary, Russian-Jewish artist Leonid Pasternak (1862–1945), related to this very conflict in his memoirs:

> … I am guilty, I know that, but the guilt is not within me but outside of me—in you, Russian Jewry of my time. My art was foreign to you and so it would continue to be for a long time … I used to paint what was in front of me in Jewish life: a provincial Jewish street, the period before Passover …
> … Artillery officers of the local battalion—not Jewish representatives of financial aristocracy—were those who bought my paintings … No one

16 Ido Bassok, *la Yofi velaNisgav Libo Er, Tchernichovsky—Chayim* (Of Beauty and Sublime Aware, Shaul Tchernichovsky—a Life), Jerusalem: Carmel Publications, 2017, 133–135.
17 Ibid. 73–74.

was familiar with Jewish artists; neither young people of the Jewish intelligent class nor the rich class (not to mention poor Jews or the Jewish masses)—all of the above had no need for art. Jews simply were not interested.[18]

Unlike the experience of Pasternak and other Eastern European Jewish artists, Lilien's works were acknowledged by the German-Jewish audience. His artistic style reflected the ideals of late nineteenth century German Reformed Jewish society since German Jewry tended to emphasize the national and moral aspects of Judaism. A clear indication for this aspiration is its choice of emblems for its symbolic representation: The Star of David (The six-pointed star), the Tablets of the Law and those of The Twelve Tribes of Israel.[19] They fixed these symbols to their Synagogue buildings' facades as a significant proclamation of their ideals.

By affixing such emblems to building interiors and facades, architects and designers emphasized the edifice's Jewish identity. They intended to exhibit an economically stable Jewish presence, an entity proud of its equal rights. The new, concise emblems were meant to represent Jewish culture as a unique phenomenon; they were expected to transmit a clear and legible message to the Christian milieu. Their placement on building facades was meant to be the Jewish counterpart to the placement of a cross on Christian edifices. This approach communicated the German-Jewish aspiration to define and convey the general concept of Judaism from a vantage point that would clarify it to the immediate, Gentile surroundings.[20]

These concepts contrasted with traditional, common Jewish motifs such as *Churban* (Destruction) and *Geulah* (Salvation), with established symbols that suggested eschatological ideas, or those showing a direct link with the Land of Israel. The German-Jewish emblems focused on Judaism's rational and moral aspects, exhibiting its openness and understanding of the Christian milieu. For example, the message of the Tablets of the Law was focused on the

18 Leonid Pasternak, *Fragmenty Avtobiografii* (Autobiographical Fragments), 1943 (unpublished), 49. Published in English as *Memoirs of Leonid Pasternak*, London: Quartet Books, 1982, as quoted by John D. Bowlt, "Jewish Artists and the Silver Age", in Susn Tumarkin Goodman, *Russian Jewish Artists in a Century of Change, 1890–1990*, New York and Munich: The Jewish Museum in association with Prestel Verlag, 1996, 44.
19 Ida Huberman, "Smalim beRu'ach haZman" (Symbols in the Spirit of their Times), in *Batey Knesset beGermaniya baMe'ah haTsha'esre* (German Synagogues in the 19th Century), (exh. cat.), Tel Aviv: Beyt haTfutzot, 1982 (unpaged).
20 Chapter 10 extends this phenomenon.

significance of the Ten Commandments in Jewish history and culture, and its contribution of moral values to Western culture.[21]

Lilien's art echoed the desire to communicate the essential spiritual concepts of Judaism to a Christian milieu by the use of standard symbols and emblems. Judaism, Christianity and Classical culture were the three major components of his work. In an attempt to trace his contribution to the creation of visual images for the Zionist movement, it is essential to first examine how he rendered the protagonists of his illustrations through the combination of these three components.

1.2 Lilien's Winged Figures

Lilien's graphic work is abundant with winged figures. They broach different messages and are based on individual iconographic characteristics. The winged figures are either male or female and are gender ambivalent only on rare occasions. The male characters are nude, virile men; their muscles rendered by firm contours conveying strength and solidity. Female figures are delicate and fragile; in most cases, they are clothed, at times their chest is exposed, and their hair is fair and flowing. The angel appearing in biblical scenes such as *The Expulsion from Eden* (fig. 1.3) is male. This trait is not necessarily Jewish, yet it sets it apart from typical Christian prototypes that are generally rendered as genderless. Since most of Lilien's winged figures are depicted in the nude, the artist had limited ways of imbuing them with individual traits. Some subject matter demanded a differentiation between good and bad angels; the artist had to devise a way to render these differences visually.

Clothed angels in Christian art suggest good angels; nude ones (most of the times represented provocatively) suggest a bad angel (or demon). Lilien differentiates between good and evil through various hairstyles, wings, and body forms.

Gabriel's hair (left in fig. 1.2) is combed and tied with a ribbon, unlike Satan's. While Gabriel's wings are reminiscent of those of an eagle, Satan's wings are a fanciful combination of bat and fowl wings. Satan's body is not smooth, like Gabriel's; fins, or scales, show on his thighs and calves, borrowed by Lilien from the Triton, a mythical sea creature. Additional types of wings, such as those of eagles or swans, are attached to angels' shoulders as in *The Creation of Man* (fig. 1.4).

21 Huberman, "Symbols in the spirit of their times".

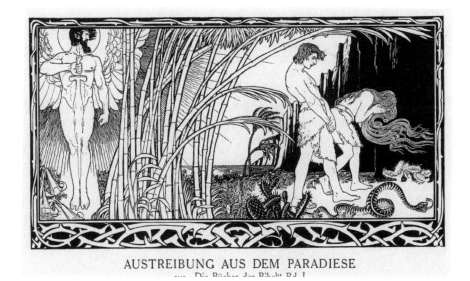

FIGURE 1.3 Ephraim Mose Lilien, *Expulsion from Eden*, illustration in *Bücher der Bibel* (Books of the Bible), 1908

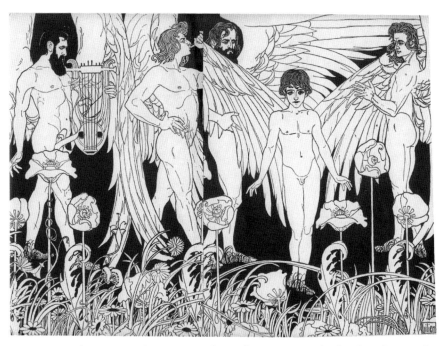

FIGURE 1.4 Ephraim Mose Lilien, *Creation of Man*, illustration in *Lieder des Ghetto* (Poems of the Ghetto), 1903

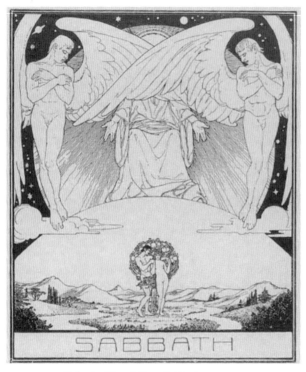

FIGURE 1.5 Ephraim Mose Lilien, *Sabbath*

Angels appear in some of Lilien's illustrations that deal with temporal Jewish subjects such as *Sabbath* (fig. 1.5). Quite surprisingly, the artist depicted God sitting on the dome of the Heavens; two nude angels cover his face with their enormous wings. The covering of God's face was more important for the artist than the covering of the angels' genitalia.

The angel plays a different role in illustrations that deal with contemporary Jewish subject matter; it may be the consoling Godly messenger, as in *In Memoriam of the Kishinev Martyrs* (fig. 1.6).[22] The angel hovers behind a figure of an old Jew and kisses his forehead. Its legs, in a diagonal pose, cross the vertical image of the martyr and may suggest the form of the Russian Orthodox

22 The Kishinev pogrom was an anti-Jewish riot that took place in the capital of the Bessarabia Governorate in the Russian Empire, on April 19 and 20, 1903. Further rioting erupted in October 1905. In the first wave of violence, which was associated with Easter, 49 Jews were killed, large numbers of Jewish women were raped and 1,500 homes were damaged. The incident focused worldwide attention on the persecution of Jews in Russia.

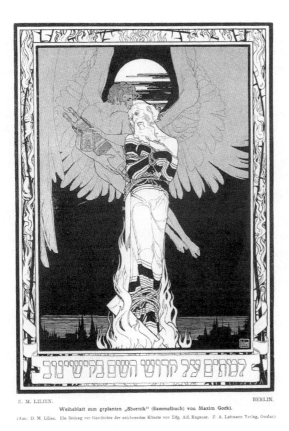

FIGURE 1.6 Ephraim Mose Lilien, *In Memoriam of the Kishinev Martyrs*, 1904

cross, with its traditionally diagonal, vertical arm. The angel's posture fits the description of the historical event.

1.3 Restrained Decadence: Jewish Angels

Lilien borrowed the models for his winged figures mostly from English art. He was influenced by the works of William Morris and Edward Burne-Jones, whose angels are commonly painted wearing classical attire, but also by Aubrey Beardsley and Walter Crane, whose angels are nude.[23] Compared with

23 Lilien owned *The Works of Walter Crane with Notes by the Artist, Published by the Art Journal Easter Art Annual*, London: Virtue and Co., 1898. The book contains remarks and

Beardsley's figures, Lilien's are much more decent. Beardsley achieved the decadent eroticism of his figures by an ambivalent rendering of their gender and also by the hint of pubic hair which rendered them as real, naked and provocative. Beardsley's males are slightly effeminate, his females are robust, exhibiting male characteristics, and some characters are frankly hermaphrodite. Lilien's winged figures are ideal and classical. His aim to portray nude, young beings, full of life and strength, collided with his wish for restraint in an attempt to preserve respectability.[24] He found the perfect model for his aspiration in the works of Walter Crane (1845–1915).

Crane's style is similar to Beardsley's, but does not contain his overt eroticism and perverse immorality and therefore considered purer and more respectable. Besides the fact that Lilien owned several of Crane's books, he could have seen some of his graphic works and oil paintings when they were exhibited in Germany.[25] Crane depicted many winged figures in his works that were modern allegorical personifications of themes such as *The Genius of Mechanical Invention Linking Agriculture and Commerce* (fig. 1.7) or *The Genius of Electricity Linking the Different Parts of the World* (fig. 1.8). His visual personifications carry modern, secular, socialist messages. Lilien was more interested in the latter's modern allegorical personifications than with Crane's individual artistic style. In accordance with Crane Lilien borrowed basic principles of this syntax that served his creative process in forming—almost from scratch—allegorical figures and visual personifications for contemporary Zionist ideas.

1.4 Olympus and Golgotha in the Service of Zionism

Lilien condensed the Zionist concept of a Jewish Renaissance, the revival of the Jewish People, or its rebirth, into a visual personification in the form of a female figure (fig. 1.9). He created this emblematic illustration for the title page of *Ost und West*. At the beginning of the twentieth-century illustrators were

interpretations of works by Edward Burne-Jones, William Morris and other British artists. Lilien brought the book with him to Jerusalem at the time he served as a designer in Boris Schatz's Bezalel School of Arts and Crafts. The book is now in the collection of the Israel Museum Library and carries the artist's Ex-Libris.

24 Heyd, "Lilien and Beardsley: 'To the Pure all Things are Pure'", 59.

25 In his book *Line and Form* Crane wrote his ideas on teaching art. The basis for the book was a series of lectures delivered by him at the Art department of The Technical School in Manchester in 1898. See: Isobel Spencer, *Walter Crane*, London: Studio Vista, 1975, 162. *Line and Form* was translated into German and published in 1901 as *Linie und Form*. Lilien owned the book and brought it to the Bezalel Library in 1906.

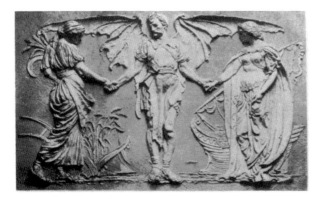

FIGURE 1.7 Walter Crane, *Genius of Mechanical Invention Linking Agriculture and Commerce*, plaster frieze

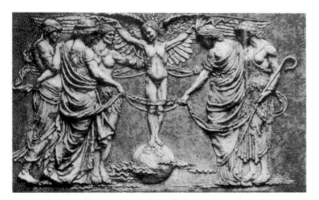

FIGURE 1.8 Walter Crane, *Genius of Electricity Linking the Different Parts of the World*, plaster frieze

faced with several issues when dealing with visual personifications or allegorical figures representing modern ideas and concepts. For the visual representation of traditional personifications such as Peace, they had at their disposal commonly used images from early periods as the Renaissance (a woman holding a dove with an olive branch in its beak). When faced with the creation of visual personifications for concepts such as Electricity, Industry, or Aviation, they had to invent modern attributes that could convey a particular message. Lilien was faced with that very issue when he aspired to render concepts such as Renewal for the Zionist movement. Attributes from Jewish culture were scant; he had to turn to other traditions to find an abundance of symbolic elements.

Earlier visual personifications of the Jewish Nation as a female figure, mainly in Christian Gothic art, juxtaposed an embodiment of Judaism next to that of

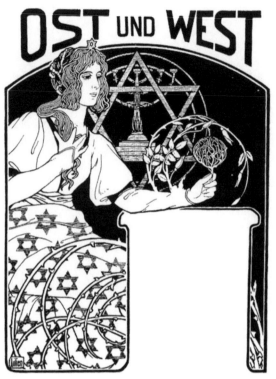

FIGURE 1.9 Ephraim Mose Lilien, *Title Page for Ost und West*, 1904

Christianity. Judaism, or *Sinagoga* (The Synagogue) was portrayed as a female figure, her eyes covered by a ribbon since she is not able to see the Truth of the New Testament. She holds the Tablets of the Law turned upside down and a broken spear. The Crown she once wore on her head had fallen. Next to her, is *Ecclesia*, The Church, or The New Testament: a proud woman, crowned, holding the triumphant Cross of the Church. The medieval *Synagoga* is a derogatory expression of the Jewish nation; Lilien's personification freed the image of its negative connotations.

Lilien's *Jewish Nation* (fig. 1.9), also known as *The Daughter of Zion*,[26] is a modern personification of Western European Jewry of the early twentieth century. The young woman's flowing fair hair is interwoven with jewelry and crowned with a Jewish Star. The lower part of her costume is also decorated with the motif of the star. She sits in front of a barbed fence; the fair woman places her arm next to her bosom in a familiar gesture of a vow.

26 Chapter 9 is dedicated to the allegorical figure of The Daughter of Zion.

In her left hand, she holds a plant, surrounded by a wreath made of small roses, leaves, and buds. The various accessories (such as the star) that accompany *The Daughter of Zion* identify her as Jewish and send a particular symbolic message. The barbed fence symbolizes Jewish suffering in the Diaspora and the specific plant she holds in her hand—a *Rose of Jericho*[27] Anastatica (Latin)—serves as an emblem of renewal, revival, and rebirth of the Jewish People. It is a weed, growing in warm deserts; *Anastatica Hierochuntica*—The Real Rose of Jericho grows in Israel's southern desert, in the Dead Sea valley and the Mountains of Moab. During hot weather, it dries out completely and appears to be dead. Once watered the plant opens up, its stems spread out and it looks as if it is coming back to life, hence its name Resurrection of Jericho. The plant gained sanctity in the Christian tradition, and it symbolizes the Resurrection of Jesus. The *Crown of thorns* is another significant attribute of Jesus, part of the symbolic group of objects known as *Instruments of the Passion*. Lilien borrowed the symbolical connotations of suffering and resurrection linked to these accessories and used them in his concise, modern, new Zionist image.

The artist expressed his profound involvement with Christian symbolism in the moto he chose for his personal *Ex-Libris*: a quotation (in German) from Paul's *Letter to Titus* 1, 15: "Den reinen ist alles rein" (To the pure all things are pure) (fig. 1.10).

Lilien had no scruples in using emblems and symbols suffused with Christian religiosity in other illustrations purporting to show the spiritual devotion of prophets, such as Isaiah (fig. 1.11). On the hem of his robe (fig. 1.11a) the artist depicted a pattern of a heart, crowned by fiery flame. *The Flaming Heart* is a Catholic emblem that functions as an attribute of two significant figures: Saint Anthony of Padua and Saint Augustine. It symbolizes their religious fervor. Saint Bonaventure added to the familiar concept of *Amor Dei* (God's Love) an image of *Divine Light* in the form of a flame, a metaphor for religious fervor.[28] A variation of *The Flaming Heart* is *The Sacred Heart*, crowned by a flame and surrounded by a *Crown of Thorns* or pierced with nails. This emblem stands for

27 See: Nomi Pinvedon-Dotan and Avinoam Danin, *haMagdir leTzimchey Bar b'eEretz-Israel* (Guide for Wild Plants in Israel), Jerusalem: 1981, 241.The plant is sold in tourist shops and is bought especially by Christian pilgrims. On the Rose of Jericho as a metaphor of the Resurrection see: Jacob Friedman, Zipora Stein and Amotz Dafni, "The Rose of Jericho, Symbol of the Resurrection", *Biblical Archeology Review*, September–October 1980, 39–42.

28 This is the source for the Christian personification of Charity, one of the Virtues. It is portrayed as a woman holding an urn emanating a red flame. Another image of Charity shows her holding a heart, crowned by a flame as a metaphor for her self-sacrifice out of religious fervor in which she offers her heart to God.

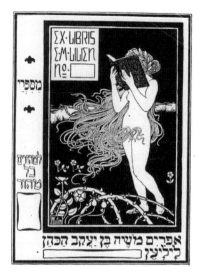

FIGURE 1.10
Ephraim Mose Lilien, *Personal Ex-Libris*, 1901

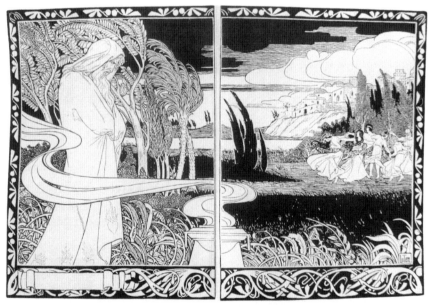

FIGURE 1.11 Ephraim Mose Lilien, *Isaiah*, illustration in *Juda*, 1900

religious fervor as well as for the Passion (fig. 1.12). It is also the emblem of the Jesuit Order and the attribute of its founder, Saint Ignatius of Loyola.

Lilien portrayed Isaiah in a contemplative gesture, as compared to the young Israelites who are passing their time dancing and rejoicing, instead of obeying God's commands. By decorating the Prophet's mantle with *The Flaming Heart*

FIGURE 1.11A
Ephraim Mose Lilien, *Isaiah* detail

FIGURE 1.12
The Sacred Heart, a popular poster

motif, Lilien extended the symbolic message of the illustration and enabled it to convey aspects of religious fervor.

Besides employing Christian attributes, Lilien used models from classical mythology. The personification of *Dror* (Freedom), a stained-glass window decoration designed by the artist for the B'nai B'rith building in Hamburg (fig. 1.13) is a mature, bearded male figure, accompanied by two accessories that act as his attributes: stone tablets and an eagle. A beard and stone tablets are the traditional attributes of Moses; the eagle is a common attribute of Zeus. The facial features of *Freedom* are those of Theodor Herzl (fig. 1.14). Lilien's modern personification of Freedom is not only portrayed as a modern leader (or even as a martyr) but is deified as well.

Theodor Herzl's facial features appear in many of Lilien's designs (for example, both angel figures on the left of figs. 1.3, 1.4). The Zionist leader's impressive and captivating appearance was conceived by the artist as a perfect representation of the ancient traits of the Jewish People: a noble spirit, vitality, strength,

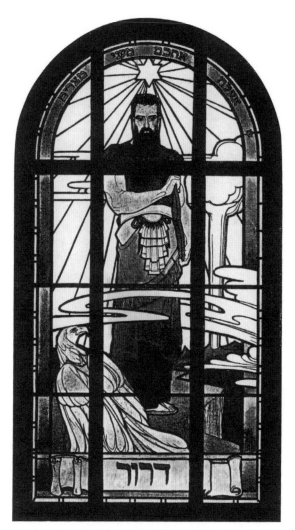

FIGURE 1.13 Ephraim Mose Lilien, *Dror* (Freedom), Design for a stained glass window for the 'Bnai Brith' Club in Hamburg

and charisma. Such characteristics are found in romantic descriptions of Jews from old times in literary works such as George Elliot's *Daniel Deronda* and Benjamin Disraeli's *Tancred*. The old splendor of a man in his prime, wearing a black beard, made an ideal visual model for the creation of an image of a powerful contemporary Jew, resembling its ancient biblical predecessor.

Herzl as Moses (fig. 1.15) makes a complete contrast to the image of a contemporary Diaspora Jew of Eastern European origin (fig. 1.16). The Jew's beard

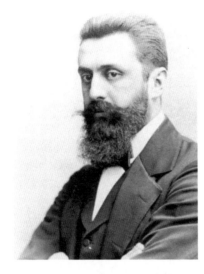

FIGURE 1.14
Theodor Herzl

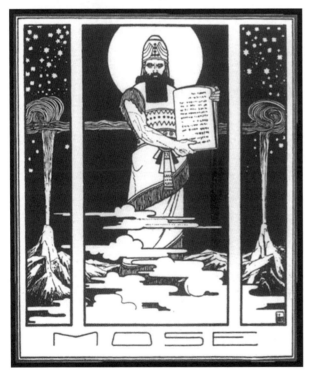

FIGURE 1.15 Ephraim Mose Lilien, *Mose* (Moses), illustration in *Bucher der Bibel* (Books of the Bible), 1908

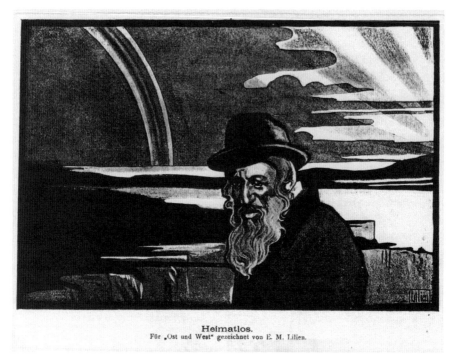

FIGURE 1.16 Ephraim Mose Lilien, *Heinatlos* (Without a Homeland), illustration in *Ost und West*, 1904

FIGURE 1.17
Ephraim Mose Lilien, *Portrait of Max Nordau*, illustration in *Ost und West*, 1904

is white; it comes down in curls on his chest; this is not a meticulously groomed beard like Herzl's or, in comparison, the fashionably groomed white beard of Zionist leader Max Nordau (fig. 1.17).[29]

The image of the feeble Jew, whose gaze suggests deep inner sadness, yearning for the coming of the Messiah, or restrained anger and misery (figs. 1.18, 1.19) is followed In Lilien's illustrations by attributes of the Exile, such as the

29 Max Nordau and his concept of a New Jew will be discussed in chapter 3.

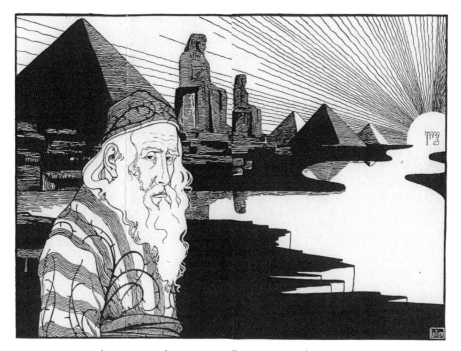

FIGURE 1.18 Ephraim Mose Lilien, *Passover*, illustration in *Juda*, 1900

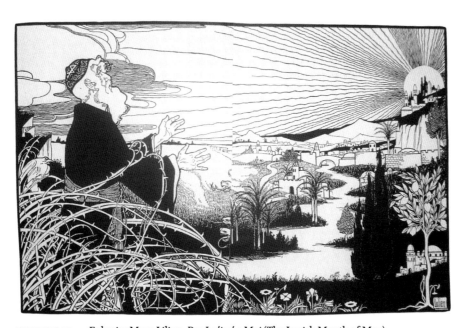

FIGURE 1.19 Ephraim Mose Lilien, *Der Judische Mai* (The Jewish Month of May)

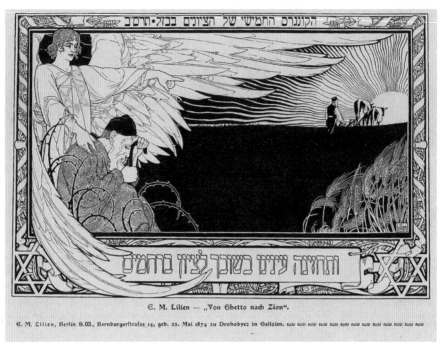

FIGURE 1.20 Ephraim Mose Lilien, *Von Ghetto nach Zion* (From the Ghetto to Zion), 1902

pyramids of Egypt or the rivers of Babylon. He wears contemporary 20th-century clothes, designating him as a Jew from the Ghetto, or a period costume comprised of a blend of the Jewish prayer shawl (fig. 1.18) and a striped coat. He is rooted in place, unable to free himself from the thorny entanglement of the Diaspora, symbol of his suffering.

Lilien's exhausted Diaspora Jew alludes specifically to Jewish *Eastern* European origins. When commissioned to design a poster for the Fifth Zionist Congress held in Basle in 1901, he was aware of how sensitive visual images can be. He took into consideration that this poster would be viewed by both Jewish publics—German and Eastern European. To avoid any possible conflict, he toned down the amount of freedom he usually exercised with his German public, which was much more open to universal ideas. The angel in Lilien's poster (fig. 1.20) is not nude. He wears a quasi-classical tunic with a large emblematic Jewish Star embroidered on his chest. The angel supports the old Diaspora Jew, and in the traditional gesture of expulsion, points to the direction of Zion, where the sun shines, and a new Jew is plowing the earth of his land. The biblical scene that depicts an angel in the act of expelling Adam and Eve from the Garden of Eden to a world of toil and tears is reversed. Lilien's old Diaspora Jew is not expelled *from* the Garden of Eden into a world of labor,

sweat, and suffering; on the contrary, he is directed to leave the cruel world of the Diaspora and go to the Zionist Garden of Eden—The Land of Israel. There he is bound to cultivate the land, an action that would redeem him from the thorny entanglement of the Diaspora.

Lilien's illustrations of Zionist concepts and ideas represent the first visual manifestation of the Jewish Renaissance. By basing his style on ancient Greek art models, he managed to suggest a youthful spirit and admiration of classic beauty, the antithesis of visual images of contemporary Diaspora Jews. His unique interpretation of Beauty and Strength—two traits that contemporary Jews were ordinarily thought to lack—assisted Zionist dogma by giving a visual expression for its process of creating a new Jew.[30]

Lilien's designs and illustrations enjoyed a widespread distribution throughout Europe, and most Zionist groups were familiar with them. They reached, among other places, Sofia, Bulgaria, and brought to the attention of Boris Schatz, a young Jewish artist who taught at the Bulgarian Academy of art at the time. Like Lilien, Schatz sought contemporary formulas for a new Zionist-Jewish art, but his solutions—dealt with in the next chapter—were entirely different.

Bibliography

Baram, Orna and Micha, *Letzayer beOr, haHebet haTzilumi bItzirat E. M Lilien* (Painting with Light, the Photographic Aspect in E. M. Lilien's Work), Tel Aviv: Tel Aviv Museum of Art, Dvir Publishing, 1990.

Bassok, Ido, *la Yofi velaNisgav Libo Er, Tchernichovsky—Chayim* (Of Beauty and Sublime Aware, Shaul Tchernichovsky—a Life), Jerusalem: Carmel Publications, 2017.

Bowlt, John D., "Jewish Artists and the Silver Age," in Susan Tumarkin Goodman, *Russian Jewish Artists in a Century of Change, 1890–1990*, New York and Munich: The Jewish Museum in association with Prestel Verlag, 1996.

Friedman, Jacob, Stein, Zipora, Dafni, Amotz, "The Rose of Jericho, Symbol of the Resurrection," *Biblical Archeology Review*, September–October 1980.

Gelber, Mark H., "E. M. Lilien veTnu'at haRenaissance haYehudit" (E. M. Lilien and the Jewish Renaissance Movement) in *Lilien baMizrach haTichon, Tatzrivim, 1908—1925* (E. M. Lilien in the Middle East, Etchings, 1908–1925) (exh. cat.), Beer Sheva, Ben Gurion University Art Gallery, 1988 (unpaged).

Hasenclever, Michael, *E. M. Lilien, Zeichnungern* (E. M. Lilien, Drawings), München, 1996 (unpaged).

30 Discussion of the New Jew as a farmer, cultivating the Land of Israel follows in chapter 11.

Heyd, Milly, "Lilien and Beardsley: 'To the Pure all Things are Pure'", *Journal of Jewish Art*, VII, 1980.

Huberman, Ida, "Smalim beRuach haZman" (Symbols in the Spirit of their Times), in *Batey Knesset beGermaniya baMe'ah haTsha'esre* (German Synagogues in the 19th Century), (cat. exh.), Tel Aviv: Beyt haTfutzot, 1982 (unpaged).

Kol Kitvei Ahad ha'Am (The Complete Works of Ahad ha'Am), Tel Aviv: Dvir Publishing and Jerusalem: Hotza'ah Ivrit, 1961.

Levoussove, M. S., *The New Art of an Ancient People, The Work of Ephraim Mose Lilien*, New York: B. H. Huebsch, 1906.

Pasternak, Leonid, *Fragmenty Avtobiografii* (Autobiographical Fragments), 1943 (Memoirs of Leonid Pasternak), London: Quartet Books, 1982.

Pinvedon-Dotan, Nomi, and Danin, Avinoam, *Hamagdir leTzimchey Bar beEretz-Israel* (Guide for Wild Plants in Israel), Jerusalem: 1981.

Spencer, Isobel, *Walter Crane*, London: Studio Vista, 1975.

Tchernichovsky, Shaul, *Shirim* (Poems), Tel Aviv: Schocken Publishing, 1959.

The Works of Walter Crane with Notes by the Artist, published by the Art Journal Easter Art Annual, London: Virtue and Co., 1898.

CHAPTER 2

Boris Schatz's Pantheon of Zionist Cultural Heroes

FIGURE 2.1
Boris Schatz

Boris Schatz (1867–1932), a sculptor of Russian descent, was the founder and head of the Bezalel School of Arts and Crafts in Jerusalem, established in 1906. He saw the great heritage of Italian Renaissance art as a worthy model for inspiration. He followed in the footsteps of Renaissance artists but did not strive to copy their works; instead, he wanted to base his innovations on their magnificent achievements by extending and accommodating them in a unique way to Jewish visual culture that was renewing itself in Palestine at the beginning of the 20th century.

Schatz was born in Lithuania and studied art in Vilnius, Warsaw, and Paris. From 1895 to 1906 he taught at The Royal Academy of Arts in Sofia, Bulgaria. In his memoirs he reminisced about his longing for the Land of Israel while living surrounded by the European non-Jewish environment:

> I grew up and learned how to beautifully paint and carve, yet I did not come to Jerusalem, and Rachel's Tomb and the Wailing Wall were not painted by me. I did not gladden the hearts of my brethren, the Sons of Israel. The Gentiles taught me their crafts, and for them I created things of beauty and worked to fulfill their aims.... I left the glorious city of Paris

with a broken spirit and confused mind. Among the cloud covered mountains and the still rocks of the blue and crimson Mediterranean Sea, I began dreaming a new dream. I dreamt about a sect of artists, suffused with a holy spirit ... artists who are healthy in body and courageous of spirit, their minds full of fantasies of light ... we all live together as brothers, and our shared mission is to show people how beautiful, how delightful is God's universe, praised God, and how much happiness awaits them as they begin to live as human beings. Even then I thought that The Land of Israel must be this holy place, where I could manifest this dream.[1]

Schatz was a fervent Zionist; it was only natural for him to choose the Renaissance, with its spirit of revival, as a model for his personal style, as well as for implementing his ideas of innovative *Hebrew*-Zionist art. The novel aspect of the European style's return to past glory must have mostly attracted his attention.

Simultaneously, he aspired to create the image of a new Jew, basking in the light of Judaism's past glory. He conceived the Israelites of biblical times and the *Maccabean* generation as proud men, free, natives of their own country, a nation like all other nations, possessing a long tradition and governing institutions.

Schatz recorded his utopian ideas in *Yerushalayim haBnuya—Chalom beHakitz* (Jerusalem Rebuilt—a Day Dream) (1923) (fig. 2.2). He wrote the book in 1918 while living in Safed during World War I after the Ottoman authorities exiled him from Jerusalem. *Jerusalem Rebuilt* is a utopian vision of The Land of Israel in which the visual arts play a significant part in its culture.

2.1 A Day Dream

Put in their proper universal context, Schatz's utopian ideas echo those expressed by European authors of the 19th century. Most of them wished to free contemporary society from the threats of the industrial world; they strove to form a new community of equal rights for all, based on ideal models from the past. Schatz was familiar with—and admired—the socialist English artist William Morris (1834–1896), who was a painter, designer, poet, and aesthete. He read Morris' book *News from Nowhere* (1891) (probably in its German translation) (fig. 2.3) in which Morris describes a future socialist society in England.

[1] Boris Schatz, "Esrim Shana leBezalel" (20 Years of Bezalel), *Yalkut Bezalel, Riv'on le'Omanut Bezalel baHoveh, ba'Avar uva'Atid* (Bezalel Files, a Quarterly for Bezalel Art of the Present, Past and Future), Jerusalem: Bezalel Publishing, 1928, 8.

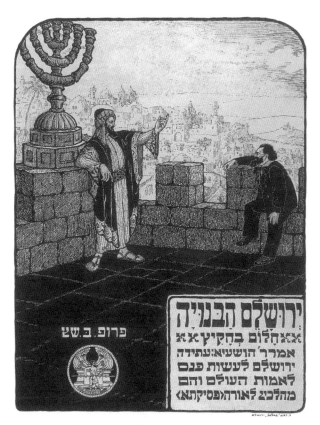

FIGURE 2.2 Ze'ev Raban, *Title page* of Boris Schatz's *"Jerusalem Rebuilt, a Day Dream,"* 1923

FIGURE 2.3
Title Page of William Morris' *"News from Nowhere,"* 1891

Morris focused on improving contemporary society by contrasting the ugly world of the present, as he saw it, with beautiful and pleasant aspects of his utopian world of the future.

The structure of Schatz's book resembles that of Morris', and small anecdotal details in the book also echo Morris's precedents. The similarities between the two are so obvious that it is hard to accept them as coincidental; it may be assumed Schatz referred to Morris' book while writing. While both utopias return to past eras, they differ in the authors' choice of the historical period they visit. Morris returns to the late middle ages, the thirteenth and fourteenth centuries, finding solutions for the destructive results of the Industrial Revolution in England. Schatz returns to fifteenth-century Italy. In both books, the return to the past is linked to a particular artistic style which plays a significant role in the two ideal future worlds.

The longing for an enchanted past, free of the chains of modern industrial society, led Morris to choose the Gothic style for his utopian society. The environments of his protagonists, their costumes, artworks, and artifacts are Neo-Gothic. His choice was a manifestation of a broader cultural phenomenon of nineteenth-century England: The Gothic Revival as an aspect of Romanticism's interest in medieval legends and forms.[2]

A significant contributor to the Gothic Revival artistic movement was Augustus Pugin (1812–1852). He signaled a new concept of the medieval period in his writings: not as a Romantic ideal but as a model for social reforms in contemporary English society. Some of Pugin's works were known to Schatz;[3] the Gothic Revival's idea of bringing back the past as a means for mending contemporaneous social issues was close to his heart. Pugin, however, had infused the Neo-Gothic style with Catholic religiosity; this aspect of the new style was foreign to Schatz, and he could not adhere to it or fit it into his Zionist-Hebrew needs. He thus turned to other artistic sources, concentrating on the Renaissance.

Schatz's vision of *Jerusalem Rebuilt* begins on a late Friday afternoon. Exhausted after a grueling workweek, he climbs to the roof of the Bezalel building and drifts into a reverie. Suddenly he is startled by an apparition. "… A tall, upright man, wearing a dark red coat; on his proud head he dons a small white hat, with dark, long hair locks flowing under it …".[4] Schatz is amazed as he

2 For the Gothic Revival see: Kenneth Clark, *The Gothic Revival, an Essay in the History of Taste*, New York: Icon Editions, Harper and Row, 1962.
3 Augustus Pugin, *Gothic Ornaments from Various Buildings in England and France*, London: Tiranti & Co., 1916. Pugin's book is in the collection of The Bezalel Library (Today the Israel Museum Library).
4 Boris Schatz, *"Jerusalem Rebuilt, a Day Dream"*, Jerusalem: 1923, 8.

recognizes the man he always considered his mentor from the glorious biblical times, Bezalel Ben Uri, the designer of the utensils of the Tabernacle in the wilderness (fig. 2.2). Bezalel accepts him as his successor and follower and speaks:

> Arise, my son, stand on your feet, wipe your tears ... a day would come— he said in a prophetic voice—my People would move mountains in order to build a new world, full of light.... You should complete the task, and you are not free to rid yourself of it. Work and believe! ... then he touched my eyes with his fingers and put his warm hand on my forehead and quietly said: Come![5]

Bezalel invites Schatz to accompany him on a tour of the Land of Israel; the year is 2006 (commemorating a hundred years since the founding of the Bezalel School in 1906). Schatz creates a historical sequence. He introduces himself as the follower of the first Jewish-Hebrew artist. Commanded by his mentor, he is expected to carry on the process of the renaissance of his People, renewing its great biblical era in the 20th century Zionist Land of Israel.

2.2 A New Florence

The public buildings in the future Land of Israel, according to Schatz's utopian vision, are designed after fifteenth-century Italian prototypes. They follow the architecture of Filippo Brunelleschi, (1377–1446). The facades of several buildings are decorated with narrow, tall and sometimes round windows, separated by exquisite colonettes. In the center of one future edifice, Schatz documents a square atrium, with the rooms of the house opening to it. In the tradition of a Florentine fifteenth-century *palazzo*, a small fountain, surrounded by pots of trees and climbers, is located in the middle of the atrium. "In the courtyard" Schatz writes "one may come across chromium colored statues and reliefs in which artists exhibit the harmony of nature in the same way we see in the best sculptures of the fifteenth century."[6] The color of the walls is light grey with a few yellow and light green patches. They are decorated with relief plaques made of majolica and mosaics.[7] Schatz also tells us that in the vision, many flat roofs, domes, and towers are typical of Islamic architecture. However, the

5 Ibid., 9.
6 Ibid., 38.
7 Ibid., 41.

FIGURE 2.4 Yosef Minor (architect), *Katzman House*, Ahad Ha'am Street, Tel Aviv (before it was torn down).

general look of his utopian architecture is more Western, and its components are more Italianate than Islamic.

Schatz's utopian vision materialized in Tel Aviv during the 1920s. Several Tel Aviv architects designed eclectic-styled buildings that contained Renaissance elements. One of them is the Katzman House (fig. 2.4). Its original plan shows significant similarities to the façade of the *Ospedale degli innocenti* (The Foundlings Hospital) in Florence, designed by Filippo Brunelleschi.

The ceramic medallions on the façade of the Florentine *Ospedale* are situated between each pair of the hospital's arches and contain images of swaddled infants, made by the della Robbia family of ceramicists. The medallions on the facade of the Katzman House in Tel Aviv show three biblical prophets and King David (fig. 2.5). Its ceramic tile decorations of biblical personages conveyed to contemporary passers-by a clear Zionist message: a link between the past of the people of Israel with the present, in which the prophecies of the Bible materialize and its Jewish inhabitants acquire a government similar to King David's.

Schatz's admiration for fifteenth-century sculpture is attested by his acquisition of copies of Renaissance masterpieces for the Bezalel museum; they were exhibited next to original works in the museum halls.

In the vision, Schatz revives the Renaissance *bottega*—a studio or workshop where the master creates the original artifacts, and his assistants copy them for sales through public commissions. Bezalel ben Uri takes him to a Jerusalem *bottega*. The two walk into the studio of Menashe ben Yehoshafat, "One of the greatest masters of sculpture in the Land of Israel." They enter a vast hall in which they behold hundreds of plaster casts:

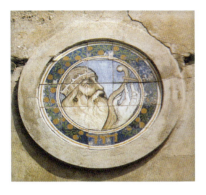 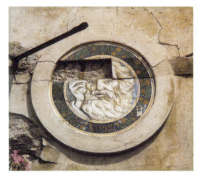

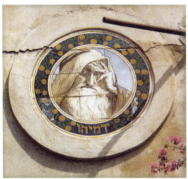 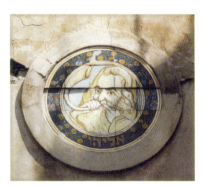

FIGURE 2.5 *Katzman House*, details: (from left to right, top to bottom) *King David, Prophet Isaiah, Prophet Jeremiah, Prophet Elijah*

More than two hundred assistants work here, in the studio of Master Menashe, not counting other laborers at the foundries and the terracotta and majolica[8] factories. All these artworks are made by him or under his supervision, signed by his very hand and seal.[9]

The real Bezalel workshops in Jerusalem functioned similarly: Bezalel senior teachers designed patterns for illumination in various media. These, in turn, were copied by assistants into products that were sold to Jewish Palestine, European and American collectors.

The 1860s saw a renewed interest in Italian Renaissance style and especially in works of the most celebrated early Renaissance sculptor Donatello (1386–1460). The Sculptor Paul Dubois (1829–1905) exhibited at the Salon of

8 Majolica is a ceramic substance. It is a glazing, made of tin compounds. The technique reached Italy from the Spanish island of Majorca and this is how it received its name.
9 Schatz, *Jerusalem Rebuilt* …, 62.

1865 in Paris a series of sculptures whose style was labeled "Neo-Florentine." Later on, nearer to Schatz's Paris period, the leading sculptor of that style was the American Augustus Saint-Gaudens (1848–1907). Known for his admiration of Donatello and Lorenzo Ghiberti's works, Saint-Gaudens was famous for his portrait reliefs, made in the spirit of the Renaissance style. It is entirely possible that Schatz became familiar with his works while studying and working in Paris.

The spirit of the Italian Renaissance nurtured not merely utopian ideas; Schatz adopted the style and implemented it in his own sculptures and reliefs. His famous piece *Mattathias*, (fig. 2.6) made during his Paris period, shows the assertive Jewish leader stepping on the corpse of a Greek soldier (who wears a helmet), calling his people to rise from under their enslavers. Schatz uses a traditional motif of Renaissance sculpture: the visual expression of ideas such as Good-Right stepping on Evil, and symbolically overpowering it.

Renaissance sculptors used mythological figures in their depiction of allegorical themes such as "Victory of good over evil" or "Victory of democracy over tyranny." *Perseus and the Severed Head of Medusa* (fig. 2.6a) by Benvenuto Cellini (1500–1571) shows the heroic Perseus, who has just vanquished and beheaded the monstrous creature Medusa. He stands proudly, holding the creature's severed head, her body at his feet. Perseus' heroic deed was assigned political meaning; it symbolized the victory of democracy over tyranny or the triumph of the Medici family, rulers of the city-state of Florence, over their enemies. Schatz followed the tradition by similarly depicting Mattathias.

2.3 A Hebrew Pantheon: Individual Commemoration

The spirit of the Italian Renaissance was evoked in one of Schatz' more significant Zionist projects—a series of visual memorials to Zionist leaders and other prominent public figures of Jewish Palestine. As a part of the general process of giving visual form to the rebirth of the Jewish People, the project expressed a component of the "rebirth" phenomenon: the creation of a national epic, carried out by the nation's new cultural heroes. Ahad ha'Am referred to the role played by Jewish cultural heroes of his time in an article he wrote to commemorate the death of the Zionist leader Theodor Herzl:

> Their [the heroes] main strength and historical value are not their real personalities or their actual deeds. Rather, it is the ideal form with which they are conceived by the people's imagination which sees whatever it wishes for in its heroes. This ideal concept, created by the nation according to its own spirit and needs, becomes a pattern, a functioning force in

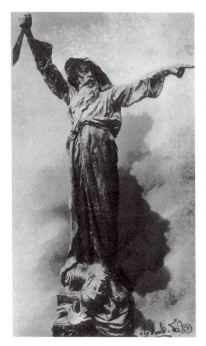
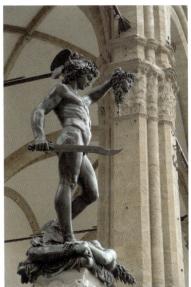

FIGURE 2.6 Boris Schatz, *Matathias* (whereabouts unknown)
FIGURE 2.6A Benvenuto Cellini, *Perseus and the Severed Head of Medusa*, 1545–1554, bronze

the people's hearts, arousing feelings and strengthening the people's will in its daily struggles and in achieving its national goals.... Indirectly, Herzl gave us one thing that might be considered greater than everything he did in reality. He gave us himself as the subject for the "poetry of revival;" a subject that the imagination can grasp and cover with every desired virtue so it can make him national Hebrew hero, in whose virtue all national aspirations would come true in real form.[10]

In following Ahad ha'Am's concepts, Schatz's portraits of the new "people's heroes" constitute the first step towards a less common phenomenon in the history of traditional Jewish culture because of its secular, non-Jewish aspects: a visual rather than a verbal commemoration of heroes.[11]

10 Achad ha'Am, "Hakdamah laChelek haShlishi" (Introduction to the 3rd Part), *Kol Kitvey Achad ha'Am* (Complete Works of Achad ha'Am), 251.
11 In the 19th century Jewish artists did create portraits of rabbis, made in *micrography* (contours of their faces comprised of miniscule Hebrew letters quoting biblical verses). However, these portraits and those of members of the elite Jewish society were privately commissioned, none of which were intended for public exposure.

Commemoration of "men of renown" (*uomini famosi*)—new national heroes—makes the first step in a phenomenon that was never prevalent in the history of Jewish culture, because of its secular aspects. The commemoration of political leaders, scholars, scientists, artists, and other public figures is a modern, secular concept, born in fifteenth-century Renaissance Italy. Humanistic approach regarded the contributions made by men of renown as an example to be followed by the entire community. Their lives served as a didactic model for a moral life, esteem for proper citizenship, patriotic feelings, and the fulfillment of a social vision. Commemoration epitaphs in Renaissance art were accompanied by visual representations of its men of renown. Schatz's commemorative plaques implemented Renaissance models and were modified to suit the commemoration of Zionist cultural heroes.

Schatz had great respect for his colleagues at the Bezalel school; he regarded them as exemplary visionaries. Shmuel ben David (1884–1927), one of Bezalel's beloved teachers, died at an early age. Artist Hayimn Glieksberg (1904–1970), tells us in his memoirs what happened on the eve of the artist's death:

> A few people gathered around the house, whispering among themselves … By the sofa, on the floor [I saw] the body, covered by a sheet, a Sabbath bread laid on top of it. In the evening (at the end of Sabbath) they brought the body to Bezalel. Some people sketched. At a late hour, Professor Schatz came. He wore a white caftan; its sleeves rolled up, his beard all ruffled. He bowed down on his knees, bent his massive forehead and anointed the deceased's face with oil. He took some plaster from a bowl, put it on [ben David's] face until it was completely covered.[12]

Glieksberg's testimony tells us that Bezalel students made portraits of the deceased on his deathbed. Moreover, it states that Schatz made a death mask of the departed, an action that violates the biblical Second Commandment concerning the creation of graven images. A few days later, in the Bezalel School's courtyard, Schatz put together a photograph of the deceased, next to which he put Ben David's last painting, the artist's death mask surrounded by olive branches and his palette, paints, and brushes (fig. 2.7). Schatz's homage to his colleague makes a visual memorial for a famous man who passed away. It is based entirely on Renaissance Humanist rituals and has nothing in common with Jewish commemorative tradition.

12 Hayim Glieksberg, as quoted by Gideon Ofrat, "Moto veChayav shel Shmuel ben David" (Death and Life of Shmuel ben David), *Haaretz*, 13.12.1982, 13.

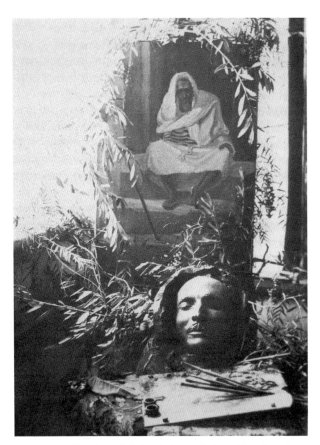

FIGURE 2.7 Death mask, last painting, palette and brushes of artist-teacher Shmuel Ben David put on display at the Bezalel courtyard, 1927

Well aware of potential criticisms regarding his artistic endeavors, Schatz contacted the esteemed Rabbi Yitzchak haKohen Kook. He sent him a list of questions, concerning Jewish laws regarding sculpture. Rabbi Kook answered directly to Schatz, and to members of the Bezalel Association. Following a lengthy introduction in which he praises Schatz's and the Bezalel enterprises in the making "… The light of splendor and Beauty shine on our People in our country and the Holy city". The Rabbi referred specifically to the biblical Second Commandment: "All faces are permitted except human faces." He then mentioned a possible way for a statue to be *kosher* [permissible and accepted] and stated that in the case of depicting a complete image of a human face in relief, "… We have certain ways [commentaries) [for Jewish artists] to be assisted by an artist who is not a member of the covenant [non-Jewish. A. M.] at the final

stage of giving the work its finishing touches, concerning the restriction." The Rabbi's basic belief is summed up thus: "… It would be praised in the context of our holy duty, that within the national treasure of our God's holy city we won't find such sculptures."[13] He concluded his letter with these words:

> When we come to practical worth that you like to bring through this honorable deed to our brethren who live in the Holy Land…. It would be worthy that the house [the Bezalel School] should not be conceived as one that stores objects which would make us look at them with loathing, inner spiritual eye, in respect of the duties of our holy religion. You intend to amend, not to spoil, to build, not to destroy. I trust your honorable souls to pay attention to my words that come out of a heart full of love and respect to the basics of your reputable will.[14]

Kook's answer is a modern *responsum* that shows that his decisions on the Jewish law were based on accepted medieval and post-medieval rabbinic authorities. The fact that rabbis of the 20th century were still questioned on the permissibility of types of sculpture indicates that for traditional Jewish circles the issue was still problematic.[15] In a *responsum* written to another person who approached him concerning issues of sculptures made by Jewish artists, the Rabbi concluded by giving the following advice: "I say that blessing will come to him who will cease from this [the depiction of human faces] and will erect to a beloved man an eternal monument in keeping with the spirit of our people and its Torah."[16]

Needless to say, Schatz ignored the Rabbi's advice. He must have expected such an answer since he was well aware of the general opinions held by the contemporary Jewish society in Jerusalem and their adherence to the alleged biblical restriction on creating images of human beings.

Schatz's memorial plaques were designed in the spirit of Renaissance tombs. They include a portrait of the person and an epitaph that relates in detail his

13 Letter of Rabbi Kook sent to Prof. Boris Schatz and Heads of the "Association for the Wisdom of Hebrew Art" at the Bezalel School in Jerusalem, 1908, Letters of Rabbi Kook, Part 1, letter 138, as quoted in Rabbi Avraham Spector, *She'elot uTshuvot veKitzur Halachot biTchumey ha'Omanut, ha'Eetzuv haGraphi vehaMachshevim, Mishnat haRav Avraham Yitzchak Kook beNos'ey Omanut* (Questions and *Responsa* and Concise Jewish Laws Concerning the Fields of Art, Graphic Design and Computers, Teachings of Rabbi Avraham Yitzchak Kook in Matters of Art), Jerusalem: Michlelet Emuunah, Erez Publishing, 1993, 271.
14 Ibid.
15 Vivian B. Mann, *Jewish Texts on the Visual Art*, Cambridge University Press, 2000, 34.
16 *Letter from Rabbi Kook to Professor Dr. Klein*, as quoted by Mann, *Jewish Texts on the Visual Art*, 34–36.

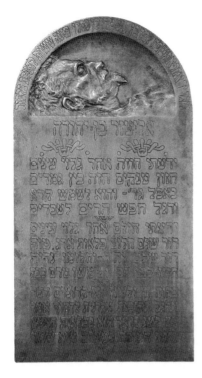

FIGURE 2.8
Boris Schatz, *Memorial Plaque for Eliezer Ben Yehuda*, 1923, plaster relief

contribution to the renewed Hebrew-Jewish culture. The plaques commemorate figures such as Eliezer ben Yehuda (1858–1922), the revivalist of modern Hebrew language, and of Zionist leaders, first and foremost Theodor Herzl.

Renaissance Humanists were depicted on their tombs lying on their deathbeds, crowned with victory wreaths fashioned after ancient Roman models. The epitaph would appear on the memorial front, summing up the cultural hero's contribution to society. Renaissance memorials reflect secular, retrospective aspects: they symbolically allude to the sorrow felt by the people of this world, faced by the cultural hero's earthly achievements.

The *Memorial plaque for Eliezer Ben Yehuda* (fig. 2.8) resembles the Renaissance prototypes: the hero's death mask appears at the top of the relief, surmounted by an arch. The epitaph, written in Hebrew by Schatz, summarizes the achievements of one of the Jewish-Hebrew revival heroes during his lifetime:

> I knew a clear-eyed seer
> Who would envision giants while dwelling among dwarves
> Living in the dark, he invoked the sun
> And raised freedom's banner for the Hebrews.

I knew a clear-eyed dreamer
For an entire generation, he spun and wove a reverie of miracles
The generation yearned—and the fantasy materialized
The vision of his heart manifested, and his sun was not extinguished.

Living in the present, he spoke the language of ancient times
Intending to roll the epochs back
His nation mocked him, but he believed in marvels
And so carried westwards his vision of the East.

Most of Schatz's memorial plaques are made of a rectangular format crowned by an arch, extremely popular with medieval and Renaissance altarpieces and public memorials. It is based on the form of Roman triumphal arches and always was associated with sacred connotations.

The top of Schatz's design for the *Plaque in honor of Otto Warburg* (fig. 2.9), a Zionist leader and one of the founders and directors of Bezalel, shows Cherubim, the angelic guardians of the Holy Ark. Next to them, Bezalel Ben Uri kneels down in veneration. These Cherubim replace the angels who usually adorn Christian Renaissance memorials in their role as the carriers of the deceased's soul into Heaven.

For the *Memorial Plaque for Theodor Herzl* (fig. 2.10), curvy columns frame the borders, replacing the customary Renaissance classical columns. They are

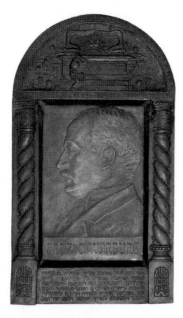

FIGURE 2.9
Boris Schatz, *Plaque in Honor of Otto Warburg*, plaster relief

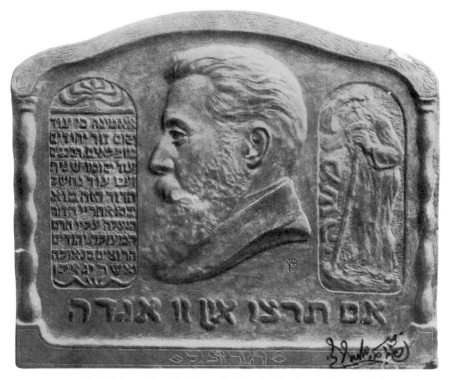

FIGURE 2.10 Boris Schatz, *Memorial Plaque for Theodor Herzl*, 1905, plaster relief

a traditional Jewish visual motif, described in the Bible, and often included in depictions of the two columns, named *Yachin* and *Boaz*, on the façade of Solomon's Temple in Jerusalem (Kings I, 7:15–20). The plaque's Hebrew inscription quotes Herzl's most famous saying "If you will it—it is no legend." On the right of Herzl's portrait, Schatz depicts Moses, leader of the Israelites in their Exodus from Egypt. Moses is presented as an allegorical figure, a prefiguration of Herzl who was responsible for the second Exodus of Jews—from the Diaspora of Europe into the Land of Israel.

All of Schatz's memorial plaques emphasize secular aspects; they exhibit neither quotations from Jewish texts included in prayers, nor a single verse from the Bible. The eulogies engraved on the plaques praise the contributions made by the deceased and assist—so he believed—to infuse pride in the hearts of contemporary Jewish spectators in Palestine. Schatz hoped that his memorial plaques would be installed in public spaces so that they may be viewed by the citizens of the future Jewish state; sadly, his wish never came true. He was, at least, able to envision them proudly exhibited in "The Song of Songs Pavilion," one of the sites he visits in his utopian book *Jerusalem Rebuilt*.

The plaques, as Schatz recounts, are displayed next to depictions of various towns in the future Land of Israel:

> Among the various paintings, I saw portraits of our national men of renown. The spectator's heart fills with pride while gazing at the beautiful cities we built, juxtaposed with the great genius spirit of our people. I had thought that a member of such a great people would not forget his virtue and his human values and consequently would not be capable of degrading his fellow men ...[17]

Schatz's attempt at creating a rebirth of Hebrew art, based on a concept of revival of a significant past period in the Jewish People's history, did not have an earlier formal source. Westminster Abbey in London, a magnificent Gothic building from the 13th century, is located next to England's Houses of Parliament, built in the 19th century in the Neo-Gothic style. The latter building's style shows how the original medieval style was revived in the modern period. A similar option of comparing the styles of two different historical periods was available to 15th century Italians. Ancient Roman ruins existed almost everywhere, and contemporary edifices, echoing the antique models, consisted of variations made according to Roman architectural principles and components. The possibility of comparison between the old and the contemporary contains, by its nature, an aspect of a historical sequence. Schatz' attempts for revival did not present his audience with such a sequential continuity. The new Jew, reviving his past in the Land of Israel, had no innate connection with fifteenth-century Italian models. No natural link existed between the Italian works of art that served Schatz as models, and Jewish tradition and spirit; his utopian ideas failed.

Moreover, Schatz's attempts to implement a revival during the early years of the 20th century, based on a European phenomenon that took place sixty or seventy years earlier, was regarded as antiquated. European revivals came to an end after the First World War; post-war Europe showed the seeds of Modernism. Schatz tried to revive a particular past in his utopian thought; clinging to a past made it impossible for him to accept the principles of Modern art and he fought against them vehemently. He was indirectly responsible, therefore, for Jewish artists in Palestine to reject the Bezalel workshops' legacy. Most contemporary Jewish artists aspired to adhere to modern art trends rather than cling to the charms of a foreign past.

17 Schatz, *Jerusalem Rebuilt ...*, 151.

FIGURE 2.11
Avraham Melnikov, *Memorial to the Heroes of Tel Chai*, 1934, stone

Schatz's concept of cultural heroes' commemoration was a strictly *individualistic* approach. Moreover, his pantheon of heroes included representations of many aspects of contemporary Jewish society. This approach changed with the Zionist concept of commemoration during the 1920s and 1930s; it replaced Schatz's individual approach into collective allegorical commemoration, as the Zionist new attitude focused on new Hebrew heroes as fighters for their Homeland. An early example of such a commemoration is the *Memorial to the Heroes of Tel-Chai* by sculptor Avraham Melnikov (1892–1960). His statue celebrates the people's courageous spirit through the image of a lion—the symbol of power, royalty, and government. The monument (fig. 2.11) is made of a slab of stone in what the sculptor conceived as the ancient Assyrian style, a decisive deviation from Schatz's Neo-Renaissance style commemorative concepts.

2.4 Collective Commemoration

Melnikov felt that he was creating an innovative Hebrew style, an absolute opposite to what he viewed as Schatz's "Diaspora style" which he wanted to eliminate by turning to the Orient:

> For many generations Jews were cut off from figurative art; there are many reasons for that, but the primary rationale is that European art is rooted in Greco-Roman culture … as long as Athens was the mother of European art, Jews, instinctively, found themselves outside its borders.[18]

18 Melnikov's words were published in *Haaretz*, 18.12.1925, as quoted in *Mlenikov—Yehuda haMit'orer—Mecheva leAvraham Melnikov, Chalutz haPisool haEretz Israeli, Psalim, Rishumim, Tziv'ey Mayim* (Melnikov—Awakening Judah—Homage to Avraham Melnikov, Pioneer of the *Yishuv* Period, Sculpture, Drawings and Watercolors), (exh. cat.), Haifa University Art Gallery, 1982, 9.

In a letter to a friend the sculptor related his ideas on this matter:

> I am sure that all these talks about Modernity that one hears Jewish Palestinian artists talk about, all their copies of Picasso, Matisse et all— all this would vanish like foam on a stirred, steaming cup of tea. If we have a right—let no one deprive us of it—to call ourselves an Oriental people, we should direct our gaze to the east. Not in vain I guided the gaze of my lion in Tel Chai to the east…. Jews were not late in securing a proper place in this [Modern] movement [the artist refers to German Expressionist art. A. M.] only after this art turned its gaze to the east. Expressionism is ours, a flesh of our flesh. It saddens me that a certain circle of artists from the Land of Israel still wallow in Japhet's soil [Gentile art. A. M.] and cannot perceive Jacob's gold [Jewish art. A. M.].[19]

Melnikov was not bothered by the fact that the art of the ancient Orient— "Jacob's gold," as he referred to it—just like the ancient art of Greece and Rome—was not "Jewish" at all. Generally speaking, most memorials erected by Jewish sculptors in Palestine since the 1930s were dedicated to a collective idea, commemorating historical events carried out by *groups* of people, rather than that of individuals. Schatz's Men of Renown were chosen from a much broader variety of occupations: next to political leaders, fighters and scholars he dedicated his commemorative plaques to scientists, authors, poets, and artists. He believed that a nation's culture is nurtured by a variety of public figures, delegates of an extensive range of professional fields. Such a notion was wholly rejected by the Zionist establishment during the early years of the state of Israel; it narrowed its pantheon to include mainly collective commemoration of land tillers, workers, and laborers in general, who dedicated their lives to their country and redeemed it either through their work or in death.

Schatz's visual commemorations of individual men of renown were forgotten; they were shunned by Israeli political as well as artistic establishments. Israeli public institutions, streets, and official edifices commemorated certain public figures in adherence to Jewish tradition by *verbally* commemorating their names. Schatz's legacy, however, was adapted into a different medium: Israeli official banknotes and stamps.

19 Ibid.

2.5 Schatz's Legacy: Models for a Sovereign State Heroes

On the occasion of Israel's tenth anniversary (1958), the Bank of Israel followed the collective concept of commemoration and issued new banknotes dedicated to Israeli personifications: a female soldier (fig. 2.112a), a factory worker (fig. 2.12b), a scientist in his laboratory (fig. 2.12c) and a fisherman. The new heroes, represent various aspects of Zionist enterprises in the state of Israel: Agriculture, Industry and Science, a concept that echoes contemporary Soviet prototypes.

A few years later, the Bank of Israel took a revolutionary step in issuing a new series of banknotes in which portraits of individual personalities replaced the collective personifications. The series included portraits of Israeli presidents Chaim Weitzman, Itzchak Ben Zvi (fig. 2.13a) and Zalman Shazar. Next came portraits of Israeli Prime Ministers David Ben Gurion (fig. 2.13b), Moshe Sharet, Levi Eshkol and Golda Meir. Also created were portraits of Jewish philanthropists and contributors to the development of Jewish settlement in Israel—Sir Moses Montefiore (fig. 2.13c), James Rothchild, and Henrieta Szold, and of Jewish geniuses Moses Maimonides and Albert Einstein.

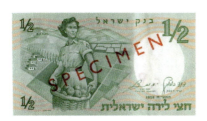

FIGURE 2.12A
Shamir Brothers Studio and Ya'akov Zim, *Israeli half a pound note*, 1958

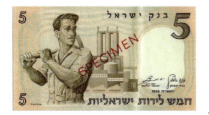

FIGURE 2.12B
Shamir Brothers Studio and Ya'akov Zim, *Israeli five-pound note*, 1958

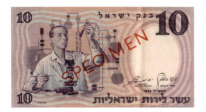

FIGURE 2.12C
Shamir Brothers Studio and Ya'akov Zim, *Israeli ten-pound note*, 1958

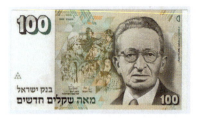

FIGURE 2.13A
Zvi Narkis, *Israeli one hundred new shekels note* (with a portrait of President Yitzhak Ben Zvi), 1976

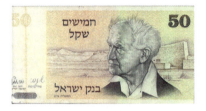

FIGURE 2.13B
Dutch artists, *Israeli fifty old shekels note* (with a portrait of Prime Minister David Ben Gurion), 1977

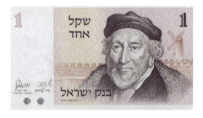

FIGURE 2.13C
Paul Kor and Adrian Sanger, *Israeli one shekel note* (with a portrait of Sir Moses Montefiore), 1980

The Bank of Israel followed a Zionist tendency that puts contributions made by humanists and scholars on a lower rung of hierarchy than that of political figures. From the sixteen personalities depicted on these Israeli banknotes, only two were Israeli men of letters: National Hebrew poet Chaim Nachman Bialik and author Shmuel Yosef Agnon.

The undecided, confusing considerations concerning the issue of the Second Commandment's alleged restrictions on portraying human figures is shown by the decision taken by the Bank of Israel to replace portraits of two Israeli presidents—Yitzhak ben Zvi (figs. 2.14a, b) and Zalman Shazar. They exemplify the indirect influence of certain clerical civil servants who must have advised bank officials of a potential problem of using portraits, as they may be regarded by some religious sectors as a transgression of the Second Commandment. A sophisticated solution was found: the portraits would be depicted as micrographic[20] images. Yitzhak ben Zvi's portrait is made of tiny Hebrew letters (*bet* ב and צ *tzadi*), the letters of his last name.

20 Micrography literally means 'small-writing'. It is a visual medium through which Hebrew letters form representational designs. Observing a visual image done in micrography—including portraits of individual persons—is considered non-transgressive of the Second Commandment's alleged prohibition of depicting human forms, since it involves *reading*

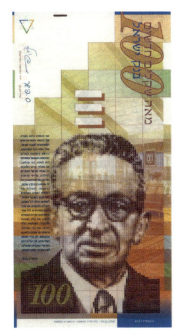

FIGURE 2.14A *Israeli banknote of 100 new Israeli shekels* (with a portrait of President Yitzhak Ben Zvi), 1976

FIGURE 2.14B *Israeli banknote of 100 new Israeli shekels*, detail

The validity of the Zionist establishment's discriminative concept between the humanist contributions to that of politicians was referred to by a short, yet instructive note, written by Menachem Brinker.[21] The scholar suggested researching official Israeli culture from a philatelic point of view. He saw in the Israel postal services' catalog a relevant source for a comparison between Israel's official culture and that of other countries.

Brinker found that many events, jubilees, public figures and dates that were deemed relevant by the bodies responsible for philatelic commemoration, and reflected social consensus, function as what sociologists call "civil religion." He gathered his findings and presented them in a table format, focusing on the

a certain *text*, thus making it permissible according to Orthodox interpretations of the restriction of beholding graven images.

21 Menachem Brinker, "Hatza'at Mechkar beNoseh Tarbut Israel haRishmit miNkudat Re'ut Bula'eet" (Suggestion for Research Dedicated to the Subject of Formal Israeli Culture from a Philatelic Vantage Point), in Natan Zach (editor), *Agrah, Almanach leDivrey Sifroot ve'Omanut*, No. 3, 1990, 9–14.

various public figures' portraits commemorated on Israeli stamps since the state's establishment in 1948 and during the country's first forty years.

In the realm of religion, policy-making, and wars Brinker found seventy portraits including martyrs, military leaders and fighters, heads of political parties, rabbis and religious clerics, presidents, and prime ministers. The list contained a single portrait of a philosopher, three musicians (all Jewish, not one of them Israeli), and no portraits of historians, educators, painters, sculptors, architects, theater actors or directors, mathematicians, physicians, jurists, fighters for human rights, and fighters for women's rights. The entire universal and Israeli science are represented on Israeli stamps by a single portrait of Albert Einstein. The whole global and Israeli cogitation are represented by Maimonides and the whole of the world and Israeli art by portraits of pianist Arthur Rubinstein and conductors Arturo Toscanini and Bronislav Huberman.

Leafing through other countries' stamp catalogs, Brinker wondered how was it possible that of all countries, the Jewish state did not commemorate on its official stamps a single portrait of a humanist, historian, anthropologist, lawyer, or a fighter for human's, women's, workers' and children's rights. The philatelic micro-cosmos of Brinker's research reflects the Israeli establishment's lack of attention to the contributions of intellectuals, academics, and people of letters to the realization of the Zionist dream.

The painted and sculpted portraits of Israeli people of letters are hardly ever exhibited in public; they are not shown as cultural heroes on public memorials either. They are absent in most public cultural institutions such as concert halls, museums, and theaters. It is only in the last few years that Israeli people of letters receive the appropriate respect they deserve still by verbal commemoration; streets in major cities are named after them. In 2015, out of four proposed designs, the Bank of Israel issued two new banknotes—a fifty and a two-hundred shekel notes, with the portraits of the poets Shaul Tchernichovsky and Natan Alterman, respectively (figs. 2.15 a, b).

Boris Schatz's ideas were extremely significant and pointed—for the first time in Jewish cultural history—to issues concerning the creation of art for a nation who was reborn. Some of these problems are still deliberated by contemporary Israeli artists. Schatz was first to deal with the *visual* commemoration of the nation's heroes, the model figures of the Jewish People's modern rebirth. He based his ideas on Western, non-Jewish concepts; the "foreign" origin of his concepts was probably the reason why prominent Israeli artists did not follow him. His war with the Zionist establishment was a bitter one as he was fighting for the acknowledgment of people of letters. He consistently lost the battles. The establishment, aided by artists, at times professional colleagues, won; the rejection of Schatz's Bezalel workshops style finally brought

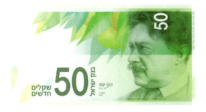

FIGURE 2.15A
Israeli banknote of 50 new Israeli shekels (with a portrait of poet Shaul Tchernichovsky), 2015

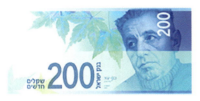

FIGURE 2.15B
Israeli banknote of 100 new Israeli shekels (with a portrait of poet Natan Alterman), 2015

the curtain down on the Bezalel enterprise in 1929. Three years later, during a tour of the United States, Schatz died in Denver Colorado.

Bibliography

Achad ha'Am, "Hakdamah la Chelek haShlishi" (Introduction to the 3rd Part), *Kol Kitvey Achad ha'Am* (Complete Works of Achad ha'Am), Dvir Publishers, Tel Aviv and *Hotza'ah Ivrit*, Jerusalem, 1961.

Brinker, Menachem, "Hatzat Mechkar beNoseh Tarbut Israel haRishmit miNkudat Re'ut Bula'eet" (Suggestion for Research dedicated to the subject of Formal Israeli Culture from a Philatelic Vantage Point), in Natan Zach (editor), *Agrah, Almanach le Divrey Sifrut ve'Omanut* (*Agrah*, Almanach of Literature and Art), No. 3, 1990.

Clark, Kenneth, *The Gothic Revival, an Essay in the History of Taste*, New York: Icon Editions, Harper and Row, 1962.

Mann, Vivian B., *Jewish Texts on the Visual Arts*, Cambridge University Press, 2000.

Melnikov—Yehuda haMit'orer—Mecheva leAvraham Melnikov, Chalutz haPisool haEretz Israeli, Psalim, Rishumim, Tziv'ey Mayim (Melnikov—Awakening Judah—Homage to Avraham Melnikov, Pioneer of Jewish Palestine Sculpture, Sculptures, Drawings and Watercolors), (cat. exh.), Haifa University Art Gallery, 1982.

Pugin, Augustus, *Gothic Ornaments from Various Buildings in England and France*, London: Tiranti & Co., 1916.

Schatz, Boris, "*Esrim Shana liVzalel*" (20 Years of Bezalel), *Yalkut Bezalel, Riv'on le-Omanut Bezalel baHoveh, baAvar uva'Atid* (Bezalel Files, a Quarterly for Bezalel art of the Present, Past, and Future), Jerusalem, Bezalel Publishing, 1928.

Schatz, Boris, *Yerushalayim habnuyah—chalom behakitz* (Jerusalem rebuilt—a Day Dream), Jerusalem, 1923.

Spector, Avraham, *She'elot uTshuvot veKitzur Halachot biTchumey ha'Omanut, ha'Eetzuv haGraphi vehaMachshevim, Mishnat harav Avraham Yitzchak Kook beNos'ey Omanut* (Questions and Responsa and a Concise Jewish Laws Concerning the Fields of Art, Graphic Design and Computers, Teachings of Rabbi Avraham Yitzchak Kook in Matters of Art), Jerusalem: Michlelet Emunah, Erez Publishing, 1993.

Zalmoina, Yigal, and Shilo-Cohen Nurit, *Bezalel shel Schatz*, Jerusalem: Bezalel.

CHAPTER 3

"The Garden of Love": Early Zionist Eroticism

In 1900, the Zionist leader Max Nordau (1849–1923) published his famous article "Muscle Judaism." His introduction begins with the following:

> Two years ago, while attending a conference with the committee of the Basle Congress, I said: "We must re-create 'Muscle Judaism.' History testifies that this kind of Judaism existed in the past. For a long time, too long, we occupied ourselves with killing our own flesh."[1]

Nordau expressed one of Zionism's central aspirations: to bring about changes in the Jewish way of life in the Diaspora. The Diasporic Jews were commonly stereotyped as *Luftmenschen*, "People of the Air." Through bodybuilding, these atrophied Jews had to be transformed into healthy individuals in both body and mind. Gymnastic exercises and strengthening the body would bring salvation to Jewish "weakness of nerves" and neuroses. Jews must become "people of muscle" and not remain slaves to their nerves. Nordau believed such a metamorphosis was plausible because Jews were the offspring of past "people of muscle" who had lived a life of freedom in the Land of Israel. At that time, Nordau claimed, the nation behaved normally and did not "kill its own flesh." To form Muscle Judaism, it was necessary to create a new culture that would advocate physical and sexual health. The two went together since, according to Nordau, physical and erotic atrophy were linked.[2]

Boris Schatz presented a utopian solution—the return to nature—to the contemporary Jewish neuroses, which he admitted he shared. In his *Jerusalem Rebuilt—a Day Dream*, he also referred to sexuality. His concepts served as a model to one of the most significant publications of early Zionist art: a series of 25 illustrations to *The Song of Songs* by Ze'ev Raban (1890–1970), one of the teachers at Bezalel. Raban's visual interpretations of verses from *The Song of Songs* echo Zionist ideas included in Nordau's Muscle Judaism and Schatz's utopian vision. His illustrations show the first Zionist search for a visual expression of Jewish-Hebrew identity through the use of universal models and principles.

1 Max Nordau "Muskeljudentum", published originally in *Judische Turnseitung* in June 1900.
2 Ibid.

3.1 The Garden of Love: a Remedial Institution for Nervous Atrophy

In *Jerusalem Rebuilt—a Day Dream* Schatz describes his tour in the future Land of Israel. He visits the newly rebuilt Temple in Jerusalem and meets a teacher with her students as they are observing and analyzing the sculptures in the Temple's museum. Schatz approaches them and contributes his own interpretations to *Moses* and *Jochebed and the Infant Moses*—existing sculptures made by him in the "past." During the conversation, he falls in love with the teacher. Later on, next to the Copper Basin in the Temple's courtyard, he decides to call her *Shulamite*. "Why do you call me Shulamite? Am I so black?" she inquires. "Because you are so beautiful, my Shulamite," he answers. Their third meeting takes place in the "Garden of Love."

Schatz is first informed of the "Garden of Love" institution by Mr. Elyashiv, a bacteriologist by profession and a boxer in his free time. Elyashiv is "An athlete whose neck is strong, and whose arm muscles are developed…."[3] Schatz meets him at a boxing match in Jerusalem and confides his depression and health problems; Mr. Elyashiv lights a cigarette and says:

> To answer your question as to what men and women who cannot have good marital relations do? Or if he or she cannot remarry? We regard the sexual act itself neither as a "holy" nor an "unholy" act. It is a natural need of every human being like eating and sleeping … We regard it as our duty to prevent any potential evil: men and women who show interest in getting married or in visiting the "Garden of Love" are first checked by a doctor for possible venereal diseases.
>
> … Men and women who come to the "Garden of Love" do not surrender their hearts. They don't even know each other's names, and do not get involved in matters of the heart; instead, they assist one another to fulfill their natural desires and to quiet their blood and nerves. Men and women, who had drifted in the wrong direction since they were unable to fulfill nature's laws, come to the "Garden of Love." Both are free creatures … They return home healthy and relieved, ready to offer their pure heart and love … Since they do not know whom they met in the "Garden of Love," their love becomes abstract and pure: Love for Love's sake … In the "Garden of Love," in that beautiful settlement, you would find no other thoughts.[4]

[3] Boris Schatz, *Jerusalem Rebuilt—a Day Dream*, Jerusalem: 1923, 122.
[4] Ibid.

"THE GARDEN OF LOVE": EARLY ZIONIST EROTICISM

Mr. Elyashiv's description provides an answer to Schatz's strong yearning to cure his sick nerves, his feeble body, and his thirst for love. Following his grand tour of the future Land of Israel he finally decides to visit the "Garden of Love" and arrives there feeling troubled and worn out:

> ... I boarded an airplane and flew to the "Garden of Love" ... The entrance arch was large and beautiful ... On top of the gate, a slogan was inscribed in gold letters: "This is the gate to Nature, human beings are welcome to enter." A secretary asked me how old I was, and what was my marital state. He did not ask for my name, and just showed me a door marked "Physician's Office." The doctor, an older man, apologized for asking me quite directly to take off my clothes. I immediately regretted the entire business, but when he said "Brother, do your duty to our sisters" I complied with all his requests.[5] He examined me and found me physical healthy ... Another motto appeared on top of a smaller gate: "To the Pure, Everything is Pure."[6]

Before entering the "Garden of Love," Schatz is given a small blue book, containing the rules of the place; the tone of the writing is serious and brotherly, like that of a doctor giving good advice to a patient:

> My brother, drain the glass of bliss the Creator had given you. But bear in mind that pleasure stops when it hurts another ... You must regard everyone here as brothers and sisters, and that is what you should call them. See yourself as one, and don't use another name ... Be aware that besides your duty to your body, more difficult duties are due to your soul. Fulfill them. Don't try to overindulge because of fear of hunger. Don't ask to be a father if it is not asked of you. Should it happen, don't demand the paternity rights ... Do not take what was already taken by your brother. Do not enter a closed door.[7]

Schatz is directed into a vacant tent; he settles in, goes out for a swim, then rests for a while. All around him, under every tree, shady niche, or flower-covered gazebo, couples are relaxing. Going for a walk in the evening, he finds a theater where a play titled "The Song of Songs" is presented. Forgetting where he is while absorbed by the erotic innuendoes of the play, Schatz is snapped

5 Ibid.
6 Ibid. this motto was on Lilien's ex-libris as mentioned in chapter 1.
7 Ibid., 116.

back to reality when he notices a woman sitting next to him: "I could not control myself any longer. I searched for the hand of my *Shulamite* … she startled, froze at the sight of me for a minute, and then embraced me … Both of us sat on one chair, silently embracing."

At the end of the play, they go outside and then Shulamite whispers in his ear: "Pull me, I will run after you." Schatz brings her into his tent.

> Put your satchel down, turn off the lantern and lie down to sleep. Oh, a deep sleep is taking over me, come to me my love, the night is cold … embraced, we dozed, not sleeping but floating in a lovers' world of imagination woven with golden threads. I fell asleep; my sleep was deep and pleasant like a child on his mother's breasts …[8]

So finally Schatz' yearnings are satisfied—but not for long. The rules of the "Garden of Love" advocate gender equality but the writer himself does not keep his word. He is tormented by jealousy and despair because after the night of love with his Shulamite, she moves on to another tent, free to find other "brothers" in the garden. The next morning Schatz sees her dancing around a bonfire, holding hands with two men. Unable to restrain his jealousy, he scolds her. "She threw at me a burning look that poured its contempt on me and said, seriously and assertively: "Stranger, in this place, a man does not speak like this to a woman." "Intellectually," Schatz writes, "I understand her, but my heart and soul do not comprehend such liberty. My heart demands that lovers would be given to one another and that their love should never be interfered with by somebody else […] I cannot free myself from the underworld, hell frightens me …".[9]

3.2 In the Song of Songs Pavilion

If, after all, Schatz could not entirely cure his nerves at the "Garden of Love," at least he was able to find satisfaction for his aesthetic needs. The task was accomplished by the Shulamite figure: a woman not of flesh and blood but an ideal one, painted on the walls of The Song of Songs Pavilion in "The Garden of Love":

> On a small hill beyond the pond, surrounded by green bushes, tall cypresses, upright palms, and many flowering shrubs stood a circular pavilion built of polished stones. Dark red marble columns topped with

8 Ibid.
9 Ibid. 162.

golden crowns lined the large porch through which one could behold a series of wall paintings. The high, round dome, made of stained glass, seemed like an illuminated sphere ...

The same year that Schatz published *Jerusalem Rebuilt—a Day Dream* Ze'ev Raban published his book of illustrations for *The Song of Songs* (1923). From the beginning of his career, Raban was exposed to contemporary Western art styles. The most popular art style of the period was *Art nouveau*. He was seventeen when he came to Munich in 1905 to begin his studies at the *Kunstgewerbeschule* (Arts and Crafts School). The style that had most influenced him was Symbolism.[10] This style strove to create art that would be universal in concept, and focus on the artist's private world, beyond the realms of everyday experiences. Charles Baudelaire claimed that art should be used for narrative or moral purposes only to express the artist's state of mind. In Baudelaire's case, this world was gloomy, dark, hedonistic and to a certain extent, even warped. Long before Freud concluded that sexuality is an essential element in human psychology, artists researched the subject in ways that made specific layers of consciousness, until then untouchable and ignored, rise to the surface.

One of the topics that Symbolist artists dealt with was the ideal portrait of a woman; often it was a portrait of a literary heroine through which they were able to project complicated personal feelings. Such a portrait expresses the artist's desires on the one hand and the remote, ideal female picture on the other. The concept of seeing the painting as a mirror, through which we behold a reflection, intensifies the visual image with further meanings: reality is the total reverse of reflection, an ideal dreamlike world which parallels the world we live in. English artists in the 19th century had developed such an image; it shows a woman possessing the dual personality of priestess and seductress.

3.3 The New Jew: Intellect and Sensuality Combined

The Song of Songs Pavilion from Schatz's vision was realized visually in Ze'ev Raban's striking illustrations. His style perfectly fitted the early Zionist concepts, expressed so well by Schatz, and regarded the modern Jew, living in his homeland, as a strong person, harmoniously and perfectly combining Jewish intellect with beauty, virility, and vitality. Like Schatz, Raban tried to revive the

10 For a detailed discussion on Raban's Symbolism see: Trude Greenspan, "Raban and the legacy of Symbolism" in *Raban Remembered, Jerusalem Forgotten Master* (cat. exh.), New York: Yeshiva University Museum, 1982, 39–50.

FIGURE 3.1
Ze'ev Raban, *Portrait of the Artist's Wife*, 1920s

past of the Jewish People through the use of universal principles in the creation of an innovative Hebrew style, based on Symbolist motifs.

Raban's elegant book opens with a dedication to Boris Schatz, clearly showing both amity and admiration. He was Schatz's friend and right hand at Bezalel. Raban was twenty-two when he came to Jerusalem in 1912; Schatz was forty-six. Undoubtedly the young artist viewed Schatz as a role model, a visionary, and an educator; he revered Schatz's ideas and was familiar with the contents of *Jerusalem Rebuilt: A Day Dream* since he had created the illustration for the title page (chapter 2, fig. 2.2).

The immediate source for Raban's illustrations for The Song of Songs is naturally the text from the Bible, but they go beyond mere visual parallels to the text. To fully fathom their meaning it would be worthwhile to note their artistic style, the background sites in which the protagonists function, the costumes, and the accessories. All of these comprise Raban's unique and enchanted world. Schatz's utopian vision of The Song of Songs Pavilion is always alluded to in the background.

The frame of the title page for *The Song of Songs* (fig. 3.2) shows a vegetal pattern of intertwined grape vines on its right and pomegranate branches on its left, topped by small foxes, who are notorious for stealing grapes from vineyards. The vegetal motifs are based on Schatz's verbal description of the wall paintings in "The Song of Songs Pavilion" in "The Garden of Love."

> I entered the pavilion. Large divans were arranged against the walls, with embroidered throws spread on them here and there; above them, brightly-colored frescoes were painted with scenes from The Song of Songs. The

"THE GARDEN OF LOVE": EARLY ZIONIST EROTICISM 73

FIGURE 3.2 Ze'ev Raban, *Title Page of The Song of Songs*, 1923

paintings were framed by garlands made of grape vines, pomegranates, and branches of citrus trees.

The bottom of the title page introduces us to the two main actors of the illustration series: King Solomon and the Shulamite. We are able then to identify the protagonists by their attributes: Shulamite is accompanied by a gazelle and the king by a lion; he wears a crown on his head and holds a harp in his left hand. The choice of King Solomon as the main protagonist realizes the Zionist aspiration for a sexually healthy man. He makes a perfect combination of intellect and sensuality, being the wisest man as well as the husband of a thousand wives. No wonder the erotic relations between Solomon and the Shulamite enchanted both Schatz and Raban.

One wonders why Raban would envision King Solomon accompanied by a lion and the Shulamite attended by a gazelle? In the long iconographic tradition

of visual depictions of the king, he is identified by no particular attribute save for a crown; at times his figure is accompanied by an elaborate throne. Raban needed additional sources, but did not have to go far in his search for proper attributes for King Solomon and the Shulamite; he could find them in legends told about the King in the *Book of Legends*. The book is a compilation of traditional Jewish Midrashic legends, collected, revised and published by H. N. Bialik, the Israel laureate poet and his associate, the author and editor Y. H. Ravnitzky. Raban knew them personally, was familiar with their work, and made several illustrations for Bialik's books. He could find the attributes of the lion and the gazelle in several stories.

The "Legend of the White Lion"[11] recounts one of King Solomon's voyages in which he meets two donkeys arguing about him, one siding with the King, the other claiming that the king is not worthy to rule since he does not understand the various languages spoken by his subjects. Since the lion is the king of the animals, Solomon orders the donkey to bring him to his court "the lion which is white as snow, his mane is a forest, his tail is like the cedar of Lebanon, and his eyes are two flaming torches." When the king meets the lion, he glares at him; "The lion's tempestuous behavior stopped immediately. He retreated, seemingly frightened, and prostrated itself before the king. The king ordered the lion to appear before him once a month … the lion obeyed, and Solomon rode the lion wherever he would wish to go".[12] The obedient lion appears in other legends, and also as a sculpted image on the king's great throne: "Two golden lions on the handles of the throne are hollow and filled with perfumes. When the King sits on his throne, the lions spread the fragrance all around the royal court to delight everyone".[13]

The gazelle's graceful look, its slim legs, slender body, and beautiful eyes, turned this animal into a symbol of grace, beauty, and gentleness.[14] The verse "Daughters of Jerusalem, I charge you by the gazelles and by the does of the field: Do not arouse or awaken love until it so desires" appears twice in The Song of Songs (2:7, 3:5). Traditional Jewish interpretations to these verses refer to the specific behavior of gazelles and deer—males and females live separately during most of the year and meet only for the mating season. By invoking deer

11 H. N. Bialik, and Y. H. Ravnitzky, "Legend of the White Lion", in "Legends of King Solomon", *Kitvey H. N. Bialik* (H. N. Bialik Works), Jerusalem and Tel Aviv: Dvir Publication 1983 (first edition 1945), 325–326.
12 Ibid.
13 H. N. Bialik, and Y. H. Ravnitzky, "*Kisseh Shlomo*" (Solomon's Throne), in "Legends of King Solomon", 332–333.
14 *Encyclopedia Judaica* s. v. Gazelle.

"THE GARDEN OF LOVE": EARLY ZIONIST EROTICISM 75

and gazelles, the heroine of The Song of Songs hints that her lover will return to her after their separation.[15]

Raban's illustrations for *The Song of Songs* show a cross of two different sites; on the one hand it is King Solomon's palace, and on the other hand, it is The Song of Songs Pavilion from Schatz's utopian vision:

> Each fresco [in the "Song of Songs Pavilion] had an inscription written underneath it: verses from The Song of Songs that served as sources for the art. The kiss is the living spirit in these pictures that depict our most ancient love poem, the poem of innocent love triumphant, love that had conquered the wisest of men ... the paintings were pure and natural, full of blossoming life and flaming love, like nature itself, hiding nothing, wholesome as the heavenly air created through God's wisdom for his beautiful world ... I felt that I was enfolded in a pink, perfumed fog as I was walking from one painting to another, unable to take my enchanted eyes off them when sunlight penetrated the stained glass dome ...[16]

The theater sets that serve as a background for the figures in *You are beautiful, my love* (fig. 3.3) and of *Let him Kiss me with the Kisses of his Mouth* (fig. 3.4) are

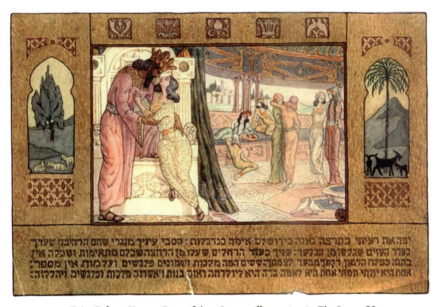

FIGURE 3.3 Ze'ev Raban, *You are Beautiful my Love....*, illustration in *The Song of Songs*, 1923

15 Ibid.
16 Ibid. 167–168.

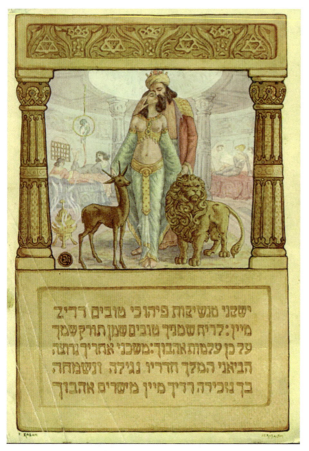

FIGURE 3.4 Ze'ev Raban, *Let him Kiss me with the Kisses of his Mouth …* illustration in *The Song of Songs*, 1923

identical. Both show scarlet columns supporting a transparent glass ceiling, large seats covered by embroidered cushions, and the wall paintings between the windows. All of the above are visual counterparts to Schatz's verbal descriptions of The Song of Songs Pavilion.

Raban's adherence to Schatz's ideas is manifested in the depiction of the figures as well. During his visit to The Song of Songs Pavilion, the author admires its wall paintings:

> Under the blue Jerusalem sky, among vines and fig trees, stands King Solomon, attired in shiny embroidered silk garments. His raven-black locks, tinged with silver, flow from under his embroidered golden headdress … His big black eyes behold with a burning fire a small, suntanned shepherdess, who is gliding towards him, her beautiful arms outstretched,

"THE GARDEN OF LOVE": EARLY ZIONIST EROTICISM 77

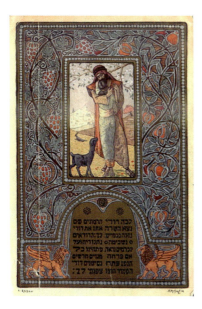

FIGURE 3.5
Ze'ev Raban, *My love, Let us Go out to the Fields*, ..., illustration in *The Song of Songs*, 1923

and her shining face full of intense love and burning desire ... she is drawn to his lips that are sweeter than the wine of Ein Gedi ...[17]

In *Let him kiss me with the Kisses of his Mouth* (fig. 3.4) Raban is faithful to Schatz's verbal description of King Solomon. The Shulamite, on the other hand, is not Schatz's well-built shepherdess; Raban depicts the beloved with her hands outstretched, entirely submissive to the King's sensual grasp, drawing her close to his face.

3.4 Kisses and Embraces

"The kiss is the living spirit in these pictures that depict our most ancient love poem, *The Song of Songs*, the poem of innocent love triumphant, love that conquers the wisest of men ..." Schatz wrote. Raban gives a visual form to his mentor's utopian ideas and extends them with additional details. The loving couple in his illustrations hugs and kisses in almost every possible posture. His attitude is a much more permissive. The man-woman relationships as portrayed in these illustrations convey a variety of situations; in some of them the man is active, and the woman is submissive—and vice-versa. The equality of the sexes, advocated by Schatz in his descriptions of "The Garden of Love," is realized visually in Raban's illustrations.

17 Schatz, *Jerusalem Rebuilt* ..., 166.

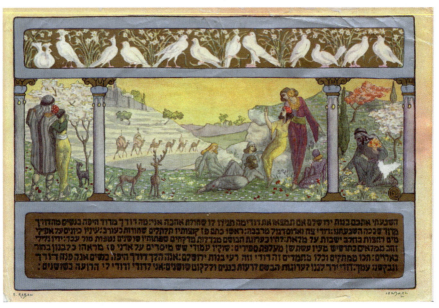

FIGURE 3.6 Ze'ev Raban, *I Made you Swear, Daughters of Jerusalem …* illustration in *The Song of Songs*, 1923

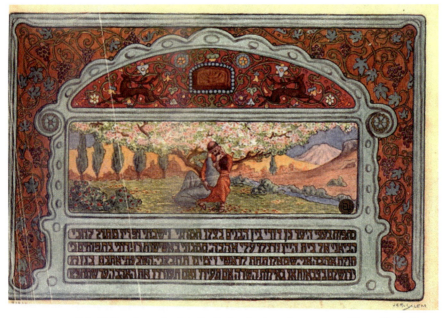

FIGURE 3.7 Ze'ev Raban, *As an Apple in the Orchard so is my Lover among Men….*, illustration in *The Song of Songs*, 1923

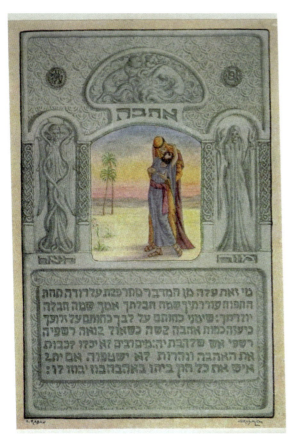

FIGURE 3.8 Ze'ev Raban, *Who is that Coming out of the Wilderness*, illustration in *The Song of Songs*, 1923

3.5 Orientalism and Symbolism in the Zionist-Biblical World

Raban's illustrations were designed to convey an idyllic-biblical world. To do that, the artist had to reconstruct four visual components: biblical landscapes, theatrical sets, individual types, and costumes. Such a historical reconstructive approach is typical of late 19th century Orientalist art. To convey these components most authentically, Orientalist artists came to the Holy Land, painted its landscapes *in situ*, and sketched various Islamic architectural edifices. They documented household utensils, furniture, and the colorful costumes of the Ottoman public servants, soldiers, farmers, and merchants. They added motifs from the visual culture of the ancient near east—Babylonian, Assyrian,

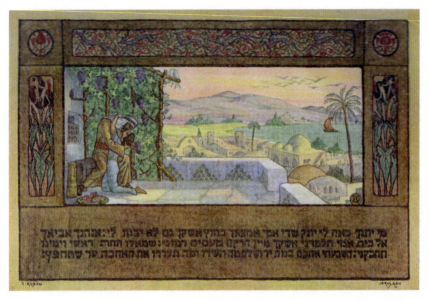

FIGURE 3.9 Ze'ev Raban, *I Wish You were as a Brother to me …*, illustration in *The Song of Songs*, 1923

Sumerian, and Egyptian. The pastiche combination of all of these ingredients created an authentic virtual reconstruction of the biblical period.

Raban did not have to go far in his search for landscape; there were plenty of empty wild outdoors areas around Jerusalem, in the Galilee and throughout Palestine in the 1920s. As for costumes and sets, he could find plenty of models for them on his trips to Egypt and his weekly strolls in the markets of the Old City of Jerusalem. Raban was also influenced by historical reconstructions of ancient periods as they appeared in sets and costumes designed for contemporary Hollywood silent films (fig. 3.10).[18]

Raban's Hebrew style comprises, therefore, a combination of visual as well as textual sources: Symbolist and Orientalist characteristics, fitted to biblical texts and Schatz's utopian vision. The result is an elegant book, containing large illustrations in magnificent colors; it became one of the most popular art books of its time.

18 Ruth Doron, the artist's daughter, told me about her father's fascination with going to the movies; he did not miss a single film shown at his local Jerusalem Theater.

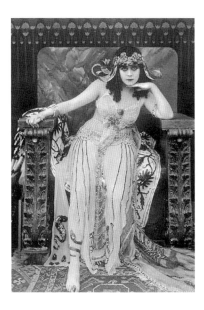

FIGURE 3.10
Actress Theda Bara in the silent film *Cleopatra*, 1917

3.6 The Secular Bride

Verses of the *Song of Songs* are recited before or after the daily evening prayer, on Sabbath's eve and after the reading of the Passover *Haggadah*.[19] The reason for reading it before the entrance of Sabbath is the preparations for Queen Sabbath that is likened to the Bride of *The Song of Songs*. By reading the text of *The Song of Songs*, Jewish readers are supposed to receive absolution for the sins committed during the week. Throughout history, Jewish sages interpreted the love relations alluded to in the biblical text as the love of God to the People of Israel. This relationship begins on Passover; the mythical couple is married during the Jewish holiday of *Shavuot* when the Law had been given on Mount Sinai. Another link between *The Song of Songs* and Passover is the many references in the *Haggadah* to the spring season.

The Song of Songs is read both at home and at the Synagogue. Its clerical interpretation regards it foremost as a song of praise to the metaphoric love relationship between God and his People. In contrast, Raban's work exhibits the text's erotic, corporeal aspects of love between man and woman. His illustrations do not even hint of metaphoric love; the book could not be admitted into a synagogue since it would be considered there as blasphemous. In his

19 Alan Macy, *The Encyclopedia of Jewish Prayer, Ashkenazic and Sephardic Rites*, Northdale New Jersey and London: Jason Aronson Inc., 1966, 305–306.

pictures for *The Song of Songs,* Raban expressed one of the first *secular* interpretations of the Bible in modern Jewish art, and later on in Israeli art. His work makes primary precedence for a secular, modern treatment of a biblical text while expropriating its clerical authorization throughout Jewish tradition. Such treatment to a biblical text was, in the 1920s, highly revolutionary.

Bibliography

Bialik, Chaim Nachman, *Kitvey Ch. N. Bialik* (H. N. Bialik Works), Jerusalem and Tel Aviv: Dvir Publication 1983 (first edition 1945).

Greenspan, Trude, "Raban and the Legacy of Symbolism" in *Raban Remembered, Jerusalem Forgotten Master* (cat. exh.), New York: Yeshiva University Museum, 1982, 39–50.

Macy, Alan, *The Encyclopedia of Jewish Prayer, Ashkenazic and Sephardic Rites*, Northdale New Jersey and London: Jason Aronson Inc., 1966.

Nordau, Max, "Muskeljudentim", *Judische Turnseitung*, June 1900.

Raban Remembered, Jerusalem Forgotten Master (cat. exh.), New York: Yeshiva University Museum, 1982.

Schatz, Boris, *Jerusalem Rebuilt—a Day Dream*, Jerusalem: 1923.

Thompson, Ian, "James Tissot peintre des scenes religieuses" in *James Tissot, 1836–1902* (cat. exh.), London: Barbican Art Gallery, Paris: Petit Palais, 1984.

CHAPTER 4

Zionist Revival and Rebirth on the Façade of the Municipal School in Tel Aviv

A massive wave of Jewish immigration to Palestine began in 1924. It was followed by unprecedented urban development, mostly in Tel Aviv; hundreds of houses were built in the city. Building projects were under contract with groups of contractors who employed numerous workers, mainly by the office for public works of the worker's union, a significant Zionist enterprise. One such project was the Municipal School, designed and built by architect Dov Herskowitz.

Ceramic tiles made in the workshops of the Bezalel School of Arts and Crafts in Jerusalem adorn the school's façade. The visual motifs depicted on them are a significant example of the Modern Zionist Hebrew culture of the 1920s. They represent ideas that had guided the creators of the culture, especially in Tel Aviv, the first Hebrew city. The desire to infuse original Hebrew style into Tel Aviv's architecture began a connection between the city and Bezalel in Jerusalem.

In 1922, Boris Schatz had a one-man exhibition at the Herzlia Gymnasium in Tel Aviv. In the speech at the opening, he expressed the hope that ceramic tiles decorations would be commissioned by the Tel Aviv municipality from the Bezalel industrial workshops.[1] Of course, he had economic considerations as well as ideological ones, but Schatz truly believed that Tel Aviv should employ the original ceramic tiles to endow its buildings with "Artistic beauty and a national Hebrew character."[2] The mayor of Tel Aviv, Meir Dizengoff, the municipal architect, Dov Herskowitz, and other well-known architects and private building contractors supported his initiative.[3]

1 Batya Karmiel, "Boris Schatz ve'Hashpa'ato al Eeturey Keramika Bezalel beTel-Aviv" (Boris Schatz and his Influence on Ceramic Tile Decorations in Tel-Aviv) in Batya Karmiel, Edina Meril-Meyer, Alec Mishory *Arichim Me'atrim Eer, Keramika Bezalel beVatey Tel-Aviv, 1923–1928* (Tiles Adorned City, Bezalel Ceramics on Tel-Aviv Houses), Tel-Aviv: Ha'aretz Museum, 1996, 63.
2 Boris Schatz "Kol Koreh leKablanim uleVa'aley haTa'assiya shel Chomrey haBinyan beTel-Aviv" (A Call to Building Contractors and Industrialists of Building Materials in Tel-Aviv), 1924, Central Zionist Archive, 1.42/69, as quoted by Karmiel, *Tiles Adorned City*, 150.
3 The tiles were manufactured at the Bezalel workshops in Jerusalem. The ceramic workshop's head was Ya'akov Eisenberg. On Eisenberg the artist and the Bezalel ceramic workshop see: Batya Karmiel, "Yaakov Eisenberg, Oman ve'Uman veToldot Machleket haKeramika

FIGURE 4.1 The Municipal School, Ahad Ha'Am Street, Tel Aviv (built 1924)

Schatz envisioned employing ceramic tiles; he wrote about it in his book *Jerusalem Rebuilt—a Daydream*,[4] and such buildings slowly materialized in Tel Aviv of the 1920s. Models for the figurative images on the Bezalel decorative tiles were traditional Jewish European models and new, local, Jewish-Hebrew motifs. They exhibit two approaches: themes that link contemporary, modern Jewish-Hebrew culture with the biblical Land of Israel, and contemporary Zionist enterprises.

4.1 Past and Present Come Together

The façade of The Municipal School (fig. 4.1) shows various traditional Jewish symbols: entwined pomegranate branches standing for the beauty and abundance of the Land of Israel and the Twelve Tribes of Israel, stylized *menorahs*, lions, and the Tablets of the Law.

A frieze made of ceramic tiles tops the two triangular frames of the entrance door shows the Twelve Tribes of Israel motif was a frequent component in Jewish art. In many cases it accompanies images of the signs of the Zodiac, symbolizing the Jewish aspiration for salvation; metaphorically they are visual

beBezalel" (Yaakov Eisenberg, Artist and Craftsman and the History of the Ceramics Department at Bezalel) in *Tiles Adorned City*, 13–49.

4 Boris Schatz, *Jerusalem Rebuilt, a Day Dream*, 41.

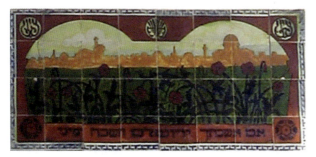

FIGURE 4.2 *If I Forget thee, O Jerusalem, May my Right Hand Forget her Cunning*, ceramic tile decoration above the central doorway of The Municipal School

representations of Messianic concepts.[5,6] The twelve signs of the Tribes of Israel on the façade of The Municipal School express the fulfillment of Jewish settlement of the Land of Israel through Zionism. The Messianic ideas traditionally associated with them in the Jewish Diaspora were secularized to express the idea that the Twelve Tribes of Israel of the 20th century are the offspring of the Israelite 12 tribes, who returned to their ancient Land.

Above the frieze of the Twelve Tribes, on the lower area of the central window, the designers of The Municipal School decorations placed a rectangular plate with an inscription (in Hebrew) that reads: *Eem eshkachech Yerushalayim tishkach yemini* (If I forget thee, O Jerusalem, let my right hand forget her cunning. Psalms 137:5) (fig. 4.2). The quote from Psalms is part of the biblical description of Jewish Exile:

> By the rivers of Babylon, there we sat down, yea, we wept, when we remembered Zion. We hanged our harps upon the willows in the midst thereof. For there they that carried us away captive required of us a song; and they that wasted us *required of us* mirth, *saying*, Sing us *one* of the songs of Zion. How shall we sing the LORD'S song in a strange land? If I forget thee, O Jerusalem, let my right hand forget *her cunning*. If I do not remember thee, let my tongue cleave to the roof of my mouth; if I prefer not Jerusalem above my chief joy. (Psalms 137: 1–6)

5 *Encyclopedia Judaica*. Jerusalem: Keter Publishing, 1971 "Zodiac" 1191–1192. Chapter 10 discusses the symbolical aspects of the twelve tribes of Israel.
6 *Encyclopedia Judaica*. Jerusalem: Keter Publishing, 1971 "Zodiac" 1191–1192.

FIGURE 4.3 David Friedlander, *Zecher laChurban (Al Naharot Bavel)* (Memorial to the Destruction of the Temple, or, On the Rivers of Babylon), 18th century, wall painting in the wooden Synagogue in Grojec, Poland (destroyed by the Nazis in World War II)

The inclusion of an image of Jerusalem that stands for destruction on a façade of a secular school in Tel Aviv may seem a bit odd; however, it shows a link to a long Diasporic Jewish tradition.

Zecher laChurban (Memorial to the Destruction of the Temple), an image of specific urban sites, was common in Jewish decorative tradition. Most often it portrays harps, or sometimes other musical instruments, leaning or hanging on trees as a visual expression of the verse "We hanged our harps upon the willows." David Friedlander,[7] an 18th-century Jewish artist,[8] painted the theme on a wall of the wooden Synagogue in Grojec, Poland (fig. 4.3). It shows a European town, with contemporary buildings, but the tower on the left identifies it as

7 Friedlander was active from the end of the 18th century to the beginning of the 19th. Except for a tombstone that he designed, still intact at the Warsaw Jewish cemetery, none of his works survived after World War 2; the Synagogue decorations he is associated with were all destroyed by the Nazis. See: David Davidovitz, *Omanut veOmanim beVatey Knesset shel Polin, Mekorot, Signonot, Hashpa'ot*, (Art and artists in Polish Synagogues, Sources, Styles, Influences), Tel Aviv: 1982, 157; George Lukomski, *Jewish Art in European Synagogues from the Middle Ages to the 19th Century*, London: 1947, 39.

8 David Davidowitz, *Tziyur Kir beVatey Knesset bePolin* (Wall Painting in Polish Synagogues), Jerusalem: Mossad Bialik, 1968, 46.

Babylon. Friedlander presented modern musical instruments: violin, cello, drums, trumpet and a French horn. What is the link, then, between an 18th-century painting from a Polish Synagogue and a ceramic tile decoration on a Tel Aviv building façade of the 1920s?

The original, Jewish visual tradition of creating memorials to the Destruction of the Temple expressed the Jewish yearning for the renewal of Jewish life in the Land of Israel. Since the Bezalel institution viewed Zionism as a modern, secular fulfillment of these desires, the motif had to change to fit the Zionist concept. Zionist enterprises showed no interest in images of destruction or lamentation; contemporary founders of the new Hebrew culture were looking for a model whose message would constitute a total reversal to the Diasporic theme. Consequently, concepts such as building and revival replaced lamentation and destruction. The Return to Zion or Revival of Zion makes the Zionist response to the Diaspora lamentation in that it expresses a new message: no more lamenting but joy in rebuilding and revival summed up by the motto "If I forget thee oh Jerusalem ...".

The new, alternative visual motif is based on verses from the Bible as well:

> Again I will build thee, and thou shalt be built, O virgin of Israel: thou shalt again be adorned with thy tabrets, and shalt go forth in the dances of them that make merry. Thou shalt yet plant vines upon the mountains of Samaria: the planters shall plant, and shall eat *them* as common things (Jeremiah 31:4–5).

Zionist response to Friedlander's *On the Rivers of Babylon* was meant to suggest the realization of Jeremiah's prophecy. A ceramic tile decoration that expresses this idea was incorporated in the overall scheme of a Tel Aviv building façade on Allenby Street (fig. 4.4). The inscription *Od evnech venivnet* (I will build you up again and you will be rebuilt), at the bottom of the decoration, refers to the modern revival of the Jewish People.[9]

9 The words *Evnech veNivnet* were taken as a motto for Tel Aviv's official municipal emblem in 1924 (fig. 4.5). Quoting Jeremiah's comforting prophecy was a common metaphor for many Zionist speeches delivered in this period; Shim'on Rokach, the founder of *Neve Tzedek*, one of Tel Aviv's early residential quarters, used it as a salutation next to his signature on official municipal documents. See: Ilan Schechori, "Haben Itzev et haSemel, ha'Aba Kava et haSissma" (The Son Designed the Emblem, the Father Composed the Motto), *Et-Mol*, volume 16, (931), October 1990, 12.

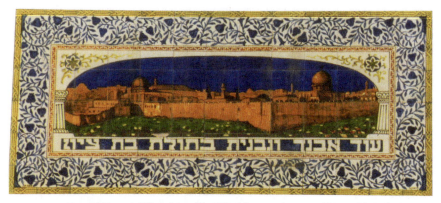

FIGURE 4.4 Bezalel Ceramic Workshops, *"I will Build you up Again and You will be Rebuilt, O Virgin Israel"*, 1920s, ceramic tile decoration on the façade of a Tel Aviv building

FIGURE 4.5
The official emblem of Tel Aviv Municipality (designed in 1924)

4.2 Four Hebrew Cities

Four large rectangular ceramic tile decorations exist on both sides of the main door between the first and second story windows. From right to left, they show images of cities; Jaffa, Tiberias, Haifa, and Hebron. The number *four* is associated with the *Arba arey hakodesh*—the Four Holy Cities, as they were named in the 19th century. They were Safed, the city of Kabbalists; Tiberias, the place of merchants and professionals; Jerusalem, the Holy City, and Hebron, the center of Torah studies and the burial site of the Cave of *Machpelah*. Donations

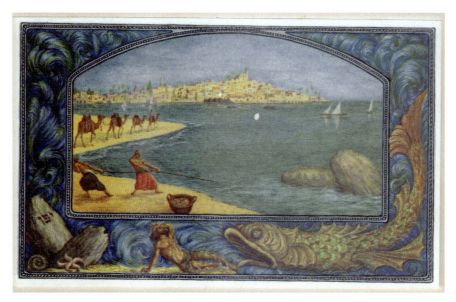

FIGURE 4.6 Ze'ev Raban, *Jaffa*, 1923, from the series *10 Towns of The Land of Israel*

from Jewish communities in the Diaspora sustained most of the contemporary inhabitants of these cities.

The ceramic tile decorations on The Municipal School has only two of the Four Holy Cities—Tiberias and Hebron; Jaffa and Haifa replace Jerusalem and Safed. Why would the designer of the Municipal School façade choose these specific towns? The models for the decorations are some of Ze'ev Raban's designs from the 1920s, included in his series of watercolor drawings of several sites throughout Palestine. *Eretz Israel Esser Tmunot* (The Land of Israel, 10 Pictures) include a panoramic view of a town within a decorative frame, with references to historical and biblical events linked to each specific location.[10]

Raban's *Jaffa* (fig. 4.6) shows the hill upon which the city is built. Sailboats ply the sea, a camel caravan approaches the city, and fishermen cast their nets upon the water. At the frame's bottom appears a giant, monstrous fish, covered with large scales, in the act of throwing up a man out of its wide-open mouth. The fish identifies the person as the prophet Jonah, who stayed in the

10 Ze'ev Raban, *Eretz Israel Esser Tmunot* (The Land of Israel, 10 Pictures) was published later on as a booklet.

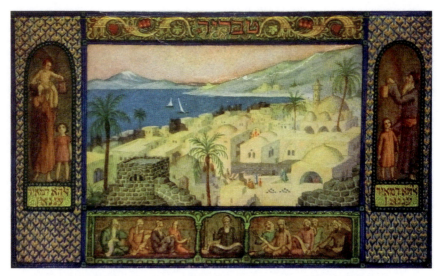

FIGURE 4.7 Ze'ev Raban, *Tiberias*, 1923, from the series *10 Towns of The Land of Israel*

ancient city of Jaffa.[11] Raban links Jonah to the contemporary Jaffa and its biblical context.

The focal point of Raban's *Tiberias* (fig. 4.7) is at the center side of the illustration. It is a multi-domed edifice—the architectural complex of *Kever Rabbi Meir ba'al haness* (the grave of Rabbi Meir the Miracle Maker).[12]

Lake Kinneret is on its left. At the bottom of the illustration, Raban portrayed the rabbi and his followers, listening to his sermon. Two arched images

11 "But Jonah ran away from the LORD and headed for Tarshish. He went down to Joppa, where he found a ship bound for that port. After paying the fare, he went aboard and sailed for Tarshish to flee from the LORD." Jonah, 1, 3.

12 Rabbi Meir the Miracle Maker was a Jewish sage who lived in the 2nd century CE. The name *Meir*, meaning Illuminator, was given to him because he enlightened the eyes of scholars and students in Torah study. He was married to Bruriah, whose sister was sent by the Romans to a brothel. Rabbi Meir took a bag of gold coins and offered the money as a bribe to the guard. The guard, worried if the money would be sufficient, asked the rabbi what to do. Meir answered: "Say, 'The God of Meir—answer me!' and you will be saved." The guard asked, "And how can I be guaranteed that this will save me?" Meir replied, "Look—there are men-eating dogs over there. I will go to them and you will see for yourself." Rabbi Meir walked over the dogs and they ran over him to tear him apart. He cried, "God of Meir—answer me!" and the dogs retreated. The guard was convinced and returned the girl to him. From then on, a tradition developed that a Jew in crisis gives charity in memory of Rabbi Meir. He then says, "God of Meir—answer me!".

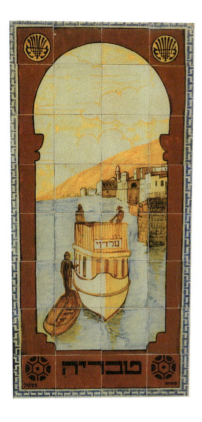

FIGURE 4.8
Bezalel Ceramic Workshops, *Tiberias*, ceramic tile decoration on the façade of The Municipal School

frame the central depiction of *Tiberias*. The miracle maker, accompanied by children, holds a charity box. The text underneath quotes the prayer said by those who pray for the rabbi's intervention on their behalf: *"Eloha Meir—Aneni"* (God of Meir answer me).

The illustration expresses one of Tiberias' traditional Jewish attributes—its mysticism. In contrast, the ceramic tile depicting *Tiberias* on The Municipal School façade (fig. 4.8) tells an entirely different story: it shows two boats on Lake Kinneret. The title of the large boat, written in large Hebrew letters, is *Nordau*, after the Zionist leader Max Nordau. The vessel was a real motorboat, used by the Jewish community of Tiberias in the 1920s. The modern history of Tiberias documents the atrocious conditions in the city during the four years of World War I; four hundred people died, mainly of starvation. After the war, one of the Jewish Town Council renewal projects involved purchasing a motorboat and using it for transportation between Tiberias and Zemach, a Jewish settlement on the southern shore of Lake Kinneret. The towboat carried passengers and goods and was known for transporting new immigrants

FIGURE 4.8A
The *Nordau* boat, photograph from the 1920s

from Kurdistan to Palestine. When the paving of the Zemach-Tiberias road was completed, there was no more need for the boat and the owners sold it.[13]

The model for the *Tiberias* tiles was a photograph of the boat from the 1920s (fig. 4.8a). The Municipal School was built three years after the inauguration of the Tiberias-Zemach road. Consequently, the inclusion of the *Nordau* boat on the tile commemorated a specific Zionist enterprise that took care of new immigrants settling in areas next to Tiberias. The tile decoration did not link the city with Jewish tradition as one of the Four Holy Cities; it used a modern, contemporary, Zionist, and secular icon.

The image of *Haifa* also focuses on a Zionist enterprise (fig. 4.9). The city is shown from a high vantage point on the Carmel Mountain. One building, in particular, rendered in an exaggerated scale in relation to others, is meant to draw our attention. It is the *Technion* building, one of Haifa's most significant public institutions. The *Technion* designed and built by Alexander Baerwald (1877–1930) is an institution of higher education, specializing in science and technology studies including engineering, physics, and chemistry. Work on the building began in 1912; just before it was completed in 1913, a conflict broke out, known in Hebrew as *Milchemet hasafot*, The War of the Languages. Dr. Paul Nathan, who had envisioned building the *Technion*, suggested that instruction in the new institution should be given in German.

The school's board of directors accepted the suggestion. The decision caused the resignation of prominent Zionist board members since they advocated a maximal use of Hebrew for teaching at the *Technion*. During the four years of World War I, the *Technion* enterprise disintegrated and finally shut

13 Oded Avissar, "*Tverya, Eer Kinrot veYishuva biR'ee haDorot* (Tiberias, City of the Lake of the Galilee and its Settlement throughout the Decades)," Jerusalem: Keter Publishing, 1962, 170.

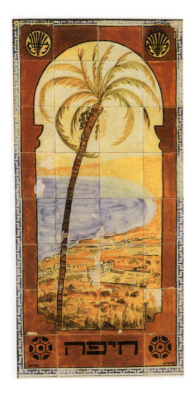

FIGURE 4.9
Bezalel Ceramic Workshops, *Haifa*, ceramic tile decoration on the façade of The Municipal School

down in 1920. The building was then sold to the Zionist Management, ending the cultural war concerning its public image with a victory for Hebrew.[14]

Zionist thought in the 1920s manifested by the establishment of Jewish settlements throughout the country, hands-on agriculture, and the adoption of Hebrew as the official language of its Jewish inhabitants. Speaking Hebrew returned Judaism to its historical-geographic site—the Land of Israel—thus realizing the pioneering aspect. Showing Haifa and emphasizing the *Technion* demonstrated that the city was a growing center of professional higher education in the Land of Israel, and celebrated the triumph of Hebrew as the native language of its Jewish population.

The tiles on the extreme left of the Municipal School façade show the town of *Hebron* (fig. 4.10), represented by the Cave of *Machpelah*. According to Jewish tradition, this is the burial site of the biblical patriarchs and matriarchs. A legend claims that Abraham chose this location because he saw that Adam and Eve were buried there, and the fragrance of the Garden of Eden permeated the

14 *Idan 12, Haifa beHitpatchuta 1918–1948* (Haifa and its Development 1918–1948), Jerusalem: Yad Yitzhak Ben Zvi, 1989, 217.

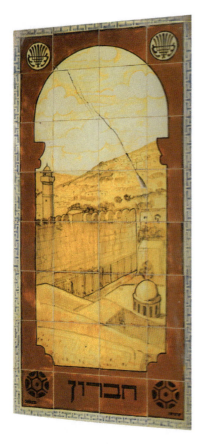

FIGURE 4.10
Bezalel Ceramic Workshops, *Hebron*, ceramic tile decoration on the façade of The Municipal School

atmosphere. Throughout Jewish history, Hebron had become a pilgrimage site and a favorite burial site due to the proximity of the nation's patriarchs' mythical graves. Employing the image on The Municipal School façade might have been intended as a link between Jewish tradition and the local Zionist revival of Jewish life, connecting Diasporic Judaism with local biblical antiquities. The Zionist link established between specific sites in the Land of Israel and events associated with them in the Bible manifests a return to Zion and the land's specific sites; a physical restoration was bound to bring about a spiritual return.[15]

The tiles showing the image of Jaffa point to another situation. Jaffa is the birthplace of Tel Aviv; the latter's first neighborhoods were *Neve Tzedek, Neve Shalom* and *Manshiya*, all founded as neighboring residential areas next to Jaffa. In the 1920s, Arab attacks on Jews and the following British hostile policies

15 Zali Gurewitch, Gideon Haran, "*Al haMakom* [*Antropologya Israelit*] (About the Place [Israeli Anthropology])," *Alpayim*, no. 4, 1991, 22.

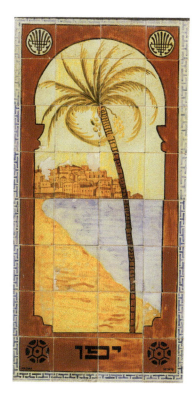

FIGURE 4.11
Bezalel Ceramic Workshops, *Jaffa*, ceramic tile decoration on the façade of The Municipal School

traumatized Tel Aviv's Jewish community. The change from military to British civilian rule, including the appointment of a Jewish High Commissioner, increased the political tensions between Arabs and Jews.

Jaffa's Jews were involved in its economy and made good connections with its Arab citizens, so when Arab attacks began in Jaffa in May 1921, they caused a great shock. The Jews founded Jewish defense forces, but the Arab attacks nevertheless led to a mass migration of Jews to Tel Aviv, boosting the growth of the first Hebrew city. The reference to Jaffa on The Municipal School's Façade alludes, therefore, to a traumatic event that took place no more than three years before its inauguration. At the same time, it presented a strong statement that in spite of Arab attacks, the Jews had not forsaken the city.

The depiction of the four towns' images on The Municipal School façade endows this educational institution with a modern Zionist message: Hebron symbolizes the link with the biblical period and the nation's patriarchs. Jaffa stands for the beginning of the realization of the Zionist dream through Jewish workforces and a building momentum of Tel Aviv. Tiberias alludes to Zionist enterprises that have to do with the settlement of the Galilee and the new immigrants who come there. And Haifa focuses on the revival of Jewish-Hebrew

higher education and the triumph of the Hebrew language. The specific use of the number four, alluding to The Four Holy cities, contrasts them with the Zionist idea of renewal. Diasporic characteristics of an old way of life, non-productive, based on philanthropy, traditionally assigned to The Four Holy Cities, are replaced with ideas such as renewal and pioneering Zionist enterprises.

The mere fact that the Hebrew culture symbols require explanations and interpretations today, less than a hundred years after their creation, points to how distanced we are from them. But when citizens of Tel Aviv in the 1920s looked at the ceramic tile decorations adorning The Municipal School's façade, they saw iconic images, taken directly from a familiar lexicon. Traditional Jewish symbols and emblems metamorphosed into Hebrew ones by the creators of the new Hebrew culture who believed that their era proclaimed the beginnings of the Jewish People's salvation in its newly cultivated homeland.

Bibliography

Avissar, Oded, *"Tverya, Eer Kinrot VeYishuva biR'ee haDdorot* (Tiberias, city of the Lake of the Galilee and its Settlement throughout the Decades)," Jerusalem: Keter Publishing, 1962.

Davidovitz, David, *Omanut veOmanim beVatey Knesset shel Polin, Mekorot, Signonot, Hashpa'ot*, (Art and artists in Polish Synagogues, Sources, Styles, Influences), Tel Aviv: 1982.

Davidovitz, David, *Tziyur Kir beVatey Knesset bePolin* (Wall Painting in Polish Synagogues), Jerusalem: Mossad Bialik, 1968.

Felix, Yehuda, *Olam haTzome'ach haMikra'ee, Te'uram shel haTzmachim sheNizkeru baTanach al Reka haKtuvim, Safrut Chazal veYavan veTeva ha'Aretz* (The World of Biblical Flora, the Description of Plants Mentioned in the Bible in Light of the Scriptures, the Literary Works of Jewish and Greek Sages and the Nature of the Land), Tel Aviv: Massada publishing, 1957.

Gurewitch, Zali, Haran, Gideon, *"Al haMmakom [Antropologya Israelit]"* (About the Place [Israeli Anthropology], *Alpayim*, no. 4, 1991.

Idan 12, Haifa beHitpatchita 1918–1948 (Haifa and its Development 1918–1948), Jerusalem: Yad Yitzhak Ben Zvi, 1989.

Karmiel, Batya, "Boris Schatz veHashpa'ato al Eeturey Keramika Bezalel beTel-Aviv" (Boris Schatz and his Influence on Ceramic Tile Decorations in Tel-Aviv) in Batya Karmiel, Edina Meril-Meyer, Alec Mishory *Arichim Me'atrim Eer, Keramika Bezalel*

beVatey Tel-Aviv, 1923–1928 (Tiles Adorned City, Bezalel Ceramics on Tel-Aviv Houses), Tel-Aviv: Ha'aretz Museum, 1996.

Lukomski, George, *Jewish Art in European Synagogues from the Middle Ages to the 19th Century*, London: 1947.

Raban, Ze'ev, *Eretz Israel Esser Tmunot The* (Land of Israel, 10 Pictures) (undated).

Schatz, Boris, *Jerusalem Rebuilt, a Day Dream*. 1923.

Schechori, Ilan, "*Haben Eeetzev et haSemel, ha'Aba Kava et haSisma*" (The Son Designed the Emblem, the Father Made the Motto), *Et-Mol*, volume 16, (931), October 1990.

PART 2

Objects and Conceptions of Sovereignty

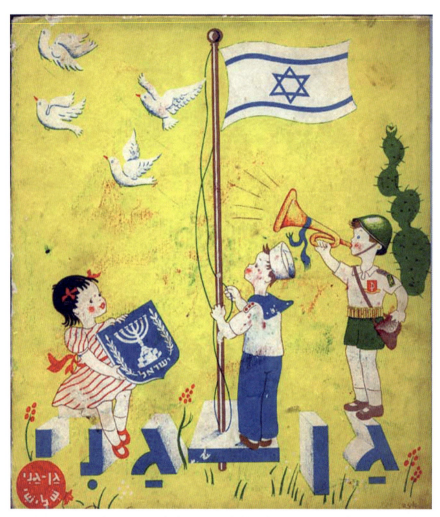

PLATE 1 *Cover of Gan Gani, Sefer la'Em velaYeled* (Kindergarten, my Kindergarten, a Book for Mothers and Children), edited and selected texts by Levin Kipnis and Yemima Tchernowitz, illustrations by Isa, Tel Aviv, Tversky Publication, 1949

When the State of Israel was established in 1948, the entirety of Zionist ideas, expressed during the pre-state period received an official governmental authorization. The state's sovereign aspect was especially empized during its first years. Some of the new official interpretations were based on emblems and icons that were in frequent use during the *yishuv* period, though extended and re-designed.

Since the early stages of the Jewish settlement project, Zionist leadership and establishment initiated and encouraged several practices that aimed to develop national awareness among the Jewish immigrants through a narrative and a sense of place based on experience and on concrete and authentic sources. Such practices included popular and professional archeological explorations, reading and investigating the Bible and other ancient Jewish writings (Such as The Talmud or Josephus Flavius' books) in a new light as books of local Jewish history, practicing, 'Homeland studies' through hikes and self-study and myth-making. Such practices intended to invest the concept of the state of Israel as a Jewish place with historical depth and authenticity.[1]

The turn towards ancient history as a basis for the construction of national identity is a common idea and practice among modern national movements.[2] The Jewish political and cultural leadership of both the *yishuv* period and that of the sovereign state of Israel applied great efforts in order to construct a sense of place as a part of identity-work and to establish it on ancient historical foundations. Their basic intention was to draw a direct link between past and present Jewish life in the land, a line which by-passing hundreds of years, during which the place was mainly under the Ottoman and British rule.

The State of Israel needed visual emblems for all public matters, including official documents, various newly formed governmental offices, public institutions, and municipalities. Generally, the design process of official emblems was as follows:

a. A governmental agency expresses the need for an emblem. A committee of public figures is formed: a select parliamentary committee

1 Many publications deal with Israel's national collective identity and its sources. See: M. Feige and Z. Shiloni (eds.). 2008. *Archeology and Nationalism in Eretz-Israel*, Sde Boker: The Ben-Gurion Research Institute, Ben-Gurion University of the Negev.[Hebrew]; Zali Gurevitch and G. Aran, 1994. "The Land of Israel: Myth and Phenomenon", *Studies in Contemporary Jewry* 10: 195–210; Yael Zerubavel, *Recovered Roots*. Chicago and London: The University of Chicago Press, 1995; Ze'ev Shavit, "The Production of a Sense of Place among Jewish Immigrants in Mandatory Palestine", *Diasporas, Histoire et Societiés* 20: 2012, 59–84.

2 See A. Smith, 'The "Golden Age" and National Renewal', in G. Hosking and G. Schopflin (eds.), *Myths and Nationhood*. London: Hurst and Company, 1997 and his "Nations and History", in M. Guibernau and J. Hutchinson (eds.), *Understanding Nationalism*. Cambridge, UK: Polity, 2001.

comprised of parliament members, or a municipal committee, including members of local townships or municipalities.
b. The committee turns directly to an artist or a graphic designer who provides them with a preliminary proposal for a project. At this stage, the committee members decide to be more objective and conduct their procedures by proclaiming a public tender.
c. The committee announces public competitions for the creation of projects. The advertisement in the daily newspapers is accompanied by demands for deadlines, and occasionally for specific visual components for the commissioned project and the message it is purported to convey.
d. To express appropriate public procedures, the committee members decide to extend their circle; they invite professional artists, architects, archaeologists, and graphic designers. Very rarely do they invite a historian or a sociologist. Heraldry experts are never consulted.
e. Minutes taken of various committee meetings reveal that in most cases committee members tend to complicate matters in light of the experts' suggestions and remarks. The committee then decides on such matters without heeding its consultants' opinions.
f. In the last stage of the process, designers are asked to serve as operators for the ideas dictated to them by the committee members.

The following chapters introduce the visual formation of Israel's national collective identity through several symbolic items. These include a scroll of vellum, a flag, a national seal, an official medal, and the Hebrew language itself, the formal, first language of the state, created within the time span of the end of British rule of Palestine and the early years of the State of Israel. The common denominator of most icons and emblems created in this period is a principle of contrast: contrasting the Zionist-Israeli present with the Diasporic past. Revival is contrasted with Exile; building with destruction; freedom with captivity, abundance with wilderness, rebirth with death, new, curious and near with familiar and old.

CHAPTER 5

Israel's Scroll of Independence

A highly significant event that took place during the declaration of Independence of Israel ceremony (May 14, 1948) was the introduction of the newly founded state's Scroll of Independence, a political document closest to the idea of a sovereign state constitution. The text was read aloud by David Ben Gurion from a piece of typewritten paper because the festive vellum scroll intended for it was not ready at the time of the ceremony. At the end of the celebratory event, members of the dais signed their names on the bottom of a blank sheet of vellum.

While various historians, sociologists, and political science scholars devote their publications to the *contents* of the scroll, the following discussion looks at its visual aspects as signifiers of Israeli symbolic visual culture.

After the ceremony, graphic designer Oteh Walisch (1906–1977) completed the calligraphic writing on the scroll, as Pinchas Jorman describes in his memoirs:

> Walisch found a piece of vellum and wanted to check its durability.... After the ceremony, he turned to the Israeli rabbinate and requested their recommendation for an experienced scribe for the sake of writing [the text] of the scroll. The one nominated by the rabbinate chose the wrong kind of ink; consequently, the vellum scroll was covered by stains that completely blurred the text. Walisch then decided to do the writing himself, assisted by Rudi Sidner. The artists chose a Hebrew font from an ancient Torah scroll.[3]

Walisch was probably ordered to approach the rabbinate due to a widespread erroneous conception that Hebrew calligraphy is the sole estate of clerk-scribes employed by Israel's rabbinate, the state's formal clerical institution. Those who sent him to the rabbinate simply weren't familiar with the Bezalel School of Art's Hebrew calligraphy department, established as early as the 1930s; Hebrew calligraphy and typography were essential subjects taught in the school. Throughout the years Bezalel produced extraordinary, innovative products. The number of Israeli Hebrew-calligraphers and typographers

3 Pinchas Jorman, *32 haDakot haRishonot* (32 First Minutes), Tel Aviv: Massada Publishing, 1978, 66.

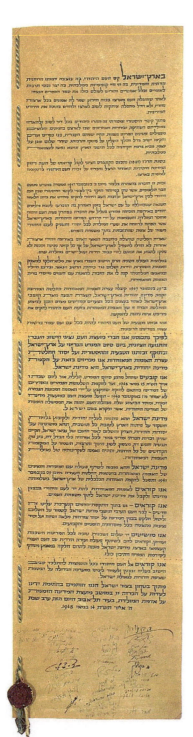

FIGURE 5.1
The *Israeli Scroll of Independence*, 1949, pen and ink on vellum

in 1948 was not small; approaching the rabbinate, therefore, went beyond an innocent search for a professional calligrapher. The mere fact that the latter failed to produce an adequate product saved the Israeli Scroll of Independence from all sorts of restrictions and other issues it was to face if Jewish religious clerks would have done it. This is despite the fact that such a secular-political document, written by pen and ink, does not fall under the jurisdiction of any Jewish rabbinic laws.

When writing the scroll's text, Walisch relied on traditional Sephardic Hebrew script. The "ancient Torah scroll" mentioned by Jorman as a model for his font was probably *The Leningrad Bible*, known as *The Leningrad Codex*: the most ancient complete Bible manuscript, written in Cairo in 1008 (fig. 5.2). Facsimiles of this document were in the collection of Israel's National Library in Jerusalem.

Before the invention of the printing press, Hebrew calligraphy was produced in two scripts: Sephardic and Ashkenazi. The most typical element that shows their unique qualities is the way scribes hold the reed pen or the nib: while writing the Ashkenazi script, he holds it in a 90-degree angle, endowing his letters with a changing modulation (thickness of lines from thick to thin), (fig. 5.3). The Sephardic script demands that scribes hold the nib at a 45-degree angle. By so doing, the scribe moves his hand from left to right in one stroke, with the same amount of pressure on it while he shapes the vertical parts of letters to make them equal in width with the horizontal (fig. 5.4). Letters of both Hebrew scripts are hung from straight lines, scratched beforehand on a piece of vellum, rather than drawing them on the lower line.

A close look at the text of the Scroll of Independence shows that it was justified as a block, all text lines ending with straight alignment (fig. 5.5). Hebrew calligraphers do so by stretching the bodies of certain letters in order to align the text with the two margins, without leaving any white gaps in it. Letters such

FIGURE 5.2 *Leningrad Codex*, 1008, Russian National Library, St. Petersburg, detail

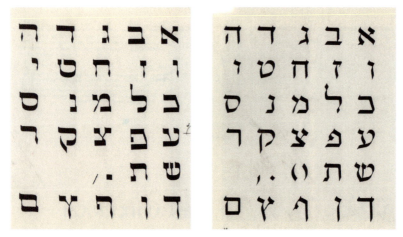

FIGURE 5.3 Ashkenazi script FIGURE 5.4 Sephardic script

as *tav* [ת] and final *mem* [ם] (at the end of the fourth line and the eighth line in fig. 5.5), the letters *chet* [ח], *hey* [ה] and *reysh* [ר].[4]

Walisch and Sidner's script attest the hypnotic fascination they had for the Hebrew letter *lamed* [ל] (fig. 5.5), as it is written in the *Leningrad Codex* (fig. 5.2). Repetitions of this letter endow the written text with a staccato rhythm, by its upper part, hoisted and breaking out of the line, flying beyond the horizontal lines of the text. Walisch and Sidner partially adhered also to Ashkenazi form by holding their pen in a 90-degree angle; consequently, their letters became heavy and cumbersome, i.e., the letter *shin* [ש] (second from the right in fig. 5.5a) looks as if its weight is heavy on the baseline because its lower part is a straight, horizontal line. The lower part of the same letter, written in Sephardic script (last on the left in fig. 5.4a) is a thin tip, an apex of two diagonal lines that places it vertically on the baseline in perfect equilibrium, evoking formal tension by the fact that such a minimal base enables it not to sway and fall.

The intention of the Israeli Scroll of Independence scribes was apparently to create a Modern Hebrew script. However, it seems that their product was not made with great effort and probably due to a pressing deadline.

Another typical characteristic of Hebrew calligraphy linking the scribes of the Israeli Scroll of Independence with older traditional Hebrew manuscripts is the use of capital *words*. It is a unique phenomenon of Hebrew manuscripts, unlike Latin manuscripts in which sentences begin with a capital *letter*. Illuminated manuscripts in Western culture show great expressive

4 Aspects of the Hebrew Alphabet are discussed in detail in chapter 12.

בְּאֶרֶץ־יִשְׂרָאֵל קָם הָעָם הַיְהוּדִי, בָּהּ עוּצְבָה דְמוּתוֹ הָרוּחָנִית, הַדָּתִית וְהַמְּדִינִית, בָּהּ חַי חַיֵּי קוֹמְמִיּוּת מַמְלַכְתִּית, בָּהּ יָצַר נִכְסֵי תַרְבּוּת לְאֻמִּיִּים וּכְלַל־אֱנוֹשִׁיִּים וְהוֹרִישׁ לָעוֹלָם כֻּלּוֹ אֶת סֵפֶר הַסְּפָרִים הַנִּצְחִי.

לְאַחַר שֶׁהָגְלָה הָעָם מֵאַרְצוֹ בַּכֹּחַ הַזְּרוֹעַ שָׁמַר לָהּ אֱמוּנִים בְּכָל אַרְצוֹת פְּזוּרָיו, וְלֹא חָדַל מִתְּפִלָּה וּמִתִּקְוָה לָשׁוּב לְאַרְצוֹ וּלְחַדֵּשׁ בְּתוֹכָהּ אֶת חֵרוּתוֹ הַמְּדִינִית.

מִתּוֹךְ קֶשֶׁר הִיסְטוֹרִי וּמָסוֹרְתִּי זֶה חָתְרוּ הַיְּהוּדִים בְּכָל דּוֹר לָשׁוּב וּלְהֵאָחֵז בְּמוֹלַדְתָּם הָעַתִּיקָה, וּבְדוֹרוֹת הָאַחֲרוֹנִים שָׁבוּ לְאַרְצָם בַּהֲמוֹנִים, וַחֲלוּצִים, מַעְפִּילִים וּמְגִנִּים מֵעֵינוּ הַפְּרִיחוֹ נְשָׁמוֹת, הֶחֱיוּ שְׂפָתָם הָעִבְרִית, בָּנוּ כְּפָרִים וְעָרִים, וְהֵקִימוּ יִשּׁוּב גָּדֵל וְהוֹלֵךְ הַשַּׁלִּיט עַל מֶשֶׁק וְתַרְבּוּתוֹ, שׁוֹחֵר שָׁלוֹם וּמֵגֵן עַל עַצְמוֹ, מֵבִיא בִּרְכַּת הַקִּדְמָה לְכָל תּוֹשָׁבֵי הָאָרֶץ וְנוֹשֵׂא נַפְשׁוֹ לְעַצְמָאוּת מַמְלַכְתִּית.

בִּשְׁנַת תרנ"ז (1897) נִתְכַּנֵּס הַקּוֹנְגְרֶס הַצִּיּוֹנִי לְקוֹל קְרִיאָתוֹ שֶׁל הוֹגֶה הַחֲזוֹן הַמְּדִינָה הַיְּהוּדִית תֵּיאוֹדוֹר הֶרְצֵל וְהִכְרִיז עַל זְכוּת הָעָם הַיְּהוּדִי לִתְקוּמָה לְאֻמִּית בְּאַרְצוֹ.

זְכוּת זוֹ הֻכְּרָה בְּהַצְהָרַת בַּלְפוּר מִיּוֹם ב בְּנוֹבֶמְבֶּר 1917 וְאֻשְּׁרָה בַּמַּנְדָּט מִטַּעַם חֶבֶר הַלְּאֻמִּים, אֲשֶׁר נָתַן תֹּקֶף בִּמְיֻחָד בֵּין־לְאֻמִּי לַקֶּשֶׁר הַהִיסְטוֹרִי שֶׁבֵּין הָעָם הַיְהוּדִי לְבֵין אֶרֶץ־יִשְׂרָאֵל וּלִזְכוּת הָעָם הַיְּהוּדִי לְהָקִים מֵחָדָשׁ אֶת בֵּיתוֹ הַלְּאֻמִּי.

הַשּׁוֹאָה שֶׁנִּתְחוֹלְלָה עַל עַם יִשְׂרָאֵל בַּזְּמַן הָאַחֲרוֹן, בָּהּ הֻכְרְעוּ לְטֶבַח מִילְיוֹנִים יְהוּדִים בְּאֵירוֹפָּה, הוֹכִיחָה מֵחָדָשׁ בַּעֲלִיל אֶת הַהֶכְרֵחַ בְּפִתְרוֹן בְּעָיַת הָעָם הַיְהוּדִי מְחֻסַּר הַמּוֹלֶדֶת וְהָעַצְמָאוּת עַל יְדֵי חִדּוּשׁ הַמְּדִינָה הַיְּהוּדִית בְּאֶרֶץ־יִשְׂרָאֵל, אֲשֶׁר תִּפְתַּח לִרְוָחָה אֶת שַׁעֲרֵי הַמּוֹלֶדֶת לְכָל יְהוּדִי וְתַעֲנִיק לָעָם הַיְּהוּדִי מַעֲמָד שֶׁל אֻמָּה שָׁוַת־זְכֻיּוֹת בְּתוֹךְ מִשְׁפַּחַת הָעַמִּים.

שְׁאֵרִית הַפְּלֵטָה שֶׁנִּצְּלָה מֵהַטֶּבַח הַנַּאצִי הָאָיֹם בְּאֵירוֹפָּה וִיהוּדֵי אַרְצוֹת אֲחֵרוֹת לֹא חָדְלוּ לְהַעְפִּיל לְאֶרֶץ־יִשְׂרָאֵל, עַל אַף כָּל קֹשִׁי, מְנִיעָה וְסַכָּנָה, וְלֹא פָסְקוּ לִתְבֹּעַ אֶת זְכוּתָם לְחַיֵּי כָבוֹד, חֵרוּת וְעָמָל־יְשָׁרִים בְּמוֹלֶדֶת עַמָּם.

FIGURE 5.5 The *Israeli Scroll of Independence*, pen and ink on vellum, detail

designs for capital letters; illuminators of Hebrew manuscripts followed suit by creating capital words. Walisch and Sidner included a few capital words in their manuscript' such as *Be'Eretz Israel* [בארץ ישראל] (In the Land of Israel), the opening words of the scroll (circled in fig. 5.5).

It is important to mention that the Israeli Scroll of Independence is a *secular* political document, written according to precedents such as the American Declaration of Independence, the British *Magna Carta*, or the French

גשהלפ

FIGURE 5.5A Walisch and Sidner's script

גהטלקש

FIGURE 5.4A Sephardic script

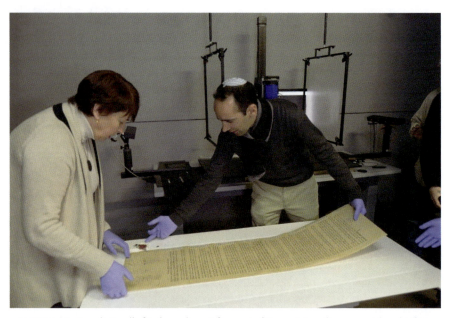

FIGURE 5.6 *Israel's Scroll of Independence* taken out of its container for a recent (2017) taking of a professional photograph at the Israel State Archive

document of Human Rights. These documents are exhibited to the public within specially made cabinets, under glass covers. The case of the Israeli Scroll of Independence is quite different: it is kept in the vaults of the Israeli National Archive in Jerusalem. To this very day, Israeli citizens can see the scroll only through photographs and facsimile reproductions.

Once they finished writing the scroll, Walisch and Sidner folded it and delivered it to the proper authorities in a cardboard container. Upon receiving the scroll, the Israeli Parliament made contact with artist David Gumbel

(1906–1992) from Bezalel,[5] who was commissioned to create a cylindrical silver container for the scroll. The artist submitted his preliminary sketch for the container in May 1949; his finished product was sent to Jerusalem in November of that year[6]

One wonders where from did the notion of sheltering the Scroll of Independence in a container come from? Who came up with the idea, and what Jewish tradition—if there is one—guided them? Documents in Israel's State Archive do not give any answers to the question, but the utensil itself attests to a very close link which is more than a coincidence—the *mezuzah*, the ritual Jewish doorpost.

A *mezuzah* is an object made to shelter a piece of vellum inscribed by verses from Deuteronomy:

> Hear, O Israel: The LORD our God *is* one LORD: 5 And thou shalt love the LORD thy God with all thine heart, and with all thy soul, and with all thy might ... And thou shalt write them upon the posts of thy house, and on thy gates. (Deuteronomy 6, 4–9)
>
> And thou shalt write them upon the door posts of thine house, and upon thy gates .Write them on the doorframes of your houses and on your gates, so that your days and the days of your children may be many in the land the LORD swore to give your ancestors, as many as the days that the heavens are above the earth (Deuteronomy 11, 20)

The *mezuzah* is a physical materialization of a Godly command. The inscription appearing on its container is *Shaddai*, an acronym for *Shomer Daltot Israel* (Keeper of [the People of] Israel's doors). Popular Jewish belief endows the *mezuzah* with magical powers: demons and evil spirits cannot dwell in a home that has a *mezuzah* installed on its doorpost.[7]

Maimonides wrote detailed rules for preparing the *mezuzah* and affixing it on every Jewish home's doorpost: "When one folds [the piece of vellum], one rolls it from its end to its beginning, so as when one opens it, he would be able

5 David Gumbel studied at the *Kunstgewerbe Schule* in Berlin. He worked as a silversmith in Stockholm and immigrated to Palestine in 1936. He taught at the Bezalel School of Arts and Crafts' department of metalwork.
6 See: *Letter from Mr. Melamed to Dorit Rosen of the Prime Minister's Office*, 4.12.1949, Israel State Archive, container S/5392, Scroll of Independence file.
7 *mezuzah* (133–134), Shema (182–183) in Alan Unterman, *Dictionary of Jewish Lore and Legend*, London: Thames and Hudson, 1991.

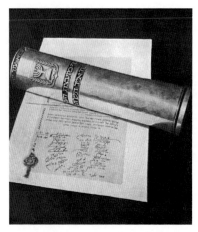

FIGURES 5.7A, B David Gumbel. Container for *Israel's Scroll of Independence*, 1949, silver

to read it properly. After it is rolled one inserts it in a wooden (or any other material) tube and affixes it to his doorpost...."[8]

When conceived as an object, the container Gumbel designed for sheltering the Israeli Scroll of Independence is a large sized version of a *mezuza* tube mentioned by Maimonides. In both cases, the object-container functions as sheltering a piece of vellum, inscribed with a sacred text. The Israeli scroll, contained within a tube, joins, in the spirit of Jewish tradition, the written oath contained in a *mezuzah*.

The inscription on top of Gumbel's cylindrical container and lid (fig. 5.7a) reads *Megilat ha'Atzmaut* (Scroll of Independence). The container's body shows three text lines, arranged as rings that surround it. The text is made in an engraved crevice. Underneath the top ring appears the national emblem of Israel. Two additional rings under it with the following text from Isaiah: "Thy sun shall no more go down; neither shall thy moon withdraw itself" (upper ring). "Signed by the People's Assembly in the town of" (second ring). "Tel Aviv, on the eve of Sabbath, 5th of Iyar, 1948" (third ring).

The full text appearing on the container comprises a documentary part next to a quotation from the Bible: "The Scroll of Independence. Signed by the People's Assembly in the town of Tel Aviv, on the eve of Sabbath, 5th Iyar 1948. Thy sun shall no more go down; neither shall thy moon withdraw itself." The quotation is taken from the first part of a verse in Isaiah, a consoling prophesy

8 Maimonides, *Mishneh Torah, Hilchot Mezuzah*, chapter 5.

in which the prophet describes a shining future of abundance and goodness for the Israelite nation after the soon to come destruction that God would cause it:

> Whereas thou hast been forsaken and hated, so that no man went through *thee*, I will make thee an eternal excellency, a joy of many generations ... Thy sun shall no more go down; neither shall thy moon withdraw itself: for the LORD shall be thine everlasting light, and the days of thy mourning shall be ended. Thy people also *shall be* all righteous: they shall inherit the land for ever, the branch of my planting, the work of my hands, that I may be glorified. A little one shall become a thousand, and a small one a strong nation: I the LORD will hasten it in his time. (Isaiah 60, 15–22).

In spite of the fact that the Israeli Scroll of Independence does not mention—even once—the name of God (God is called there *Tzur Israel*, the rock of Israel), those who commissioned the writing of the scroll saw to it that metaphorically it would be worthy of God's protection by means of a citation from Isaiah. Through his words they saw that the establishment of the state of Israel was not created thanks only to its citizens and leaders; rather it was founded thanks to heavenly grace.

•••

The 1980s show a growing influence of the Israeli orthodox religious parties on everyday aspects of the life of its citizens. The treatment of the Scroll of Independence is an appropriate example. A long time after it was composed, Israeli historians, sociologists, political scientists, and other scholars returned to the scroll's text to reexamine its political, sociological, and moral aspects. In 1988, forty years after the foundation of the state of Israel, artist-designer David Tartakover (b. 1944) gave this general preoccupation a visual expression. He held an exhibition which he labeled *The Declaration of the Foundation of the State, 21 Plates on [Israel's] Scroll of Independence*. Through 21 collages next to which he quoted his personal choice of paragraphs from the Scroll of Independence, he created a critical reading of the text. Tartakover initially planned to exhibit his works at the Tel Aviv Museum, since the founding of the state of Israel was declared at the museum's old edifice. For various political considerations, the museum's management decided not to approve of what they saw as an artistic protest, so the exhibition took place at the Israel Museum in Jerusalem.

Each of Tartakover's plates makes a contemporary visual interpretation of a sentence or a series of consecutive sentences from the Scroll. He designed a new Hebrew typeface, uniquely fitted to the plates, basing it on a font designed

FIGURE 5.8 David Tartakover, *Plate 13* of the *Declaration of the Foundation of the State, 21 Plates on [Israel's] Scroll of Independence* series, 1988

by Pesach Eer-Shay.[9] Tartakover crowned his Hebrew letters with serifs, thus creating a prominent bold text conveying strength and hinting at a virtual loud voice while reading and pronouncing it. His innovating Hebrew typography is a complete antithesis of Walisch and Sidner's calligraphy.

Most of the plates of Tratakover's series refer to the Israeli Scroll of Independence's paragraphs by showing his contemporary view of their meaning forty years after they were conceived. His plates reverberate with cynical, yet a lamenting approach for concepts promised but never materialized. He formulated his art as a protest, a rebuke of Israeli political leaders' forgetfulness of their own declarations of the scroll.

Tartakover's Plate 13 illustrates the following verses of the scroll:

> The State of Israel will be open for Jewish immigration and for the Ingathering of the Exiles; it will foster the development of the country for the benefit of all its inhabitants; it will be based on freedom, justice, and peace as envisaged by the prophets of Israel; it will ensure complete equality of social and political rights to all its inhabitants irrespective of religion, race or sex; it will guarantee freedom of religion, conscience, language, education and culture; it will safeguard the Holy Places of all

9 Eer-Shai's contributions to Modern Hebrew typography will be discussed in chapter 12.

religions; and it will be faithful to the principles of the Charter of the United Nations.

Tartakover's collage presents The Prophets of Israel by a reproduction of Michelangelo's *Moses*; to his left, he places a portrait of Israeli scientist-philosopher Yesha'yahu Leibovitch. Leibovitz was an Israeli Jewish intellectual, professor of biochemistry, organic chemistry, and neurophysiology at the Hebrew University of Jerusalem. He was polymath known for his outspoken opinions on Judaism, ethics, religion, and politics, and an adamant supporter of separation between religious institutions and the state. He was among the first Israeli intellectuals to state immediately after the 1967 Six-Day War that if the occupation continued, it would lead to the decline in moral stature.

Contemporary alleged prophets are also represented. On the right are rabbi Kahana and rabbi Levinger. Kahana, an American Orthodox rabbi, immigrated to Israel in 1971. Believing that the Jewish state and Western democracy were incompatible, he founded the political party *Kach* (Thus) and was elected member of the Israeli parliament (1984). Later, he was convicted for conspiracy to manufacture explosives and for his anti-democratic claims, including the expulsion of the Arab population from Israel, revoking Israeli citizenship of non-Jews, and banning Jewish-Gentile marriages and sexual relations; he and his party were banned from the Israeli parliament. Back in the US in 1990, he was assassinated by an Egyptian born American citizen.

Levinger was also an Orthodox Rabbi, a leading figure of Jewish Israeli settlers in the territories occupied by Israel during the 1967 Six-Day War. He was involved in multiple violent acts against Palestinians, and arrested several times for disrupting the separation between Jewish and Muslim worshippers, rioting in the Hebron market, firing his pistol and assaulting Israeli soldiers, and blocking an army commander from entering the town.

Other images are a group of religious school students and a group of Israeli soldiers taken prisoners by the Syrian Army during the Yom Kippur War (1973). On the top left is an Arab Israeli citizen during the vote for the Jerusalem Municipality. These images stand for the phrase "Complete equality of social and political rights." Guaranteeing "Freedom of religion" is represented by the inauguration ceremony of Israel's first president Chayim Weitzman in the presence of Israel's chief rabbis and Supreme Court judges while the background shows a "production line judicial sentences" of Palestinians in the 1980s. On the bottom right, the artist places a tiny, yet significant observer of the whole narrative: the Baba Sali,[10] a Jewish ascetic,

10 Rabbi Sali was an ascetic mystic, a man who devoted his life to prayer, study, fasting and monasticism.

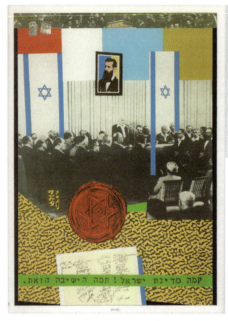

FIGURE 5.9 David Tartakover, *Kama Medinat Israel, Tama haYeshiva haZot*, (The State of Israel is Founded, this Meeting is Adjourned), *Plate 19* of *The Declaration of the Foundation of the State, 21 Plates on [Israel's] Scroll of Independence* series, 1988

his hands thrown to the sides of his body, placed within a yellow cross-shaped frame is next to a documentary photograph of Jews standing on the roof of the *Machpela Cave* in Hebron. Tartakover's message claims that most hallowed declarations included in the Israeli Scroll of Independence were ignored during the first 40 years of the state's existence, never fulfilled, and dominated by Jewish Orthodox leadership.

The text of the last plate in Tartakover's series is the closing sentence of the Scroll of Independence:

> Placing our trust in the Almighty, we affix our signatures to this proclamation at this session of the Provisional Council of State, on the soil of the Homeland, in the city of Tel-Aviv, on this Sabbath eve, the 5th day of Iyar, 5708 14th May, 1948.

The central motif in *Plate 19* (fig. 5.9) is taken from a historical photograph, documenting the dais, from which David Ben Gurion read the text of the Scroll. Tartakover crowned the collage by four light blue, white, gold and crimson rectangles, holy colors taken from Jewish tradition as symbols of the People of Israel due to their appearance on the high priest's garments and the sheets

covering the Tabernacle in the wilderness.[11] On top of them the artist places images of religious school students; on the left, portraits of the Lubawitz rabbi and parliament member Yitzhak Peretz observing the ceremony of founding the Jewish State. Peretz was a religious court judge. In 1984 he was Minister of the Interior and Immigration. He is known for what was labeled sarcastically as "the stinking affair," in which he managed to neutralize his opponents in his political party, left it and founded one of his own. In 1985, as Minister of the Interior, he was quoted referring to a terrifying train accident in which several school children lost their lives by reasoning that it happened due to secular Israeli citizens blaspheming the Sabbath as well as the fact that the train did not have *mezuzas* on its doors. The rabbi seems to be smiling. By that very smile, or rather a smirk, Tartakover conveys the clerical political parties' victory over Israel's *secular* institutions. He implies that since there is no separation of Church and State in Israel, these parties are the dominant rulers of Israeli democracy.

Bibliography

Israel State Archive, container S/5392, Scroll of Independence file.
Jorman, Pinchas, *32 haDakot haRishonot* (32 First Minutes), Tel Aviv, Massada Publishing.
Maimonides, *Mishneh Torah, Hilchot Mezuzah*, chapter 5.
Narkis, Bezalel, *Hebrew Illuminated Manuscripts*, Jerusalem: Keter Publishing House, 1969.
Smith, A., 'The "Golden Age" and National Renewal,' in G. Hosking and G. Schopflin (eds.), *Myths and Nationhood*. London: Hurst and Company, 1997 and his 'Nations and History,' in. Guibernau, M., and Hutchinson, J., (eds.), *Understanding Nationalism*. Cambridge, UK: Polity, 2001.
Tartakover, David, *21 Luchot al Megilat ha'Atzma'ut, haHachraza al haMdina* (21 Plates on Israel's Scroll of Independence, the Declaration of the State), Tel Aviv: Modan Publishing, 1988.

11 The traditional colors of the Jewish People will be referred to in detail in the next chapter.

CHAPTER 6

Hues of Heaven: the Israeli Flag

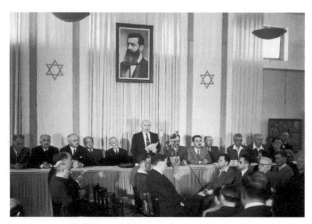

FIGURE 6.1 The dais during the proclamation of the founding of the State of Israel ceremony, 1948

The podium from which David Ben Gurion delivered his proclamation of the establishment of the State of Israel was decorated with a large portrait of Zionist leader Theodor Herzl, flanked on both sides by flags of the Zionist Organization (fig. 6.1). The flag was the familiar emblem of the Zionist movement and accepted as such by most Jewish communities throughout the world. It was only natural to exhibit it during the formal event. When the United Nations declaration in support of the establishment of a Jewish State in Palestine was aired on the radio, thousands of celebrants in urban centers crowded the streets while hoisting the Zionist flag that served them as a unifying symbol.

A few days after the realization of the Zionist dream, a question was raised as to whether this Zionist icon was worthy of becoming the national flag of the newfound state. Some voiced the opinion that it should be replaced by a newly designed flag. On November 12th, 1948, following nine months of indecision, the Provisional State Council of Israel finally issued the following declaration (fig. 6.2):

> Provisional State Council
> Declaration on the official flag of the State of Israel
> The Provisional State Council hereby declares that the flag of the State of Israel is as depicted and described below:

HUES OF HEAVEN: THE ISRAELI FLAG

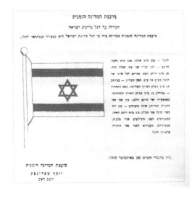

FIGURE 6.2
The official proclamation of the Israeli flag, 1948

25 of Tishri 5709 (October 28th, 1948)
Yosef Shprintzak
Chairman

Visually, the Israeli flag is identical to the flag of the Zionist Organization. However, the symbolic messages each one conveys are different, due to various historical events and the official bodies they represent. The decision to adopt the Zionist Organization's flag as the official flag of Israel attests to the latter's symbolic power that expresses the spirit of the Zionist movement.[1] Members of the State's Provisional Council tried to replace it with another and finally changed their minds again and adopted the Zionist flag.

6.1 The Zionist Flag

Zionist tradition endows David Wolfsohn, one of its principal leaders, with the invention of the organization's flag. Twenty-five years after the First Zionist Congress Wolfsohn wrote:

> By order of our leader Herzl I traveled to Basle to take care of all the preparations for the Congress ... One of the questions I was faced with—not a prominent one nevertheless not an easy one—entailed something of the great Hebrew [Jewish] problem. What flag should we decorate the Congress hall with? What are its colors? Is our People capable of distinguishing one color from another? Our People that takes precautions not

1 M. Eli'av, "leKorotav shel haDegel haTzioni" (On the History of the Zionist Flag), *Kivunim, Ktav Et leYahadut uleTziyonut*, June 1979, 49–59.

to behold any sculpture and any picture? Then, suddenly, an idea flashed my mind: we do have a flag, white and blue; the *talit* (prayer shawl) that we wrap ourselves with when we pray—this *talit* is our symbol. Let us unpack it from its bag and unroll it facing all of [the People of] Israel, for the eyes of the whole world to behold. I then proceeded to order a white and blue flag with a *Magen David* [literally King David's shield, the Jewish Star] marked on it.[2]

This myth goes on to tell of the specific moment in which Wolfsohn had this stroke of genius: that in one of the preliminary sessions of the first Zionist Congress in Basle, Theodor Herzl raised the flag issue. Since his proposed design, a white background surmounted by seven golden stars did not gain acceptance by the other Zionist members, Wolfson is said to have risen from his chair and declare the following: "Why do we bother ourselves looking for something—here, this is our national flag." He accompanied his words by waving his *talit*. Everyone present then saw the national flag: a white field with light blue stripes on its edges.[3]

This beautiful and dramatic myth presents us with a picturesque, yet absurd image: It is a little strange to imagine the Zionist dignitaries participating in the First Zionist Congress all seated wrapped up in prayer shawls. Whether it was David Wolfsohn or another delegate who suggested the familiar image of the Zionist flag,[4] envisioned three significant components: a white field of the Jewish prayer shawl, the two light blue stripes adorning its borders, and an added blue six-pointed star. Each element carries traditional Jewish symbolic connotations and should be referred to separately.

6.2 The *Magen David* (David's Shield) or the Jewish Star

Unlike the lion of Judah and the *menorah*, the seven-branched candelabra from Solomon's Temple, the Jewish Star was never a uniquely Jewish symbol.[5]

2 David Wifsohn, "haDegel vehaShekel" (The Flag and the Shekel) in L. Yaffe (editor), *Sefer haYovel liMlot Chamesh ve'Esrim Shana laKongreess haTzioni haRishon* (The Jubilee Book for the Twenty Fifth Anniversary of the First Zionist Congress), Jerusalem, 1923, 296–297. Originally, Wolfsohn published his article in *Hatzfira* in 1911.

3 Meir Chartiner, "Kidmat Tzaeynu haLe'umiyin" (The Past History of our National Colors), *Moladeti*, 13–15, 1950, 94.

4 There were others who claimed to be the inventors of the Zionist flag, among them Morris Harris from Stamford Connecticut, a member of Lovers of Zion Club In New York. See: "Symbol for Fellow Zionists Made by Harris in the 90s", *The Stamford Advocate*, May 18, 1948.

5 These symbols will be discussed in detail in the next chapter.

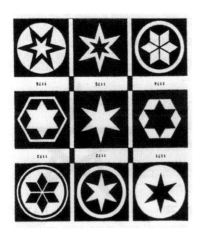

FIGURE 6.3
Variations of the six-pointed star design.

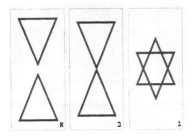

FIGURE 6.4
Two triangles forming the shape of the six-pointed star

It is common in many cultures and various historical periods. The universal geometrical form is called a hexagram, or a six-pointed star, a combination of two intertwined triangles. It is an ancient symbol, and its visual styles and interpretations vary in diverse cultures (fig. 6.3).

The search for national emblems during the early years of the State of Israel made their designers investigate the sources of some traditional Jewish signs and emblems, and see how fitting they would be as modern emblems for the newborn state. The Jewish Star was an extremely popular symbol, and precisely for that reason, it made scholars try and fathom its significance. Gershom Scholem (1897–1982)[6] wrote a treatise on the history of that sign and its link to Judaism while trying to give a response to the issue raised whether it was worthy of use on the state's flag or national emblem.[7]

6 Scholem was a German-born Israeli philosopher and historian, widely regarded as the founder of the modern, academic study of *Kabbalah*, Jewish mysticism.
7 Gershon Scholem, "Magen David Toldotav shel Semel" (The Shield of David, History of a Symbol), in *Lu'ach Ha'aretz*, Tel Aviv, 1948, 148–163. The article's English version "History of the Six-pointed Star, Hebrew: the 'Magen David' Became the Jewish Symbol", *Commentary*, 8, 1949, 243–251.

FIGURE 6.5
The six-pointed star as a magic symbol

FIGURE 6.6
The six-pointed star on an amulet

As to the Jewish term Shield of David—given to the six-pointed star, Scholem notes that many legends were frequent among medieval occultists about the secret power of King David's shield with which the King saved the Israelites in their wars.[8]

A Jewish Star first appeared as a visual component in Jewish printers' banners (logos) and on title pages of Hebrew book publications (figs. 6.7, 6.8). The use of printers' banners coincides with the invention of the printing press.[9]

The six-pointed star served as a sign by many Jewish congregations for their official seals; its earliest use was in 17th century Prague, and from there, it spread to Moravia and Austria. Scholem believed that the main reason for the spread of this sign was Judaism's desire to imitate Christianity. During the Jewish Emancipation, several Jewish communities searched for a sign that would parallel the universal quality of the Christian Cross. They aspired to project from the tops of their modern Synagogues something culturally similar to the cross. The significance of the six-pointed star was extended in the 19th

8 Ibid. (Hebrew), 153–154.
9 Ibid., 155–157.

FIGURE 6.7
The Jewish Star on a printer's banner, 16th century

FIGURE 6.8
The Jewish Star on a printer's banner from Prague, 16th century

century to its use as a decorative emblem on ritual objects, Synagogue facades and more.

In Scholem's opinion, this non-Jewish emblem, which does not even convey a Jewish message, was particularly fitted for Zionist needs. Its unprecedented spread among Jewish communities occurred *because* it had no religious associations whatsoever.[10] The six-pointed star became a symbol of Zionist Judaism and was accepted as representing not only the Zionist movement but Judaism in general.

10 Ibid., 9–162.

6.3 The Blue Stripes

The interpretation of the *talit* stripes relates to their light blue hue and their shapes. Contemporary prayer shawls are not identical to those from antiquity. The *talit* in antiquity was an ordinary costume for Jews just like the *toga* for Romans. The *talit* edges were thrown over the shoulders or wrapped around the person's body.[11] The Bible commands Jewish males to attach tassels (*tzitzit*) on the borders of their garments and to add a cord (*ptil*):

> And the LORD spake unto Moses, saying, Speak unto the children of Israel, and bid them that they make them fringes in the borders of their garments throughout their generations, and that they put upon the fringe of the borders a ribband of blue: And it shall be unto you for a fringe, that ye may look upon it, and remember all the commandments of the LORD, and do them; and that ye seek not after your own heart and your own eyes, after which ye use to go a whoring: That ye may remember, and do all my commandments, and be holy unto your God. I *am* the LORD your God, which brought you out of the land of Egypt, to be your God: I *am* the LORD your God. (Numbers, 15, 37–41)

> Thou shalt make thee fringes upon the four quarters of thy vesture, wherewith thou coverest *thyself*. (Deuteronomy, 22:12)

The *tzitzit* is a braid of interwoven threads used for decoration. Ancient Middle Eastern sculptures and reliefs show Kings' and nobles' garments decorated at the edges with tassels and cords of various kinds. When Jews were exiled from the Land of Israel and were spread among the nations of the world, they adopted native, local costumes. A separation should then be made between the biblical commandment relating to a *tzitzit* and later periods in Jewish history in which garments and costumes changed and consequently the *tzitzit* changed from an everyday garment into a clothing accessory with sacred connotations, used only during prayers.[12] Some claim that the incorporation of the blue stripes into the *talit* was meant as a reminder for the light blue cord of the *tzitzit*.[13]

11 A. Rubens, *History of Jewish Costume*, London: 1973, 27; *Talit*, Encyclopaedia Judaica, Jerusalem: 1971 cols. 743–744.
12 Talit, *Judaica*, 743.
13 Ibid.

The biblical command refers only to the *tzitzit* and not to the *talit*. Therefore, its white background was not necessarily adopted by all Jewish communities. In Yemen, for example, they were made of black wool with red, green or yellow stripes.[14] However, all Jews adhered to the biblical rule that the *tzitzit* must include at least one cord of the hue called *tchelet* in Hebrew.

In modern Hebrew usage, *tchelet* means light blue. However, determining the exact hue expressed by the word *tchelet* in the Bible is complex and challenging. Its nature was never agreed upon and occupied generations of commentators, researchers and Jewish Bible students. The development since antiquity until the present day in matters concerning colors and hues and the semantic differentiation between them brought about ambivalent claims to the true nature and appearance of *tchelet*. The predominant current view is that what the Bible calls *tchelet* is a greenish blue hue.[15] The dye was produced from a snail, whose natural habitat is the Mediterranean shores. The liquid extracted from the snail is initially greenish-yellow, but when exposed to the sun it changes into a variety of greens, blacks, reds, and blues. Yarn threads were soaked in the clean dye; the final hue depended on the process and the type of snails. The method of making the *tchelet* dye was expensive and highly valued for its remarkable resistance to fading, and therefore acquired noble and royal traits. Later on, the meaning of the Hebrew word *tchelet* was commonly accepted as blue, or sometimes light blue.

Many symbolic interpretations were given regarding the color *tchelet*. Rabbi Meir claimed that it reminds one of the colors of the sky and therefore of God's throne. Rabbi Yehuda, son of Rabbi Eilay, contended that *tchelet* was the color of God's scepter and the Tablets of the Law and therefore God commanded the Israelites to incorporate it on their *tzitzit*. "As long as [the People of] Israel look at this *tchelet* they remind themselves of that which is written in the tablets of the law and keep them [the ten commandments]."[16] In other words, this Jewish sage claimed that the visual image of a specific hue causes people to keep the Ten Commandments.

14 A. Muller-Lancet, "Jewish Ethnographic Costume", *Encyclopedia of Jewish History*, Ramat Gan: Massada Publishing, 1985.
15 Jewish scholars maintained that "One says that the *tchelet* resembles the sea, the sea resembles seaweed, sea weed resembles the sky". *Jerusalem Talmud, Brachot Tractate*, 1, 5, 71.
16 Zvi Meirovich, *Perush haGadol al Chamisha Chumshey Torah Chibro Rabbi David ben Rabbi Amram ha'Adani, Sefer Bammidbar, Yotze la'Or al pi Ktav Yad eem Mavo, Chilufey Nuscha'ot veHe'arot* (The Great Commentary on the Five Books of Moses, Written by Rabbi David son of Amram from Aden, The Book of Numbers, Published according to a Manuscript with an Introduction, Exchange of Wordings and Comments), Jerusalem, 1973, 254.

White and light blue, together with gold and crimson, were the colors of the High Priest's garments as well as the colors of the Tabernacle in the wilderness. They denoted purity and symbolized the spirituality of the Jewish People.

During the Modern period, the first to claim that blue and white were the national colors of the Jewish People was the Austrian-Jewish poet Ludwig August Frankl (1810–1894).[17] Thirty years before the first Zionist Congress took place, Frankel published a poem called *Judas Farben* (Judah's colors):

> While his heart is full of exalted emotions
> He is adorned with the colors of his country
> He prays, standing, wrapped in
> A gleaming white mantle.
>
> The edges of his white garment
> Are crowned with wide light blue stripes;
> Like the mantle of the High Priest,
> It is adorned with bands of light blue threads.
>
> These are the colors of the beloved country
> Light blue and white are the borders of Judah;
> White is the priestly radiance;
> And blue is the sky's brilliance.[18]

Frankels' poem was first translated into flowery Hebrew and published by the Hebrew newspaper *Chavatzelet* in Jerusalem (1889).[19] There is no evidence that the early Zionist leaders were familiar with Frankl's poem; nevertheless, almost all flags representing the first Zionist associations quoted the light blue stripes from the *talit*. A white and blue flag was first hoisted in 1885 in Rishon leZion, honoring the first 30 years of its foundation.[20] With no connection to the Rishon leZion event, a white and blue flag was hoisted in 1891 in Boston, honoring the inauguration of the Bnay Zion hall. The Boston flag had two blue stripes and a Shield of David in between them and the inscription Maccabi (fig. 6.9).[21]

17 Frankel was a physician and poet, born in Bohemia and lived most of his life in Vienna. In 1856 he was sent to Jerusalem by philanthropist Eliza Herz in order to establish an educational institution for children, named after her father. The Simon Lemel school functioned for many years in Jerusalem.
18 A. L. Frankel, "Judas Farben" in *Ahnenbilder*, Leipzig, 1864, 127.
19 As quoted by Eliav, "On the History of the Zionist Flag", 51.
20 Ibid.
21 Ibid., 54.

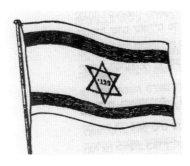

FIGURE 6.9
Flag of the Bnay Zion Association in Boston, 1891

The light blue stripes of the Zionist flag make a counterweight for the Jewish Star's message. They endow the flag with a religious-ritualistic aspect, completely lacking in the Jewish Star. Whether the symbolic elements of the blue stripes were adopted consciously or subconsciously, the mere fact that they are borrowed from the Jewish prayer shawl alludes to the biblical commandments. The flag, therefore, sends the message of the unity of the People of Israel using the Jewish Star, guided by the biblical commandments expressed by the light blue strips and white background.

6.4 First Proposals for an Israeli Flag

After about fifty years during which the Zionist flag was used throughout the world, a select committee of Israel's Provisional State Council decided "… To establish a significant differentiation—as far as possible—between the State's flag and the Zionist one in its traditional form."[22] Moshe Sharet, Israel's Foreign Minister, explained why this decision was made: "… To prevent complications in the status of Jewish communities in various countries when they display the universal Jewish flag, that is the Zionist flag, since the possibility exists of a mistake being made or that it would create the impression that they are displaying the flag of a country while [in fact] they are not its subjects".[23] Due to the concern of placing world Jewry expressing dual loyalty it was decided to proclaim a public competition for a national flag for the state of Israel that would be different than the Zionist flag.

22 Moshe Sharet is quoted in *Minutes of the Provisional State Council, Tenth Meeting, Tel Aviv, July 5, 1948*, 9.
23 Ibid., 10.

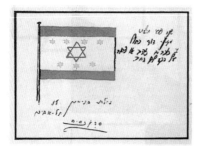

FIGURE 6.10
Nissim Sabach, *Proposal for Israel's National Flag*, 1948

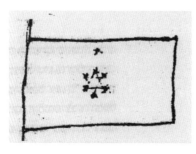

FIGURE 6.11
Herzl's proposal for a flag for the future Jewish State

In a tender published in May 1948, the general Israeli public was asked to submit proposals for a flag. The response was spectacular: the select committee assigned to deal with the flag issue received 164 entries.[24]

Nissim Sabach's minimalistic proposal (fig. 6.10), for example, included the components that would be used in most of the other proposals submitted to the committee: two light blue stripes, white background with a Jewish Star in its center, accompanied by Herzl's seven golden stars. Sabach's proposal testifies to how much the Zionist flag was rooted in the subconscious minds of his compatriots; it was hard to disconnect oneself from its familiar components, and therefore all of them were included in his proposal. The Tel Aviv designer added Herzl's seven golden stars to these traditional elements (fig. 6.11), representing the seven-hour workday he envisioned for the citizens of the future Jewish State.

Another proposal, presented to the committee in five variations, placed the seven golden stars on a blue background (fig. 6.12). Herzl's modern concept of Judaism is juxtaposed in these proposals next to Jewish tradition, represented by the white and blue colors, alluding to the colors of the *talit*.

Mordechai Nimtza-Bi, an Israeli heraldry expert, published in July 1948 a book entitled *haDegel* (The Flag) in which he included several proposals for

24 Proposals are kept at the Israeli National Archive in Jerusalem, *Box 3/195, File 5–6*.

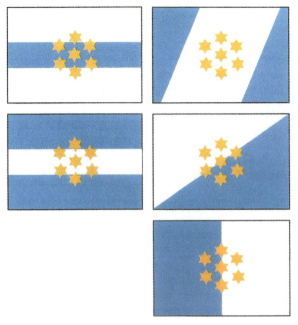

FIGURE 6.12 Anonymous artist, *Five Variations for a Proposed Israeli Flag*, 1948

the national flag (fig. 6.13). Nimtza-Bi agreed with Sharet's opinion that the Zionist flag should be replaced by an *Israeli* flag. "Even after the establishment of the state [of Israel] Jews will continue to live in the Diaspora," he wrote. "If the Zionist flag would turn into the national flag of Israel, these Jews, who are the subjects of their [sovereign] countries, would be displaying a flag of a foreign country as a flag representing their political movement."[25]

Nimtza-Bi thought that the national flag of Israel should symbolize the link that exists between the Jews of the state and Jews in the Diaspora. To resolve the double loyalty issue, he suggested "to incorporate the entire design of the Zionist flag into the Israeli flag. This way the State [of Israel]'s flag would be reminiscent of the Zionist flag and at the same time would be different".[26] Nimtza-Bi was fluent in heraldic lore and rules, especially with the heraldry of the British Empire. Well-versed with the symbolic messages that the British Commonwealth flags convey, he pointed out the fact that most of them include an image of the Union Jack at one of their corners or the flag's central area. The various proposals he

25 Ibid.
26 Nimtza-Bi, *The Flag*, 1948, 29.

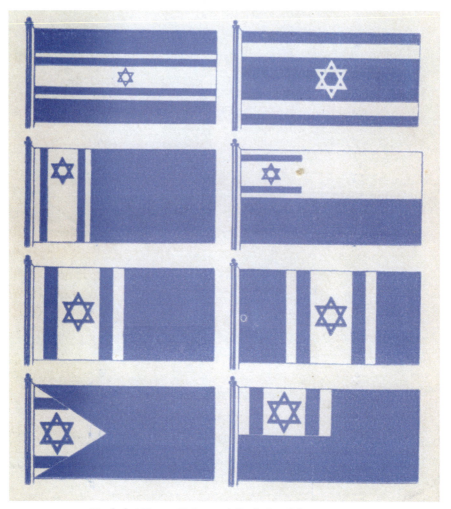

FIGURE 6.13 Mordechai Nimtza-Bi, *Proposals for the Israeli flag*, 1949

created for Israel's national flag show that he aspired to endow the state of Israel with a spiritual authority vis a vis Zionist organizations throughout the world, in a similar way to that of British political authority and the countries of the British Commonwealth. The Provisional State Council did not accept his proposal or any of the 164 other proposals submitted by the general public.

During the tenth meeting of The State Provisional Council, Moshe Sharet presented the members of the committee with a proposal made by graphic designer Oteh Walisch[27] (fig. 6.14). Sharet made it clear that this was one of

27 Walisch was mentioned in chapter 5 as the designer of the dais for the declaration of the state of Israel ceremony.

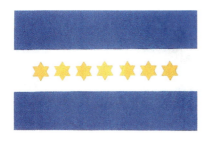

FIGURE 6.14
Oteh Walisch, *Proposal for the Israeli flag*, 1948

two designs accepted by the select committee formed by the State Provisional Council to deal with such matters.[28]

Walisch's design is divided horizontally into three equal parts: the two stripes on its edges are blue, and the golden stars are situated on a horizontal white stripe. This layout differs from that of the Zionist flag that contains *five* stripes: two light blue stripes in between three white stripes. The width of the blue stripes in Walisch's proposal is also different from the Zionist flag. His design exhibits a conscious deviation from the plan of the Zionist flag; more than that, it deviates from the traditional division of stripes on the Jewish *talit*. The stripes were moved to the upper and bottom edges of the design. The lack of a clear allusion to the *talit* endows Walisch's design with a distinctive *secular* aspect, unlike the one typical of the Zionist flag.

When the members of The Special Committee of the State Provisional Council received copies of Walisch's proposal, they were bothered by the absence of the Jewish Star. A few were in favor of removing it, but others demanded that it must be incorporated in the design. Finally, it was decided to appoint yet another committee to be responsible for the state's flag and emblem issues. The proposed committee was asked to bring a final proposal to the next meeting of The State's Provisional Council.[29]

In the meantime, Moshe Sharet decided to check the Jewish organizations' attitude towards the Israeli flag. He sent cables to Dr. Haim Weitzman in Switzerland, Rabbi Aba Hillel Silver in New York, Prof. Zelig Brodetzky in London, and the General Committee of the Zionist Organization in Johannesburg, explaining his fear of the double loyalty. His addressees had no problem with Israel's institutions' adoption of the Zionist flag as its national flag though some suggested a few symbolic and heraldic components.[30]

28 *Provisional State Council, Tenth Meeting*, 9.
29 *Minutes of the Flag and Emblem Committee*, July 28, 1948, Israel National Archive, Box 3/195, File 5–6.
30 Ibid.

On October 14th, 1948 the Committee for the State's Flag and Emblem decided to reject all alternative proposals for the state's flag and to adopt the flag of the Zionist Organization as the official flag of The State of Israel.[31]

The Jewish Star is an excellent example for the changing qualities of symbols; the power of the message they convey is given to them less by the original idea according to which they were designed, and more due to significant residue they were imprinted with through their use in historical events. At the beginning of its use by Jewish institutions, the Star did not have any religious connotations, political or social. Later on, it was given immense powers through the horrendous way the Nazis used it. In the conclusion of the article about the history of the six-pointed star Gershom Scholem wrote:

> But even Zionism did not do so much to confer the sacredness of a true symbol on the Shield of David as did that mad dictator who made of it a badge of shame for millions of our people, who compelled them to wear it publicly on their clothing as the badge of exclusion and of eventual extermination. Under this sign, they moved along the road of horror and degradation, struggle and heroism. If there be such a thing as a soil that grows meaning for symbols, this is it. Some have said: the sign under which they went to destruction and to the gas chambers deserves to be discarded for a sign that will signify life. But it is also possible to think in the opposite fashion: the sign that in our days was sanctified by suffering and torture has won its right to be the sign that will light up the road of construction and life. 'The going down is the prelude to the raising up;' where it was humbled, there will you find it exalted.[32]

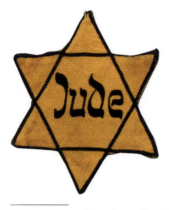

FIGURE 6.15
The *Yellow Badge*, a badge of shame for Jews made by Nazi Germany

31 *Minutes of the Flag and Emblem Committee*, September 11, July 28, 1948, Israel National Archive, *Box 3/195, File 5–6*.
32 Scholem, "The Shield of David, History of a Symbol".

The emblems and symbols created by Nazi Germany for its myths visually manifest the power of an insane system that had turned every single human value upside down. The thought and attention to detail the Nazis employed to create each one, aspiring to arrive at a concise visual image with maximum suggestive powers, did not neglect the design for the Jewish badge of shame.

The Yellow Badge shows a Jewish Star surrounded by a black contour, with the letter J or the word *Jude* in its center. In western Christian culture, the combination of black and yellow symbolizes death, treason and heresy,[33] contrasting with white and blue, which symbolize purity and life. The two pairs of colors constitute complete opposites even from a scientific, optical point of view; a simple experiment proves it. If after a few seconds of looking at the Yellow Badge, with its black and yellow colors, we shift our gaze to a white or light grey background, we would see an after-image of a white Jewish Star contour with a blue inner area. In other words, the Yellow Badge is a malevolent reversal of the symbol of Judaism even in its scientific aspects.

In conclusion: the light blue stripes and the white background of the Israeli flag stand for a life of purity according to biblical laws; the Jewish Star symbolizes rebirth and a new life out of the atrocities suffered by the Jewish People. These symbolic elements link the State of Israel with the present, past and future. It is due to these symbolic components that the image of the Zionist Organization's flag withstood all other political considerations that faced the leaders of the young state who proposed to replace it with various visual alternatives.

6.5 A Multitude of King David's Shields

The acknowledged Israeli national emblems and symbols penetrated public awareness and had become actual icons. Searching for means to express messages about Israeli-Jewish existence, the political situation in Israel, or social phenomena typical of it, Israeli designers turn to the familiar symbols and use them in creating artistic commentaries.

The Israeli flag was an august national asset in Israeli culture since the establishment of the State. It was not intended for use for any purpose apart from national representation, on national holidays, or for covering the coffin

33 Yellow in Christian art is one of Judas Iscariot's attributes; his garment most often depicted in yellow. Black, is commonly held as the color of death. See: "Judas", in James Hall, *Dictionary of Subjects and Symbols in Art*, New York: Icons Editions, Harper and Row Publishers, 1972, 179.

FIGURE 6.16 Ohad Shaltiel, *Mishmeret 1* (Watch 1, literally, First watch), 1977, tar on canvas, mixed media

at official and military funerals. The way Israeli artists use the flag or its motifs is based on precedents created primarily in the second half of the twentieth century in American art, like Jasper Johns' iconic series of *Flags*, in which he created many variations on the familiar Stars and Stripes. When relating to the national flag in their works of art, some artists made use of it as a whole (stripes + Jewish Star) while others related only to the star.

First Watch (fig. 6.16) is a work composed of rectangular boxes covered by three flags, which were custom made for the artist.[34] The materials Shaltiel used in his work are gold paint and thinned tar, so the blue and white colors of the Israeli flag practically disappear. To some extent, Shaltiel's boxes hint at the shape of a coffin covered by the flag, carrying great sorrow. The artist may be implying the value crisis in Israel, or even longing for the pre-State generation, yearning for a dream gone forever.

34 Lida Sharet-Massad, *Degel—Le'om—Degel* (Flag—Nation—Flag) (exh. cat.), Haifa, Pyramida Center for Contemporary Art, Artists' Workshops, Wadi Salib, 1998.

HUES OF HEAVEN: THE ISRAELI FLAG 133

FIGURE 6.17 Eitan Busheri & Tomer Shemi, *Hamishim Shana liMdinat Yisrael* [Israel's 50th anniversary], 1998, poster

A poster in honor of Israel's 50th Independence Day, created by Busheri and Shemi (fig. 6.17), shows a morphologically changed Israeli flag, fluttering in an imaginary wind. The designers retained the original stripe construction but altered the Jewish Star. The familiar idyllic combination of two triangles creates the complex symmetrical shape of the Jewish Star. The designers disassembled it and displayed the two triangles side-by-side rather than intersecting one another. The six-pointed star that symbolizes the Jewish People disappeared, and along with it the idyllic combination. The red-orange color of the background may hint at flames; this gives the poster its dramatic tension: the flag waving in the wind did not yet catch fire—but will soon.

In 2005, the Jewish Star appeared as an icon in a different political context. It was adopted by groups of Jewish-Israeli citizens to protest the government's decision to remove the settlers of *Gush Katif* in the Gaza Strip from their homes and relocate them to other areas in Israel, in what is known as the

Disengagement Plan. For the settlers' slogan, "A Jew does not banish a Jew," an anonymous designer created an orange-colored logo configured in the image of the Nazi badge of shame. The orange color was probably chosen because it was close to yellow, the color of the original Nazi badge. The designer turned the Yellow Badge of Shame into an Orange Badge of Shame. It is unlikely that the designer foresaw the furious public reaction to the immense power of the message that this emblem transmits and to its complete disregard and contempt of Holocaust survivors' feelings both in Israel and throughout the world. The copywriter's horrendous gimmick was accepted by the settlers without a moment of contemplation on its horrible connotations. They made kindergarten toddlers wear it for photos taken for newspapers advertising. Because of its resemblance to one of the most sensitive and charged symbols of the Holocaust, it aroused enormous protest on the part of the Israeli public, and the use of the Orange Badge of Shame was stopped. It was reduced to an orange-colored ribbon tied to cars' radio antennas to distinguish the group of citizens who opposed the Disengagement Plan from other groups in Israeli society.[35]

The treatment of the national flag by two Israeli commercial airlines is interesting. The first, El Al Airlines created a flawed one and the other, Israir, improved on the shape of the Jewish Star and tailored it, in its opinion, to a young, international clientele. As already mentioned, there are five stripes on the official Israeli flag. Israeli designer Dan Reisinger created El Al's logo and the general look of its airplanes[36] (fig. 6.18). The fuselage of the airplane shows that Resinger narrowed their number to three—one wide white stripe in the center and two blue ones at the top and bottom. He filled in the two triangles that compose the Jewish Star with blue, and thus deprived the star of its Israeli context and turned it into a generic six-pointed star (he did render a true image of the Israeli flag on the airplane's tail). Israir airlines (fig. 6.19) changed the color of the Jewish Star from blue to orange and added to it a point. In this way, a *seven*-pointed star was created in the company's logo, designed, according to its public relations officer, to transmit "a sense of motion, dynamics, and youth."

35 Typical of the iconographic history of symbols and signs, the orange strips that appeared throughout Israel in 2005 were erroneously linked to the contemporary "Orange Revolution" in the Ukraine and the orange-clad demonstrators in Kiev, which took place after the presidential election in 2004. The Disengagement Plan of the Israeli government had nothing to do with the Ukraine, either historically or from a color-symbolic point of view.

36 See: Tirza Benporat, ""haLogo keGesher: Hitpatchut haZehut haTa'agidit shel El Al" (The Logo as a Bridge: the Development of El Al's Corporation Identity)," in *Dan Reisinger* (exh. cat.), Jerusalem: The Israel Museum, 2017, 66.

HUES OF HEAVEN: THE ISRAELI FLAG 135

FIGURE 6.18 Logo of *El Al* National Israeli Airlines

FIGURE 6.19 Logo of *Israir* Israeli Airlines

Bibliography

Chartiner, Meir, "Kidmat Tzvaeynu haLe'uniyin" (The Past History of our National Colors), *Moladeti*, 13–15, 1950.

Dan Reisinger (cat. exh.), Jerusalem: The Israel Museum, 2017.

Eli'av, M., "leKorotav shel haDegel haTzioni" (On the History of the Zionist Flag), *Kivunim, Ktav Et leYahadut uleTziyonut*, June 1979.

Hall, James, *Dictionary of Subjects and Symbols in Art*, New York: Icons Editions, Harper and Row Publishers, 1972.

Koch, Rudolph, *The Book of Signs with Comments on All Manner of Symbols Used from the Earliest Times to the Middle Ages by Primitive Peoples and Early Christians*, Translated from the German by D. Holland, New York, 1955.

Meirovich, Zvi, *Perush haGadol al Chamisha Chumshey Torah Chibro Rabbi David ben Rabbi Amram ha'Adani, Sefer Bammidbar, Yotze la'Or al pi Ktav Yad eem Mavo, Chilufey Nuscha'ot veHe'arot* (the Great Commentary on the Five Books of Moses, written by Rabbi David son of Amram from Aden, The Book of Numbers, Published according to a Manuscript with an Introduction, Exchange of Wordings and Comments), Jerusalem: 1973.

Minutes of the Flag and Emblem Committee, Israel National Archive, *Box 3/195, File 5–6*.

Muller-Lancet, A., "*Jewish Ethnographic Costume*," *Encyclopedia of Jewish History*, Ramat Gan: Massada Publishing, 1985.

Rubens, A., *History of Jewish Costume*, London: 1973.

Scholem, Gershon, "History of the Six-pointed Star, Became the Jewish Symbol," *Commentary*, 8, 1949, 243–251.

Scholem, Gershon, "Magen David Toldotav shel Semel" (The Shield of David, History of a Symbol), in *Lu'ach Haaretz*, Tel Aviv, 1948.

Sharet-Massad, Lida, *Degel—Le'om—Degel* [Flag—Nation—Flag] (exh. cat.), Haifa, Pyramida Center for Contemporary Art, Artists' Workshops, Wadi Salib, 1998

Talit, Encyclopaedia Judaica, Jerusalem: 1971 cols. 743–744.

Wofsohn, David, "haDegel vehaShekel" (The Flag and the Shekel) in L. Yaffe (editor), *Sefer haYovel liMlot Chamesh ve'Esrim Shana laKongress haTzioni haRishon* (The Jubilee Book for the Twenty-Fifth Anniversary of the First Zionist Congress), Jerusalem: 1923.

CHAPTER 7

Menorah and Olive Branches on Israel's National Emblem

On February 11, 1949, the following declaration was published in *Iton Rishmi* (Official Paper), the authorized organ of The Provisional State Council of the state of Israel:

> The Provisional State Council of the state of Israel
> The Provisional State Council of the state of Israel hereby declares and announces that the emblem of the State of Israel is as shown:
>
> 10th February 1949
> The Provisional State Council of the state of Israel
> *Joseph* Shprinzak
> chairman[1]

The official emblem of the state of Israel is stamped on its official documents. It crowns official buildings within the country and consulates and embassies abroad. Its creation involved the consideration of many designs and ideas. While the state's flag was created in the Diaspora by utopian dreamers, the

FIGURE 7.1
Official declaration of Israel's National Emblem

1 *Iton Rishmi*, 50, 11.2.1949, 404. This chapter is a revised edition of *"Menorah ve'Anfey Zyit, Korot Eetzuvo shel Semel Medinat Israel"* (Menorah and Olive Branches, the Design Process of Israel's National Emblem), in my book *Shuru Habitu u'Ru, Ikonot uSmalim Chazutiyim Tzioniyim baTarbut haIsraelit*, (Lo and Behold, Icons and Zionist Visual Symbols and Emblems in Israeli Culture), Tel Aviv: Am Oved Publication, 2000, 138–164.

emblem of the state of Israel was to be formed in the new state. A deep feeling of mission and heavy responsibility was shared by everyone involved in the emblem's design.

On July 15 1948, about two months after the establishment of the State, The Provisional State Council gathered for its tenth meeting. Foreign Minister Moshe Sharet, handed copies of a sketch for the state's flag and emblem, proposed by the graphic designers Oteh Walisch and David Strossky (fig. 7.2). Their sketch was chosen from 450 bids submitted by 164 people who participated in a competition declared a short time beforehand.[2]

The central motif in Walisch and Strossky's sketch is a *menorah,* a seven-branched candelabrum. It is the most ancient Jewish symbol, representing the Temple in Jerusalem. The visual model for the *menorah* is taken from its image depicted in relief on the *Triumphal Arch of Titus,* erected by the Roman Senate in 81 CE in Rome (fig. 7.3).[3] The designers simplified its shape to a schematic white silhouette set on a light-blue background. The upper part of the crest-shaped emblem comprised of a white band studded with seven golden stars, whose source was Theodor Herzl's suggestion of a national flag for the future Jewish State (fig. 6.11 in chapter 6).

Had the emblem designed by Walisch and Strossky was accepted and authorized, it would have conveyed two basic symbolic ideas. On the one hand was the *menorah*, whose religious-ritual aspect emphasized the bond between the Jewish People in its new state and its past glory. On the other hand, Herzl's

FIGURE 7.2
Walisch and Strossky, *Proposal for Israel's National Emblem*, 1948

2 *Rashumot Moetzet haMdina haZmanit, haYeshiva ha'Asirit*, (Notes of the Provisional State Council, 10th Meeting), July 15, 1948, 10.

3 The arch of Titus and its commemorative relief will be discussed in detail in the next chapter.

FIGURE 7.3
צורת המנורה בצלת שבעת הקנים, 577
שביעה בקשת טיטוס

The *Temple Menorah* as depicted in relief on the *Triumphal arch of Titus* in Rome

modern, socialist vision was expressed by the seven golden stars with their Zionist-secular concept.

7.1 In Search of a National Emblem

The Provisional State Council was not hasty in accepting and authorizing the sketch; it decided to postpone the vote. Prime-Minister David Ben-Gurion adjourned the meeting by saying that "[A decision on a state's flag and emblem] should not be taken lightly."[4] Consequently, a special committee of cabinet members and ministers was set up to deal exclusively with new proposals for the state emblem.

The committee met on July 28th. Additional visual elements were suggested, including the Tablets of the Law, candles for the *menorah*, the Lion of Judah, and the inscription *Medinat Israel* (The State of Israel). To give the design a more professional look, the committee decided to include a team of experts: graphic designers, a painter, an archaeologist and an architect. Finally, the committee agreed that the emblem should consist of three elements: a *menorah*, Tablets of the Law, and Herzl's stars.[5]

4 Ibid.
5 *Minutes of the Committee for the State's Flag and Emblem*, July 28, 1948, Israel State Archive, Unit 78, container 395, file 1005, 1.

7.2 Archaeology and Socialism: Jewish Tradition versus Secularism

Two weeks passed, and on August 6, the committee held its third session. Architect Arieh El-Chanani, archaeologist Prof. Lipa Sukenik, painter Reuven Rubin and artist-architect Leopold Krakauer were invited to attend the meeting as experts. They suggested that the design of the emblem should employ elements of "the [Jewish People's] ancient tradition," and that designers should refrain from using "modern symbolism." Professor Sukenik, who had unearthed a 6th century Synagogue mosaic floor in Jericho about a year before, suggested that the *menorah* on the emblem should not constitute a singular element since "in many cases [the *menorah* appears] with other symbols next to it like a *shofar* (a ram's horn) or a palm branch."[6] Sukenik also drew the committee members' attention to the fact that The Jewish star is not a Jewish symbol and suggested to refrain from using "such a dubious symbol" on the State's emblem. Finally, the committee decided to turn to artists Ismar David, Francisca Baruch, Yerachmiel Schechter, and Oteh Walisch and ask for new sketches for the emblem.

On the fourth session, on September 29, David and Schechter submitted two sketches. Following discussions and changes, the committee agreed that one should include only a *menorah*, and the other would include a *shofar*, a palm branch, and the inscription *Shalom al Israel* (Peace Upon Israel) (fig. 7.4a).[16]

For the image of the *menorah*, David and Shechter used a model from the ancient Synagogue's mosaic floor, suggested by Sukenik (fig. 7.5).[7] What sets it apart from the *menorah* on the Arch of Titus is its base. On the Arch, the *menorah*'s seven branches stem from a base made of steps or chests. In most mosaic floor representations the base is a tripod, like the one on the Jericho Synagogue mosaic.

The *Shalom al Israel* inscription is taken from the last verse of Psalms: "Do good, O LORD, to those who are good, to those who are upright in heart. But those who turn to crooked ways the LORD will banish with the evildoers. Peace be upon Israel" (Psalms 125).

6 Ibid.
7 For a detailed discussion of the *menorah* images in ancient Jewish art see: Erwin Goodenough, *Jewish Symbols in the Greco-Roman Period*, Vol. VII, *Pagam Symbols in Judaism*, Pantheon Books, Bollingen Series, XXXVII, 1956; Steven Fine, *Sacred Realm, the Emergence of the Synagogue in the Ancient World*, New York and Oxford: Oxford University Press, 1996; Steven Fine, *The Menorah, from the Bible to Modern Israel*, Cambridge Massachusetts, London England: Harvard University Press, 2016.

FIGURE 7.4A
Ismar David and Yerachniel Schechter, *Proposal for Israel's National Emblem*, 1949 (first version)

FIGURE 7.5
Synagogue floor mosaic decoration, 6th century CE, Jericho

David and Shechter's proposal shows similarities to the model. However, they made several changes—they lengthened the *menorah*'s branches, sharpened their edges, and stylized the ancient Hebrew letters by making them more precise, proportional, and legible; they aligned the ram's horn and palm branch with the emblem's format. The most significant change in their proposal is the format itself; they discarded the circular shape of the Synagogue mosaic decoration and replaced it with an ancient seal-like elliptical contour. Such elliptical seals were common in ancient Judea unearthed during archeological excavations (fig. 7.6).

The *menorah* in David and Schechter's proposal points to a direct link with the People of Israel's past by quoting a visual model from a Synagogue that was regarded as a symbolic memory of the Temple in Jerusalem. Their proposal is therefore endowed with ritualistic-religious connotations, strengthened by the inclusion of the biblical verse. The seven stars appearing at the top of their

חותמות מביעים בכלים שנמצאו בארץ ישראל 208—205
ורשום בהם, למלך.

FIGURE 7.6
Seals unearthed in Palestine with the inscription "To the King"

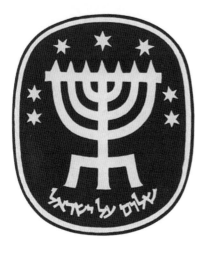

FIGURE 7.4B
David and Schechter, *Proposal for Israel's National Emblem*, 1949 (second version)

emblem symbolized Herzl's modern-liberal-secular concepts, accompanied by the state's aspirations for Peace.

The introduction of David and Schechter's second version attests to the struggle between the secular and the ritual-religious aspects of the emblem voiced by two factions of the committee members. Following their wishes, the second version contains all of the motifs mentioned above except the *shofar* and the palm branch (fig. 7.4b). The extent of the committee members' involvement in the decision-making process was expressed in the words of Pinchas Rosenblit, who informed the committee members that "[The voice of] the *shofar* always terrified me when I was a little boy." Consequently, he wished to omit the *shofar* image in the proposed emblem.[8] Rosenblit's claim is typical of a group within the committee members who tended to stress the future emblem's secular-modern aspect rather than emphasizing a ritual-religious one. They regarded the *menorah* motif as sufficient for conveying the symbolic

8 *Minutes of the Committee for the State's Flag and Emblem*, July 28, 1948, Israel State Archive, Unit 78, container 395, file 1005, 1.

tie with Jewish tradition. The obliteration of the palm branch and the *shofar* from the second version of the emblem manifests their detachment from the original decorative context; the logical link with ancient Synagogues is erased, and thus the second version becomes more secular.

The State Provisional Council met again on October 28 to re-examine David and Shechter's proposals. An honest reaction to the polarized religious-ritualistic versus secular-socialist symbolic components of the proposed emblems was Zerach Warhaftig's stance:

> If we were to be virtuous, we would have the two Tablets of the Law as our emblem ..., nevertheless, to my chagrin, when this proposal was brought to this meeting, I heard some people rightly say that such an emblem [showing the Tablets of the Law. A. M.] would be considered as coercive to some parts of Israeli society. Although the giving of the Law was a coercive occasion, an all-encompassing event forced upon the People of Israel, indeed this coercion was made by Heaven. Man is not supposed to coerce his fellow man. Consequently, I am willing to accept it ... with a slight change made in it. I believe that an emblem can not be renewed. Our state is ancient; we are merely renewing a state that existed in the past, we are not establishing a new state.[9]

Warhaftig suggested the authorization if David and Schechter's proposal with the removal of Herzl's stars, but a defense of the socialist connotations of Herz's stars was expressed by M. Mikunis of the Communist party:

> ... There are those who see in the seven stars seven hours of daily work in our country. I think that the entire council understands that we will work seven hours a day even without these stars ... It seems to me that if we were to allow freedom of action to our painters, they would not be tied to a two-thousand-year-old tradition ...[10]

One of the Jewish People's traits according to Mikunis' odd observation is its stubbornness, a trait that according to him could easily be symbolized by The Burning Bush motif. For the background of the emblem, he suggested an image of Israeli landscape and some sheaves of corn and perhaps a brick, standing for Israel's agriculture, industry, and building enterprises.

9 Ibid.
10 Ibid.

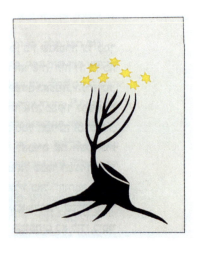

FIGURE 7.7
Nachshon, *Proposal for Israel's National Emblem*, 1948

The Committee for the State's Flag and Emblem asked several experts to assist in its decision-making process, serving as suppliers of visual models and aesthetic concepts. When it came to decisions concerning the nature of the proposed emblem, however, they were made solely by the committee members. Josef Shprintzak, chairman of The State Provisional Council, explained his attitude to the experts:

> We heard the suggestion made by the minister of transportation relating to Professor Sukenik's right of voicing himself here [...] we asked Professor Sukenik to attend this meeting ... However, at the house of the people's representatives, those who speak are only the elected and the members of this government. We cannot form a precedent that is liable to extend borders and make it possible for undesired elements enter this house [...] Professor Sukenik is here; if he desires to make any comments, he may do so in writing.[11]

Instead of the vote taken by The State Provisional Council, a new public tender was published in several daily newspapers, seeking new proposals for the state's emblem. The number of participants this time was 131, most showing the already familiar motifs of the *menorah*, Jewish star, and Herzl's seven stars. One proposal (fig. 7.7) shows an interesting combination of these motifs: a felled tree trunk symbolizing Death (a common visual

11 *Rashumot Moetzet haMdina haZmanit, haYeshiva ha'Asirit*, (Notes of the Provisional State Council, 10th Meeting), October 28, 1948, 10.

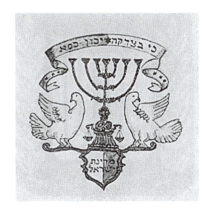

FIGURE 7.8
An unknown designer, *Proposal for Israel's National Emblem*, 1948

FIGURE 7.9
Dr. Solnik, *Proposal for Israel's National Emblem*, 1948

motif on Jewish tombstones) sprouting a fresh shoot whose branches grow in an amorphic shape resembling a *menorah*; its seven flames are Herzl's seven stars.

Another bid shows two doves flanking the *menorah* on each side (fig. 7.8). Its base functions as the symbolic scales of justice which would guide the path of the new state. The emblem is crowned by a band showing Herzl's seven stars and bearing an inscription in Hebrew: *Ki beTzedek Yikon Kisseh* (The Throne would be established with Justice).

Numerous proposals show a lion (fig. 7.9). One presents a majestic image of golden Lion of Judah on a blue and white background, topped by a crown with the Jewish star. Other proposals show the lion in various postures such as lion rampant, lion holding a *menorah* in one of its paws and a crouching lion (figs. 7.10, 7.11). An anonymous designer alluded to the state's aspirations for Peace (the two olive branches in the central heraldic shield format), to the Jewish aspect of the state (The Jewish star motif) and to its sovereignty (the lions). Herzl's seven stars take the form of flames on top of a crown. Twelve additional stars probably allude to The Twelve Tribes of Israel.

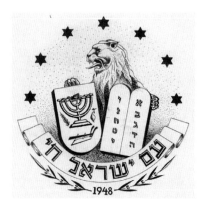

FIGURE 7.10
Unknown designer, *Proposal for Israel's National Emblem*, 1948

FIGURE 7.11 Unknown designer, *Proposal for Israel's National Emblem*, 1948

7.3 The Shamir Brothers Studio's Proposal

On December 28, the Flag and Emblem Committee decided that the sketches submitted by the Shamir Brothers Studio met most of the needs of the emblem. However, they requested some changes before resubmission in three versions.[12]

The format of the first sketch resubmitted by The Shamir Brothers studio is heraldic. The *menorah*'s branches are topped by Herzl's seven stars, and the candelabrum is flanked by stylized olive branches. In an interview with the press, artist Gavriel Shamir talked about the design process:

> ... After we decided to use a *menorah* [motif], we searched for additional [visual] elements. We chose olive branches since they make the most

12 *Minutes of the State Flag and Emblem Committee*, December 28, 1948.

beautiful expression for the love of peace among the People of Israel. The [olive] leaves constitute a very decorative element as well. Later on, we were faced with a problem: what form should the *menorah* be like? ... We then decided to design a stylized image for the *menorah*, refraining from basing its design on ancient models. Our intention was to create a modern emblem and to reject its traditional connotations. In our hearts, we felt that the *menorah* image, by nature, is an ancient symbol and that the mere fact that its image is included in the emblem is in itself a traditional element and that the *menorah* image should be modern.[13]

Indeed, the *menorah* designed by The Shamir Brothers Studio (fig. 7.12) is modern; its shape has no precedent in the long Jewish tradition. The branches are shaped as straight lines, drawn in a 90-degree angle as they stem from a straight central branch. The 90-degree angle differs from the traditional curve on the ancient prototypes. Its base is proportionally extremely small, making it seem unable to support the weight of its branches.

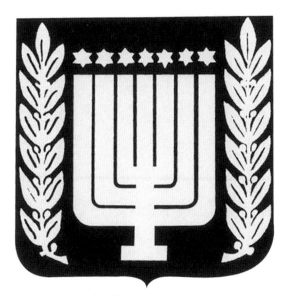

FIGURE 7.12 The Shamir Brothers Studio, *Proposal for Israel's National Emblem*, 1948 (first version)

13 A. P., "Kach Nolad Semel Medinat Israel" (This is how the Emblem of the State of Israel was Born), *Ma'ariv*, February 16, 1949.

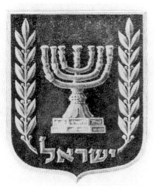

FIGURE 7.12A
The Shamir Brothers Studio, *Proposal for Israel's National Emblem*, 1948 (second version)

When members of the committee convened for the seventh time on January 10th, 1949, they examined the Shamir sketch; torn by doubts due to the modern shape of the *menorah* motif, even though it was so designed according to their own demands, they returned to the idea of shaping it according to ancient models. The one chosen was again taken from the Arch of Titus in Rome.[14] Finally, the committee decided to commission the Shamir Brothers to produce yet another sketch for the State's emblem; it was meant to include "The *menorah* [of the Arch of] Titus."[15]

On February 7th, 1949, the Shamir Brothers Studio presented the committee with two new sketches. The first included "The *menorah* from the Arch of Titus with two olive branches" (fig. 7.13); the second had "The *menorah* from the Arch of Titus with two olive branches and seven stars." On examination, the committee members decided to accept the first version—the *menorah* from the arch of Titus with two olive branches and the word Israel under the *menorah*. They planned to bring only this particular version for authorization by The State Provisional Council.[16]

At the 40th session of The State Provisional Council, on February 10th, 1949, the Shamir Brothers' proposal was accepted unanimously.

7.4 Prophet Zecharia's Vision: Harmony between State and Church

So far, the *menorah* and olive branches were related to as two separate visual motifs, joined together in an attempt to convey the complex message of Israel's

14 *Minutes of the State Flag and Emblem Committee*, January 10, 1949.
15 Ibid.
16 *Minutes of the State Flag and Emblem Committee*, February 7, 1949.

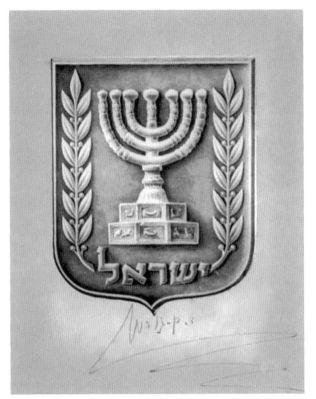

FIGURE 7.13 The Shamir Brothers Studio, *Final Version of a proposal for Israel's National Emblem*, 1949

vision in realizing the Zionist dream. The juxtaposition of the two, allegedly conceived by the Shamir Brothers Studio, does have precedents in the long history of Jewish visual images. In such visual representations the *menorah* and the olive branches are inseparable, presenting a single metaphoric motif whose source is a vision of prophet Zacharia, which took place about two years after the reinstitution of the sacrificial rituals at the Temple:

> And the angel that talked with me came again, and waked me, as a man that is wakened out of his sleep, And said unto me, What seest thou? And I said, I have looked, and behold a candlestick all *of* gold, with a bowl upon the top of it, and his seven lamps thereon, and seven pipes to the seven lamps, which *are* upon the top thereof: And two olive trees by it, one upon the right *side* of the bowl, and the other upon the left *side* thereof.... Then answered I, and said unto him, What *are* these two olive trees upon the right *side* of the candlestick and upon the left *side*

thereof? And I answered again, and said unto him, What *be these* two olive branches which through the two golden pipes empty the golden *oil* out of themselves? And he answered me and said, Knowest thou not what these *be*? And I said, No, my lord. Then said he, These *are* the two anointed ones, that stand by the Lord of the whole earth. (Zechariah 4, 1–3, 11–14).

Zacharia's vision is believed to be based on a real visual experience. The prophet allegedly saw a seven-branched candelabrum, accompanied by other ritual utensils of the Temple during its reinstatement in Jerusalem, as part of the Return to Zion In 521 BCE. The Temple's renovations involved erecting an altar, making sacrifices, importing cedars from Lebanon, and engaging stonemasons and craftsmen. For the first time in fifty years, the Israelites gathered in Jerusalem to celebrate the new Jewish year and reinstitute the high holidays rituals.

The prophet describes the *menorah* in detail; its top bowl (*gulah*), was probably meant to contain the oil which would be fed to the seven lamps. The two olive branches flanking the *menorah* allegorically supply the oil to the bowl. The self-flowing oil from the olive branches into the *menorah* alludes to the functions of the high priest, Yehoshua ben Jehotzadak, and the appointed political ruler, Zerubavel ben Shealtiel. Zacharia's vision tells of the *menorah*'s mysterious light, illuminating the interior of the Temple. The light passes from the interior of the building to the outdoors. The symbolic meaning of such light's movement was interpreted by Jewish scholars as God, guiding the People of Israel with His light. As a token of thanks, the People of Israel enkindles light and dedicates it to God. Consequently, the *menorah* symbolizes the Divine.[17] The two anointed ones are probably tubes or pipes, possessing occult, magical powers; they stand for the roles played by the high priest and the political ruler. The two feed the heavenly lampstand and are responsible for its safekeeping as well as the edifice in which it stands. Zacharia's vision endows the high priest and the political ruler functions with cosmic, mysterious values.[18]

[17] See: Goodenough, *Jewish Symbols in the Greco-Roman Period*, 90.
[18] Yechezkel Koyfman, *Toldot ha'Emuna haYisraelit miYemey Kedem ad Sof Bayit Sheni* (History of Israelite Belief from Ancient Times to the End of the Second Temple), Jerusalem and Tel Aviv: Mossad Bialik and Dvir Publication, 255.

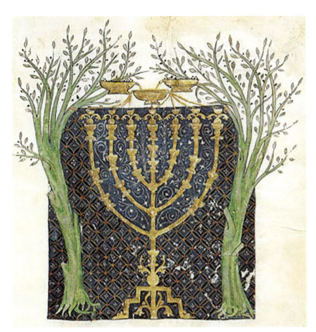

FIGURE 7.14 Yosef haTzarfati, *Vision of Prophet Zacharia* (carpet page from *The Cervera Bible*), 1300, illuminated manuscript

7.5 A Visual Precedent from 1300

Ever since the destruction of the Temple and throughout Jewish history, learned Jews were familiar with the symbolic connotations of the Temple *menorah* and the ritual utensils accompanying it. They were usually regarded as symbolic objects, representing the longing for the Messiah, who would rebuild the Temple upon his coming. An illuminated page from *The Cervera Bible*, a 14th-century manuscript, illustrates Zacharia's *Menorah Vision* (fig. 7.14). The message conveyed by such illustrations as Yosef HaTzarfati's stressed the eschatological aspects of both the *menorah* and the olive branches as images that express Jewish aspiration for the rebuilding of the Temple in Jerusalem when the Messiah comes.

Zacharia's vision occurred more than 600 years before the Shamir Brothers incorporated the motif in their version of the two elements appearing on the national emblem of the state of Israel. However, the symbolic reference to Zecharia's vision on the emblem is not mentioned in any of the minutes taken during the meetings of the Committee for the State Flag and Emblem, nor in the lengthy, detailed protocols that quote its members' speeches. Members

of the committee were so involved in philosophical discussions concerning the realization of the Zionist dream that they probably did not bother to present all of their ideas to The State Provisional Council. Referring to Zacharia's vision was probably discussed in one of the committee's last meetings; it was then dictated to the Shamir Brothers Studio without any detailed explanations.

About forty years after the official authorization of the Israeli national emblem I spoke to parliament member Zerach Warhaftig, who was one of the members of the Committee for the national Flag and Emblem. I presumed that he was the person who introduced the inclusion of the image of Zecharia's vision in the proposed emblem (see his reaction to David and Shechter's proposal mentioned above). When I asked him if I was correct in this assumption, his immediate answer was "Of course, why did you wait forty years to ask me that?" Warhaftig was surprised when I told him that no one took the trouble to document his suggestion. I also visited Gavriel Shamir of the Shamir Brothers studio; I brought with me a reproduction of Zecharia's *Menorah Vision* by Yosef HaTzarfati. Shamir looked at it with a smile and said that he never saw it before and that nobody ever told him about such an image.

The official emblem of the state of Israel appropriates Zacharia's vision and transforms it into a modern-day Zionist idea. The establishment of the modern Jewish state parallels the biblical Return to Zion in Zecharia's period. The pair of olive branches from the prophet's vision was regarded in 1949 as elements of extreme significance: in the new sovereign state of Israel: Church and State—represented by the two anointed ones, the high priest and the political ruler—stand side by side in the fulfillment of the Zionist dream.

7.6 Public Reactions to the Design of the National Emblem

Public reactions to the new emblem were swift in coming. Most critics were not familiar with its symbolic contents and referred primarily to its visual aspects. Two days after the official announcement, the new emblem was attacked by Gershon Schocken, editor of the daily *Haaretz*; he demanded that the emblem would be changed:

> This proposal ... is nothing but an atrocious thing from an aesthetic point of view. If this emblem would be displayed on the Provisional Council and soon enough on the various embassies of the state of Israel throughout the world, indeed, from a universal point of view, it would proclaim the government of Israel's and its legislators' lack of taste and lack of aesthetic culture.... The emblem's execution is vulgar and dilletante to such

an extent that no commercial firm that respects itself would have it as its trademark or logo ... The olive branches, purported to frame the heraldic format, are so large in size, and so rough, as to overshadow the *menorah* that is supposed to be the dominant element. The proportionally small *menorah* is squashed by the two enormous olive branches that look more like swords than leaves of the tree that stands for peace. The empty space above the *menorah* is extremely ugly; it testifies to the total incapability of the emblem's designers. The word Israel is written in such a typeface that shows the artisan's complete ignorance in matters of Hebrew typography. All of the above are squeezed into a poster-like format, like those used by prizes for winners of sportive competitions.[19]

Another reaction was made by Yitzhak Herzog, the chief rabbi of Israel: "The decision taken by our government is not good; once we are fortunate to behold the light of Zion anew, it is symbolized by the *menorah*, which, unfortunately, is an imitation of its image on the Arch of Titus. The latter shows that foreign hands made it...."[20]

A supportive reaction to the image of the *menorah* appropriated from the arch of Titus appeared in *Israele*, an Israeli daily newspaper published in Italian. The anonymous author admired the idea of the visual quotation and claimed that "After having symbolized for generations on end the Jewish People's exile, it [the *menorah*] symbolizes now the sovereign unity of the state of Israel which Titus thought he annihilated forever and ever." Contemplating the new emblem of the state, the author wrote that "The symbolic return of the *menorah* and its reinstatement on the state emblem, from which it would shine its light on the reinstituted Land of Israel, is indeed standing for the coming of a peaceful and just period for the state of Israel and for the entire world."[21]

Gavriel Talpir, the editor and publisher of the monthly literary *Gazit*, vehemently criticised the new emblem both for its design and for the archeological source it was modeled after:

> It should be mentioned here that The State Provisional Council's decision to authorize this emblem was made haphazardly, as if someone was

19 Gershon Schocken, "Semel haMdina o Te'udat Aniyut" (The State's Emblem or a Poor Certification), *Haaretz*, February 13, 1949.
20 Y. Herzog, "Tzurat haMenorah shebeSha'ar Titus" (The shape of the *menorah* on the Arch of Titus), in *Sefer haZikaron liShlomo S. Meir: Kovetz leToldot Yehudei Italia* (Memorial Book of Shlomo S. Meir: a Compilation on the History of Italian Jews), Milano and Jerusalem: 1957, 95–98.
21 *Israele*, XXXIV, February 24, 1949.

trying to sneak this thing and present it to the committee as a *fait accompli*. This is a scandal from public as well as a cultural point of view. It was always clear to us that we do not have a single symbol but the *menorah* to represent the whole nation in a most direct and obvious way, even though our state is not theocratic.... Are we lacking, when it comes to artists, who can shape the *menorah* anew?... Do we always have to revert to archeology, and moreover to that particular archaeology that is not ours? I wonder! Whoever suggested taking this *menorah* as a model, whoever was responsible for carrying out this rough work ... missed the point, not only in relation to good taste but first and foremost against Israeli history and against our present generation. It is true that archaeology was the state and its authorities' plague; it is time to renounce this illusion. We are compelled to create new values for the needs of the new state.

As for the olive branches—their nature is violent and rough. They are elevated with a kind of spite, that evokes a smell of Wilhelmine Germany ... the name Israel was carved in such a typeface as attesting to the ignorance of its creators.

By all means, the design and the execution of this emblem should be changed. It is not Israeli. It emanates a strong smell of the Gentiles.[22] Authorising the emblem in its present form is a badge of shame, not only for those responsible for its design but to all artists of this country, to all art institutions. If they still possess some kind of a sense of pride, they should all rise up in rebellion, write letters and memorandums to all the government members and for God's sake, have them change and correct the emblem.[23]

Despite the criticism thrown at it, it seems that the national emblem of the state of Israel makes a logical, well-conceived graphic design. It conveys a sophisticated, multi-faceted message, based on verbal metaphors, visual and textual models, and citations. Together, its small number of components—the *menorah*, olive branches and the inscription Israel—function and deliver the message faithfully, directly and concisely.

22 In his claim that the emblem "smells of the gentiles", Talpir is consistent with his ideas that Israeli visual culture should be based on Jewish art precedents. It is interesting to note that his comment is similar to the chief rabbi's.

23 Gavriel Talpir, "be'Eenyan haSemel" (Concerning the Emblem), *Gazit*, volume 10 June July 1949.

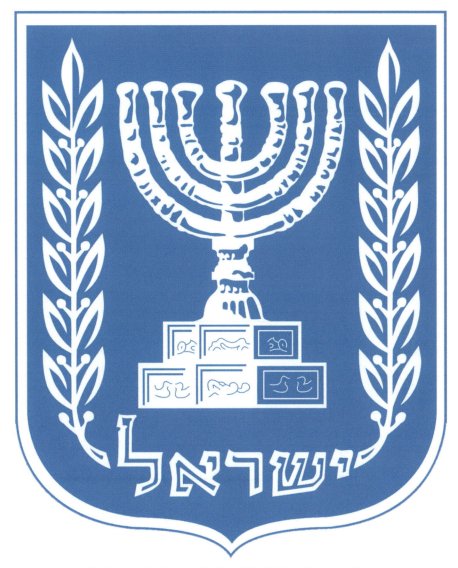

FIGURE 7.15 The Shamir Brothers Studio, *The official National Emblem of Israel*, 1949

The sophisticated message conveyed by the Israeli state emblem was never revealed to the Israeli public; not a single government office or department saw to its explanation, except for the official declaration of 1949. The lack of knowledge concerning the complicated process that led to its creation yielded short, generic, general official publications, such as the one distributed by the Israeli Foreign Ministry among Israeli embassies and consulates throughout the world:

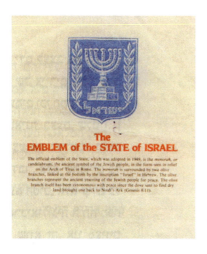

FIGURE 7.16
A brochure issued by Israel's Foreign Ministry explaining the symbolism of the State's official emblem

The official emblem of the State of Israel, adopted in 1949, is the *menorah* (or The Seven-Branched Candelabrum), the ancient symbol of the People of Israel, as it is depicted on the Arch of Titus in Rome. The *menorah* is flanked by two olive branches, crossing each other on the bottom of the frame and the inscription 'Israel' in Hebrew. The olive branches represent the Jewish People's ancient aspiration for Peace. The olive branch was a symbol of Peace since the dove, sent by Noah to tour the world for [dry] land has brought it to the ark (Genesis 8, 11). [fig. 7.17].

The lack of interest shown by Israeli official government offices in interpreting the message conveyed by the country's national emblem was joined by an apparent wish to assign to its components clerical-religious connotations (Noah's dove). Moreover, a closer look at the Shamir Brothers' final version for the emblem, published in 1949 (fig. 7.13) reveals the designers' faithful adherence to the Roman model, in which the base of the *menorah* is decorated with images of probably (before the deterioration of the relief throughout time) images of mythical creatures. A very similar depiction of such like decorations is known from several column base friezes at the Apollo Temple in Didyma (nowadays Turkey) (fig. 7.17).

In contrast, all Israeli official emblems, published and printed after 1949 until today, erased most traces of the Shamir Brothers' *menorah* base depictions in what seems like an attempt to free the Jewish state's national emblem of any trace of pagan graven images. Contemporary prints of the national emblem (fig. 7.15) show only abstract, linear, hard to recognize ambivalent images. The emblem's message, erroneously expressed by the official pamphlets, is, after all autocratic-religious; the reference made in it to a Genesis is false. The verses

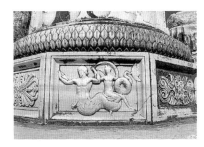

FIGURE 7.17
Column base frieze in the Temple of Apollo at Didyma, 4th century BCE

from Genesis were neither considered by any of the committee members who were responsible for its design process, nor by its artists and designers.[24]

Bibliography

A. P., "Kach Nolad Semel Medinat Israel" (This is how the Emblem of the State of Israel was Born), *Ma'ariv*, February 16, 1949.

Fine, Steven, *Sacred Realm, the Emergence of the Synagogue in the Ancient World*, New York and Oxford: Oxford University Press, 1996.

Fine, Steven, *The Menorah, from the Bible to Modern Israel*, Cambridge Massachusetts, London England: Harvard University Press, 2016.

Goodenough, Erwin, *Jewish Symbols in the Greco-Roman Period*, Vol. VII, *Pagan Symbols in Judaism*, Pantheon Books, Bollingen Series, XXXVII, 1956.

Herzog, Y., "Tzurat haMenorah shebeSha'ar Titus" (The shape of the *menorah* on the Arch of Titus), in *Sefer haZikaron liShlomo S. Meir: Kovetz leToldot Yehudei Italia* (Memorial Book of Shlomo S. Meir: a Compilation on the History of Italian Jews), Milano and Jerusalem: 1957.

Israele, XXXIV, February 1949.

Iton Rishmi, 50, 11.2.1949.

Koyfman, Yechezkel, *Toldot ha'Emuna ha:usraelit miYemey Kedem ad Sof Bayit Sheni* (History of Israelite Belief from Ancient Times to the End of the Second Temple), Jerusalem and Tel Aviv: Mossad Bialik and Dvir Publication.

Minutes of the Committee for the State's Flag and Emblem, Israel State Archive, Unit 78, container 395, file 1005.

24 Since the celebrations of Israel's 50th anniversary (1998), the contents of this chapter was quoted as the accepted interpretation of Israel's National Emblem. https://he.wikipedia.org/wiki/%D7%A1%D7%9E%D7%9C_%D7%9E%D7%93%D7%99%D7%A0%D7%AA_%D7%99%D7%A9%D7%A8%D7%90%D7%9C.

Rashumot Moetzet haMdina haZmanit, haYeshiva ha'Asirit, (Notes of the Provisional State Council, 10th Meeting), July 15, 1948.

Schocken, Gershon, "Semel haMdina o Te'udat Aniyut" (The State's Emblem or a Poor Certification), *Ha'aretz*, February 13, 1949.

Talpir, Gavriel, "be'Eenyan haSemel" (Concerning the Emblem), *Gazit*, volume 10 June July 1949.

CHAPTER 8

From Exile to Homeland: the Mythical Journey of the Temple Menorah

8.1 An Icon of Destruction

The Temple *menorah* portrayed in a narrative relief on the inner side of the Arch of Titus in Rome may be one of its earliest and most significant visual renderings. It turned into an expressive icon, a traditional Jewish symbol for the destruction of the Jerusalem Temple and the beginning of the Jewish Exile in the first century CE.[1]

Many legends had been associated with it, most of them telling that when the Messiah comes, the *menorah* will shine again and illuminate the rebuilt Temple in Jerusalem. A few years before the establishment of the State of Israel, these myths became the base for a popular symbolic concept. It secularized the *menorah*'s reappearance by claiming that its modern Return to Zion is analogous to its Messianic homecoming.

The story began in 81 CE when the Roman Senate erected a triumphal arch in the Forum to commemorate the military victories of Vespasian Caesar's son Titus. The contemporary historian Flavius left us a detailed testimony of Titus' Triumphal march in Rome:

> Now it is impossible to describe the multitude of the shews as they deserve; and the magnificence of them all: such indeed as a man could not easily think of ... For there was here to be seen a mighty quantity of silver, and gold, and ivory ... But what afforded the greatest surprise of all was the structure of the pageants that were borne along ... For many of them were so made, that they were on three or even four stories one above another ... And many resemblances of the war ... For there was to be seen an happy country laid waste; and entire squadrons of enemies

1 This chapter is a revised edition of "*leMi Triumph leMi Shirey Halel: Menorat haMikdash Chozeret hHabayta*" (Whose Triumph is it, whose Songs of Praise: The Temple *Menorah* Returns Home) in my book *Shuru Habitu u'Ru, Ikonot uSmalim Chazutiyim Tzioniyim baTarbut haIsraelit*, (Lo and Behold, Icons and Zionist Visual Symbols and Emblems in Israeli Culture), Tel Aviv: Am Oved Publication, 2000, 165–199.

slain; while some of them ran away, and some were carried into captivity: with walls of great altitude, and magnitude overthrown, and ruined by machines; with the strongest fortifications taken; and the walls of most populous cities upon the tops of hills seized on; and an army pouring itself within the walls …

Fire also sent upon temples was here represented; and houses overthrown, and falling upon their owners … On the top of every one of these pageants was placed the commander of the city that was taken; and the manner wherein he was taken …

But for those that were taken in the temple of Jerusalem, they made the greatest figure of them all…. The candlestick also, that was made of gold; though its construction were now changed from that which we made use of. For its middle shaft was fixed upon a basis, and the small branches were produced out of it to a great length: having the likeness of a trident in their position, and had every one a socket made of brass for a lamp at the tops of them. These lamps were in number seven; and represented the dignity of the number seven among the Jews …

After which Vespasian marched in the first place: and Titus followed him … For it was the Romans ancient custom to stay till some body brought the news, that the general of the enemy was slain. This general was Simon, the son of Gioras. A rope had also been put upon his head; and he had been drawn into a proper place in the forum … And the law of the Romans required, that malefactors condemned to die, should be slain there. Accordingly when it was related that there was an end of him, and all the people had set up a shout for joy … And as for some of the spectators, the Emperors entertained them at their own feast …[2]

8.2 The Arch of Titus: a Symbol of Destruction and Exile

While detailed and moving, Josephus' description cannot recount the event as expressively as the sculpted relief; the power of the visual record is much more significant due to its pictorial minimalism in conveying a direct message, and because of its accessibility. The Arch of Titus stands in an open urban space, familiar and available to all since the day it was erected. It is not surprising, then, that the arch itself and the relief represented on it turned into a

2 Josephus Flavius, *The Jewish Wars*. http://penelope.uchicago.edu/josephus/war-7.html.

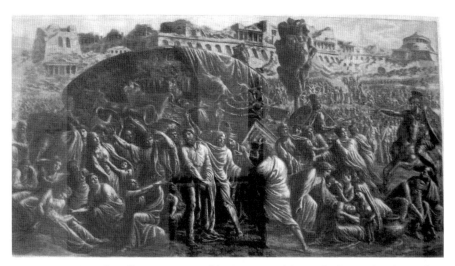

FIGURE 8.1 Luigi Ademollo, *Preparations of the Captives and the Spoils of War Taken during the Conquest of Jerusalem for Emperor Titus' Triumphal March in Rome*, ca. 1838, etching and aquatint print

traditional Jewish symbol for destruction and exile for hundreds of years up to the modern era. The Arch was a model for modern Christian visual rendering of its relief subject, since Christianity conceives of Titus' triumph over Judea as the victory of Christianity over Judaism.

Two 19th century prints describe in detail the preparation for Titus' triumphal march (fig. 8.1) and the event itself (fig. 8.2). Outside the city walls, a group of captives stands in front of a large pile of objects. Their gestures denote terror, agitation, and submission. On the right are the Roman soldiers who guard them. *The menorah* is just one of the various spoils of war; the Temple curtain is dropped on what may be identified as the *keeyor*, the massive copper basin from the Temple yard.

The inscription on the second print includes a quote from Luke (in Latin), recounting Jesus' visit to the Temple and a prophecy he tells his disciples about its destruction. "And they shall fall by the edge of the sword, and shall be led away captive into all nations: and Jerusalem shall be trodden down of the Gentiles, until the times of the Gentiles be fulfilled." (Luke 21, 24).

The large-scale image on the print is followed by two small pictures documenting the fate of the spoils of war after the march was over:

> Triumph of Titus, during which Simon Giora, head of the Zealots was condemned to death. The Book of the Law and the curtain of the Temple

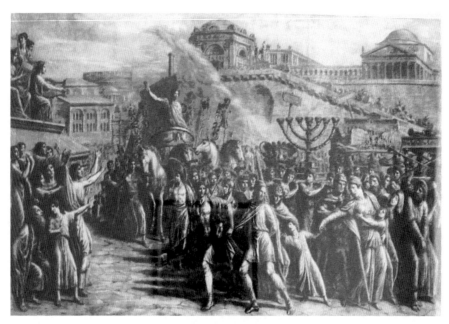

FIGURE 8.2 Luigi Ademollo, *Emperor Titus' Triumphal March in Rome after the Destruction of Jerusalem*, ca. 1838, etching and aquatint print

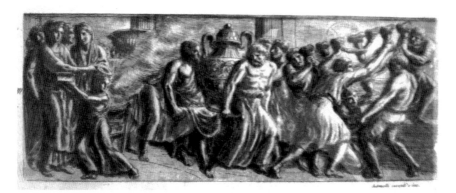

FIGURE 8.2A Luigi Ademollo, *Emperor Titus' Triumphal March in Rome after the Destruction of Jerusalem*, detail, *The Candelabrum Brought into the Temple of Peace*

were placed in the Palatine Library, the altars, and the Candelabrum in the Temple of Peace.[3]

3 "*Trionfo di Tito, in cui fu posto a morte Simone Giora, capo degli Zalutori. Il volume della Legge ed il Velo del Tempio furano posti nella Biblioteca Palatina l'ari ed il Candelabro nel Tempio della Pace.*"

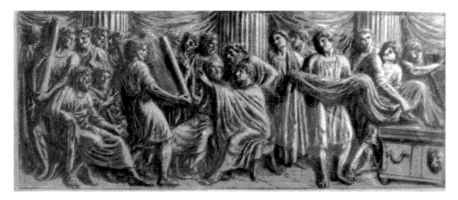

FIGURE 8.2B Luigi Ademollo, *Emperor Titus' Triumphal March in Rome after the Destruction of Jerusalem*, detail, *The Book of the Law and the Temple Curtain put in the Palatine Library*

The image on the left shows the Temple curtain[4] brought to the Palatine Library; the right shows the *menorah* brought to the Temple of Peace.

Jewish representations of the Temple *menorah* in the ancient world, usually on Synagogue mosaic floors and in medieval manuscripts, conveyed nostalgic as well as messianic messages.[5] Visual portrayals of the Temple utensils in Jewish culture presented them as symbols for the future coming of the Messiah. In contrast, the specific design of the *menorah* from the Arch of Titus was never repeated in Jewish visual renderings of the *menorah*. In Jewish tradition it does not carry any messianic connotations; it is an icon that stands only for destruction.

The ideas of destruction and exile associated with the *menorah* may explain its widespread inclusion in modern images of *The Ninth of Ab*, the date of the destruction of the Temple in Jerusalem.

The central image in an illustration by Ze'ev Raban[6] (fig. 8.3) shows the Wailing Wall, the only surviving element of the Herodian Temple, with people praying next to it on the Ninth of Ab. At the bottom of the illustration, the

4 The curtain is also a significant symbolic object of the Jerusalem Temple as it was mentioned on Matthew's description of Jesus dying on the cross: "And, behold, the veil of the temple was rent in twain from the top to the bottom; and the earth did quake, and the rocks rent" (Matthew 27, 51).
5 Steven Fine, *Sacred Realm, the Emergence of the Synagogue in the Ancient World*, New York and Oxford: Oxford University Press, 1996; Bezalel Narkis (Foreword by Cecil Roth), *Hebrew Illuminated Manuscripts*, Jerusalem: Keter Publishing House, 1969.
6 Ze'ev Raban and Avi-Shai, *Chageynu* (Our Holidays), New York: Miller Lynn Publications (undated, 1920s).

FIGURE 8.3 Ze'ev Raban, *Tish'ah be'Av* (The ninth of Ab), illustration in *Chageynu* (Our Holidays), 1920s, New York, Miller Lynn Publications

artist included two silhouettes, representing the Jewish captives led to Rome. On the right, the figures' gestures denote frenzied mourning caused by their inability to cope with the tragic event. On the left, the *menorah* is carried by men on their shoulders, a visual paraphrase of the sculpted relief on the Arch of Titus.

The Messianic connotations ascribed to the Temple *menorah* were developed and extended in modern Zionist legends. Most popular of these was *The Hidden Menorah*, a story written by Stefan Zweig and translated into Hebrew.[7] Zweig recounts the history of the *menorah* brought to Rome by Titus. Three hundred years later, when the Vandals pillaged the city, the Jews of Rome tried to prevent the conquerors from seizing the *menorah* as spoils of war, but their efforts were in vain; it was taken to Carthage. In the following century, the *menorah* was found in Byzantium. The Jews of that city had an audience with Emperor Justinian and asked to redeem it. One of the Jewish elders warned the Emperor that the only way he would be saved from danger was to return the *menorah* to Jerusalem. Justinian commanded his servants to do

7 Stefan Zweig, *The Hidden Menorah*, translated into Hebrew by Israel Fishman, Tel-Aviv: Yoseph Shrebrek Publication, 1944.

so and ordered, as a precaution, that it should be put there under the altar of the church built by Empress Theodora. In the meantime, Zerubbabel, a Jewish silversmith, made a copy of the *menorah* and kept the original at home. At the time the copy was sent to Jerusalem by the Emperor, the real *menorah* was placed in a coffin and shipped to the Holy Land. It arrived at the port of Jaffa and was carried to Jerusalem, there to be placed in a tomb, whose whereabouts are unknown. Since then, the *menorah* is waiting to be redeemed by the Jewish people. Zweig's story ends as follows:

> … And thus years and generations pass, and no one knows, and no one speaks of the *menorah*'s destiny. Will it be hidden forever and lost to its ever wandering people in the lands of the Gentiles, or will it rise from the darkness of its grave, on the day the rejected people of Judah return to their land? Will it then shine its precious light in the Palace of Peace?[8]

During the Second World War, the Arch of Titus and its sculpted *menorah* acquired new symbolic Jewish connotations. A parallel was drawn between the Roman act of destruction and the Nazi destruction of Jewish communities throughout Europe. The Jewish National Fund issued a series of stamps in 1942, expressing this idea. The stamps illustrate Jewish monuments, public institutions of Jewish communities throughout Europe, and reproductions of artworks by Jewish artists. The sites shown include, among others, the Yoseph Ibn Shushan Synagogue in Toledo, Theodor Herzl's Tomb in Vienna, and the Great Synagogue in Rome. Surprisingly, the series includes an image of the Arch of Titus in Rome (fig. 8.4). Its inclusion is odd since it has nothing in common with the other monuments in the series. The reason for the inclusion was probably its powerful, timeless symbolism of destruction and humiliation.

8.3 "Oh Titus, Titus, If You Could Only See!"

By the end of the Second World War, the Jewish symbolic connotations attributed to the Arch of Titus were reversed: from an image designating destruction, humiliation, and disgrace, it turned into a symbol for rising, revival, and triumph. Popular myths, typical of the *yishuv*, regarded it as an element in which Zionist ideas of Liberty and Revival contrast with those of defeat and destruction of contemporary European Jewish communities. The Jewish population in Palestine regarded the soldiers of the Jewish Brigade as the

8 Ibid., 102.

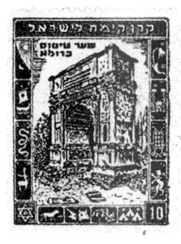

FIGURE 8.4
The Arch of Titus, 1942, stamp from The *Diaspora* series, issued by the Jewish National Fund, 1942

descendants of the Hasmonean warriors, emissaries to Europe from Palestine and witnesses of the victory over Fascism, assisting their Jewish brethren in the long process of coming home.

The symbolic role played by the Arch of Titus is best expressed in *Kol haDrachim hen Movilot leRoma* (All roads lead to Rome), a popular song written by poet Yitzhak, and performed by The Entertainment Troupe of The Jewish Brigade in the late 1940s. It tells of a male and female Jewish soldiers from *Emek Yizrael* (The Jezreel Valey) strolling in Rome at night. They arrive at the Arch of Titus, and there they mock the Emperor's triumph, which they claim to be obsolete. They behold the fall of modern Fascist Rome and by contrast, contemplate upon the eternity of the Jewish People:

> All roads lead to Rome
> Therefore, girl, one should not despair
> All roads lead to Rome
> So we shall meet there someday.
> We will stroll
> Under the Cathedral's shadow,
> St. Peter's square of the Vatican.
> The Pope and his cardinals
> Won't have a clue that we are here.
> Two people in love,
> Two *Sabras* from Canaan,
> Ruth and Amnon from *Emek Yizrael*.
> Taking a stroll, never done before,

> To the Arch of Titus at midnight.
> Under the arch, in the shadow of ruins
> Kisses would bloom
> What are we waiting for?
> Oh Titus, if you could only see
> Whose triumph is it? Who is the man
> Of those hymns of praise!
> Next to the arch you have erected
> Stand two people in love from *Eretz Israel*
> Two soldiers—just to spite—from *Eretz Israel.*

And thus the circle was closed. Initially, the Arch of Titus symbolized the beginning of the exile for the Jewish people. In the late 1940s, it metamorphosed into a symbol of the exile's end.

8.4 The *Menorah* Returns Home

The popular symbolism of the late 1940s endowed the Titus' *menorah* with a new ending: it would be miraculously removed from the Arch in Rome and brought back to the Land of Israel by messengers of the Jewish People. The innovative symbolism is the return home not with the help of the Messiah, but the messengers who would gather secular Jewish People from the exile. The *menorah* returning home is not just any seven-branched candelabrum but specifically the one sculpted in relief on the Arch of Titus in Rome.

Artist Arieh Allweil (1901–1967) made an early visual portrayal of *The Menorah Returns Home* motif. "Egypt" in *On the Way to the Liberated Jerusalem* (fig. 8.5) has become ... the narrow path in which the Jews walked in the Diaspora, a path which turned, during the Nazi slaughter years, into a dead-end from which, apparently, there was no escape.[9] Allweil's lost his entire family in that "Egypt." M. Lask's text, accompanying this illustration, points to the central symbolic ideas referred to by the artist:

> What is the meaning of the State of Israel's Declaration of Independence? We feel as if the Temple utensils, petrified in the relief on the Arch of Titus in Rome, are reincarnated. The Temple's holy utensils are returning to Jerusalem. A soldier of the Israeli Defense Forces marches on, carrying not a weapon, but rather the Temple *menorah*. He is followed by

9 Max Brod, I. M. Lask, *Allweil,* Tel-Aviv: Sinai Publication, 1956 (unpaged).

FIGURE 8.5 Arieh Allweil, *On the Way to Liberated Jerusalem*, 1949, illustration in a *Passover Haggadah*, tempera on paper

many others, who came from the Seven Seas and from the Four Cardinal Directions to assist him. They are marching towards Jerusalem where they would find other Israeli soldiers guarding the city against siege and bombardments, during which women and children seek shelter from danger.[10]

Israeli artist Aba Fenichel (1906–1986) published a caricature in which *The Menorah Returns Home* motif is given its most direct visual expression (fig. 8.6). It shows how Jews from different countries in the Diaspora removed it from the Arch of Titus, put it on their shoulders and went on their way to return it to Jerusalem.

10 *Allweil*, 71–75.

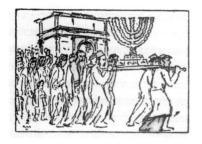

FIGURE 8.6
Aba Fenichel, *The Temple Menorah Returns Home*, 1950, caricature published in *Ha'aretz* daily paper

8.5 A Miraculous Translocation

The Menorah Returns Home motif involves a conceptual act of transformation or translocation: the object is metaphorically removed from the arch and is being transported to a different site. The transfer of a ritual object—whether physically or allegorically—is a common phenomenon in Western culture. Throughout history, many acts of shifting objects from one site to another were charged with ritual or political connotations. The most relevant example in this respect is the actual relocation of the Temple *menorah* and the other Temple utensils from Jerusalem to Rome, as spoils of war, into the realm of the victorious conqueror.

In 1798, Paris repeated Titus's transportation act: the procession of the *Fête de la liberté* (The Feast of Liberty) marched in the streets of Paris, exhibiting works of art brought from Italy as war trophies by Napoleon's army. The pillaged artworks manifested a twofold authority: cultural and political. It celebrated a symbolic unification of the ancient world's politics and art, causing Rome to relocate to 19th century Paris.

Such miraculous moves are known in Christian lore as well. The Holy House (*La Santa Casa*), the family house of Jesus, is believed to be transported on angels wings from Nazareth to Loretto in Italy in 1291. The myth aimed at the development of Loretto as a pilgrimage site.[11]

The Temple *menorah*'s return constitutes a conceptual-metaphoric relocation of its sculpted *image* back to its homeland through visual citations in works of art. It maintains that as long as the act is merely conceptual-mythical, it does not clash with the Jewish belief that the only entity assigned to bring it back to Jerusalem physically is the Messiah.

11 David Friedberg, *The Power of Images, Studies in the History and Theory of Response*, Chicago and London: The University of Chicago Press, 1989, 309–310.

When the state of Israel celebrated its eighth's anniversary, this vital principle was either forgotten or disregarded. In 1956, a huge bronze *menorah*, weighing more than four tons, was hurled on the waters of the Mediterranean, sealed in a large wooden box, making its way to Jerusalem inside the hull of the Israeli ship *Rimon*.

8.6 A Gift from the Mother of Parliaments to the New Israeli Parliament

A group of representatives of the two Houses of the British Parliament visited Israel in the spring of 1951. Upon their return to England, Lord Samuel (son of Herbert Samuel, the first British High Commissioner of Palestine and one of the delegation members), suggested "To express the admiration of the British Parliament, its homage and its warm, long going friendship with the new State of Israel, to its people and to its entire *Knesset* [Parliament]"[12] by presenting it with a symbolic gift. The nature of the gift was probably suggested by Lord Samuel himself and by the British artist Benno Elkan (1877–1960).[13] The future gift was to be a large-sized bronze *menorah*, covered by a series of reliefs meant to represent the essence of Jewish history from the biblical period to 1948 (fig. 8.7).

Five years elapsed between the inception of the gift idea and its creation and shipment to Jerusalem. From the outset, those responsible for the project were confronted with difficulties. First, the project demanded substantial funds. Second, they feared that the Israeli clerical-religious parties would disqualify it, or create obstacles and prohibitions because of its ritual-symbolic aspects. Solving the financial problems was not hard; patrons were found in abundance. However, the fear of the clerical parties was justified and entailed great difficulties. The project that began as a symbolic goodwill gesture of the

12 *Speech of Clement Davies, MP, at the Presentation of the Knesset Menorah to the Israeli Knesset*, April 15th, 1956, The Israeli Knesset Archive, file 557, box 16.

13 Elkan was born in Germany. He studied at the Munich Academy and was greatly influenced by Renaissance portraiture. He moved to Paris and lived there for eight years. Later on he returned to Germany and created mainly portraits. After the First World War, he resided in Frankfurt and was known for his War Memorials. In the early 1930s he was working on a large bronze candelabrum intended for a church. In 1933, after the Nazis ascent to power, he fled to Britain, bringing along with him the unfinished candelabrum. See: Karl Schwartz, *Jewish Sculptors of the 19th and 20th Centuries*, New York: Philosophical Library, 1949, 128–132.

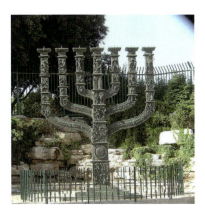

FIGURE 8.7
Benno Elkan, *The Knesset Menorah*, 1956, bronze, Jerusalem, garden of the *Knesset*

British Parliament became so complicated as to necessitate the involvement of several public figures from all over the world.[14]

The first to express his fear of the Jewish clerical establishment's reaction was Alec Lerner, MP. His letter to Lord Samuel speaks for itself:

> ... While spending my holiday in Israel, I thought a good deal about the character of the gift; I confess to a certain uneasiness I have in mind: the biblical injunction against the making or use of graven images. Orthodox Jews take this prohibition very seriously, and I wonder whether we are right in assuming that the gift would be acceptable by the *Knesset*.
>
> ... The *menorah* has human faces and figures carved on it in various degrees of relief ... The orthodox party in Israel is one of the strongest single parties in the country, and it would be most embarrassing for us if a gift intended as a token of goodwill should be either rejected outright or else become a cause for dispute between parliamentary parties in the *Knesset*.[15]

14 The English protagonists were Lord Samuel, Benno Elkan (the sculptor), David Hilman, the Israeli chief rabbi's brother in law and Clement Davis, Chairman of the British House of Representatives. In the United States the person involved with the project was Steven Keiser, curator of The Jewish Theological Seminary of America's Jewish Museum in New York. In Israel, those who pulled the strings were Eliyahu Eilat, Israel's Ambassador to Britain, Joseph Shprintzak, Chairman of the *Knesset*, Moshe Rosetti, secretary of the *Knesset*, rabbi Herzog, chief rabbi of Israel, Mordechai Ish-Shalom, deputy mayor of Jerusalem and Mr. Hatozr, officer of the *Knesset*.

15 *Letter from Alec Lerner to Lord Samuel, dated September 10th, 1951*, The Israeli Knesset Archive. Lord Samuel passed Lerner's letter to Eliahu Eilat, Israeli Ambassador to Britain and asked for his advice. See: *a Letter from Lord Samuel to Eliahu Eilat* September 11th, 1951,

The fear of the clerical parties cast its shadow on Elkan while designing the reliefs for his *menorah*, so he turned to a Jewish art expert for advice. Stephen Kaiser, the curator at The Jewish Theological Seminary of America's Jewish Museum, assured the artist that his proposed reliefs would be acceptable. Elkan sent a photograph of his sketches, and they were given to Rabbi Herzog, the chief rabbi of Israel. Herzog posed the following questions:

a. Are the figures in the relief to be depicted in the nude?
b. Are they facing the spectators or are they turning their backs on them?
c. What is the size of the reliefs' protrusion from the background? Are the figures engulfed by the sculptural construction?

The rabbi added that he would pass judgment on the complex issue only upon receiving the proper answers to his questions,[16] that they should be presented to him in English, and be written by no other person than his brother in law, so "that no mistakes may occur."[17]

Two months later, Lord Samuel received the chief rabbi's first answer. It included the following proclamation:

> [I will] put all my efforts in trying to find a way of making it [the *menorah*] permissible from the standpoint of our [Jewish] law, but I cannot absolutely promise to do that.... I am aware, of course, of the seriousness of the matter in the event of taking a negative decision and this [thought] makes me apply strenuous mental efforts [into the matter].[18]

With a gentleman's sensitivity, Lord Samuel postponed passing the chief rabbi's answer to Elkan, fearing that it would sadden the artist or even affect his frail health. In a letter he wrote to the Secretary of the *Knesset* Samuel revealed his fears:

> ... The project has already suffered a year's delay, mainly caused by the chief rabbi's doubts and procrastination.... The result could hardly fail

The Israeli Knesset Archive. Eilat sent the two letters to Joseph Shprintzak, Chairman of the Knesset. See: *A Letter from Eliahu Eilat to Joseph Shprintzak* September 20th, 1951, The Israeli Knesset Archive.

16 *Letter to Eliahu Eilat from Moshe Rosetti, Secretary of the Knesset* December 31st, 1951, *The Israeli Knesset Archive.* In his letter Rabbi Herzog explained that the issue at hand is a candelabrum and not a *chanukia* (a Hanuka menorah) and therefore it does not require containers for oil or for candles.

17 Ibid.

18 *A Letter from the Chief Rabbi of Israel to Lord Samuel dated October 24th 1952*, The Israeli Knesset Archive.

to lead to controversy both here and in Israel. It might indeed contribute to something in the nature of a *Kulturkampf* [culture war] against clerical interference in a matter which relates not to any Synagogue or other ecclesiastical edifices, but to the Parliament House of the People of Israel.[19]

After all these struggles and delays, the Israeli Parliament ignored the chief rabbi of Israel's advice. The unveiling of the *Knesset Menorah* took place in Jerusalem: thousands of Jerusalemites crowded the sidewalks and stood on roofs and balconies in the vicinity of the *Knesset* building on King George Street. The *menorah* was installed on a special platform. Fluttering in the wind in front of it were the flags of Israel and Britain, accompanied by several other Israeli flags at half mast, honoring Memorial Day and the Fallen.[20] The British Parliament was represented by Mr. Clement Davies. In his festive speech he said the following:

> ... We, in Parliament ... were mindful of many events, occasions and incidents in which the history of the British People and the history of the Jewish People were intermingled and entwined ... Mr. Speaker, this *menorah* is itself a further pledge from Members of the British Parliament of our firmly held notion, that the State of Israel is a living State, which does, and shall ever continue, to hold an honorary place among the Nations of the World.... We sincerely, humbly, fervently but most hopefully pray that from this Eternal City of Jerusalem, set upon a hill, the light will shine on the People of this Holy Land and through them, upon the Peoples of the whole world.[21]

Joseph Shprintzak followed the British representative speech and said the following:

> It is with great love and appreciation that we accept the *menorah* by Elkin [sic] ... We accept this *menorah* as a gift of Zionist Britain [a country] in which, at various periods of time, [lived] visionary people, noble of spirit and ideas—sons of Britain, who were among the announcers

19 *A Letter from Lord Samuel to Moshe Rosetti dated October 29th, 1952*, The Israeli Knesset Archive.
20 "The Huge *Menorah* was presented—the gift of the British Parliament to the *Knesset*", *Haaretz*, April 6th 1956.
21 Ibid.

of the Revival of [the People of] Israel and encouraged it[22] …, The *menorah* would be placed, for the time being, in the heart of Jerusalem, as a memorial for the friendship between Zionist Britain and the State of Israel. Congratulations for those who initiated it and blessings to our brother Benno Elkin [sic] the creator of this *menorah*.[23]

The two Houses of the British Parliament, who had conceived this gift for the young Israeli parliament, were not acknowledged, nor were they thanked in the speech delivered by the Speaker of the House of the Israeli *Knesset*. The gift, according to Shprintzak, was given to the Israeli Parliament by its British Zionist brethren and not by the entire British People, and its house of representatives.

The ceremony that took place on King George Street in Jerusalem was accompanied by sounds of the British national anthem, *Hatikva*, Israel's national anthem, the screeching sounds of sirens announcing the end of the Memorial Day, and finally by hallowed silence. The spectators could not see the *Menorah* very well, or examine its details. The clouds of pathos that engulfed the unveiling masked the object's sculptural details.

The first to weave the quasi-cosmic setting for the *menorah* was the sculptor himself. From the moment his fingers touched the crude clay from which he was to mold the *Knesset Menorah*, Benno Elkan felt that he was charged with a twofold mission: As a Jew, he felt charged with, as he himself put it, "The first materialization of Jewish History in its entirety." As a Universal man, he regarded his sculptural work as a complex, unprecedented piece in the history of art. Elkan's megalomania led him into fostering an extraordinary conviction and his strong, persistent will engaged no less than two Houses of Parliament, rabbis, and several other dignitaries.

8.7 Benno Elkan: a Self-Anointed Modern Bezalel

In a letter to Moshe Rosetti, Secretary of the *Knesset* Elkan wrote the following:

> … Some time ago, someone wrote to me about the *menorah* and the future role it is bound to play. People go to Rome to see the Sistine Chapel, [they

[22] Shprintzak mentioned Benjamin D'Israeli (who was not Jewish when he was Britain's prime minister), Lord Balfour and Josiah Wedgewood.

[23] *Speech of the Israeli Knesset Chairman, Mr. Joseph Shprintzak at the Presentation of the Menorah, April 15th, 1956*, The Israeli Knesset Archive.

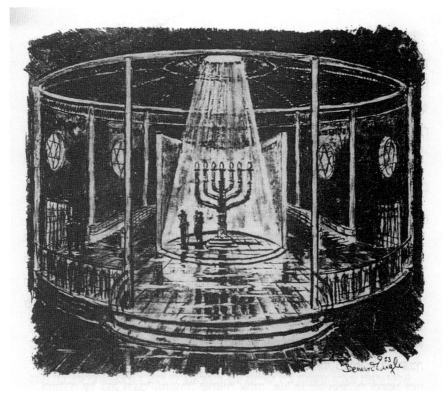

FIGURE 8.8 Bernard Engel, *Sketch showing the proposed future installation of Elkan's Knesset Menorah*, 1954

go] to Paris for the admirable statue of the Milo Venus, [they travel] to Florence for the Doors of the baptistery by Ghiberti—and finally—[they go] to Jerusalem to see the Great *menorah* on Zion hill.[24]

The heroic, miraculous characteristics of the object and its virtuosity of execution made Elkan worry about the way it should be exhibited. He demanded that his *menorah* should be installed *inside* the *Knesset* building, not outside in the garden. A sketch in the brochure presented to The Menorah Fund Committee (fig. 8.8) shows the setting in which the *Knesset Menorah* was meant to be installed: the lobby of the future building, a semi-darkened interior space in which the *menorah* would be lit by a dramatic beam of light shining upon it from above.

24 *A Letter from Benno Elkan to Moshe Rosetti, Secretary of the Knesset* dated January 28th 1957, The Israeli Knesset Archive.

The quality of genius that Elkan had assigned himself gave birth to a sense of mission, bestowed upon him by mystical forces commanding him to become the modern follower of Lorenzo Ghiberti. Being Jewish and a fugitive of the Nazi regime convinced him that he was the follower of Bezalel Ben Uri, the biblical first Hebrew artist, designer of the Tabernacle and its utensils.

8.7.1 Links in a Chain: Candelabras in Milan Cathedral, Westminster Abbey and the Parliament of Israel

The brochure distributed to the members of The Menorah Committee (and to the potential supporters of the *Menorah* project) opened with the following lines: "The external measurements of the *Menorah* are height: 14 feet, width: 12 feet. It is a little larger than the candelabrum of the Milan Cathedral (fig. 8.10)."[25] One may wonder about the possible link between the Milan Cathedral and a modern *menorah*, designated as a Zionist symbol for the Israeli House of legislators. It would become clear if one returns to Elkan's career as a sculptor.

When he fled from Nazi Germany to London in 1933, Elkan brought with him an unfinished Church candelabrum. There he found a patron who helped him to finance the finishing of the work and made the right connections with Westminster Abbey. Eventually, Elkan's Seven Branched Candelabrum was purchased for Westminster Abbey. Through the Seven Branched Candelabrum, the Christian Church aspired to stress its direct link to Solomon's Temple in Jerusalem. It regarded itself as its new metaphoric manifestation, a perfect representation of Solomon's Temple. As early as the fourth century, Christian theologians regarded the Solomon Temple as a perfect example for every future ritual edifice.[26] The design process of a candelabrum, assigned for a Church, was based on biblical texts, relating to the form of the *menorah*, and on a specific visual model—the relief on the Arch of Titus in Rome. During the Middle-ages, Christian theologians linked the Seven Branched Candelabrum with the symbolic ancestral tree of Jesus, portraying the concept taken from the book of Isaiah:

> And there shall come forth a rod out of the stem of Jesse, and a Branch shall grow out of his roots: And the spirit of the LORD shall rest upon him, the spirit of wisdom and understanding, the spirit of counsel and might, the spirit of knowledge and of the fear of the LORD; (Isaiah 11, 1–2).

25 *The Menorah Fund Committee, British Gift to Israel*, 1954, The Israeli Knesset Archive. On the *menorah* in Milan Cathedral see: Silvio Leydi, "The Trivulzio Candelabrum in the Sixteenth Century: Documents and Hypotheses", *The Burlington Magazine*, CLIII, January 2011, 4–12.

26 Peter Bloch, "Seven Branched Candelabra in Christian Churches", *Journal of Jewish Art*, Chicago: Spertus College of Judaica Press, 1974, p. 46.

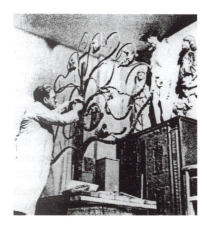

FIGURE 8.9
Sculptor Benno Elkan working on *The New Testament Candelabrum*, 1940

FIGURE 8.9A
Benno Elkan, A Sketch for *The Old Testament Candelabrum*

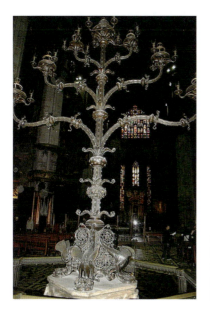

FIGURE 8.10
The Trivulzio candelabrum, c. 1200, with additions of the mid-sixteenth century, bronze with inlaid gemstones, approx. 5 by 4 m, St. Mary of the Wood Chapel, Milan Cathedral

FIGURE 8.11
Two types of the seven-branched candelabrum

The verses from Isaiah, announcing the coming of a Messiah from the House of David, were included in medieval Christian paintings as a schematic family tree. Many show Jesse, David's father, reclining on the ground, a tree growing from his loins. The ends of the tree branches in these illustrations are usually crowned with portraits of Jesus' forefathers, including King David and the prophets Isaiah and Jeremiah, and Mary and Jesus top the tree. Another association was assigned to the seven branches of the *menorah*: they stand for the Seven Gifts of the Holy Ghost.[27] The affinity to Solomon's Temple, Jesus's family tree, and the Seven Gifts of the Holy Ghost are bound together to form the Christian concept that makes the seven-branched candelabrum into a perfect symbol of the Christian Church.

Elkan's candelabra,[28] made for Westminster Abbey, are based on a crossbreeding between the seven branches and the genealogy tree (fig. 8.9). The shape of their branches/stems is relevant to the later *menorah* made by the artist for the Israeli *Knesset*. Most visual depictions of the Temple *menorah* follow the shape of the stems appearing on the Arch of Titus in Rome; they are shaped like three half circles crossing a vertical, straight stem (fig. 8.11 left). In contrast, Elkan's Christian branches/stems grow from the central stem, as arcs curving downwards (at the crossing point with the vertical stem) and then upwards (fig. 8.11 right). The artist himself called his candelabra trees: "Thirty-two types from the Old Testament, prophets, fighters, kings and heroines, distinguished teachers, small people are to be found in between the tree branches [...]."[29] It is this concept of the candelabrum that Elkan recycled in his *Knesset Menorah* design; its branches stem from the central stem in a likewise fashion (fig. 8.7).

27 The gifts are based on the verses from Isaiah: Wisdom (*Sapientia*), Intellect (*Intellectus*), Counsel (*Consilium*), Heroism (*Fortitudo*), Knowledge (*Cognitionis*), Fear (*Timor*). To the six mentioned in the Bible a seventh was added: *Pieta* (Piety and Mercy).

28 Elkan made two candelabra for Westminster Abbey; one is called "The Great Menorah of the Old Testament" and the other "The Great Menorah of the New Testament." Figures from the two sources appear on them accordingly.

29 *Westminster Abbey: The Great Candelabrum of the Old Testament* (a brochure from the early 1950s), The Israeli Knesset Archive.

8.7.2 A Modular Iconographic System

Biblical figures constitute essential elements of iconographic systems in Christian art; they present artists and theologians with a modular range for expressing the message the work is supposed to convey. Each biblical figure is known for several traits; Moses may convey the traits of a leader in one work of art and symbolize the law-giver in another. Therefore, when Elkan planned his iconographic system for the *Knesset Menorah* with the intent of conveying the history of the Jewish Nation, he had the option of recycling his chosen biblical figures in an entirely different iconographic plan—the forefathers of Jesus. Indeed he testified to the fact that in the grouping of his figures and the scenes they represent on the *Knesset Menorah* "... Are intentionally dispersed, without chronological order, each relief on one of the left stems is echoed by a relief on one on the right by a different aspect of the same theme."[30]

8.7.3 Concise Rendering of Alleged Jewish History

Elkan's twenty-nine reliefs on the *Knesset Menorah* exhibit the following images:

Jewish Martyrs: Hananya ben Tardion, Rachel
Fighters: Five Maccabees, Bar Kochba, Moses, Warsaw Ghetto fighters
Spiritual Leaders: Jochanan ben Zakkai, Maimonides
Rulers: King David
Destruction: The prophet Jeremiah
Exile: Babylon
Visionaries of Redemption and the Return to Zion: Materialization of goals, Ezekiel
Obedience to God's Will: Abraham, Job
Faith and the Essence of Judaism: The Tablets of the Law, "Hear oh Israel"
Yearnings for the Messiah: A Hassid, Ezra, Babylonian *Talmud, Halacha, Aggadah, Kabbalah,* Hillel the Elder
Rehabilitation of Ruins: Nehemiah, Jewish pioneers.

30 *The Menorah Fund Committee, British Gift to Israel,* 1954. The Christian aspect of the project was known to all those responsible whether in Israel or in Britain. The brochures describing the candelabra made by Elkan for Westminster Abbey are found at the Israel Knesset Archive and were apparently sent to the *Knesset* by the artist himself for his own promotion. All those responsible disregarded the Christian aspect.

The iconographic plan of a work of art is usually based on serious preparations.[31] As a rule, artists seek the advice of theologians, historians, aesthetes, and philosophers. Such consultants are well versed in heraldry and in historical associations; they are acquainted with the religious, social and cultural contexts of the visual images chosen for the making of such a compound plan. Except for his own ideas, Elkan was satisfied with a single advisor: Mr. Hillman, the Israeli chief rabbi's brother in law.

The sculptor's decision to attach twenty-nine reliefs to the *menorah* branches is odd; the number has no symbolic meaning. Furthermore, the lower branches of the *Knesset Menorah* are left bare (figs. 8.7, 8.12). One may assume that Mr. Hillman, who visited Elkan in London and to whom the artist sent a few thank-you notes for his help, could have suggested to add a few verses from the book of Zechariah onto the two lower (bare) branches of the *Menorah*, and thus to imbue them with meaning.

Elkan's pretension to containing the entire history of the Jewish People on this one object excluded the recipients of the gift entirely. The Israeli experience is represented on his *Menorah* by a single relief: Pioneers, and does not mention any of Israel's achievements during the State's eight years of existence at the time of the *Menorah*'s unveiling. The Jewish culture which constitutes a significant basis for the State's existence is expressed only in terms of Martyrdom, War, Authority, and Faith.

Fortunately, Lord Samuel's concern that Elkan's *Menorah* was apt to cause a culture war in Israel did not materialize. Still, his words touched upon the sensitive nerve of Israeli secular-Jewish culture: the impossible separation between Church and State. He was right to assume that the Israeli House of Representatives was neither a Synagogue nor any other type of religious-ritual edifice. Such a conviction naturally led him to believe that the Israeli clerical establishment would leave it alone and would not regard it as a clerical-ritual edifice. But, as history shows us, Lord Samuel—like so many others after him—was wrong. The Israeli clerical parties regard the Israeli House of Representatives, as well as many other secular institutions throughout the country, as clerical institutions that must obey what the orthodox label as "Traditional Jewish restrictions."

One of the most striking and surprising features of this fledgling discourse in the 1950s was its unique religious-clerical character. Even though it pertained to

31 The iconographic plan for Ghiberti's *Doors of Paradise* for the Florence Baptistery was conceived by several theologians. Even the Divine Michelangelo, to whom Elkan compares himself, did not conceive the compound iconographic scheme of the Sistine Chapel frescoes single handed; he was assisted by philosophers and theologians.

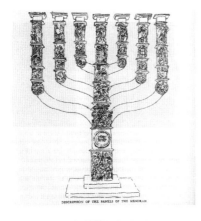

FIGURE 8.12
Benno Elkan, *Sketch showing the various reliefs on The Knesset Menorah*, 1954

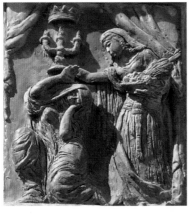

FIGURE 8.7A
Benno Elkan, *Ruth and Rachel*, relief on *The Knesset Menorah*

monuments designed for secular settings, the different participants were heavily guided by reliance on various prohibitions derived from Jewish tradition—prohibitions that apply very strictly only to Synagogues, Jewish cemeteries and ritual objects. One should note that throughout the Jewish communities in the Diaspora—in Europe, the United States, and Moslem countries—the public, urban spaces were always considered outside the jurisdiction of the Jewish clerical establishment.

The question of whether Jewish law permits the installation of works of art in public places throughout Israel was hardly new.[32] A salient instance of the establishment of this quasi-religious discourse can be seen in the words of Shimshon Kreutner,[33] head of the committee for the planning of Theodore

32 Boris Schatz's correspondence with rabbi Kook were discussed in chapter 2.
33 Shimshon Ya'akov Kreutner was born in Germany and studied at the Universities of London and Copenhagen. After immigrating to Palestine in 1935 and occupying different

Herzl's Tomb (1951).[34] In his response to questions raised by competitors for the Tomb's design—questions such as whether it was permissible to sculpt human figures—Kreutner formulated a series of prohibitions, guidelines, bans and licenses, all of which he bound up in the new, supposedly self-explanatory concept of The Israeli tradition. Kreutner was one of the advisors approached by Joseph Shprintzak about Elkan's Knesset Menorah. His response to the speaker of the Knesset was as follows:

> ... At the time, this problem [of depicting human figures whether in paintings or in sculpture] was dealt by a jury during the competition for the design of Theodor Herzl's tomb. The jury stated that Israeli tradition should be understood as follows: It is forbidden to depict human images in sculpture. It is permitted to depict images of animals, plants, and symbols in relief, in mosaics or in any other artistic medium. One should regard this opinion as accepted by all [Israeli] social circles.[35]

Kreutner's wording for the rules concerning the design for Herzl's Tomb and Elkan's *Knesset Menorah* demonstrate that he was not acquainted with common restrictions and authorizations according to which the Jewish-Israeli clerical establishment made decisions on the fitness of sculpted image. Nobody else bothered to check if the prohibitions were relevant to a modern, secular sovereign state. After they had checked and understood all the subtleties of Elkan's proposed designs, it seems that all efforts were made in vain. Elkan's sculpture was accepted as if it were made strictly according to all the rules so meticulously feared by all the clerical dignitaries who spent a long time appraising it.

The site chosen for the installment of the *Knesset Menorah*—next to the old *Knesset* building and nowadays, outside, next to the new building—makes Elkan's *Menorah* a mere decorative piece of sculpture. In both places, the *Knesset Menorah* had been placed outside the building, in a garden. The promise given to Elkan to place it inside the building was never kept.

positions in the Zionist Agency (most notably of which was as General Manager of its European Department), he also acted as secretary of several Zionist congresses. He published several articles and essays on Zionist subjects, as well as books on the immigration of Jews to Israel and the Jewish community of Leipzig.

34 Herzl's tomb project will be discussed in chapter 13.
35 *A Letter from Mr. Kreutner of "The Organizational Department of the Zionist Organization" to Mr. Lior, Secretary of the Israeli Knesset*, November 16th, 1951, The Israeli Knesset Archive. The answers were formulated during the meeting of the Jury for the Competition of Herzl's Tomb, 6.2.1951. Ibid. file S510.433.

The pathos accompanying Elkan's object—less for its own sake and more for its return home—had faded away. The fact that nowadays it is placed outside the *Knesset* building is a symbolic phenomenon in itself. Placing it inside as the artist envisioned could enable it to express, its message that the elected representatives of the Israeli People, who endeavor to make declarations and laws which they pass within the *Knesset* building, are guided by the light of the *menorah*. As it turns out, the *menorah* is not only installed *outside* the building but has a fence around it, preventing any attempt of observing it closely.

8.8 The *Menorah*'s Penultimate Station on Its Way Home: Kssalon Settlement

After it finally came home and was installed in the garden next to the *Knesset* building in Jerusalem, one would presume that the mythical *menorah* from the Arch of Titus finally reached its symbolic destination and could rest there in peace. But things turned out differently. Thirteen years later, it was shaken away from its Roman dwelling and was brought home again, this time to the Kesalon Forest, in the vicinity of Jerusalem. The Jewish sculptor Natan Rapoport,[36] blessed with a self-proclaimed mission no smaller than that of Benno Elkan's, created there a monumental sculptural memorial entitled *The Scroll of Fire* (fig. 8.13).[37]

The artist considered *The Scroll of Fire* the epitome of his artistic career. Through it he sought to convey tidings that would be understood by Christians and Jews alike, resembling Elkan's purposes. Rapoport's two huge bronze half-cylinders were installed on top of a mountain, in the heart of the Holy Martyrs Forest. The work purports to involve "Some of the greatest epics of the Jewish People, wrapped inside the scroll, the essence of Jewish Spirit and Thought."[38] The reliefs on *The Scroll of Fire* incorporate themes such as the Holocaust and Jewish Revival, culminating with allegorical portrayals of two Israeli wars: the War of Independence in 1948 and The Six Day War in 1967.

36 Other Rapoport works will be discussed in chapter 14.
37 *Megilat ha'Esh* (Scroll of Fire) is a poem by Israel's laureate poet Chayim Nachman Bialik, a part of the series *Shirey haChurban* (Poems of Destruction). It is one of the poet's most enigmatic works in which he describes a story of the historical period of the second Temple's destruction. Bialik's poem's title became a popular symbolic term for Jewish martyrdom.
38 *Natan Rapoport 1987—1991, A Presentation of Works*, Tel-Aviv: ha'Aretz Museum, 1991, 10 (in Hebrew).

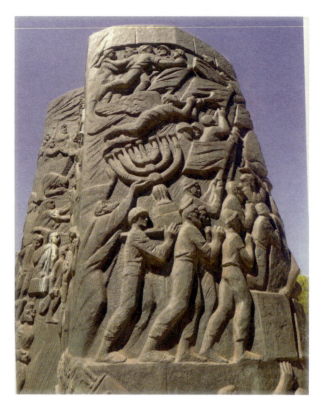

FIGURE 8.13 Natan Rapoport, *Megilat ha'Esh* (The Scroll of Fire), 1969, bronze monument, Forest of Martyrs, Kssalon Settlement

Rapoport manifested the climax of the work's narrative in a unique, new version for the *Menorah Returns Home* motif. The most significant difference between his version and the original visual examples of the motif from the 1940s lies in the fact that his monument was created after The Six Day War. While Benno Elkan hardly referred in his reliefs of the *Knesset Menorah* to the sovereign State of Israel, Rapoport mentions the Israeli victories in a war that took place only two years prior to the installation of his monument.

The Menorah Returns Home motif on Rapoport's *Scroll of Fire* presents three figures carrying the *menorah* from the Arch of Titus on their shoulders (fig. 8.13). The first (on the right) is a visual personification of an Israeli type: a young man wearing a summer hat on his head, dressed in a short-sleeved shirt. The two figures behind him are visual personifications of the two Israeli wars: a soldier of the 1948 War, identified by the contemporary *kova gerev* (a stocking hat). The facial features of the soldier marching behind him, are those of

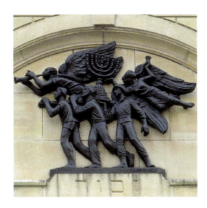

FIGURE 8.14
Natan Rapoport, *Memorial Reliefs*, 1980, New York, Park Avenue Synagogue

General Moshe Dayan, as a personification of The Six Day War of 1967. An allegorical figure of Victory (or a Jewish angel?), hovers on top; two gigantic wings are attached to her shoulders, and she blows a triumphal trumpet.

During the years before the establishment of the state of Israel, and throughout the country's early years, the *menorah* from the Arch of Titus symbolized the end of Jewish Exile; in comparison with these, its symbolic connotations on Rapoport's relief are odd in their militaristic attributes. Israeli *soldiers* carrying the Arch of Titus *menorah* in a procession similar to that of the Roman Emperor's triumphal march transforms the *menorah* back to its original role as spoils of war. Rapoport's overrated self-esteem, similar to that of Benno Elkan brought forth a monument whose symbolic message is both distorted and false.

8.8.1 *The* Menorah's *Last Station?*

Rapoport recycled the *Menorah Returns Home* motif on the facade of an edifice far from Jerusalem, on Park Avenue in New York City. He created a relief commemorating Janusz Korczak and his children, as symbolic representatives of the million Jewish children who perished in the Holocaust. The artist re-used the image of the three figures carrying the *menorah* on their shoulders, this time in reverse, marching from right to left. The first is an Israeli *kibbutznik*, the second is, again a 1948 War soldier, and the last a soldier wearing a helmet and army boots. The allegorical Victory was not passed over and appears here as well. "The *menorah* comes home from the Arch of Titus, commemorating the defeat of the Jews," Rapoport was quoted, "But Rome of the days of Titus is destroyed, and we have a State."[39]

39 *Natan Rapoport 1987—1991, A Presentation of Works*, 20.

FIGURE 8.15 Michael Druks, *Menorah,* wax and wicks, exhibited and self-consumed in 1983

With these prophetic words, the artist removed the layers of dust covering the myth of the ancient *menorah* and succeeded in endowing it with trite qualities. He himself regarded the myth as neither antiquated nor out of place for New York; the nature of his words prove that the idea of the *menorah* returning home to Park Avenue in New York was taken by him to be an artistic feat of great seriousness and a deep symbolic meaning.[40]

8.9 Visual References to the Israeli *Menorah* Motif

Different approaches to the *menorah* of Israel's official emblem were expressed by referring to its political aspects. Israeli artist Michael Druks (b. 1940) made seven thin white candles form a *menorah* (fig. 7.15). The artist's choice of a medium that by its nature is self-consuming makes a significant metaphor of great communicative strength. The awareness that lighting the wax-made *menorah* would cause its own destruction makes a powerful warning against inflammatory activities or arson that may bring the *menorah*—or the state of Israel—to its final self-destruction.

40 For more cases of "The Menorah Returns Home" motif see: Fine, *The Menorah, from the Bible to Modern Israel*, 2016, 209–225.

FIGURE 8.16
Ministry of the Interior and of Happiness, Identity Card of Nachman from Uman, plastic binder for an incantation

A plastic binder, meant to cover Chassidic rabbi Nachman of Braslav's incantation on a virtual Israeli official identity card conveys mockery of the official document. The magical incantation reads—Na, Nachm, Nachman, me'Uman—the first two Hebrew letters of his name, then three, and finally his whole first name with the indication that he comes from a place called Uman: נ.—נחמ—נחמן—מאומן. The plastic binder (fig. 8.16) was designed in such a way as to remind its owner of the common Israeli identity card; it shows the state's emblem slightly changed: the *menorah* is lit, crowned with seven flames. The Hebrew inscription reads "Ministry of the Interior and of Happiness, Identity Card of Nachman from Uman." Giving Israeli citizenship to a deceased person, plus the visual image of the *menorah* as lit, which is forbidden by rabbinical decrees, indicates the identity of those who produced the card: members of the ultra-orthodox Jewish community in Israel who do not recognize the sovereignty of the state and abhor its Zionist aspects.

Bibliography

Bloch, Peter, "Seven Branched Candelabra In Christian Churches", *Journal of Jewish Art*, Chicago: Spertus College of Judaica Press, 1974.

Brod, Max, Lask, I. M., *Alweil*, Tel-Aviv: Sinai Publication, 1956.

Doner, Batya, *Natan Rapoport Oman Yehudi* (Natan Rapoport, Jewish Artist), Givat Haviva and Yad Itzchak Ben Zvi, 2015.

Fine, Steven, *Sacred Realm, the Emergence of the Synagogue in the Ancient World*, New York and Oxford: Oxford University Press, 1996.

Flavius, Josephus, *The Jewish Wars, translated from the Greek by Dr. I. N. Simchon* (Hebrew), Tel-Aviv: Massada Publishing, 1959.

Friedberg, David, *The Power of Images, Studies in the History and Theory of Response*, Chicago and London: The University of Chicago Press, 1989.

"The Huge *Menorah* was presented—the gift of the British Parliament to the *Knesset*," *Haaretz*, April 6th, 1956.

Israeli Knesset Archive, file 557, box 16.

Leydi, Silvio, "The Trivulzio Candelabrum in the Sixteenth Century: Documents and Hypotheses," *The Burlington Magazine*, CLIII, January 2011, 4–12.

Narkis, Bezalel, (Foreword by Cecil Roth), *Hebrew Illuminated Manuscripts*, Jerusalem: Keter Publishing House, 1969.

Natan Rapoport 1987—1991, A Presentation of Works, Tel-Aviv: Ha'aretz Museum, 1991.

Raban, Ze'ev, and Avi-Shai, *Chageynu* (Our Holidays), New York: Miller Lynn Publications (undated, probably 1920s).

Schwartz, Karl, *Jewish Sculptors of the 19th and 20th Centuries*, New York: Philosophical Library, 1949.

Zweig, Stefan, *The Hidden Menorah*, translated into Hebrew by Israel Fishman, Tel-Aviv: Yoseph Shrebrek Publication, 1944.

CHAPTER 9

Zionism Liberates the Captured Daughter of Zion

The Hebrew Nation, or The People of Israel, is personified by a female figure in the Bible and has several names, including The Daughter of Zion, The Virgin of Israel, The Virgin, Daughter of Judea, and The Virgin, Daughter of Zion. References to The daughter of Zion motif focus on two of her main states. In the positive state, she is free, proud, and full of accomplishments. The negative state describes her as captive, haunted, sad, lamenting her own destruction, and yearning for salvation. The captive Daughter of Zion in Jewish tradition symbolizes the people's suffering while being exiled from its homeland.

9.1 The *Judaea capta* Coin

The most significant and evocative *visual* source of the lamenting Captive Daughter of Zion is her image on a Roman coin: *Judaea capta* (Captive Judea). The suggestive power of the Roman image was highly significant during the early years of Jewish settlement in Palestine and a common source for conveying ideological messages. Similarly to the *menorah* of the Arch of Titus in Rome, they transformed the original vision of captivity, humiliation, and destruction into images of freedom, pride, and revival.

The Roman Emperor Vespasian commemorated the destruction of Jerusalem in 70 CE by striking two versions of a coin (figs. 9.1, 9.2). The images characterize the uniqueness of Roman art—the ability to create visual personifications and allegorical figures in a concise way that can accommodate itself to the miniature format of a coin. The front of the Roman coin shows a portrait of the Roman Emperor, crowned with a victorious laurel wreath (fig. 9.1). The reverse side conveys the emperor's conquest through a small number of graphic components: two figures, a tree, shields, weapons, and a Latin inscription.

In the Roman culture, palm branches symbolized triumphs; they were the attributes of Victoria, the allegorical figure of Victory, who would present heroes with a palm branch upon vanquishing their foes. The palm tree on the *Judaea capta* coin stands for Vespasian's victory.[1] On the tree's left, the Emperor

1 Image of the palm tree appears on various Roman coins as a typical plant of the Mediterranean region and was not considered as specifically typical for Judea. Scholars see this particular fresh and blooming tree as symbolizing the Emperor's victory. See: Erwin Goodenough,

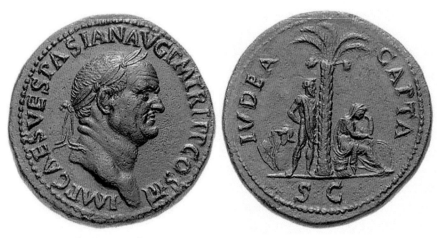

FIGURE 9.1 The Roman *Judaea capta* coin, 81 CE

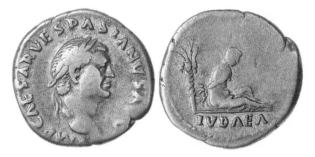

FIGURE 9.2 The *Judaea capta* coin, 71 CE

stands in an upright attitude (fig. 9.1), his left leg resting on a helmet. In his right, he holds a dagger (*parazonium*), a symbol of political power and authority. A female figure sits on the ground, on the tree's right. Her right hand rests on her lap; her head leans to her left, in a mourning gesture. In the other version of the coin (fig. 9.2, right) the captive woman bends forward, her hands bound behind her back. She conveys sadness, humiliation, and mourning.

Roman designers created a concise allegorical depiction of captivity and humiliation, contrasted with Victory. The artist's intent to create an allegorical image as a commemoration of a specific historical event probably led him to seek models from the abundant variety of mythological figures and personifications available to him in Rome. A possible source was Niobe, daughter of Tantalus and wife of King Amphion of Thebes. She had scorned Leto, one

Jewish Symbols in the Greco-Roman Period, Vol. VII, *Pagan Symbols in Judaism*, Pantheon Books, Bollingen Series, XXXVII, 1956, 89–90.

of Zeus' wives, who boasted that her two children, Apollo and Diana are the most beautiful, intelligent and strong children of all. Niobe claimed that Jupiter and Leto had only two children while she gave birth to fourteen: seven boys and seven girls. Pride made Niobe to try and stop the women of Thebes from worshiping Leto. Apollo and Diana felt duty-bound to protect their mother's honor; known for their savage cruelty, they punished Niobe for her arrogance by shooting and killing all her children with arrows. In her terrible grief, Niobe asked the Gods to turn her into a rock.[2] A new visual image developed, showing Niobe after her death; the rock is shedding tears.[3]

Western culture turned Niobe into an allegorical figure of punished pride. There is no proof that her image was the source for the creation of the Captive Judaea motif; nevertheless, her refusal to worship Leto (and indirectly to worship Apollo and Diana) parallels the unwillingness of the kingdom of Judea to worship Roman Gods. As Niobe was punished, so was Judea.

For the specific posture of Judea on the Roman coin, the artist could find models in Greek and Roman steles or in various Roman sculptures that depict women in mourning. Most of them are shown seated; their heads bent on one of their hands.

Roman coins were known throughout the middle ages. Images appearing on them made a rich visual source for Renaissance and Baroque artists. Renaissance *medals* were not used as currency; they were a means of commemorating historical events and prominent public figures. The Captive Judea motif was quoted on a medal struck by Stephan Batori, King of Poland, in 1583. It commemorates his victory over Ivan the Terrible, the Russian Czar (fig. 9.3). The front of the medal shows the king's portrait, and its reverse depicts a heap of weapons. A man sits next to it. He wears a pointed hat and a multi folds cloak; he leans his head on his right hand. A woman stands next to a palm tree, her hands tied behind her back. On the image's extreme right a young man looks upwards, his hands lifted above his head. The Latin inscription reads LIVON. POLOT.Q.RECEP (The Livonia and Polock provinces are brought back).

The figures' costumes and the old man's long beard and cloak identify them as Jews. Why, then, would Jews be depicted on a Polish medal, commemorating the return to Polish authority of two provinces? One possible answer claims that the political situation of the Jews in Poland was better than that of their brethren in Russia. The Jews depicted on this medal were supposed to be represented as captives, symbolizing the Jews of Russia; the free young man

2 James Hall, *Dictionary of Subjects and Symbols in Art* (Introduction by Kenneth Clark), Icon Editions, Harper and Row Publishers, 1974, 224–225.
3 Ovidius, *Metamorphoses*, VI.

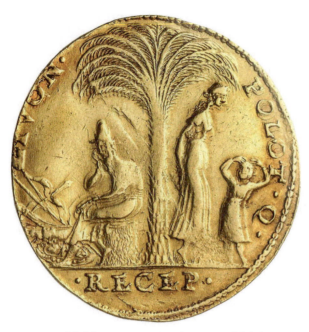

FIGURE 9.3 Medal, commemorating the victory of Polish King Stefan Batori on Russian Czar Ivan the Terrible, 1583

possibly stands for the liberated life awaiting Russian Jews under Polish rule, after the annexation of the provinces by Poland. The message conveyed by the Polish King's medal inverts the message of the Roman *Judaea capta* coin: it expresses freedom, through the identical symbolic images previously stood for enslavement and captivity.

9.2 Jewish References to the Roman *Judaea capta* Coin

Artist-designer E. M. Lilien created one of the first Modern references to the *Judaea capta* coin in an etching expressing Jewish Exile (fig. 9.4). The artist portrayed a group of mourners who find themselves unable to sing songs of praise to the Lord in a strange land. Most of their postures are reminiscent of the contemplative and mournful moods expressed by the female figure of the *Judaea capta* coin. Lilien was familiar with the coin; in a letter to his fiancée he refers to it explicitly:

> ... A day before yesterday, I visited *Beytar* with Prof. Boris Schatz. This ancient city is known for its heroic battles conducted by Bar Kochva

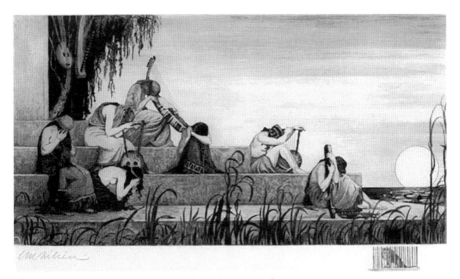

FIGURE 9.4 E. M. Lilien, *By the Rivers of Babylon*, 1910, etching

against the Romans. We found a silver coin struck by Titus after the [Roman] conquest. The coin is well preserved; it shows a lamenting woman under a Roman soldier's armor. On the bottom [you can see] an inscription: JUDAEA CAPTA ... the image will always remind you of the wound, suffered by our People two thousand years ago, a wound that still bleeds to this very day ... Judea was destroyed two thousand years ago, her sons were exiled from their homeland; until today they are wandering upon the earth, with no homeland, and with no refuge, Judea mourns today just like she did on Titus' coin![4]

It is not important whether Schatz and Lilien found the coin in *Beytar* or bought it from an antique dealer in the Old City of Jerusalem, nor is Lilien's mistake in telling his fiancée that the coin was struck by Titus rather than by Emperor Vespasian. His letter attests to the link made at the beginning of the 20th century between the allegorical image of the Jewish People as The abandoned daughter of Zion and its connection with the image appearing on the Roman coin.

4 *Letter from E. M. Lilien to his fiancée*, Jerusalem, 26 April 1906 as quoted by Ruth Ofek (editor), *E. M. Lilien, haOman haTzioni haRishon, Michtavim, Eeyurim, Tachritim veTzilumim* (E.M. Lilien, The First Zionist Artist, Letters, Illustrations, Etchings and Photographs), Tefen: The Open Museum, 1997, 33.

The most famous example in which the motif of The abandoned daughter of Zion is referred to in poetry, is *Hatikva* (The Hope), later on to become Israel's national anthem, a poem written by Naftali Herz Imber (1856–1909). The fifth stanza of the original poem mentions her specifically:

Fifth stanza:
As long as on the barren highways
The humbled city-gates mark,
And among the ruins of Jerusalem
A daughter of Zion still cries.

Refrain:
Our hope is not yet lost,
The ancient hope,
To return to the land of our fathers;
The city where David encamped.[5]

The central role played by this motif and the frequency of its use were part of the collective Zionist culture that was crystallizing with the Jewish community in Palestine at the beginning of the 20th century. It penetrated every aspect of public life, especially in educational institutions. The Captive Daughter of Judea was a frequent subject of plays performed in Jewish schools. Documentation of one of these ceremonies mentioned a theatrical play put on by The Evelyn de Rothschild Girls' School in Jerusalem in 1907. One of the students played the role of the weeping daughter of Zion, awaiting her salvation (fig. 9.5).[6]

Another connection made between the visual image of the Roman coin and a literary image is a story included in Avraham Shalom Friedberg's *Zichronot leVeyt David* (Memoirs of the House of David').[7] Friedberg (1839–1912) was mainly a translator and editor of historical texts. The basis for *Memoirs...* was German author Herman Rekendorf's *Geheimische der Juden* (The Jews' Secrets). Freidberg's *Memoirs...* was published in Warsaw (1903–1909). It

5 The entire poem is quoted by Ruth Karton-Blum, *haShira ha'Eevrit biTkufat Chibat Tzion* (Hebrew Poetry in the Love of Zion Era), Jerusalem: Mossad Bialik, 1979, 125–126.
6 The performance was staged for a Jewish delegation from Germany at the Girls School in Jerusalem in 1907 "The most noticeable figure was that of the sad Daughter of Zion, distinguished by her black widow costume." See: Theodor Olchinsky, "Mein Aufenhalt in Palästina" (My Visit to Palestine), *Ost und West*, May, 1907 318.
7 Avraham Shalom Friedberg, *Zichronot leVeyt David Sipurim miDivrey Yemey Israel* (Memoirs of the House of David, Stories from the History of the Jewish People), Tel Aviv, Massada Publishing, 1958.

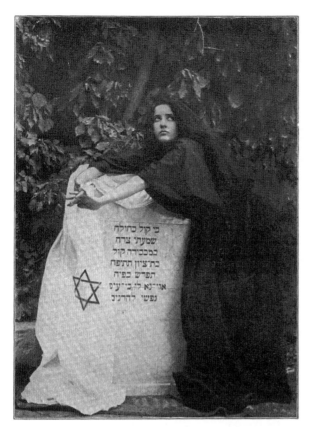

FIGURE 9.5 *Leah, a student of the Evelyn de Rothschild Girls School in the role of The Weeping Daughter of Zion*, photograph published in *Ost und West*, May 1907

comprises of sixteen chapters called *megillot* (scrolls), each named after an object. Each scroll is written by a public figure, commemorating a historical-cultural event in Jewish history. The various chapters focus on the chronological history of the Jewish People, beginning with the biblical Return to Zion and culminating in the 17th century with the story of Sabbatai Zevi. The book was extremely popular in Jewish Palestine. The parallel drawn between the biblical return to Zion and its 20th-century Zionist counterpart was a widespread concept shared by many.

The narrator of *haChevel vehaKotz* (The Rope and the Thorn) scroll included in the book is written by Shimon Ben Yair, son of Chizkiya, son of Shevna, son-in-law of Hillel haNasee. Shimon witnessed the Roman destruction of Jerusalem. After the conquest of the city, he was one of the seven hundred

renowned Judean heroes, chosen to honor Titus' chariot on his triumphal entry to Rome. Shimon narrates the painful event:

> ... Once again the daughter of Judea sat upon her ruins, like a forsaken widow, weeping and lamenting over her sons, who found her, and the lost honor of her daughters, exiled from her and taken into captivity, to be tortured by their captors and sold into slavery. This is how Vespasian Caesar depicted her on coins, struck for his people in commemoration; an image of a disconsolate woman seated on the ground under a palm tree, her hands bound with handcuffs.[8]

9.3 From *Judaea capta* to Judaea liberata

At the beginning of the twentieth century, a new image of The Daughter of Zion emerges: early examples show her freeing herself, and at the end of the process she becomes wholly liberated. The first to express this image visually was Lilien; his design for the title page of the Zionist Journal *Ost und West* depicts a personification of the Jewish nation (discussed in chapter 1). Lilien's modern Daughter of Zion served as a model for Jewish artists who followed in his footsteps in their creations of allegorical figures and visual personifications of the reviving Jewish nation.

On the front piece for a musical score titled *Redemption March*, the artist depicts a winged female figure, leading an endless procession (fig. 9.6). Her breasts are bare, her skirt flutters in the wind, and she is wearing a wide belt with a Jewish Star engraved on its buckle. The mythological winged figure of Nike[9] probably served the artist in the design for this modern personification of Jewish Redemption. Nike's trumpet is replaced here by a *shofar* (a ram's horn). The roaring lion, the symbol of the tribe of Judah, identifies her as a variation of Judea.

Another addition to the image of Judea freeing herself and standing for Liberty or Freedom are broken fetters. Such an image appears on a New Year's greeting card from Germany (fig. 9.7). It shows Theodor Herzl holding a book while contemplating his vision of a multitude of people in a long procession journeying to the Land of Israel. They are led by an allegorical figure who points

8 Friedberg, *Memoirs ...*, Ibid.
9 In Greek and Roman mythology *Nike* (Greek) or *Victoria* (Roman) was a personification of victory, as a winged female figure. She was the messenger of the gods who descended to earth to crown victors in contests of arms, athletics and poetry. Hall, *Dictionary of Subjects and Symbols in Art*, 231.

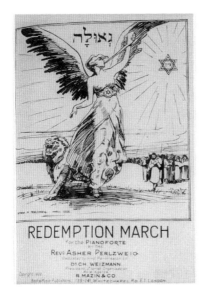

FIGURE 9.6
Heiman Perlzweig, *Frontispiece for the musical score of the Redemption March*, London, 1922

FIGURE 9.7 New Year's greeting card from Germany, 1909

the way with her right hand, while the other hand holds the Zionist flag. The fetters on its left hand are shattered.

The European Zionist image of the Jewish Nation freeing itself from the fetters of the Diaspora and the freedom that awaits it in the Land of Israel was extended there. The new image presents Judea in the act of freeing herself on the very site where she was captured two thousand years before. Ideas of revival were particularly reinforced in 1917 after the British Mandate replaced the Ottoman Empire rule of Palestine.

An early allusion to the Liberated Judea motif was made by Ya'akov Ben Dov (1882–1968), a pioneer cinematographer and a significant photographer who

FIGURE 9.8
Ya'akov Ben Dov, *Frontispiece of The Liberated Judea film program*, 1918

was active in the *yishuv* at the beginning of the 20th century. From December 1917 to August 1918, Ben Dov filmed various events and sites throughout the country. His film comprised of thirty-four scenes, shot in Jerusalem, Jaffa and several settlements throughout the country. He called it *Yehuda haMeshuchreret*, The Freed Judea, or Liberated Judea) (fig. 9.8).

Ben Dov published a series of postcards dedicated to The Jewish Brigade veterans of the First World War (fig. 9.9) The Liberated Judea motif receives one of its earliest visual depictions on the Ben Dov envelope, designed by artist Ze'ev Raban. It presents The Daughter of Zion as a young, assertive woman. She holds the banner of The Jewish Brigade in her right hand, and in her left a shield, engraved with emblems of the twelve tribes of Israel. She is identified as Judea by the Lion of Judah standing by her side. The shattered fetters on the lion's back and paws are additional attributes signifying her liberty.

Raban and Ben Dov played a significant part in the conceptual program of the Bezalel School. The teaching staff of Bezalel, headed by Boris Schatz, regarded the Palestine archeological findings as representing the glorious past of the Jewish People in its homeland. Visual motifs appearing on archeological findings were used by Bezalel designers as models for contemporary icons that were meant to convey ideas of Jewish revival and rebirth. A series of ceramic tile decorations, commissioned from the Bezalel workshops by national Hebrew poet Chayim Nachman Bialik for his mansion in Tel Aviv, make a prime example for the visual realization of these Zionist concepts.

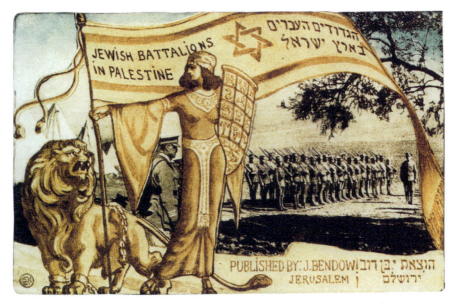

FIGURE 9.9 Ze'ev Raban, Cover of an envelope containing a series of postcards dedicated to *The Jewish Battalions in Palestine*, 1918

FIGURE 9.10A The *Judaea capta coin*, ceramic tile decoration on an entrance lobby column in Bialik's house, Tel Aviv

FIGURE 9.10B The *Judea frees herself coin*, ceramic tile decoration on an entrance lobby column in Bialik's house, Tel Aviv

Two of the decorative motifs that adorn the ceramic tiles on columns in Bialik house's lobby show images of coins, framed by elliptical and round formats: one is the *Judaea capta* coin, the other, a fictitious modern counterpart—Judea freeing herself (figs. 9.9a, b). Next to a palm tree, on the contemporary virtual coin, the figure of Judea is dynamic; she frees herself from captivity by

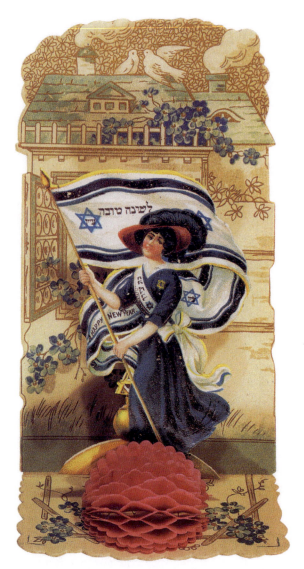

FIGURE 9.11 New Year's greeting card, New York, early 20th-century

breaking her fetters, still clinging to her hands . Her companion, on the other side of the tree, is a young man holding a sword, marching forward. This image of Judea freeing herself reflects the Zionist present as a period of liberty and revival, contrasted with the past that stands for captivity and destruction.

In the 1920s, the Mourning Daughter of Zion started smiling. Various images of her were published on Jewish New Year greeting cards (fig. 9.11). They present her as a Modern woman, reminiscent of pictures of suffragettes. She holds

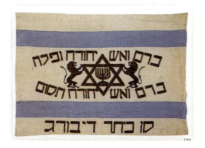

FIGURE 9.12
Official flag of the *Beytar* Association in Dieburg, Germany; the inscription in Hebrew reads In blood and fire Judea fell—in blood and fire Judea will rise

the Zionist flag and is identified by the ribbon on her chest which is carrying a Hebrew inscription: *Bat Zion*—The Daughter of Zion.

The 1930s present us with an entirely new—and different—concept of The Daughter of Judea when next to utopian yearnings one encounters calls to arms. Contemporary myths of heroism—the most familiar is that of *Tel Chai*[10]—were linked to the heroic past of the Maccabean and Hasmonean periods. A poem entitled *haBiryonim* (The Ruffians), written by Yaakov Cohen, was a source for a contemporary popular slogan while creating a verbal image of The Fighting Judea. *Bedam va'esh Yehuda nafla—bedam va'esh Yehuda takum* (With blood and fire Judea had fallen—with blood and fire Judea will rise).[11] The powerful verbal statement was repeated and often quoted on contemporary banners and flags (fig. 9.12).

The establishment of the state of Israel in 1948 was symbolically conceived as the reinstatement of ancient Judea. Consequently, the use of the Liberated Judea motif was widespread during its first years. In 1949, a short time after the establishment of the state, the minister of transportation David Remez (1886–1951) suggested striking an official medal commemorating the revival of, as he put it, The New Kingdom of Judea. He commissioned sculptor Michael Kara (1885–1964) to design the medal. Kara was expected to include specific visual elements, whose message would convey a complete reversal of the one expressed by the *Judaea capta* coin. The artist made several plaster relief sketches for the medal and labeled it *Judaea restituta* (Judea Reinstated) (figs. 9.13a, 9.13b).

Kara's sketches show a group of people marching in a single file, lifting their hands in what seems to be gestures of a quasi-ritual dance, as they are approaching their homeland. A few are young—a mother holding an infant in her hands—and old—an elderly man assisted by a cane. Boats are seen in the background. The inscription (in Latin!) on one of the sketches (fig. 9.13a) is

10 The Tel Chai memorial to heroic fighters was mentioned in chapter 2.
11 To the best of my knowledge, there are no *visual* interpretations for the Fighting Judea concept as a woman, personifying the modern Daughter of Zion motif.

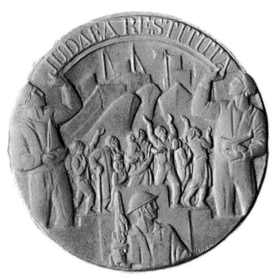

FIGURE 9.13A Michael Kara, *Judea Restituta* (sketch for a proposed medal), 1949, plaster relief

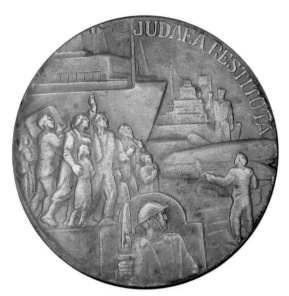

FIGURE 9.13B Michael Kara, *Judea Restituta* (sketch for a proposed medal), 1949, plaster relief

supported by two soldiers; the one on the right is identified by his rank marks on his left sleeve. Both sketches show attributes of transportation: a boat on the left and an airplane above the figure on the right. Kara's other sketch (fig. 9.13b)

FIGURE 9.14 *Envelope commemorating the country's first Independence Day*, 1949

shows the transportation vehicles more clearly. A third soldier, at the bottom, wears a helmet and holds a sword entwined with olive branches. He is meant to represent the Israeli army, fighting the war of his Jewish brethren and responsible for bringing them back to their homeland.

9.4 The *Judaea capta* Image on Official Israeli Publications

While during the period before the establishment of Israel images of the Roman *Judaea capta* coin served to create icons conveying freedom, the young state regarded itself not only as freed but as a realization of sovereignty, contrasted with previous foreign rules.

The *Judaea capta* coin appeared as a visual icon for an official, festive postal envelope, commemorating the country's first Independence Day (May 1949) (fig. 9.14). The Roman coin, retaining the original message of captivity, is placed on the left. On the right is the emblem of the Israeli Army conveying messages of defense and peace. Above them, the Israeli national emblem presents sovereignty and aspirations for peace. The state's flag, shown on the stamp allude to Jewish tradition. The role played by the *Judaea capta* coin in this context may be interpreted as a contrasting icon, signifying the end of British rule of the country in 1948 through the use of the allegorical Roman icon.

Israel celebrated its tenth anniversary in 1958. It was, apparently, impossible not to return to the iconic image of the *Judaea capta* coin. According to a suggestion made by Leo Kadman, a numismatic expert, the state issued its first official medal, designed by Oteh Walisch, following a sketch by Kadman (fig. 9.15).

In the center of the medal, Walisch quoted one version of the Roman coin. It is framed by fetters and crowned with an inscription in Hebrew—*Galta Yehuda*

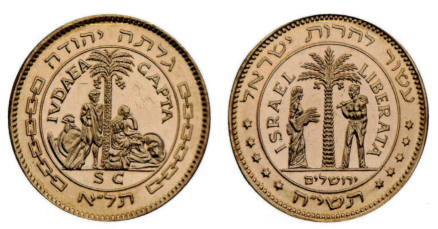

FIGURE 9.15 Oteh Walisch, *Ten Years of Liberty* (*ISRAEL LIBERATA*), 1958, gold medal

(Judea is exiled). On the bottom, he added the Jewish date for the beginning of exile—the Jewish year 3431 (also in Hebrew letters). The outer ring of the medal shows fetters. The medal's reverse shows an Israeli version of the *Judaea capta* coin: the palm tree is placed in the middle, similar to its original placing on the Roman coin. On the left, a woman holds stalks of grain; to the right, a man holds a hoe on his shoulder. An inscription frames the inner circle; it reads *Israel Liberata* (in Latin). On the bottom of the inner circle, Walisch added the word Jerusalem (in Hebrew). The inscription on the outer ring reads *Assor leCherut Israel* (a decade of Israel's freedom) and the Jewish year 1958 (in Hebrew letters). Between these elements the designer placed five stars on each side, standing for ten years of Israel's sovereignty. Ten thousand copies of the medal were cast in gold and were in high demand; the medal was re-issued in a different format to meet public demand.

The new issuing of the medal was commissioned from Studio Roli (Gerard Rothschild and Ze'ev Lifman). The designers quoted the images from the Roman coin: (fig. 9.16). They show the fetters and the date of destruction. Strangely enough, in the Studio Roli version, the destruction of Judea occurred a year earlier; the date inscribed on the medal (again in Hebrew letters) is 3430. The reverse of the medal repeats the motif of the palm tree.

On its left stands a woman, holding an infant and raising it upwards. On the right, a man is crouching and planting a seedling. The inscription on the bottom of the ring reads (in English) Israel Liberated 1948 and on its top *Israel haMeshuchreret* (the freed Israel) in Hebrew.

There is no doubt that the intentions of Walisch and Studio Roli were patriotic. However, their modern interpretations of the visual motifs appearing on the Roman coin seem a bit odd. The original message conveyed by the coin

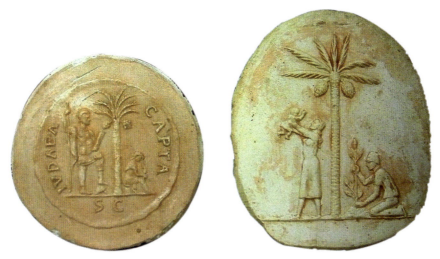

FIGURE 9.16A Studio Roli (Rothchild and Lifman), sketches for *ISRAEL LIBERATED* 1948, 1958, plaster casts

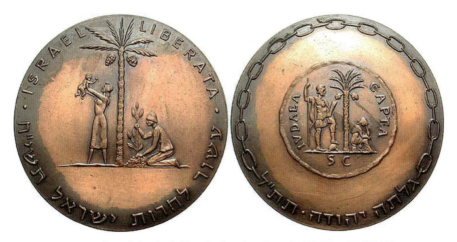

FIGURE 9.16B Studio Roli (Rothschild and Lifman), *JUDEA CAPTIVE 70 CE ISRAEL LIBERATED* 1948, 1958, bronze medal

was achieved, first and foremost, by a principle of contrast—the juxtaposition of two visual personifications, that of the conquering Caesar, the other of vanquished Judea. The contrasting components create tension because the two are not equal. The conquering figure dominates that of the submissive, mourning one. Consequently, the contrasting images allude to human emotions such as pride and might on the one hand, and oblivion, despair, and feebleness, on the other. The minimalistic approach taken by the designer of the Roman coin

succeeds in causing the spectator's stirring identification whether it is with the conqueror or the defeated.

The Walisch, as well as the Studio Roli's modern versions of the *Judaea capta* coin, show no contrast and therefore are devoid of expressive artistic tension. They illustrate a Zionist response to the Roman concepts of conquest with a depiction of modern Israeli counterparts. Walisch's figures are characterized by traditional attributes of Agriculture—a hoe and sheaves of corn. Studio Roli assigned to his female counterpart, the Jewish-Zionist-Israeli woman, the role of a child bearer, a mother, in charge of the upbringing of children while her husband redeems the land by planning a young seedling.

Captivity and destruction of the *Judaea capta* coin were replaced in Israel's first official medals by images of farmers. The Captive Daughter of Zion's mourning comes to an end; at present she reaps wheat. Her captive partner freed himself from the fetters that bound his hands behind his back, and at present, he tills the land. The palm tree, symbolizing the victory of the Roman Empire over Judea, did not go through any process of metamorphosis and its convincing symbolic aspects are totally lost; it now serves merely as a decorative, background motif, for the two farmers, in a minuscule palm orchard.

The Daughter of Zion's process of freeing herself is coming here to an end; she is now a modern personification of Zionist enterprises, summed up as merely agricultural and maternal achievements. The Jewish nation, so faithfully represented in Zionist thought and visual images by The Daughter of Zion motif is no more. The long Zionist history preceding the foundation of the state of Israel is replaced by a farming woman, the symbol of the here and now, with no ties whatsoever to her long tradition.

9.5 A Late Israeli Daughter of Zion

At the height of Israel's Lebanon War (1984), twenty-six years after the issue of the *Israel liberata* medal, graphic designer Ilan Molcho published a poster and labeled it *Yehuda haShvuya* (The captured Judea) (fig. 9.17). The main protagonist of his image is a woman, holding the hand of a small girl, saluting a soldier. Though her costume might identify her as an Arab woman, this is not quite clear. The soldier is easily identified as Israeli, thanks to his particular uniform and the gun he holds in his hands. An abstract, amorphous shape appears at the top of the poster; its contours delineate the shape of a tree, the cedar of Lebanon. The bottom of the poster shows a reproduction image of the Roman *Judaea capta* coin. Molcho used the familiar message of the Roman coin to

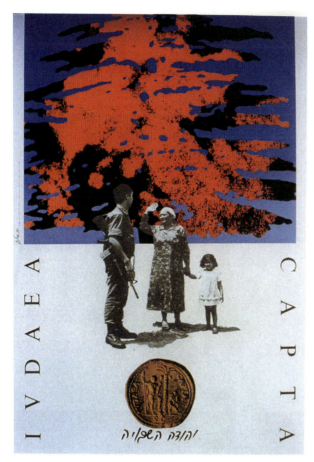

FIGURE 9.17 Ilan Molcho, *Yehuda haShvuya* (The Captured Judea), 1984, poster

express his own view of contemporary Israel, personified by the Daughter of Zion. The poster's caption then may be interpreted as claiming that in spite of the fact that she is liberated for quite some time, The Daughter of Zion, or, rather, the State of Israel is captured once again, not by foreign conquerors rather by its own deeds.

Bibliography

Friedberg, Avraham Shalom, *Zichronot leVeyt David Sipurim miDivrey Yemey Israel* (Memoirs of the House of David, Stories from the History of the Jewish People), Tel Aviv: Massada Publishing, 1958.

Goodenough, Erwin, *Jewish Symbols in the Greco-Roman Period*, Vol. VII, *Pagan Symbols in Judaism*, Pantheon Books, Bollingen Series, XXXVII, 1956.

Hall, James, *Dictionary of Subjects and Symbols in Art* (Introduction by Kenneth Clark), Icon Editions, Harper and Row Publishers, 1974.

Karton-Blum, Ruth, *haShira ha'Eevrit biTkufat Chibat Tzion* (Hebrew Poetry in the Love of Zion Era), Jerusalem: Mossad Bialik, 1979.

Ofek, Ruth, (editor), *E. M. Lilien, haOman haTzioni haRishon, Michtavim, Eeyurim, Tachritim veTzilumim* (E. M. Lilien, The First Zionist Artist, Letters, Illustrations, Etchings, and Photographs), Tefen: The Open Museum, 1997.

Ost und West, May 1907.

CHAPTER 10

The Twelve Tribes of Israel: from Biblical Symbolism to Emblems of a Mythical Promised Land

10.1 The Twelve Tribes of Israel: Symbolizing the Unity and Diversity of the Jewish People

Modern scholarship is not sure about the origin or even the existence of the Twelve Tribes, and there are several schools of thoughts regarding their nature. Were they an alliance of nomadic, independent desert tribes, united for military or political reasons? A confederation of Israelite tribes that took place between the period of the Judges and the Monarchy? Were they merely groups of people named after locations in the Land of Israel? Were some of them historically the sons of Leah and Jacob? Is the number 12 symbolic or real? Were some of them really lost during the Diaspora? There are more questions than answers. Nevertheless, the concept of the twelve tribes of Israel, including their history, lore, and visual representations is still very much alive in Israeli Jewish identity, ideology, art, literature, geography, politics, and on-going controversies; they will most likely remain so indefinitely.

The twelve tribes of Israel stand for the unity and diversity of the Jewish People in Jewish lore. This twofold concept was extensively dealt with by Jewish and non-Jewish sages, and by scholars from the Middle Ages all through the Modern period; however, the tribes' *visual* expression as emblems has rarely been subject to comment. The heraldry of the twelve tribes of Israel has reasonable cause to be considered a distinctive religious iconographic invention; secular Jewish expression of the theme emerged in Reformed Jewish German culture as late as the 19th century. Zionism picked up its legacy to convey the message of unity through diversity as parallel to the modern ingathering of exiles and the return to Zion. In contemporary Israel, it is also used by political ideologists as a message of the return to the biblical Promised Land.

The number twelve placed the tribes of Israel in various sacred, symbolic contexts. For example, their unified faith in God was symbolized by the twelve gems set in the High Priest's breastplate. Twelve is also the number of the signs of the Zodiac. "Just as the heavens cannot endure without the twelve

constellations so the world cannot endure without the twelve tribes for the world was created by their merit."[1]

10.2 Biblical and *Midrashim* Sources

Three passages in the Bible refer to Jacob's twelve sons, each of them a father of one of the twelve tribes of Israel. The first is Jacob's blessing of his sons (Genesis 49:1–27). The second is his blessing to his two grandchildren (Genesis 48:8–14). The third is Moses' blessing of the tribes (Deuteronomy 33). Jacob's blessing offers seven options for a potential translation from verbal to visual by comparing some of his sons to plants, objects, or animals. The remaining five have no affiliation with these elements, and consequently, their graphic icons had to be based on other biblical references to various occurrences in which Jacob's sons were involved, and also on the *Midrashim*—the Jewish rabbinic literature which contains early commentaries on the Five Books of Moses.

Jacob's Blessing of his twelve sons and his two grandchildren, Ephraim and Manasseh, became popular in the Middle Ages through Christological symbolism.[2] The narrative of Jacob's blessing to his two grandchildren tells us that "… And Israel [Jacob] stretched out his right hand, and laid it upon Ephraim's head, who was the younger, and his left hand upon Manasseh's head, guiding his hands wittingly …" (Genesis 48:1–21). The Christian interpretation of this homage, done by Jacob deliberately crossing his arms to favor Ephraim, gave it extraordinary popularity. Jacob's preference of Ephraim, conceived as a personification of the Gentiles, to Manasseh, representing the Jews, is a prefiguration of Jesus who would substitute a people who errs with a new people of God. This is the symbol of the substitution of the Synagogue by the Church, or the New Testament replacing the old one. Jacob's crossed arms gesture while blessing his two grandchildren was regarded a pre-figuration of Jesus on the cross.[3]

The *Midrashim* concerned primarily with the twelve tribes of Israel are *Bereshit Rabbah* (*Genesis Rabbah*) and *Bamidbar Rabbah* (*Numbers Rabbah*).[4]

1　*Exodus Rabbah*, 15:6. *Exodus Rabbah* is a *midrash*—one of Jewish rabbinic literature which contains early commentaries on the five books of Moses. The *Midrashim* will be discussed later on.
2　Louis Réau, *Iconographie de l'art Chretien* (*Tome II, Iconographie de la Bible, Ancien Testament*) (Iconography of Christian Art, Volume II, Iconography of the Bible, Old Testament), Paris: Presses Universitaires de France, 1956, 169.
3　Réau, *Iconographie de l'art Chretien*, Ibid.
4　The following quotes from *Genesis Rabbah* and *Numbers Rabbah* translated by the author are taken from Etz Yosef (Rabbi Chanoch Zundl), Anaf Yosef (Rabbis Yitzhak and Zvi

The first was probably written between 300 and 500 CE with some later additions. It contains ancient rabbinical homiletical interpretations of Genesis with its text expounded verse for verse, often word for word. *Numbers Rabbah* was written much later, probably in the 12th Century.

What was discussed so far suggests a migration of ideas and concepts between Jewish and Christian scholars in general, and Hebraists in particular. Moshe haDarshan (11th century), was the founder of Jewish exegetical studies in France. Though he was considered a rabbinical authority, he owes his reputation principally to the fact that he was the most prominent representative of symbolic Bible exegesis. Scholars believe that his teachings were not in harmony with the spirit of the rabbinical *Midrashim* and even contained Christian theological concepts. Unfortunately, his work on the Bible is known only by quotations, found mostly in Rashi's commentaries.[5]

Raymond Marti, born in the first half of the 13th century, was a Dominican friar and theologian, remembered for his polemic work *Pugio Fidei* (Dagger of Faith, ca. 1270). Marti was well versed in Hebrew literature, quoting not only from the Talmud and *Midrashim* but the writings of Medieval Jewish scholars' such as Rashi, Abraham Ibn Ezra, Maimonides, and others. Several scholars claimed that some ideas contained in his *Pugio Fidei* strongly recall Moshe haDarshan's teachings.

10.3 Verbal Turned Visual: Heraldic Emblems of the Twelve Tribes

The Bible mentions the heraldry of the twelve tribes in the context of their encampment around the Tabernacle in the wilderness after the Exodus from Egypt, three tribes to the north, the east, the south, and the west. Each tribe owned a distinctive banner, and had a patriarch termed *nassi* as its leader: "And the children of Israel shall pitch their tents, every man by his own camp, and every man by his own standard, throughout their hosts." (Numbers 1:52).[6]

An illustration in the *Florsheim Haggadah*, a 16th century Passover *Haggadah* (fig. 10.1) shows four groups of Israelites, headed each by their *nassi*, who carries a tribe banner; the banners do not show precise images.[7]

Kopelowitch), *Midrash Rabot eem Be'urim Ahuvim uVrurim* (Commentaries with Beloved and Clear Explanations), Warsaw: 5624 (1886) (not paged with Roman numerals).

5 "R' Moshe haDarshan", *Encyclopaedia Hebraica* [In Hebrew], Jerusalem and Tel Aviv, Vol. 24, 573.
6 The following chapter 2 in Numbers contains a detailed description of the twelve tribes' encampment including names of the tribes' Patriarchs and the number of people in each tribe.
7 For a substantial information on the *Florsheim Hagaddah* see: Yael Zerlin, "Discovering the Florsheim Hagaddah", *Ars Judaica*, volume 1, 2005, 91–108.

FIGURE 10.1 Illustration for "To Him who led his People in the Wilderness" in *The Florsheim Haggadah*, ca. 1503. North Italy, Zurich, Florsheim Collection

FIGURE 10.2 Jacob Judah Leon Templo, *Retrato del Tabernaculo de Moseh* (Description of Moses' Tabernacle), 1654, Amsterdam: Gillis Joosten

By the end of the sixteenth century, the heraldic devices of the twelve Patriarchs and their descendants were usually represented by tents, with each Patriarch's name written on, or next to them. *Retrato del Tabernaculo de Moseh* (Description of Moses' Tabernacle) is an example of this extremely popular subject (fig. 10.2). It shows the placing of each tribe around the Tabernacle, though still without their visual signs.

It was probably at the beginning of the 17th century that the theme of the twelve tribes was imagined and expressed for the first time in Christian

publications. The tents of the tribes eventually came to display not only the names but the standards of the individual Patriarchs. In a detailed article, Clare Tilbury surveys the tribes' emblems and claims that

> ... It is unclear who first drew out these ensigns and whether on the continent or in England but the heraldry of the twelve tribes, together with tents, appears for the first time in England on the frontispiece to the Geneva Bible, published in London and Amsterdam in 1599. The tents are named and enclose the heraldic shields of the tribes (fig. 10.3).[8]

Tents frame the title on the left of a Geneva Bible, balancing half-length images of the Twelve Apostles on the right (fig. 10.3). Jesus chose his twelve Apostles deliberately and told them that they would sit on twelve thrones judging the tribes of Israel. This typological pairing of Apostles and tribes is confirmed in John's vision of the Heavenly Jerusalem: "And had a wall great and high, *and* had twelve gates, and at the gates twelve angels, and names written thereon, which are *the names* of the twelve tribes of the children of Israel ... And the wall of the city had twelve foundations, and in them the names of the twelve apostles of the Lamb" (Revelation 21, 12, 14).

Images of the Geneva Bible frontispiece exemplify the most common Christian reference to the twelve tribes of Israel as symbols of the Old Testament. These early 17th century emblems were to serve as models for future emblematic depictions of the twelve tribes of Israel in various European publications.

The specific heraldic shields that appear on the tents' ensign of each tribe's *nassi* were never mentioned in the Bible; the English designer must have been familiar with a verbal source, most likely *Numbers Rabbah*. Authors of *Numbers Rabbah* extended the biblical description by detailed documentation of the images which they believed appeared on each *nassi* banner. They stated that their background colors followed the precious stones set upon the High Priest's breastplate. They named each particular gem, noted the background color of the tribes' banners, and described the images depicted on each of them:

> ... The Holy One blessed be He said to Moses make them banners to my name for they are my armies (Exodus 7) "and I shall get my people, the sons of Israel out of Egypt ... and since they are my army I shall make banners for my namesake."
>
> Each Patriarch [*nassi*] had a *mapa* [banner; literally map in modern Hebrew]; their colors were as the colors of the precious stones set upon

[8] Clare Tilbury, "The Heraldry of the Twelve Tribes of Israel: An English Reformation Subject for Church Decoration", *Journal of Ecclesiastical History*, Volume 63, Issue 2, 2012, 281.

FIGURE 10.3 Frontispiece to a Geneva version of the *Bible*, London 1599

FIGURE 10.3A Frontispiece to a Geneva version of the *Bible*, details

Aaron's heart from which [Gentile] kingdoms learned how to make banners with particular colors for each one. Every tribe had a *nassi,* and his banner color resembled that of its particular stone.

Reuben's stone is *odem*;[9] his banner's color is red, on top of it appears [an image of] mandrakes.

The mandrakes on Reuben's tribal banner are based on Genesis 30:14: "During wheat harvest, Reuben went out into the fields and found some mandrake plants, which he brought to his mother Leah."

Simeon's stone is *pitedah* his color is green and his sign is Shechem.

Simeon's walled city of Shechem is based on Genesis 34:1–30: "Now Dinah, the daughter Leah had borne to Jacob, went out to visit the women of the land. When Shechem son of Hamor the Hitite, the ruler of that area, saw her, he took her and raped her ... two of Jacob's sons, Simeon and Levi, Dinah's brothers, took their swords and attacked the unsuspecting city, killing every male. They put Hamor and his son Shechem to the sword and took Dinah from Shechem's house and left."

Levi's stone is *bareket,* his coloring is one third white, one third black and one third red, depicting the High Priest's breastplate.

Levi's High Priest's breastplate is based on Moses' blessing (Deuteronomy 33: 8): "About Levi he said: 'Your Thummim and Urim [the High Priest's breastplate] belong to your faithful servant.'"

9 Some names of gems mentioned in the Bible were adopted to modern Hebrew, i.e., *odem* is ruby, *yahalom* is diamond and *sapir* is sapphire. However, we do not really know what gems like *pitedah* or *bareket* looked like or which particular gem they were. Bible scholars were intrigued with a modern identification of these gems. An early commentary on the subject is *Sefer Aaney haChoshen al pi Seder haShvatim* (The Order of Gems on the High Priest's Breastplate According to the Arrangement of the Tribes), a 16th century commentary, written in Jewish-German from the Moscow-Ginzburg manuscript 333/12, quoted in *Sefer Sgulot ha'Avanim Tovot* (Book on the Qualities of Precious Stones), Jerusalem: Yarid haSfarim Publication, 2005, 120–124. A recent publication on the subject is Dov Ginsburg's article "LaZehut haMinerologit shel Avney haChoshen" (Concerning the Mineralogical Identity of the High Priest's Breastplate Gems), in *Sefer Shmot Meforash bidey Amos Chacham* (Commentary on Exodus by Amos Chacham), Jerusalem: haRav Kook Institute, 1991, 167–173. Ginsburg's article includes color photographs of minerals such onyx, aquamarine, malachite, emerald (and more) as potential equivalents for the gems mentioned in the Bible.

> Judah's stone is *nofech*, his color resembles the sky with an image of a lion.

Judah's lion is based on Jacob's blessing (Genesis 49): "You are a lion's cub, Judah; you return from the prey, my son ... The scepter will not depart from Judah, nor the ruler's staff from between his feet, until he to whom it belongs shall come and the obedience of the nations shall be his."

> Issachar's stone is *sapir*, his coloring is black resembling blue with a sun and a moon drawn upon it (Chronicles I, 12).

Another common image on Issachar's emblem is a donkey; it is taken from Jacob's blessing (Genesis 49, 13–14): "Issachar is a rawboned donkey lying down among the sheep pens. When he sees how good is his resting place and how pleasant is his land, he will bend his shoulder to the burden and submit to forced labor".

> Zebulun's stone is *yahalom*, his coloring is white with a drawing of a ship.

Zebulun's ship is based on Jacob's blessing (Genesis 49:13): "Zebulun will live by the seashore and become a haven for ships; his border will extend toward Sidon."

> Dan's stone is *leshem*, his coloring resembles the *sapir* stone, drawn with a snake.

Dan's snake is taken from Jacob's blessing (Genesis 49:16–17): "Dan will provide justice for his people as one of the tribes of Israel. Dan will be a snake by the roadside, a viper along the path, that bites the horse's heels so that its rider tumbles backward."

> Gad's stone is *shvo*, his banner color is neither white nor black but a mixture of white and black with an image of a camp.

A tent usually represents Gad's camp. It is based on Jacob's blessing (Genesis 49:19): "Gad will be attacked by a band of raiders, but he will attack them at their heels."

> Naphtali's stone is *achlama*, his banner color resembles clear wine whose redness is not strong, with an image of a doe.

THE TWELVE TRIBES OF ISRAEL

FIGURE 10.4
The Patriarchs banners as described in *Numbers Rabbah*. Reconstruction by the author. The pairs are (top to bottom, left to right) Reuben and Levi, Simeon and Judah, Issachar and Zebulun, Dan and Gad, Naphtali and Asher, Ephraim-Manasse and Benjamin

Naphtali's doe is taken from Jacob's blessing (Genesis 49:21): "Naphtali is a doe set free that bears beautiful fawns."

> Asher's stone is *tarshish*, his banner color resembles that of precious stones with which women adorn themselves, drawn with an olive tree.

Asher's olive tree or oil jug is taken from Moses' blessing (Deuteronomy 33, 24): "About Asher he said: 'Most blessed of sons is Asher; let him be favored by his brothers, and let him bathe his feet in oil. The bolts of your gates will be iron and bronze, and your strength will equal your days'."

> Joseph's stone is *shoham*, his banner color is strong black, drawn for two Patriarchs, that of Ephraim and Manasse; Ephraim's image is an ox. Manasse's banner shows an oryx.

Ephraim and Manasse's ox and oryx are based on Moses' blessing (Deuteronomy 33, 17): "In majesty he is like a firstborn bull; his horns are the horns of a wild ox. With them he will gore the nations, even those at the ends of the earth. Such are the ten thousands of Ephraim; such are the thousands of Manasse."

> Benjamin's stone is *yoshpeh*, his banner colors resemble all twelve colors with an image of a wolf.

Benjamin as a wolf is based on Jacob's blessing (Genesis 49:27): "Benjamin is a ravenous wolf; in the morning he devours the prey, in the evening he divides the plunder."[10]

Numbers Rabbah is the only reference to the images and colors of the tribes' banners and therefore must have been the sole verbal source in the service of future designers in their creation of the tribes' emblems. In the 17th century, the specific images appearing on each tribe's banner became a common phenomenon of Bible title pages and other illustrations throughout Europe (fig. 10.5).

10.4 From Christian Bibles to Jewish Synagogue Decorations

It is unclear when Jewish counterparts of Christian emblems of the twelve tribes of Israel found their way to Synagogue decorations, but their earliest visual tradition was found in Eastern European Jewish communities in the second half of the 19th century. Wall paintings on the holy ark of the Cekiske Synagogue in Lithuania (inaugurated ca. 1887) are early examples of this phenomenon (fig. 10.6). Later on, the Jewish artist Avraham Mendel Grünberg (Grinberg) (d. 1928) painted images of the twelve tribes ensigns on Synagogue walls in Romania (figs. 10.7, 10.8). There is no doubt that Grünberg was familiar with *Numbers Rabbah*. Not only did he paint the specific colors of each tribe banner's background as *Numbers Rabbah* describes it, but he even labeled each banner with the Hebrew word *mappah,* as the banners of the twelve tribes are called in *Numbers Rabbah* (figs. 9.10, 10.10).

These Synagogue decorations are religiously connected with the Messianic days, anticipating the gathering and reuniting of the tribes and their return to

10 *Numbers Rabbah* portion 2, 5, 6.

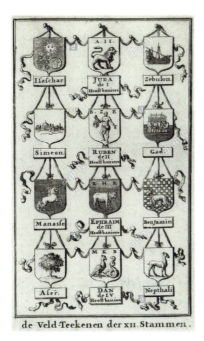

FIGURE 10.5
Jan Luyken Willem Goeree, *The Emblems of the Twelve Tribes of Israel,* illustration in a Dutch Bible, 1683

FIGURE 10.6
Artist unknown, *Emblem of the Tribe of Zebulun* (right) and *Emblem of the Tribe of Dan*, late 19th century, wall paintings on the Torah Ark, Synagogue in Cekiske, Lithuania

Zion. But in the early 20th century, a different, secular approach to this theme expressed itself in book illustrations and Zionist educational materials.

Designers of these secular emblems must have been familiar with the Christian precedents as well as with *Numbers Rabbah*. Those who knew Hebrew could read the original; others were aided by translations, mainly into German. One such book is *Geschichte der Judisch-Hellenistischen und Talmudischen Litteratur, eine Anthologie für Schule und Haus* (History of Jewish-Hellenistic and Talmudic Literature, an Anthology for School and Home) by Dr. J. Winter and Prof. Aug. Wünsche, (Berlin: M. Poppelhauer, 1897). Although the book does not contain a full translation of *Genesis Rabbah* or *Numbers Rabbah*, it provides readers with a synopsis of their contents.

FIGURES 10.7, 10.8 Avraham Mendel Grünberg (Grinberg), (left) *Banner of the Tribe of Judah*, (right) *Banner of the Tribe of Zebulun*, wall paintings, ca. 1900–1920, The Great Synagogue in Harlau, Romania

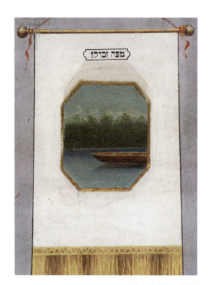

FIGURES 10.9, 10.10 Avraham Mendel Grünberg (Grinberg), (left), *Banner of the Tribe of Zebulun*, (right) *Banner of the Tribe of Benjamin*, wall paintings, 1927–1928, Grain Merchants' Synagogue in Bacau, Romania

For German Reform Judaism, the significance of the twelve tribes went beyond a narrow, straightforward notion of their symbolism for the Jewish People's unity through diversity. It could be read as something vaguer—the concept that lies in the German term *Zwölf Stämme* (twelve tribes). A tribe was

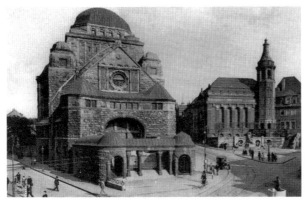

FIGURE 10.11 *The Essen Synagogue*, inaugurated in 1913, destroyed during *Kristallnact* 1938 and restored in 1994

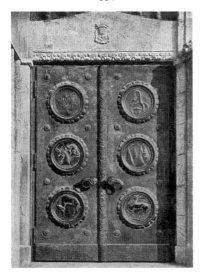 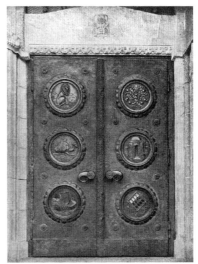

FIGURES 10.12, 10.12A Essen Synagogue bronze doors, 1913

precisely how Reform Judaism envisioned Jews in Germany; one of the German tribes, just like the Bavarians, Saxons, Badenians, Pomeranians, Silesians, etc., which together make up the German Nation. By adhering to such a concept, Reformed Jews advocated the fact that they were a natural part of the German nation which was comprised of many tribes.[11]

11 On German-Jewish "tribal" identity see: Jens Neumann-Schiliski, *Konfession oder Stamm : Konzepte jüdischer Identität bei Redakteuren jüdischer Zeitschriften 1840 bis 1881 im internationalen Vergleich* (Confession on the Tribes, the Concept of Jewish Identity in Contemporary Jewish Publictions, 1940–1881), Edition Lumiere, 2011.

Emphasizing the Jewish-German connection is best represented on the doors of the Synagogue in Essen, Germany (inaugurated in 1913, figs. 10.11, 10.12). This Synagogue is a prime example of the German Reform Judaism's *Stämme* concept. Its façade boasted three bronze doors, two of which with reliefs, illustrating the emblems of the tribes. The images were set in roundels; the name of each tribe was inscribed (in Hebrew lettering) at the bottom of each. The doors were cast in bronze and decorated with color enameling.[12] The building was partially destroyed during *Kristallnacht* (1938), and the present doors are a reconstruction of the original ones.

Since the original doors of the Essen Synagogue did not survive, their sole visual documentation is black and white photographs which, of course, do not document the doors' original coloring. Fortunately, we have a detailed verbal description from 1913 that tells us the exact color of each original door's enameling. Not surprisingly, it shows that their designers adhered—though only partially—to the specific coloring mentioned in *Numbers Rabbah*.[13] The emblems' images on the Essen Synagogue doors (see Table 1) are thought to be based on the graphic work of artist Ephraim Mose Lilien.[14]

10.5 E. M. Lilien's Legacy

Lilien first included the twelve tribes' emblems within his designs for *Lieder des Ghetto* (Songs of the Ghetto, 1902) by the Jewish poet Morris Rosenfeld. A decorative frame (fig. 1.13) shows that his emblems echo both Christian Bible title pages (published at least 400 years prior to his) and wall paintings in Eastern European Synagogues. The artist used the tribes' emblems in illustrations he contributed to other Jewish publications (fig. 10.14).

Lilien's large-scale stamp collection album in the Israel Museum Library collection in Jerusalem (fig. 10.15) contains stamps issued by the Jewish National Fund in Berlin. The stamps carry no date; it is, therefore, unclear

12 Brocke, Schwwiderowski, Strehlen, Kohn, *Architektur—Kultur—Religion, Ein Spaziergang durch die Alte Synagoge* (Architecture—Culture—Religion, a Stroll inside the Old Synagogue), Essen: Alte Synagoge Essen, 2010, 21.

13 "Reuben's enameling of the background and in between the fruits was red; Simeon's name was enameled in green; Levi's background was one third white, one third black and one third red; Judah's color was blue; Zebulun's color was white and Gad's colors were white and black". Brocke, Schwwiderowski, Strehlen, Kohn, *Architektur—Kultur—Religion, Ein Spaziergang durch die Alte Synagoge,* 20–26.

14 Ibid. 20.

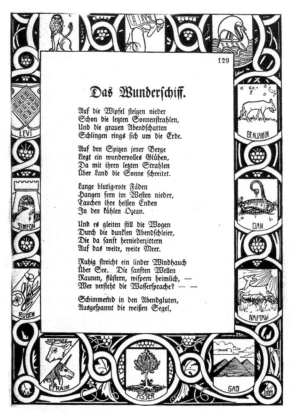

FIGURE 10.13 Ephraim Mose Lilien, *Illustration for Das Wunderschiff* (The Ship of Wonders), in *Lieder des Ghetto* (Songs of the Ghetto) by Morris Rosenfeld, Berlin: Calvary Verlag, 1902

whether they were designed by another artist *after* Lilien's illustrations or served Lilien as sources for his own designs. As a fervent Zionist, Lilien's associations with the Jewish National Fund show in several of the Fund's projects. His emblems of the twelve tribes, appearing on the title page of *The Golden Book* of the Jewish National Fund (fig. 10.16), also frame the upper part of the Fund's certificate awarded to donors, almost all are exact copies of Lilien's designs (fig. 10.17).

Lilien's images served other Zionist publications such as posters, children's games, and educational books. Maps of the Land of Israel played a significant role in contemporary Zionist thought and education, functioning as visual images and cartographic texts of the Homeland. Some of these maps were based on an earlier tradition of maps of the Holy Land that showed

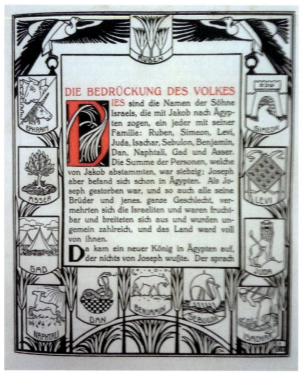

FIGURE 10.14 Ephraim Mose Lilien, *Frame for Die Bedruckung des Volkes* (Oppression of Nations), chapter in *Bücher des Bibel* (Books of the Bible), 1909

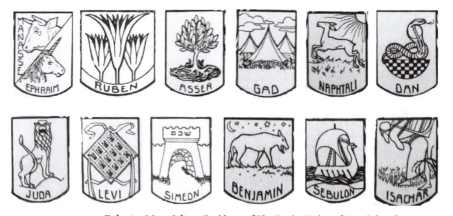

FIGURE 10.14A Ephraim Mose Lilien, *Emblems of The Twelve Tribes of Israel*, details

contemporary towns and villages within a virtual framework of the biblical twelve tribes' estates.

THE TWELVE TRIBES OF ISRAEL

FIGURE 10.15
Ephraim Mose Lilien's stamp collection album, The Israel Museum Library Collection

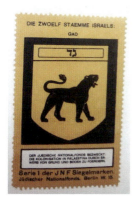
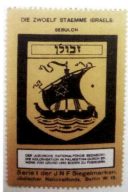
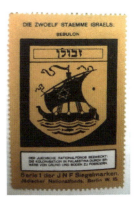

FIGURE 10.15A Jewish National Fund, *Twelve Tribes of Israel* stamps

FIGURE 10.16 Ephraim Mose Lilien, *Design for the Cover of the Jewish National Fund Golden Book*, ca. 1902

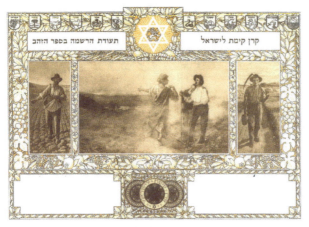

FIGURE 10.17 Emil Ranzenhofer (1864–1930), *Jewish National Fund Golden Book Certificate*, 1902

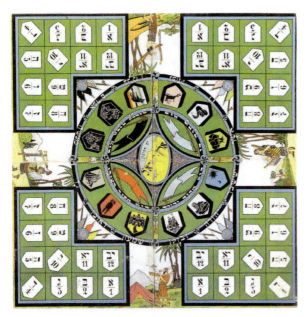

FIGURE 10.18 Lewin Epstein Bros. (publishers), Gameboard for *Entry of the Twelve Tribes into the Land of Israel*, Warsaw, 1920s

Players of the game *Entry of the Twelve Tribes into the Land of Israel*, published in Warsaw in the 1920s (fig. 10.18), advanced from the borders of the game board to its round center. That point was the site of *Eretz Israel* (The Land of

FIGURE 10.19
Banner of the Hebrew Gymnasium in Lodz, after 1901, 135 × 180 cm, blue and white silk, blue and gold embroidery

Israel), surrounded by crest-shaped emblems of the tribal Patriarchs' banners, arranged in a circle. All of them echo Lilien's designs.

Contemporary Jewish educational institutions also embraced the emblems' Jewish identity of unity and diversity. The Hebrew Gymnasium in Lodz, Poland, a boys school founded in 1901 (fig. 10.19), had a banner made from light-blue and white silk material. Its central motif of a *menorah*, mistakenly depicted as a nine-branched candelabrum instead of the correct number of seven, is accompanied by the Hebrew words *Vayehi or* (Let there be light). Emblems of the twelve tribes of Israel within decorative entwined vegetal branches appear on its reverse.[15]

10.6 Beyond Lilien's Legacy

In 1919 German industrialist Konrad Goldman commissioned Artist Friedrich Adler (1878–1942) to design the interior of an agricultural farm, established to prepare young people for their immigration to Palestine. Adler created a pair of large stained glass windows. The farm was sold in 1926, and five years later, Goldman decided to donate the window to the Tel Aviv museum. It was shipped to Palestine and installed in the museum in 1932.[16]

Adler's magnificent window (fig. 10.20) exhibits an original visual version concept of the twelve tribes emblems. The artist adhered to traditional tribes' attributes but stayed away from the colors mentioned in *Numbers Rabbah* and excluded mentioning their names. His modern design distances itself

15 An inventory card (B-190) of the Jewish Historical Institute in Warsaw contains a detailed description of the images depicted on the banner: Naphtali's emblem shows a doe, Gad shows a banner, Issachar's a donkey, Judah's a lion, Reuben's a jug with a sword, Simeon's a sun, Levi's a palm tree, Benjamin's a wolf, Dan's a snake, Zebulun's a wave and a ship on the shore, Asher's a bowl of fruit and Joseph's shows a bunch of grapes.
16 Bat Sheva Goldman Ida, *Friedrich Adler* (exh. cat.), Tel Aviv: Tel Aviv Museum of Art, 2013, 18–19.

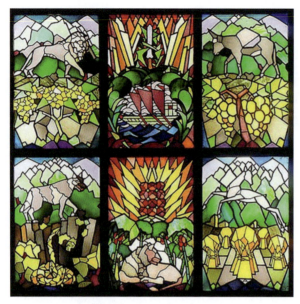

FIGURE 10.20 Friedrich Adler, *The Twelve Tribes*, 1919, stained glass window, made of six parts, 53.5 × 81 cm each

from Lilien's *Jugendstil* model and shows a personal style, close to the *Wiener Werkstäte* ideals.[17]

The window shows (top row, left to right): Judah, symbolized by a lion in front of white, snowy mountains. Simeon is represented by a white sword, pointy shapes in the background (probably a suggestion of spears or lances). Issachar is shown as a donkey laden with a burden. The second row, left to right, shows Asher, represented by a large treetop in front of clumps of earth and green hills. Next is Zebulun. Within a format of a wreath, a three-sail ship with three oars. The background shows white clouds. Within a rectangular shape, the artist signed his work with the letter A, the first of his last name. Third row, left to right shows Benjamin: a wolf marching in front of snowy mountains. Levi's priestly breastplate is comprised of twelve red stones, emanating shining rays of light. Naphtali is symbolized by a leaping gazelle in front of snow-covered mountains. Bottom row, left to right shows Dan, a golden serpent in

17 Adler's work was set on one of Tel Aviv Museum's windows; it remained *in situ* until 1973 when the museum moved into its new edifice. The work was removed and put in the new museum's basement only to be exhibited forty years later in an exhibition of some of his works (2013).

a desert environment; Gad, in a nonconventional depiction of a lioness in a flowery field and Joseph as sheaves of corn, symbolizing his brothers as he saw them in his dream (Genesis 37:5).

A later, famous artistic interpretation of the twelve tribes theme is Marc Chagall's twelve stained glass windows at the Hadassah Hospital Synagogue in Jerusalem (inaugurated in 1962). The Synagogue is a cubical edifice; its windows are arranged in groups of three, an arrangement that echoes the encampment of the twelve tribes of Israel around the Tabernacle in the wilderness. This arrangement seems to be the only traditional element in Chagall's design. Although dedicated to the twelve tribes of Israel theme, the artist hardly adhered to the long tradition of depicting the tribes' banners as emblems; his work is mainly impressionistic.[18]

10.7 Symbols of Sovereignty

The twelve tribes of Israel theme was destined to play a significant role in the overall inventions of Israeli symbolism.[19] During the state's early years, new words and terms were formulated to serve the need of a new nomenclature for notions of sovereignty, words that hardly existed before in modern Hebrew, let alone in Jewish Diasporic culture. The constitutive source for their creation was the Hebrew Bible; words that had certain contextual meanings were turned into modern Hebrew equivalents for contemporary concepts and ideas, political and cultural. One such word was *nassi* whose biblical meaning designated each of the twelve tribes' Patriarchs. In later periods of Jewish history, the term was bestowed on heads of formal institutions of leadership, differentiating themselves by their secular functions from contemporary religious functionaries. When the Israeli parliament ruled for a presidency, the modern Hebrew language had nothing to offer for such a political function; the word *nassi* was then coined as the Hebrew counterpart for president.

In 1948, Chaim Weitzman (1874–1952) was elected the first president of Israel. The committee in charge of designing the official state emblem and

18 Ziva Amishai states that while working on biblical themes Chagall "... gradually freed himself from the text, creating an iconography for the expression of his own philosophy and personal feelings". This is true of the Jerusalem windows as well. See: Ziva Amishai, "Chagall's Jerusalem Windows", in Moshe Barash *Studies in Art,* vol. XXIV, Publications of the Hebrew University, Jerusalem: The Magness Press, the Hebrew University, 1972, 147–182.

19 Emblems of the twelve tribes of Israel were mentioned in chapter 4, as part of the Municipal School's ceramic decorations.

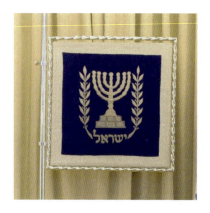

FIGURE 10.21
Nes haNassi, the Israeli Presidential Standard

flag was asked by the Prime Minister's Office to produce an official standard for the newly elected president. Its name in Hebrew was to be *ness hanassi*, turning both biblical references of *ness*—flag, or banner, and *nassi*, the tribe's Patriarch, into the new, Israeli Hebrew term for the presidential standard.

The Provisional Government's State Emblem and Flag Committee announced a competition. Its members were advised about potential images for the presidential standard. They finalized their ideas on the European models of rules governing the design of modern, international heraldry of presidential standards.

An unsigned letter, sent to the Flag and Emblem Committee informed its members that

> ... Switzerland does not have a Presidential standard ... Czechoslovakia's presidential standard comprises of the state's emblem on a white background (fig. 10.22). The French Republic presidential standard uses the tricolor flag (fig. 10.23)... One should note that all presidential standards' formats are square ... I suggest adopting the Czech example: to tie ribbons around the state emblem blue and white ribbon and add silver tassels.[20]

In early September 1949, the committee announced the winner of the competition: Israeli graphic designer Franz Kraus (1905–1998). The official minutes document the components of the presidential standard and its colors.[21] Devoid

20 *Letter of 22.11.1949*, Israel State Archive, File 18-395-ג.
21 The width was to be 35 centimeters and the height of the presidential standard was to be 40 centimeters. Its colors were to be blue and white. See: *Protocols of the State Emblem and Flag Committee*, 1.9.1949, Israel State Archive, file g-395–18.

THE TWELVE TRIBES OF ISRAEL

FIGURE 10.22
Czech Presidential standard (1918–1939), 1945–1960

FIGURE 10.23
French President Vincent Auriol's standard 1947–1954

of its crest format, the Israeli official state emblem appears on the square format of the presidential standard (fig. 10.21). It is framed by a decorative silver border and is attached to a silver pole, surmounted by a Jewish Star. The linking of the twelve tribes' tradition to the newly formed presidency of Israel as a sovereign state was most likely the vision of the Transportation Minister David Remez. Remez served as the head of the committee and shared with it his considerable knowledge of Jewish lore in general and its symbolism in particular.

The great immigration waves in the 1950s brought natives of many countries and nations to Israel. The second president, Yitzhak Ben-Zvi, who served during those years, referred to them in the Hebrew term *shevet*—tribe. Ben-Zvi initiated monthly meetings at the Presidential Mansion for which representatives of various communities—Hungarian, Greek, Yemenites, Indian and many more—were invited. "The aim of these meetings," states a book which surveyed them, "was one of the Israeli Presidential Mansion's missions to

consolidate the tribes, who immigrate from it [Jewish Diaspora] in order to integrate them into a single Nation."[22]

This very idea guided Israeli artist Shalom (Siegfried) Seba (1897–1975) in his proposal for a mausoleum for Chaim Weitzman, the first president of Israel, who died in 1952. Seba's design for the burial site comprises of twelve sketches for stained glass windows, each dedicated to one of Jacob's sons (fig. 10.24).

Seba's choice to depict the twelve tribes of Israel as human figures was innovative and revolutionary. Facing Jewish and Zionist emblematic traditions, the artist extended them and gave them more substance. Such an individualistic approach enabled him to endow each tribe with human traits. Exemplary sketches will show how the artist translated his verbal inventory of human traits and feelings into a varied visual rendering of facial expressions, body language, costumes, and accessories.[23]

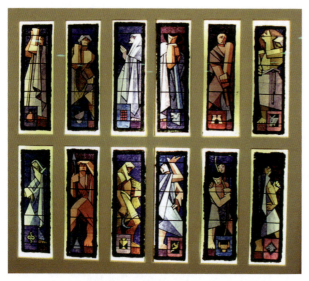

FIGURE 10.24 Shalom (Siegfried) Seba, *The Twelve Tribes of Israel,* sketches for stained glass windows, watercolor on transparent paper

22 *Shivtey Israel beVeit haNassi biYerushalayim* (Tribes of Israel at the Presidential Mansion in Jerusalem), Tel Aviv: Dvir Publication, 1959 (unpaged).
23 For a full discussion of Seba's twelve tribes sketches see my catalogue entry in *Bypassing Abstraction: Hidden Gems from the Yossi and Daniela Lipschitz Collection,* Ra'anana: The Open University of Israel Art Gallery, 2014. Seba's psychological mappings are quoted here by quotation marks, followed by my own descriptions of each sketch.

FIGURE 10.24A
Shalom (Siegfried) Seba, *The Twelve Tribes of Israel*, detail, *Judah*

"Judah" (fourth from the left in the upper row of fig. 10.24, 10.24a), Seba wrote, "[is] a knight, courageous, sure of himself, calm, gracious, fair. His character is the noblest of all. He deserves the recognition and trust [of his brothers]. Association: Steel and Crimson".[24] Judah wears a white and blue cape. His hair

24 Seba in a letter to a friend (written in German) as quoted in Gideon Ofrat, *Shalom Seba, Monographya* [Shalom Seba, Monography], Ein Harod: Mishkan leOmanut Ein Harod, 1994, 93.

FIGURE 10.24B
Shalom (Siegfried) Seba, *The Twelve Tribes of Israel*, detail, *Benjamin*

is black. His left hand leans on his shoulder. He is shown from a three quarters vantage point. At the bottom of the sketch, the artist depicted the traditional stylized emblem of a lion's head.

"Benjamin" (first on the right in the lower row of figs. 10.24, 10.24b), he wrote, "[is] the robber, stubborn, dandy, self-satisfied, arrogant. The youngest of Jacob's sons, spoiled, despises people. Association: threat." We see Benjamin from the back; he turns his gaze backward, to meet our eyes. His face expresses

THE TWELVE TRIBES OF ISRAEL 235

FIGURE 10.24C
Shalom (Sigfried) Seba, *Naphtali*

worry. His diagonal eyebrows turn upwards. He holds a sword in his left hand, as if hiding it stealthily behind his back. With pride, he places his right hand next to his waist in a gesture of defiance. The bottom shows the traditional stylized emblem of a wolf.

Naphtali (fig. 10.24c) "Enthusiastic, complacent, free of worries, mischievous, full of imagination, stunning, combines word and gesture. Singer and dancer, representing everything that bears association to the Muses. Association:

clarity, cheerfulness." Seba's Naphtali is a youth, wearing what may be taken as a Greek *peplos*, depicted in a ritual dancing posture. His open mouth suggests that he accompanies his dance by singing. He lifts his right hand upwards, fingers spread open. His left points downwards, its inner part with fingers suggesting a dance movement. His emblem is a stylized gazelle.

Jewish traditional concept of the twelve tribes of Israel regarded them as symbols of the entire Jewish People; all traits and characteristics, activities and various ways of human behavior symbolized in a general way the complexity of Jewish society and culture. Shalom Seba imbued this general concept with human, secular aspects. Polar approaches such as the figures of Benjamin and Judah, the "stubborn, dandy, self-satisfied, arrogant, spoiled," as opposed to the other, "the noblest of them all," make Seba's work unique in comparison with former Jewish artists' works who were satisfied with traditional iconic emblems.

Saba's goal in designing the gravesite for the first president of the State of Israel meant to present the complexity of the new Israeli society and endow the institution of the presidency with a sovereign aspect. His revolutionary ideas, however, were not accepted by the conservative public committee appointed for the design of the gravesite. Ultimately, after discussions and deliberations, the project was granted to a sculptor who designed a standard tombstone, devoid of symbolic significance and meaningful expression.[25]

Echoing Yitzhak Ben Zvi's conception, emblems of the twelve tribes of Israel appeared for the first time on an official Israeli stamp, designed by Oteh Walisch (figs. 10.25, 10.25a), printed in dark blue and grey-silver, the colors of the Israeli presidential standard. The stamp shows the Temple *menorah* in the center, surrounded by crest-shaped ensigns of the twelve tribes. The inscription on the bottom is a quotation from Numbers: "And the children of Israel shall pitch their tents, every man by his own camp, and every man by his own standard, throughout their hosts." (Numbers 1:52). The image of Waliish's stamp is a minimalistic, modern recreation of the twelve tribes' encampment around the Tabernacle in the wilderness. The central *menorah* stands for a concise representation of the Tabernacle, as one of its most sacred utensils.

Walisch's stamp parallels Seba's aim at creating metaphorical, unique representation of the various groups of people who form Israeli society. Seen as representatives of the young state's social groups as they are arranged around the institution of the presidency links biblical times with contemporary Israel. The *Menorah* stamp first-day issue envelope shows a map of the twelve tribes' estates in the Land of Israel.

25 Competition for Chaim Weitzman's Burial Site file, *The Vera and Chaim Weitzman Mansion Archive*, Rechovot.

THE TWELVE TRIBES OF ISRAEL

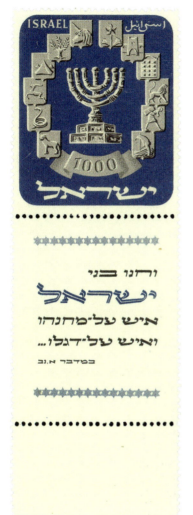

FIGURE 10.25
Oteh Walisch, *The Menorah Stamp*, 1952

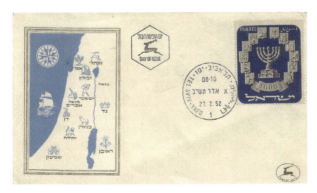

FIGURE 10.25A
First-day issue envelope,
27.2.1952

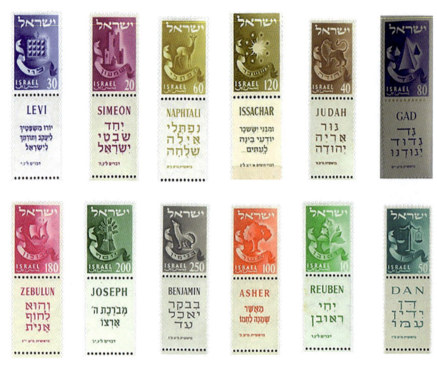

FIGURE 10.26 George Hamori, *Twelve Tribes of Israel Stamps*, 1956

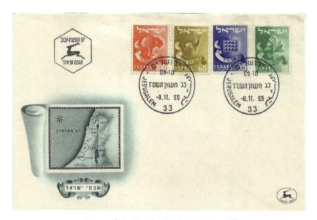

FIGURE 10.26A *Map of the Twelve Tribes Estates,* illustration on the first-day issue envelope for the *Twelve Tribes of Israel* stamp series, 1956

Four years after the issue of The *Menorah* stamp, Israel Postal Services issued a series of twelve stamps, each one depicting an individual emblem of the twelve tribes (1956) (fig. 10.26). They replace Lilien's black and white linear images with colored, tonal effects that make them look like three-dimensional

reliefs. The series shows Dan's snake replaced by scales; Issachar's traditional donkey replaced by sun, surrounded by 8 Jewish Stars.[26] A different version of a map depicting the twelve tribes' estates in the Land of Israel follows the one of the 1952 issues.

10.8 Emblems of a Mythical Promised Land

The conquest of the Land of Canaan by Joshua and the twelve tribes as related in the Bible,[27] and the region's geographical division into their estates, is alive in contemporary Israel, bypassing hundreds of years that separate the biblical Kingdoms of Judah and Israel from the 20th century sovereign state of Israel.[28] Certain areas of the country are linked to the tribes' estates and are named accordingly; i.e., *Gush*[29] *Dan* is the central part of the country bordering the Mediterranean Sea, Tel Aviv being its largest city. *Emek Zvulun* (Zebulun's Valley) is in the north of the country, next to the city of Haifa, a large seaport, whose municipality emblem quotes the iconic ship that traditionally appears on Zebulun's emblem (fig. 10.27). Jerusalem's municipal emblem quotes the lion of Judah, as the city lies within the biblical estate of the tribe of Judah (fig. 10.28).

After the Israeli Six Day War (1967), the country extended its borders; the West Bank became an integral part of the Israeli map. These added territories—held as freed by certain sections of the Israeli society or conquered and occupied by others—brought forth a new concept: a replacement of the concrete geographical borders of the sovereign state by an eschatological view of *Eretz Israel* (The Land of Israel). Reconstructed maps of the twelve tribes' biblical estates serve to replace the legitimate geographical maps of the sovereign state into a mythical map of a Promised Land, disregarding any geographical facts of international boundaries.

The biblical term *Eretz Israel* mentioned above is not the same as the formal, legitimate term of the sovereign State of Israel. It is based on an a-historic mixture of two entities—an alleged revival of the biblical kingdom of Judah combined with the biblical Kingdom of Israel. It is used by Israeli political right-wing ideologists in their reasoning for *Ertz Israel hashlema*—the whole Land of Israel,

26 See also Table 1.
27 The history of Joshua's conquest of the Land of Canaan is told in Joshua, chapters 1–8.
28 For a detailed discussion of the biblical conception of territories reflected in Israeli geography see: Lea Mzor, "Beyn Mikra leTzionut, haTfisa haShivtit shel haMerchav haMishtakefet biShmot Yishuvim mehaAssor haRishon laMdina" (On Bible and Zionism, the Tribal Conception of Territory Reflected in Israeli Place Names During the First Years of Statehood), *Cathedra* no. 110, December 2003, 102–122.
29 *Gush* in Hebrew means a group of adjoining cities that spread to become a single entity.

FIGURE 10.27
Haifa's *Municipal Emblem*

FIGURE 10.28
Jerusalem's *Municipal Emblem*

or the land's borders promised by God to the Israelites. According to this notion, all contemporary *Jewish* citizens of the sovereign state of Israel are seen as their natural descendants, while the country's non-Jewish minorities don't count.

Certain Israeli municipal councils situated outside the pre-1967 sovereign borders of Israel adopt the traditional emblematic images of the tribes and incorporate them in their official emblems. The lion of Judah appears on *Mateh Yehuda* (literally Judah's staff, Judah's region) Regional Council

FIGURES 10.29A, B, C, D From left to right: *Mateh Yehuda* [Judah] Regional Council; *Mateh Binyamin* [Benjamin] Regional Council; *Bney Shim'on* [Simeon] Regional Council; *Mateh Asher* Regional Council

(fig. 10.29). Simeon's jug and sword appear on the *Bney Shim'om* (Simeon's Sons) Regional Council (fig. 10.29b). Benjamin's wolf is incorporated into the *Mateh Binyamin* Regional Council (fig. 10.29c). Asher's olive tree appears on *Mateh Asher* Regional Council emblem (fig. 10.29d).

The difference between a Zionist symbolical-metaphorical conception of the biblical description of the twelve tribes estates, appropriated by regional councils and municipalities located within Israel before 1967 and that of those situated outside these borders, lies in the latter's claim for them to be neither symbolic nor metaphorical but a historical fact.

By incorporating the emblematic ensigns of the twelve tribes onto their contemporary official emblems, Israeli municipal councils make a political statement; indirectly, they revive a biblical past which enables them to blur Israel's pre-1967 sovereign borders with a virtual mapping of a Promised Land. It serves the a-historical parallelism drawn between the tribes' conquest of the Land of Canaan, based on biblical descriptions of the tribes' estates, with its Israeli conquest in the 20th century of certain geographical areas previously within the borders of the sovereign states of Jordan and Syria, some of which turned into Palestinian territories. Through the use of familiar and popular emblems, the purpose of such parallelism is meant to legitimize the country's extension of its borders.

TABLE 1 Images appearing on the emblems of the twelve tribes of Israel

	Geneva Bible (1599)	E. M. Lilien (1902)	Essen Synagogue (1913)	Israeli postal authority stamps (1956)
Judah	Lion	lion	lion	lion
Zebulun	ship	ship	ship	ship
Issachar	donkey	donkey	Laden camel	Sun surrounded by 8 Jewish stars
Simeon	Sword	Fortress gate	Fortress gate	gate

TABLE 1 Images appearing on the emblems of the twelve tribes of Israel (*cont.*)

	Geneva Bible (1599)	E. M. Lilien (1902)	Essen Synagogue (1913)	Israeli postal authority stamps (1956)
Reuben	Crest with wavy horizontal lines	Three lilies standing for mandrakes	Flowers standing for Mandrakes	Plant standing for Mandrakes
Gad	Flag (banner)	Tent	Tent	Tents
Manasse	–	ox	Head of an ox	–
Ephraim	–	unicorn	unicorn	–
Benjamin	Wolf	wolf	wolf	wolf
Asher	Chalice	tree	tree	tree
Dan	snake	snake	snake	scales
Naphtali	Deer (with horns)	doe	doe	gazelle
Levi	Open book	High Priest's Breastplate	Ephod (priestly breastplate)	Ephod (priestly breastplate)
Joseph	ox	–	–	Sheaf of corn

Bibliography

Amishai, Ziva, "Chagall's Jerusalem Windows," in Moshe Barash *Studies in Art*, vol. XXIV, Publications of the Hebrew University, Jerusalem: The Magness Press, the Hebrew University, 1972.

Etz Yosef (Rabbi Chanoch Zundl), Anaf Yosef (Rabbis Yitzhak and Zvi Kopelowitch), *Midrash Rabot eem Be'urim Ahuvim u'Vrurim* (Commentaries with Two Beloved and Clear Explanations) [In Hebrew], Warsaw: 5624 (1886) (not paged with Roman numerals.

Ginsburg, Dov, "laZehut haMinerologit shel Avney haChoshen" (Concerning the Mineralogical Identity of the High Priest's Breastplate Gems), in *Sefer Shmot Meforash bidey Amos Chacham* (Commentary on Exodus by Amos Chacham), Jerusalem: haRav Kook Institute, 1991.

Goldman Ida, Bat Sheva, *Friedrich Adler* (exh. cat.), Tel Aviv: Tel Aviv Museum of Art, 2013.

Mishory, Alec, *Bypassing Abstraction: Hidden Gems from the Yossi and Daniela Lipschitz Collection*, Ra'anana: The Open University of Israel Art Gallery, 2014.

"Moshe haDarshan", *Encyclopaedia Hebraica* [In Hebrew], Jerusalem and Tel Aviv, Vol. 24.

Ofrat, Gideon, *Shalom Seba, Monographya* (Shalom Seba, Monography), Ein Harod: Mishkan leOmanut Ein Harod, 1994, 93.

Réau, Louis, *Iconographie de l'art Chretien* (Tome II, *Iconographie de la Bible, Ancien Testament*), Paris: Presses Universitaires de France, 1956.

Schwwiderowski, Brocke, Strehlen, Kohn, *Architektur—Kultur—Religion, Ein Spaziergang durch die Alte Synagoge* (Architecture—Culture—Religion, a Stroll inside the Old Synagogue), Essen: Alte Synagoge Essen.

Sefer Sgulot ha'Avanim Tovot (Book on the Qualities of Precious Stones), Jerusalem: Yarid hasfarim Publication, 2005.

Shivtey Israel bevit hanassi biYerushalayim (Tribes of Israel at the Presidential Mansion in Jerusalem), Tel Aviv: Dvir Publication, 1959 (unpaged).

Tilbury, Clare, "The Heraldry of the Twelve Tribes of Israel: An English Reformation Subject for Church Decoration," *Journal of Ecclesiastical History*, Volume 63, Issue 2, 2012.

Uri, Lesser, "Gedanken über Judische Kunst" (Passing Thoughts about Jewish Art), *Ost und West*, February 1901.

CHAPTER 11

Old and New in Land of Israel Flora

11.1 Israeli Plants as Local Icons

> ... So what business did your mother have with Tonichka's grave ... she used to take the girl there and I would see how both of them stand next to the grave and all around them cyclamens in bloom, just like anemones always grow on top of ancient ruins so cyclamens love graveyards. Any place you see anemones, people used to live there and any place you see gravestones it seems that they are like rocks for cyclamens ...[1]

This is how Israeli author Meir Shalev refers to two iconic flowers in Israel; his anecdote is based on myths created for these Israeli plants.

Throughout the history of Jewish culture, the Flora of the Holy Land was steeped in beliefs, legends and myths. From time immemorial Jews were familiar with *The Seven Kinds*—fruits, plants and vegetables which stand for the Land of Israel's bounty and goodness. Jews blessed *The Four Species*, comprised of citrus fruit, myrtle, palm and willow, symbolizing the various types of people who form a Jewish community. Jews fantasized about the enormous cedars of Lebanon used by King Solomon for building the Temple in Jerusalem. They evoked the palm tree and the prophetess Deborah who sat under it while speaking her words of wisdom. The Rose of Sharon and the Lilly of the Valley mentioned in The Song of Songs added an erotic aspect to Jewish yearning for the Land of Israel.

The legendary flora of the land formed the base for one of Zionism's most significant ideas: The conquest of the wilderness, or Making the Desert Bloom. This Zionist concept claims that at the turn of the nineteenth century, Palestine was a barren place; the first Zionist settlers' almost mythic role was redeeming it from such a disastrous state and make it bloom by carefully planned agricultural enterprises. Removing rocks, planting, and engineering watering systems would rejuvenate the land and restore life to the country's long gone bounty and fertility. Such agricultural enterprises would bring back the country's mythic qualities, as they are believed to exist during the biblical and Hasmonean eras. The settlers of the new-born Land of Israel created modern legends concerning the country's flora and added them to their rich extant tradition.

[1] Meir Shalev, *keYamim Achadim* (As a Few Days), Am Oved 1994, 132. (My translation).

Botanical study and research of local flora became a popular subject among the settlers and aided them in creating new legends and myths for the flora of their new land. By adhering to such scientific concepts, the scholarly research of the Land of Israel's flora focused on local plants that Jews were already familiar with in the Diaspora. Well-versed in Jewish traditions, the settlers could easily identify these familiar plants. The significance of returning to the land was reinforced symbolically as the New Jews arrived at a place whose flora they were familiar with in theory; there, on the land itself and for the first time, they came face to face with it in reality.

Yehoshua Margolin, a science teacher, reminisced about his first encounter with the Land of Israel:

> [It is] the end of the month of *Elul*. I find myself on the deck of a ship, making its way to the shores of my beloved patriarchs' land. My eyes are fixed on the east, a place where a string of mountains, behind the blue fog, charm my heart. From within the misty air, gradually, my beloved land reveals itself to me. Mount Carmel is nearing us; a Group of palm trees on the beach appear to me like a group of sacred priests, approaching with their hands stretched out to greet the sons who are returning to the bosom of their Motherland. Peace unto you, palm leaves! Oh, how I have yearned for you from the far Diaspora! And now, here I am, ready to plow, sow and plant, ready to listen to the whispers of grass roots and trees![2]

Zionist aspects of renewal, revival, and fulfillment were incorporated into the symbolism of the Land of Israel's familiar plants. In most cases, the plants' traditional religious-ritualistic aspects were neutralized; the emphasis was put on their contemporary aspect as representatives of the land's bounty.

11.2 Familiar Biblical Plants: the Seven Kinds

The most specific biblical image of the Land of Israel's bounty tells about a variety of plants: "A land of wheat, and barley, and vines, and fig trees, and pomegranates; a land of oil olive, and honey; A land wherein thou shalt eat bread without scarceness, thou shalt not lack any *thing* in it; a land whose stones *are*

[2] Yehoshua Margolin, "Arba'at haMinim" (The Four Species), *Moladetenu*, 7–8 as quoted by Yom Tov Levinski, "Sukot," in *Sefer haMoadim, Parashat Mo'adey Israel, Erkam, Giluyeyhem veHashpa'atam, beChayey Israel veSafruto, miYemey Kedem ve'Ad haYom haZeh*, (Book of Jewish Festivals, Issue of Jewish Festivals, their Values, their Manifestations and their Influence on Jewish Everyday Life and Literature from Ancient Times to this Very Day), Tel Aviv: Dvir Publishing, 1957, 126.

iron, and out of whose hills thou mayest dig brass" (Deuteronomy 8–8, 8–9). This grouping of seven plants is called *The Seven Kinds*. While Diasporic visual images of *The Seven Kinds* in Synagogue decorations acted as symbolic elements connoting longing for a return to the Land of Israel, their use as images in the *yishuv* period signified a fulfillment of that yearning. Images of *The Seven Kinds* group stand for both the return to the land and the privilege of enjoying the country's abundance. The great popularity of the visual *The Seven Kinds* motif is also derived from the fact that such a visual rendering of flora is not subject to rabbinical restrictions, unlike the illustration of human figures.

Zionist thought created significant changes in the traditional Jewish symbolism of *The Seven Kinds*. *Tu biShvat*, the 15th of the Month of Shvat is a winter festival commemorating the first flowering of fruit trees, and *Shavuot*, or Festival of Weeks, celebrates the end of summer and harvest. Both relate directly to the country's plant life; the Zionist re-creation of these holidays was marked by process of secularization.

Ceremonies and celebrations conducted in schools throughout the country connected Jewish holidays with Zionist agricultural enterprises. *Shavuot* became a ceremony celebrated in both agricultural settlements and urban centers with school children bringing baskets of fruits to representatives of The Jewish National Fund. Baruch Ben Yehuda describes the celebrations:

> The idea of bringing the first fruits to The Jewish National Fund on *Shavuot* was first conceived in the Jezreel Valley and from there made its way to Haifa. This city conducted … a great ceremony of the festival for adults, with the participation of tens of thousands from all over the country, and especially from Israel's cooperative settlements … It was only The Teachers' Council that could make this idea a reality.[3]

Ben Yehuda's enthusiastic appreciation for The Teachers' Council, loses its momentum when later on he mentions an obstacle it had to overcome. Israeli religious party members found a rabbinical flaw in such a ceremony "At a time when the Temple is no more." They forbade The Teachers' Council to conduct such ceremonies. Long debates followed, at the end of which a compromise was reached according to which the festival's title would be changed to "A festival *in memory* of the first fruits" and that it would be conducted as a narrative, recounting events from the past.[4]

3 Baruch Ben Yehuda, "Chag Zichron haBikurim" (Festival in Commemoration of the First Fruits), as quoted in Levinski, *Book of Jewish Festivals* … 202–204.
4 Ibid.

Certain Zionist "First fruit" or *Shavuot* ceremonies included a totally new and unique ritual entitled "Binding of *The Seven Kinds*" in which youth groups carried branches or stalks of one of *The Seven Kinds*. They offered them to the representative of The Jewish National Fund who would take the branches from them, bind them together into a bundle and say: "Now that they [the branches] became one, they stand for the entire People of Israel. One after the other, the sons of the People of Israel would be gathered from all parts of the Diaspora and would become a great bundle and a great nation."[5]

The biblical symbolism assigned to *The Seven Kinds* is meant to show the bounty of the land of Israel from a botanical point of view. First fruits were brought by the Israelites to Jerusalem there to be received by the Temple priests. In the Zionist ceremonies their meaning was extended into a new symbolic system: examples of plants of the land, conveying a message of "Gathering of the [Jews of the] Diaspora." The symbolic act of binding was enacted by a secular high priest, the representative of The Jewish National Fund. He, in turn, brought the first fruit back to The Jewish National Fund, the modern incarnation of a Zionist Temple.

The Seven Kinds binding performance was, in fact, a mix-up of two groups of plants: that of *The Seven Kinds* and *The Four Species*. It was a Zionist attempt to blur the traditional Jewish symbolism assigned to the two separate groups of plants and extend their secular aspects.

11.3 The Four Species

The symbolic grouping of the *hadas* (myrtle), *lulav* (palm branch), *arava* (willow tree), and *etrog* (citron) is one of the symbols of *Sukkot,* Feast of Tabernacles or Feast of Booths: "And ye shall take you on the first day the boughs of goodly trees, branches of palm trees, and the boughs of thick trees, and willows of the brook; and ye shall rejoice before the LORD your God seven days" (Leviticus 23:40). The 'Shaking of The Four Species,' bound together, is a ritual performed in commemoration and celebration of God's bounty, given to men at the end of the harvest period. The grouping of *The Four Species* is associated with the prayer for rain at the end of the *Sukkot* holiday.

This group of plants is a traditional metaphor for the essence of Jewish communities throughout the world. Its symbolism is based on the senses of smell and taste: taste stands for Torah studies and smell stands for a person's good

5 N. Ben Ari, "Tekes Hava'at haBikurim bIshuvey ha'Ovdim" (Ritual of Bringing the First Fruits in Workers' Settlements), in Levinski, *Book of Jewish Festivals* …, 210–211.

deeds. The palm tree's fruit tastes good but has no smell, therefore it represents Jews who study the Law but are not known for their good deeds. The myrtle bush has a good smell but no taste; the willow tree has no taste and no smell. The citron has both.

The traditional aspect of unity, symbolized by *The Four Species* was removed from this group of plants during the Zionist "First Fruit" ceremonies and was given to *The Seven Kinds*. One could expect the organizers of these ceremonies not to change the clear association of *The Four Species* with the *Sukkot* holiday, but that was not the case. The *Sukkot* ceremonies held at co-operative settlements included similar binding rituals. Dancers would hold palm branches and citrons; children would offer the representative of the Jewish National Fund their produce of the fields and gardens, and then one of them would recite the following:

> ... [Jewish] pioneers arrived in the land of their forefathers, into a good land, a land of water creeks and springs that spring forth out of its mountains and valleys, a land of wheat and barley, vines, figs, pomegranates, a land of olive oil and honey.[6]

The *Four Species* of the *Sukkot* holiday were given the basic characteristics of the *Shavuot* holiday grouping of *The Seven Kinds*. The ceremonies carried out in Israel's rural settlements could also be celebrated in urban centers. In addition to agriculture lessons conducted in elementary schools, in which a certain area within the schoolyard was set aside for a vegetable garden, every classroom had one wall decorated by Jewish National Fund posters. The *Tu biShvat* holiday planting and the "Ceremony of the First Fruits" are shown in these posters, usually as staged ceremonial processions, whose sources were the actual processions in the co-operative settlements.

The *Shavuot* poster (fig. 11.1) shows an Israeli rural settlement, identified by its small white houses with red roofs, spread throughout a vast vacant space. In the foreground, the artist pictures a procession of eight children, carrying First Fruits. They wear flower wreaths on their heads as they march towards a decorated archway at the entrance to a settlement. The arch is decorated with green boughs, flowers and blue and white ribbons. It is crowned by a large emblem of The Jewish National Fund.

6 Ibid.

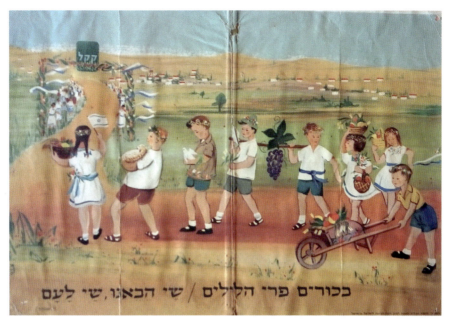

FIGURE 11.1 Zim, *Poster for Shavuot*. 1950s

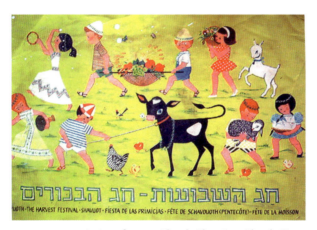

FIGURE 11.2 Artist unknown, *Chag haShavu'ot—Chag haBikurim* (Festival of *Shavuot*—Festival of the First Fruits), 1950s

Another poster (fig. 11.2) shows a direct reference to *The Seven Kinds*; two children carry them in a small basket (at the top). The procession is led by dancing girls, dressed in allegedly Israeli costumes, holding tambourines.

The Seven Kinds as a visual motif was incorporated in various Synagogue decorations. This traditional Jewish phenomenon was carried on by Jewish

artists in Palestine; various sites show examples of the motif along with those of The Twelve Tribes and The Signs of the Zodiac. The façade of *Moshav Zkenim* (Old Folks Home) *Synagogue* in Tel Aviv is decorated with ceramic tiles depicting The Seven Kinds (fig. 11.3) alluding to the return of the Jewish People to its homeland, a place where it is promised a life of plenty.

11.4 Grapes, Figs, and Pomegranates as Symbols of Sovereignty

Zionist thought tried to divert from the Diaspora Messianic way of representing *The Seven Kinds* motif and finding different connotations associated with

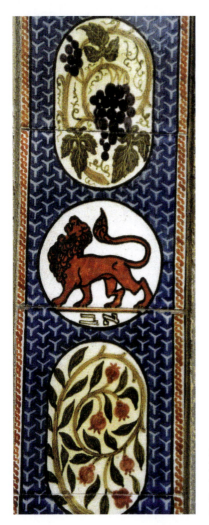

FIGURE 11.3
Bezalel Ceramic Workshops, *Pomegranates, Grape vines*, detail of *The Seven Kinds* decorations, 1923, ceramic tiles, façade of the *Moshav Zkenim Synagogue*, Tel Aviv

 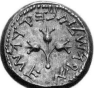

FIGURE 11.4 Hasmonean coins FIGURE 11.5 Bar Kochva coin, 134–135 CE

it, whose models should come from the biblical golden age of the People of Israel. The chosen models signifying sovereignty were either Hasmonean or the Bar Kochva revolt coins (figs. 11.4, 11.5). The designs on these coins linked the bountiful land with its aspects of political sovereignty, through visual images of *The Seven Kinds*.

The designers of these ancient coins were especially aware of the bounty aspect associated with each of *The Seven Kinds* plants. Two of them in particular—grapevines and figs—are referred to individually in the Bible in a different context; they represent hallowed periods of peace and tranquility, both during the biblical period and in prophesies concerning the End of Days: "But they shall sit every man under his vine and under his fig tree; and none shall make *them* afraid: for the mouth of the LORD of hosts hath spoken *it*" (Micah, 4, 4). The biblical metaphoric image of peace and tranquility on these ancient coins conveys a twofold message: the country's bounty and the political aspect of sovereignty and independence.

When the State of Israel was declared, an immediate need for stamps led members of the Provisional State Council to approach the graphic designer Oteh Walisch and commission him to design the first Israeli stamps. His series of stamps is called *Do'ar Ivri* (Hebrew Post) since Walisch created them a few days before the establishment of the state and its official name (fig. 11.6). He based his designs on ancient coins; by stylizing the images of the coins on his stamps, he created a symbolic, inseparable link between the free Judean state of the 2nd century and the new sovereign state of Israel.

A few years later, the same ancient model was used by the Bank of Israel for new Israeli coins (fig. 11.7). The symbolic message was extended as if the modern State of Israel and the ancient Judean state share common fiscal means.

11.5 The Spies Motif

The spies sent by Joshua to tour the Land of Canaan returned to the Israelites camp in the wilderness with proofs of the country's abundance: "And they came

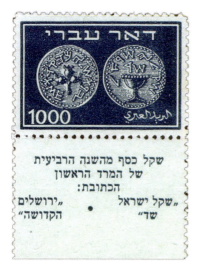

FIGURE 11.6
Oteh Walisch, *Do'ar Ivri* (Hebrew Post) stamp, 1948

FIGURE 11.7
The *Pruta* series of Israeli coins, 1952

unto the brook of Eshcol, and cut down from thence a branch with one cluster of grapes, and they bare it between two upon a staff; and *they brought* of the pomegranates, and of the figs." (Numbers, 13, 23). Prior to the establishment of the State of Israel, *The Spies* motif *was* a popular visual image, standing for the agricultural abundance of the land. It appeared in trademarks and on Zionist postcards. Its popularity is attested by decorations included in the architectural design of national Hebrew poet H. N. Bialik's house in Tel-Aviv: The living room fireplace has ceramic tiles portraying two pairs of men carrying loads (fig. 11.8). One is that of the spies, carrying an enormous cluster of grapes. The other shows two priests carrying the Ark of the Covenant.

Processions, ceremonies, and carnivals in Tel-Aviv of the 1920s often had pairs of students in a *tableau vivant* of *The Spies* motif. The *Daughters of Judea—Present Day* (fig. 11.9) is one of many examples of Zionist produced postcards, documenting contemporary Jewish conquest of the Land of Israel's wilderness, linking its contemporary abundance to biblical prophecies.

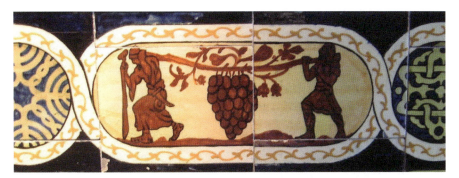

FIGURE 11.8　Bezalel Ceramic Workshops, *Spies,* 1934, ceramic tile decorations on the fireplace in Bialik's House, Tel Aviv

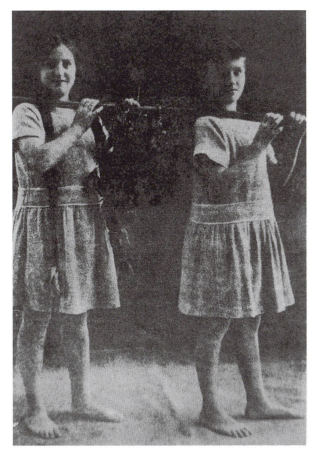

FIGURE 11.9　Avraham Soskin (photographer), *Daughters of Judea—Present Day* (Sisters Fira [left, the author's mother] and Ida Wissotzky, students at the *Herzliya* Gymnasium), 1920s, souvenir postcard

11.6 The New Jew as a Tiller of the Soil

The idea of the modern return to Zion was closely linked with verses from Psalms, commonly familiar to every practicing Jew since they are included in the daily Jewish blessing after the meal:

> (A Song of degrees.) When the LORD turned again the captivity of Zion, we were like them that dream. Then was our mouth filled with laughter, and our tongue with singing: then said they among the heathen, The LORD hath done great things for them. The LORD hath done great things for us; *whereof* we are glad. Turn again our captivity, O LORD, as the streams in the south. They that sow in tears shall reap in joy. He that goeth forth and weepeth, bearing precious seed, shall doubtless come again with rejoicing, bringing his sheaves *with him.* (Psalms, 126, 1–6).

One of the first visual images of the New Jew as a tiller of soil was made by Ephraim Mose Lillien (see chapter 1, fig. 1.20). His illustration contrasts the image of the New Jew with that of the Diaspora Jew, drawn as a stooping and low spirited old man. In Zionist Land of Israel, the new Jewish farmer was portrayed engaged in an array of agricultural activities. Images of a farmer sowing, a reaper, and a shepherd are represented on ceramic tile decorations on the facade of a Tel Aviv building (figs. 11.10, 11.11, 11.12). They are framed by a horseshoe-shaped arched window and surrounded by intertwined pomegranate branches bearing fruit, symbolizing abundance.

A revealing detail in both the sowing farmer decoration and the shepherd is a large sized cypress tree. It is mentioned specifically in the Bible for its affinity with Jerusalem; there is a reason to believe that its inclusion in these ceramic tile decorations was linked with an event in the life of Theodor Herzl.

11.7 Herzl's Cypress Tree Myth

When Herzl visited Palestine in 1898, he traveled "… One afternoon [with Zionist leader David] Wofsohn and Bodenheimer, accompanied by a farmer [named] Brozah to *Motza* [a site near Jerusalem]. [Herzl] listened to [the farmer] story, [recounting the Jewish settlers'] stubborn perseverance and the struggle with the land, waiting for it to bear fruit. On Brozah's plot of land Herzl planted a young cypress tree"[7] (fig. 11.13).

7 Alex Bein, *Theodor Herzl, Biyografia* (Theodor Herzl, a Biography), Jerusalem: 1967, 249–250.

FIGURES 11.10, 11.11, 11.12 *Shepherd*, *'Those who sow with Tears,'* *'Those who Reap with Joy,'* 1925, ceramic tile decorations on the Lederberg House, Allenby Street, Tel Aviv

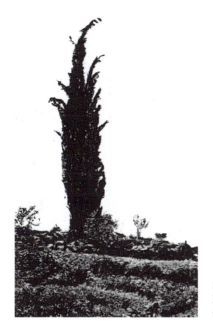

FIGURE 11.13
Herzl's cypress tree in *Motzah*, photograph from the 1920s

Herzl's tree was burnt down, probably in 1929, and only a small remnant of it survived the fire. Alex Bein, Herzl's biographer, notes that "By mistake [people] thought that Herzl planted a cedar tree."[8] The confusion between cypresses and cedars mentioned by Bein stems from a long history of that confusion in Jewish tradition, based on a mix-up between cypress trees and cedars in

8 Bein, Ibid.

the Bible. The cedar of Lebanon is associated with Jerusalem; its affinity is expressed in Psalms: "The righteous shall flourish like the palm tree: he shall grow like a cedar in Lebanon" (Psalms 92, 12). A biblical context refers to the cypress as a symbol for the blooming of the desert: "I will plant in the wilderness the cedar, the shittah tree, and the myrtle, and the oil tree; I will set in the desert the fir tree, *and* the pine, and the box tree together. (Isaiah, 41, 19). During the Mishna period and later on, the proper Hebrew name *erez* (cedar) was extended into a generic name for barren trees. The Talmud replaced the biblical cedar with the modern *brosh* (cypress). And thus, in Jewish symbolism, both trees were assigned similar traits.

The confusion between *erez* and *brosh* is clearly expressed in images of "The Site of the Temple Mount" pictured on 19th-century Jewish souvenirs of Jerusalem. Images of trees were used for visual expressions of the verses from Psalms. *Mizrachim* (the plural form of the Hebrew word *mizrach*, east) are painted panels, traditionally hung on walls in Jewish homes to signify the direction of prayer towards the east towards the Land of Israel and Jerusalem. The most common image on the *mizrachim* was that of the Temple Mount in Jerusalem. Moshe ben Yitzhak Mizrachi, a 19th-century *mizrachim* painter from Jerusalem, placed the Dome of the Rock mosque in the center of his work as a symbol for the Temple Mount. Next to the Mosque, he depicted cypress trees (fig. 11.14).

Bein's statement that "by mistake [they] thought Herzl planted a cedar tree" has a firm basis. The act of planting formed a base for a myth by imbuing the specific plant with symbolic connotations. Herzl did not plant a eucalyptus tree or any fruit tree; his choice of a cedar/cypress tree apparently was not arbitrary.

Herzl cypress myth recounts that it came to life after it was burnt down (or felled). The essence of the myth was included in children's textbooks both in Israel and in the Diaspora:

> Not far from Jerusalem, between mountains and rocks, Herzl planted a cypress tree. The tree grew and turned into a magnificent plant. Children came to sit under its shade and birds came to sing on its branches. One dark night some bad people came and felled the tree with axes. The children saw it and said: one tree was felled—many trees will be planted! They keep their vows: every year children collect donations for tree planting on the Jewish National Fund sites. Many trees were planted already and they turned into a big forest—The Herzl Forest.[9]

9 *Herzl's Cypress Tree*, in Y. Weingarten *Sefer Shlishi leSafa veleNikud* (Third Textbook, for Language and Spelling), Tel Aviv and Warsaw, 1937.

OLD AND NEW IN LAND OF ISRAEL FLORA 257

FIGURE 11.14
Moshe ben Itzchak Mizrachi, *Mizrach*, 1920s, poster

FIGURE 11.15 Illustration for *Herzl's Cypress Tree,* in Y. Weingarten *Third Textbook, for Language and Spelling*, Tel Aviv and Warsaw, 1937

The Herzl cedar/cypress myth soon became a model for visual images portrayed on Jerusalem souvenirs. The Carpet Workshop of Bezalel produced silk tapestries showing the tree as a visual icon. One of them (fig. 11.16) shows the tree next to Abraham's *eshel* (tamarisk), another mythical plant capable of making the desert bloom. The two tree icons are located next to a mythical site: Mount Sinai. An allegedly historical sequence is thus produced between ancient biblical times of the Patriarchs and the modern Zionist era through the mythical scene of "Receiving the Law."

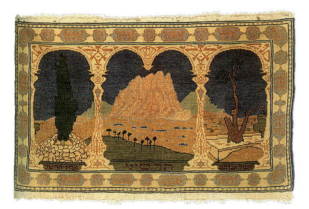

FIGURE 11.16 Bezalel Carpet Workshop, *Abraham Tamarisk Tree, Mount Sinai, Herzl's Cedar Tree*, ca. 1910, silk tapestry

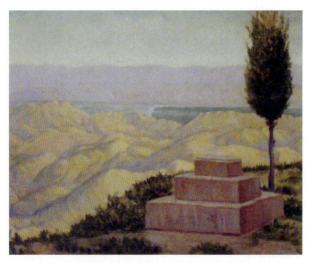

FIGURE 11.17 Aharon Shaul Shur, *The Cornerstone of the Hebrew University in Jerusalem*, 1920s

FIGURE 11.17A
Avraham Melavsky, *Laying the Cornerstone to the Hebrew University on Mount Scopus*, 24.7.1918, photograph

Painter Aharon Shaul Shur (1864–1945), one of the teachers at Bezalel, painted *The Cornerstone of the Hebrew University in Jerusalem* (fig. 11.17). The ceremony of laying the cornerstone for the university in Jerusalem took place on July 24, 1918, on Mount Scopus in Jerusalem. Twelve stones were piled up, representing the Twelve Tribes of Israel.

Shur's painting shows the Judean mountains, bathed in a yellowish light of the setting sun, with bluish-purple shadows. In the foreground, he painted the pile of stones, as they are documented in a contemporary photograph that shows them on a barren hill. In the photograph, the stones are facing a row of cypresses (fig. 11.17a). However, Shur painted only a single cypress tree. It is very likely that he intended to refer to Herzl's cypress; by including the cypress tree in his painting, Shur must have meant to hint at fulfillment of Herzl's vision in the foundation of the Hebrew University.

11.8 Unfamiliar Wild Plants

When they first came to Jewish Palestine, Zionist settlers came across unfamiliar wild flora, not mentioned in the Bible. They created modern legends and myths about them. Professional botanists were naturally familiar with the wild flora of Palestine; however, the plants' nomenclature was expressed in Latin or in the language of the country from which the botanist came from. Consequently, the first settlers' encounter with the country's flora demanded the creation of a Hebrew nomenclature. The existing vocabulary was extremely limited; the Bible mentions many names for trees and fruits, but when it comes to flowers, there are only three: *Shoshana* (rose), *Shoshan* (lily) and *Chavatzelet haSharon* (rose of Sharon)—all of them mentioned in the Song of Songs.

The new Hebrew botanical nomenclature was meant to create a link between the familiar plants with the unfamiliar wild ones. The common language used in this nomenclature for both groups of plants is another expression of the Zionist attempt to create a historical sequence between the present and the past periods of Jewish existence in the Land of Israel.

Hebrew poet Shaul Tchernichovsky made a significant contribution to the formation of Hebrew nomenclature for plants. The poet's early poems of the 1890s are filled with descriptions of nature; they contain expressive descriptions of panoramic landscapes, and at times, the reader's attention is focused on specific wild plants. All the plants Tchernichovsky mentions have Hebrew names. The poet invented most of these names, basing his innovative nomenclature on direct translation of the plant's name from Russian, Ukrainian, or German. He also links the plants' symbolic connotations in Western culture with themes or stories from the Bible.

Agadot ha'Aviv (Spring Legends),[10] a poem written in 1890, talks about flowers, blooming in a wild field:

> A group of *tzitz bar* (a wild flowery bud) springs from the bowels of the earth
> *Eynei tchelet* (light blue eyes) flower opens [its petals]
> *Tzitz zichrini* (a bud of Forget me Not) gazes in the meadow
> The *paamonit* (Campanula flower), a smile on its lips, [grows] on the side of the road and in valleys
> Under the sun's blessing, a *shen ha'arieh* (Lion's tooth, dandelion) bends its golden head.

Tzitz zichrini in Hebrew makes a direct translation of the flower's name in German: *Vergissmeinnicht* (Forget me not). The *paamonit* in Hebrew is *Campanula* in Latin or *Glockenblume*, bellflower in German. *Shen ha'arieh*, *Taraxacum* in Latin, *Lowenzahn* in German (a Lion's tooth).

FIGURE 11.18
The *Viola tricolor* flower, called *Amnon veTamar* in Hebrew

10 Shaul Tshernichovsky, *Shirim*, (Poems), 68. Free translation by the author.

Tschernichovsky's poem *Agadat Amnon veTamar* (The Legend of Amnon and Tamar),[11] written in 1899, tells the story of a flower named after the two protagonists of the poem's narrative. The flower is *viola tricolor*, (fig. 11.20), a European perennial which grows all over Europe between September and April. In *Midsummer's Night's Dream,* Shakespeare tells how Oberon squeezes the juice of this flower into Titania's eyes, magically causing her to fall in love with Nick Bottom. Aware of this aphrodisiac association of this flower, Tschernichovsky links it with the biblical love story of Amnon and his half-sister Tamar (2 Samuel, 13). The story conveys an odd mythological theme as well by turning human beings into flowers:

> And God saw their misery [...]
> And repented of his evil act
> And turned them into innocent flowers;
> They grow together on a mutual stalk
> Distinguished by different hues:
> Light blue and golden buds
> Meant for each other forever.
> Amnon became a wildflower,
> His petals—dark blue
> And his sister Tamar became a yellow spot on his chest.

FIGURE 11.19
Chavatzelet, Illustration in *Schiot haMikra* (Treasures of the Bible)

11 Tchernichovsky's *Amnon and Tamar* was inspired by the Russian name of the plant: "Ivan and Maria". Ido Bassok, *Yofi velaNisgav Libo Er, Tchernichovsky—Chayim* (Of Beauty and Sublime Aware, Shaul Tchernichovsky—a Life), Jerusalem: Carmel Publications, 2017, 115.

FIGURE 11.20
Shoshana, Illustration in *Schiot haMikra* (Treasures of the Bible)

...
The sons of the earth knew of the deed
And named the flower—forever and ever –
Amnon veTamar (Amnon and Tamar).[12]

Tchernichovsky's sophisticated process of linking universal and Jewish traditional themes makes an early attempt for coining a modern Hebrew botanical nomenclature. His innovations are taken for granted by contemporary Hebrew speakers; they are usually surprised to find out that the familiar names of flowers were never mentioned in the Bible prior to late 19th century.

The invention of modern Hebrew names for the Land of Israel flora was a very important feature within the overall Zionist-Hebrew concept of revival and return to the Land of Israel. Stories, legends, and myths about particular plants could only be composed if they had proper, common names. In order to fathom the complexity of the task, one should examine *Schiyot haMikra* (Treasures of the Bible), a popular book published in Hebrew in 1923 in Berlin, Germany. Its editor produced a detailed illustrated chapter dedicated to the Land of Israel flora and fauna. The flower in fig. 11.20 is an anemone; in contemporary Hebrew, it is called *kalanit*. Its caption is *shoshana*. Illustration 11.19 is an iris. In contemporary Hebrew it is called *iris*; the book labels it *chavatzelet*. The editor's choice of these names is not accidental: they were taken from the Bible, since he did not have at his disposal other Modern Hebrew names for these flowers—they were not invented yet.

The lack of Hebrew names for flowers was a task that demanded studying and research. Next to professional botanists, the subject was mostly dealt with by elementary school science teachers. They encouraged their students

12 Tshernichovsky, 114–115. Free translation by the author.

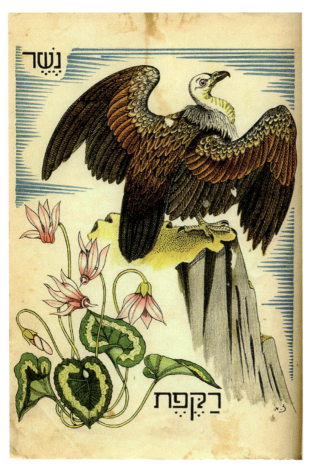

FIGURE 11.21　Zvi Livni, *Nesher, Rakefet* (Vulture, Cyclamen), illustration in Smoli, *Yafa at Artzenu, Sipurim al ha'Chai vehaTzomeach* (You are Beautiful, our Country: Stories of Fauna and Flora), 1951

to observe nature closely. Some did it outdoors, as educational school trips. The teachers' aim was "[To encourage] in the hearts of city children the will to move to country [rural] lifestyle—to tilling of the land, to which we all aspire" as one science teacher wrote.[13]

In the 1950s, Israeli schools taught *Moledet* (literally Motherland), a subject combining science and geography lessons intended to bring their students closer to the country's flora and fauna. Teachers needed images that would

13　Oz Almog, *haTzabar—Diokan* (The Native Israeli—a Portrait), Tel Aviv: Am Oved Publishing, 1997, 259–260.

tone down the scientific aspects of botanical illustrations; the answer for this need was found in Zvi Livni, an Israeli artist-designer, famous for his illustrations of children's books. Livni illustrated Eliezer Smoli's *Yafa At Artzenu: Sipurim al ha'Chai vehaTzomeach* (You are Beautiful, our Country: Stories of Fauna and Flora).[14] *Vulture and Cyclamen* by Livni (fig. 11.21) shows the flower with its stem and flowers, and although the designer refrained from drawing the bulb, as in a botanical illustration, his image still retains botanical traits.

A different approach in drawing a cyclamen was taken by Baruch Ur (fig. 11.22). The flower is shown in its natural surroundings, next to a rock. Two children kneel on the ground next to it. The boy looks at the flower in admiration. The rendering of a narcissus was done in a similar approach (fig. 11.23). The flower is placed in its natural surroundings and is the subject of the children's observation. The boy explains something to the girl—about the flower or about the unidentifiable insect, flying above it. Ur's illustration demonstrates the artist's intention to stay away from a scientific botanical rendering. By placing the flower in its natural surroundings and with the addition of two actors, he turned it into a visual narrative. An intended lack of proportion was taken by the illustrator in the rendition of the plant; its size is enormous in comparison with that of the two children. The readers' process of examining Ur's illustration carries a twofold aspect: they concentrate on the aesthetic narrative aspect of the flower illustration, and at the same time, they learn something about its botanical details.

Familiarizing children with Israeli plants could not be achieved solely by quasi-botanical images; Israeli flora deserved to achieve equal status with the biblical plants. Various poets and authors bridged this gap by composing modern legends, poems, songs, and stories. The cyclamen and the anemone, two of Israel's popular wildflowers, were blessed with legends written especially for them perhaps more than for any other wild plant. They turned into Israeli icons like Herzl's cypress.

11.9 "A Very Lovely Cyclamen"

One of the earliest references to a cyclamen in Hebrew poetry was *Shir haRakefet* (The cyclamen Song) written by Levin Kipnis. It opens with these lines:

> Underneath the rock, wondrously grows
> A very lovely cyclamen

14 Eliezer Smoli, *Yafa at Artzenu, Sipurim al haChay vehaTzomeach* (You are Beautiful, our Country, Stories about Flora and Fauna), Tel Aviv: Yavneh Publishing, 1951.

FIGURE 11.22 Baruch Ur, *Illustration for haRakefet* (Cyclamen) in Levin Kipnis *Tzmacahi, Prachai* (My Plants, my Flowers) ca. 1950

FIGURE 11.23 Baruch Ur, *haNarkis* (Narcissus) in Levin Kipnis *Tzmacahi, Prachai* (My Plants, my Flowers) ca. 1950

> The shining sun kisses it
> and adorns it with a pink crown.[15]

Kipnis' lyrics are a Hebrew variation of *Margeritkelech* (pimpernels), a popular song in Yiddish, written by Zalman Shneur in 1909. The song's melody was a

15 *Prachay, Tzmachay, haShirim Levin Kipnis, ha'Eeyurim Baruch Ur* (My Flowers, My Plants, Poems by Levin Kipnis, Illustrations by Baruch Ur), Tel Aviv: Neidet Publishing, ca. 1950 (undated). Free translation by the author.

traditional Jewish tune to which Kipnis fitted his Hebrew lyrics. *Margeritkelech* are European flowers; Kipnis turned them into a local flower, symbolizing primal Israeli roots.

Expressions of warmth and beauty assigned to the cyclamen flower in Kipnis's song are totally reversed in a story written by Eliezer Smoli; his *rakefet* (fig. 11.21) is bound to lead a miserable life and meet a tragic end. Smoli's legend personifies the cyclamen flower and gives it a quasi Israeli Shirley Temple image: a little orphan girl called *Rakefet* (cyclamen), who lives on the Judean Mountains. "Her face is pink and many curls crown her head." A rich farmer proposes that she become a shepherdess for his flock. In return, he would see that she is taken care of and fed properly. On a cold rainy day, the farmer orders *Rakefet* to take the sheep to pasture. "A heavy rain kept pouring down throughout the day, and cold hail was mixed with it. A strong wind was blowing and the child *Rakefet* was trembling and shivering from the cold and dampness."[16] The lonely shepherdess finds shelter from the rain behind rocks; she bends her head, leans it on her chest and cries bitterly. The tragic end of the story recounts of the sleeping *Rakefet* who dies beside the rocks: "Among the rocks, where she fell asleep, a beautiful flower bloomed, in memory of the shepherdess girl. Its color is pink, like *Rakefet*'s bent face. Every winter, when the rains come, the flower rises from within the rocks ..."[17]

A similar horrible fate to that of the cyclamen flower awaits *Narkis* (fig. 11.24). Like *Rakefet,* he is a shepherd, taking good care of his flock. One hot summer day he leads his flock to a river. One of the sheep goes deep into the water and the strong current sweeps it deep down. The sheep calls to the shepherd: *"Meh-Meh,* save me, my good shepherd *Narkis!* ... Pull me out from the abyss; I am drowning!" *Narkis* jumps into the water to save the drowning sheep "But the sheep was heavy ... it sank into the water and drowned. And with it sank and drowned the good, faithful shepherd *Narkis.*"[18]

Smoli takes his theme of flowers and Death from classical mythology; Flora, the Greek Goddess of flowers (*Chloris* is Latin), was the wife of Zephyr, the Western Wind, who gives birth to flowers. Zephyr presented his wife with a gift: a flower garden, all of which were human beings who had metamorphosed into flowers after death. Clytie, a girl who fell in love with Apollo, the Sun god turned into a sunflower because of her constant gaze at the sun (Apollo). Anemone, in an earlier incarnation, was Adonis, a beautiful prince from Paphos in Cyprus. Venus, the Goddess of Love, fell in love with him. Adonis was attacked one

16 Ibid.
17 Ibid.
18 Ibid.

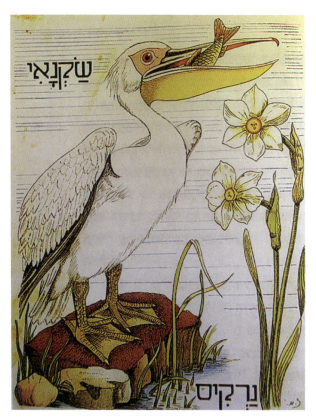

FIGURE 11.24 Zvi Livni, *Saknai, Narkis* (Pelican, Narcissus), illustration in Smoli, *Yafa at Artzenu, Sipurim al ha'Chai vehaTzome'ach* (You are Beautiful, our Country: Stories of Fauna and Flora), 1951

day by a wild boar; Venus tried to help him but came too late. Anemones then bloomed on the spot where Adonis bled to death. A similar fate happened to Narcissus; because he refused to respond to the courting of the nymph Echo, the Goddess Juno punished him and made him fall in love with himself and die while looking at his own reflection in a pond. Flora's garden tells of flowers that grow on the very site where death took place. Consequently, the site becomes a symbol of renewal, of rebirth, resurrection, and transformation.[19] Other legends and myths about flowers are based on natural botanical cycles: they bloom in spring, die during Summer and resurrect, or are reborn, the next Spring.

19 James Hall, *Dictionary of Subjects and Symbols in Art*, New York: Icons Editions, Harper and Row Publishers, 1972, 125.

11.10 "We Shall Return as Red Flowers"

The mythical connection between flowers and Death was extended in Israeli-Zionist thought, especially during the state's early years. Flowers and Death became a common theme, drenched with symbolic messages during the 1948 War. It was especially associated with the Fallen and became one of Israel's most familiar myths, carrying great evocative expression.

In 1948, Israeli poet Chaim Guri (1923–2018) published *Bab el Wad* (in Arabic Gateway to the Gorge) in which cyclamens and anemones are used as a metaphor for the young soldiers killed in the war. The fifth stanza of the poem opens with the following:

> A spring day will come, the cyclamens will bloom,
> Red of anemone will cover hills and slopes.
> He, who would take the path we trod,
> Do not forget us, *Bab-el-Wad*.

The same theme is expressed in yet another poem by Guri: *Hineh Mutalot Gufoteynu* (Our Bodies are Cast Here):

> Here are our bodies, cast, [in] a long line, we are not breathing.
> But the wind blows strongly on the mountains…. and it does breathe.
> The morning is born, and the shimmering dew is fresh.
> We will meet again, we will come back as red flowers.
> You would immediately recognize us, [we are] the mute "Mountain squad."
> We would bloom, when the cry of the last shot is silenced on the mountains.[20]

It is interesting to note that the mythic affinity with anemones was created a short time after the end of the British mandate in Palestine. This very flower, during the British Mandate, stood for the British soldiers serving in Palestine. The Jews nicknamed them *kalaniot*, a derogatory nickname for their Red Berets. *Kalaniot*, a contemporary popular song, written by Israeli poet Natan Alterman, is usually regarded as referring to the British red berets. However, we cannot be sure whether this was the poet's direct intention; the theme of flower resurrection or rebirth is mentioned in it as well:

20 Chayim Guri, *Shirim* (Poems), free translation by the author.

Sunsets on the mountains would burn and die out
But *kalaniot* would always bloom.
Many a storm would whirl and rumble
But anemones would always burn anew.
Kalaniot, kalniot, reddish, ruddy *kalaniot*.[21]

Within the elements of Nature, described as in a constant process of change and storm, there exists a consistent element that repeats itself incessantly: anemones always bloom again and again.

A series of stamps published by the Israeli Postal services in 1952 alludes to this symbolic combination. The Israel Post introduced a tradition of issuing stamps on Memorial Day and Independence Day. The series (fig. 11.25) commemorates sites of decisive battles in the 1948 War, each with one of Israel's wildflowers. The 110 *pruta* denomination stamp shows a soldier's grave marked by a sign with the inscription "Fell in action"; the city of Safed is in the background; next to it, an anemone is in full bloom. The 60 *pruta* stamp of 1954 (fig. 11.26) shows the ruined Gadin fortress in which members of Kibbutz Yechiam found shelter during the war juxtaposed with the *dam haMakabim* (Maccabees' blood) flower. The 350 *pruta* stamp shows a bridge on the Jordan river, next to Kibbutz Gesher, with a narcissus.

Five years later, the concept was repeated, this time without the battle sites images. The designer used only a flower: a narcissus, an anemone, and a

FIGURES 11.25
Oteh Walisch, *Independence Day Stamp*, 1952

21 Free translation by the author.

FIGURE 11.26
Oteh Walisch, *Independence Day Stamp*, 1954

cyclamen (figs. 27a, b, c). The flower became an icon that represents the fallen in battle; an image of the battle site was no longer necessary.

11.11 "Nobody Understands Cyclamens Anymore"

The heroic conception linked to Israel's 1948 War and the early years of the state changed during the 1960s and the 1970s. The Six-Day War, which took place 20 years after the state of Israel's establishment, utterly transformed the character of the country, and cracks appeared in the traditional attitude toward its early years. Israeli artists created new and critical views of the heroism myth. In 1978, Israeli artist Michael Gross made a minimalist print entitled *Ish Aino Mevin Shuv Rakafot* (No one Understands Cyclamens Anymore) (fig. 11.28). On the upper left, the artist quoted the final line from *Shir haRakefet* (The Cyclamen Poem), by Israeli poet Yehuda Amichai (1924–2000):

 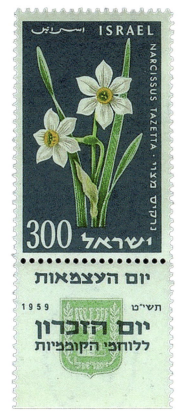

FIGURE 11.27 Zvi Narkis, *Independence Day Stamps*, 1959

We were there time and time again
We will be there many times more
Under a rock grew a cyclamen
Nobody sees cyclamens

Don't go home, love
Feelings apparently aren't used anymore
Love has grown within our hearts
Like the mosquito in Titus' head

Don't heed [don't put your heart] the heart
Will put itself heavily on the world
Don't sing aloud because
If someone would hear, everything will cease.

FIGURE 11.28 Michael Gross, *Ish Aino Mevin Shuv Rakafot* [Nobody Understands Cyclamens Anymore], 1978, silkscreen print

Tired hours are coming back,
Eyes would shut like stores
Electricity would return in a long way
To the turbines, through the whole thread.

No one would receive compensations
They all need to learn languages
But under the rock a cyclamen screamed
No one understands cyclamens anymore.[22]

Gross's print (fig. 11.30), created about 30 years after the 1948 War, carries a completely different message from that of works produced in the earlier period of Israel's existence (the series of stamps mentioned above). His different approach to this Israeli myth parallels the difference expressed in Yehuda Amichai's poem in comparison with the messages conveyed in the poems of Chaim Guri, written in 1948. The symbolic concept of fallen soldiers who are resurrected through flowers that bloom on the battle sites of 1948 changed; the symbol that consoled Guri during the 1948 war causes Amichai to feel anger and frustration. The earlier perception of the symbol as the purveyor of solace and faith in what was to come turned into the foreboder of pessimism and despair. The absence of a visual image of a cyclamen in Gross's work may be

22 Free translation by the author.

interpreted that there are no more cyclamens, that there is no more resurrection, or that despite the cyclical blooming of cyclamens, Israelis forgot what they stand for and are deaf to the cry from beneath the rock.

The same feeling of desolation appears ten years later in the works of Israeli artist Moshe Gershuni (1936–2017). His quasi-abstract print (fig. 11.29) pictures images of cyclamens with long stems and heart-shaped leaves. The artist made these images with his fingers, dipping them in paint and smearing it onto the bedding in repetitive circular motions. In the midst of the cyclamens he incorporated text fragments in Hebrew: *Yom Aviv Yavo* (A Spring day would come …), *Yitbarach* (May [his great name] be blessed) and Y*ishtabach* ([May his great name be] praised).

It is obvious that the texts Gershuni incorporated in his work, and the title he gave it, bear an affinity to *Bab el Wad*—Chaim Guri's poem mentioned above. The flowers in his print do not function as symbols for blooming, resurrection or life. They are not lovely or "crowned by a pink crown," as cyclamens are described in Levin Kipnis' lyrics. Gershuni's cyclamens are crude and look like monumental, fleshy growths. Their leaves remind one of human body

FIGURE 11.29 Moshe Gershuni, *Yom Aviv Yavo veRakafot Tifrachna* (A Spring Day would Come and Cyclamens would Bloom), 1981, silkscreen print

parts, perhaps even genitalia and buttocks. Their flowering or wilting may be interpreted as a projection of the artist's emotional state, with the cyclamen serving as his self-personification.

Most scholars' commentaries on Gershuni's *Cyclamen* series discuss it by referring to the artist's personal life; they hardly touch on its Jewish contexts.[23] By quoting verses from Guri's poem, Gershuni identifies the flowers with the fallen in battle, and they parallel the soldiers' life cycles after coming back to life. The words *Yitbarach* and *Yishtabach* are taken from the *Kadish*, a prayer recited by Jewish mourners in memory of someone that passed away.[24] When The Mourner's *Kadish's* last verse is recited, the worshipper turns to God and asks to bring peace unto the Jewish People: "[...] He who makes peace in his high holy places, may he bring peace upon us, and upon all Israel; and say Amen."

By quoting a secular poem side by side with a traditional religious prayer and juxtaposing them with an image of cyclamens, a meaningful symbol from the past, Gershuni expresses the Israeli tragedy of bereavement and loss in war and his own longing for peace. His *A Spring Day would Come, and Cyclamens would Bloom* is an example of conveying a sharp and convincing message using a popular icon that is transformed and presented in a new context. The flora of Israel, which was initially used as a symbol of the love of the land and belonging to it, is also used as a pessimistic symbol of the same country in which the flowers grow; a land that imposes a heavy price on its inhabitants.

11.12 Local Plants Revisited

The iconic image of anemones was used by artist-designer David Tartakover in several of his posters in which he expresses his protest against political events in Israeli history. *Ke'ev* (or *Ke'av*) (fig. 11.30), a poster published in 1989, shows a face of a little girl who was shot and lost her eye. A *kalanit*—anemone—covers her face. The image is based on a contemporary photograph that was published in a daily newspaper, documenting the Palestinian plight during the *Intifada*. Tartakover's image of the girl is ambivalent; consequently, she can be identified either as an Arab or as a Jewish girl.

23 See: Yigal Zlamona (curator), *Moshe Gershuni 1980–1986* (.exh. cat), Jerusalem: The Israel Museum, 1986; Itamar Levi (curator), *Moshe Gershuni, Avodot 1987–1990* (Moshe Gershuni Works, 1987–1990) (exh. cat.), Tel Aviv: Tel Aviv Museum of Art, 1991.

24 "... May his great name be blessed, forever and ever. Blessed, praised, glorified, exalted, extolled, honored elevated and lauded be the Name of the holy one, blessed is he...."

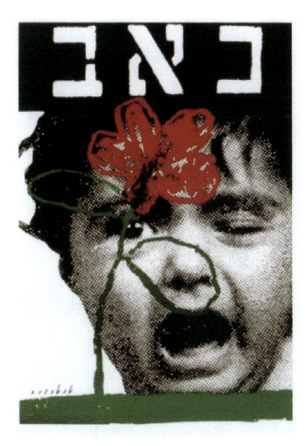

FIGURE 11.30 David Tartakover, *Ke'ev* (or *Ke'av*) (Pain or as a Father), 1989, poster

The ambivalence is intensified by the title of the poster as well; three Hebrew letters—without Hebrew punctuation—that can be read in two different ways: *ke'ev*—pain—or *ke'av*—as a father. The first reading conveys a more general message, referring to the plight of innocent war victims. The second may be interpreted as a Jewish-Israeli father's concern for that very plight, a father who beholds the atrocities performed all around him and cannot do anything to stop it. The Hebrew inscription is done in white; the other colors of the poster are red, black and green. Together, as a group, they are the colors of the Palestinian flag. When Tartakover published this poster, the public display of the Palestinian flag was illegal in Israel, which endows his poster with a clandestine and subversive aspect. Tartakover was very much aware of the strong image he created for this poster; using the familiar iconic emblem of an anemone, he was sure of the Israeli audience's reception of it and realized its

FIGURE 11.31 David Reeb, *Kalaniyot III* (Anemones III), 2013, oil on canvas

powerful potential as a visual means for political protest by claiming that the little Palestinian girl is a martyr, a result of Israeli wars.

David Reeb (b. 1952) created an almost sacrilegious act by using anemones (fig. 11.31). His painting shows a young Palestinian, recognized by his *keffiah* headdress, holding a red flower in his hand. His gesture borders on the absurd; his colleagues are busy throwing rocks, as part of their protest against Israeli soldiers, while he stopped for a minute to pick a flower. The landscape is that of the Judean hills; it is the same site referred to by Israeli poets in 1948. Reeb appropriates the highly charged metaphor of the Israeli Fallen to the Palestinians; his painting presents an alleged, everyday phenomenon of a man picking flowers.

About twenty years after Moshe Gershuni established the image of the cyclamen as one of the most familiar icons of Israeli-Jewish visual culture rendering of bereavement and the wish for peace, Uri Gershuni (b. 1970), the artist's son, returned to it in a series of photographs, in which he fashioned a link between his work and his father's (fig. 11.32). The artist photographed various corners of his apartment and created a series of interiors; each photograph includes a flowerpot with cyclamens. All the components in the photographs—the overall cleanliness and minimalism, the white walls, the bare floor—serve to accentuate the cyclamen's glowing color. All the cyclamens are at the peak of their bloom, beautiful and alive; the artist restores their pink crown which had been lost in his father's works. The cyclamens in Uri Gershuni's photographs are not wildflowers; they are cultured cyclamens grown in hothouses and not found in nature. They do not express any of

FIGURE 11.32 Uri Gershuni, *Aviv* (Spring), a series of color photographs, 90 × 120 cm, 30 × 40 cm

the Israeli myths that Moshe Gershuni mourned; these are pushed aside and replaced by a synthetic culture—decorative, cold, distant and alienated, as signifying the artist's cultural and historical milieu.

Artist Eli Shamir created a post-modern comeback to the Seven Kinds motif, combining it with a renewed reference to classical mythology. He linked the traditional pomegranate with contemporary Israeli existence in his *Persephone* (fig. 11.33), the daughter of Demeter, Goddess of the Harvest. Hades, King of the Underworld, noticed her one day and fell in love. He planted a narcissus in a meadow to entice her to pick it; pulling on the flower opened up the Underworld, and Hades sprang out and carried her off to his underground realm. Demeter searched for her everywhere and stopped all crops from growing until her return. When she finally found Persephone, Hades refused to set her free. The two finally reached an agreement, but before Persephone went back, he fed her pomegranate seeds. Eating the seeds bound her to the

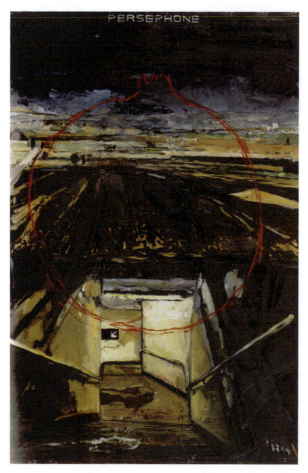

FIGURE 11.33 Eli Shamir, *Persephone*, 1992, oil on canvas, 183 × 121.5 cm

underworld forever, and she had to stay there one-third of the year. When Persephone stays in the underworld, Demeter refuses to let anything grow, and winter starts. In spring, when Persephone stays with her mother, plants grow again. She thus turned into a symbol of renewal, new birth, and resurrection, and her attribute is the pomegranate.[25]

The upper part of Shamir's painting shows a nocturnal rendering of the Jezrael valley. The lower part shows a staircase, leading to an underground shelter. Shamir tied two themes together: he established a link between a mythological figure, mentioned only in the work's title at the top of the painting,

25 Hall, *Dictionary of Subjects and Symbols in Art*, 259–260.

FIGURE 11.34 Michal Shamir, *Untitled*, 2000, candies and gum-drops on a metal armature

the pomegranate as a red outline juxtaposed on the picture plane, and Israeli reality. The mythological abyss becomes an underground shelter in Shamir's painting. Persephone's shuttling between the underworld and the surface of the earth becomes a metaphor for the Israeli way of life. The underworld represents the underground shelter which is always a part of their life, a constant reminder of wars. It is opposed to periods of peace and prosperity, as conveyed by the panoramic view of the fields.

Works by Michal Shamir[26] and Ilan Averbuch use different materials for their references to the grapevine motif, signifying the bounty of the Land of Israel as perceived by Joshua and the spies. Shamir's *Untitled* (fig. 11.34) refers to Isaiah's admonishment prophecy:

> Now will I sing to my wellbeloved a song of my beloved touching his vineyard. My wellbeloved hath a vineyard in a very fruitful hill: And he fenced it, and gathered out the stones thereof, and planted it with the choicest vine, and built a tower in the midst of it, and also made a winepress therein: and he looked that it should bring forth grapes, and it brought forth wild grapes [*be'ushim* in Hebrew].[27] (Isaiah 5)

Shamir's sculpture is made of colorful candies and gumdrops, taken from their real function as savory sweets and turned into a sticky bunch of grapes in the

26 No relation to Eli Shamir.
27 The word *be'ushim* in Hebrew usually means smelly and spoilt fruit.

process of slow decomposition and rotting. Averbuch's grapevine (fig. 11.35) is a huge composition of rough rocks, hung on heavy wooden railroad beams. Shamir's sculpted grapes were covered by flies and insects, sucking its sweet juices and bringing the sculpture into total extinction. The size of Averbuch's grapes does echo the biblical description as symbolizing, by their enormous size, the bounty of the land; however, *Promises, Promises*, the title he gave his work mocks God's promise as unfulfilled.

Probably after getting acquainted with Lillien's *Daughter of Zions* illustration (chapter 1, fig. 1.10) artist Larry Abramson (b. 1954) made a series of works entitled *Rose of Jericho* (fig. 11.36). His research of local Israeli symbolic elements led him to an early legend, written in the 1930s, about various plants of the Land of Israel. Baruch Chernick wrote a legend about Moses' last days:

> When the day came for Moses to die ... God showed him the entire area of the Land of Israel.... God saw what was in Moses' heart and ordered the winds of heaven to bring Moses gifts from the country's bounty ... the winds rose to their task and gathered in their wings delightful scents of laurels, thyme, jasmine, and other mountain plants. Moses suddenly noticed something fluttering in the air, slowly coming down, landing next to his feet. Moses picked it up, and saw that it was a dry plant, curled into a ball ... God [said]: "Take a little water and sprinkle it on the plant." Moses took some water and sprinkled it on the plant, wetting it.

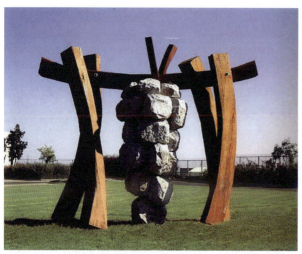

FIGURE 11.35 Ilan Averbuch, *Havtachot, Havtachot* (Promises, Promises), 1990s, rocks, wooden railway beams

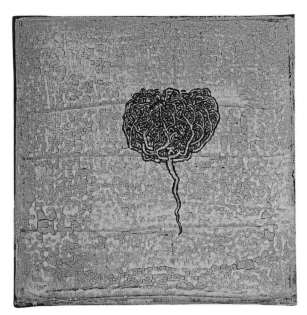

FIGURE 11.36 Larry Abramson, *Rose of Jericho III*, 2003, oil and acrylic on canvas, 38 × 38 cm

The minute the water touched the plant, it recovered and its stems straightened and became a rose. Then God said "Fear not, Moses my servant! As this plant, your spirit and memory will live and be blessed forever and ever." ... From that time onward, after producing its seeds, the Rose of Jericho curls up, lifts it roots, and drifts to wherever the winds would carry it. When the rain comes, its stems rise and straighten, and alive once more, the rose sheds its seeds.[28]

Both Chernick and Abramson, as Lilien before them, transformed the Christian symbolic connotations of the plant into a Jewish and then an Israeli context of resurrection. Abramson's earlier preoccupation with biblical themes dealt with Mount Nebo, the last site mentioned in the Bible from which Moses could view the land promised by God to the Israelites. On the *Nebo* series of paintings, as he was quoted describing it as a metonym of the land, a fragment that

28 Baruch Chernick, *Tzimchey El, Agadot veSichot al Tzimchey Eretz Israel* (God's Plants; Legends and Conversations about the Land of Israel Flora), Tel Aviv, 1930. See also: Tami Manor Friedman, *Larry Abramson, Shoshanat Yericho* (Larry Abramson, the Rose of Jericho) (exh. cat.), Jerusalem: Sadnat haHedpes, 2004.

cuts itself off the land and finds itself rolling to the brim, to Nebo, to gaze at the unattainable. Abramson identifies with Moses' unattainable stance and compares it with his own stance as an artist, whose task is a series of attempts at describing the unattainable.[29]

11.13 A Symbol Shared by Two Peoples: the Israeli Cactus

Israeli-Jewish culture also allocated symbolic meanings to other plants that grow in the Israeli geographical space. One of these, the prickly pear, called *tsabar* in proper Hebrew and *sabres* in the vernacular, has no roots in Jewish culture. It became a Jewish-Israeli icon (though it eroded by years of usage). According to an early pre-State Zionist concept, the fruit—prickly on the outside, soft and sweet on the inside—stood for the *sabra*, the native New Jew, a complete negation of the old Jew of the Diaspora. The *tsabar* symbol was used extensively in commercial visual communications, especially in posters and caricatures.

A pain of otherness typifies the late works of Assim Abu Shakra (1961–1989) in which he conveys social-cultural messages both concerning himself as an Israeli-Palestinian artist and indirectly, metaphorically, of his Arab society and culture. In a minimalistic drawing (fig. 11.37) he shows an image of an Israeli soldier, holding a machine gun in his left hand, his right pointing, directing the attention of a man, standing next to him, to a hedgerow of cactus bushes. The man is a stereotype, derogatory image of an Arab: unkempt, unshaved, barefooted, his shoes held in his hands. We don't know what the artist saw in his mind's eye when he drew this drawing; nevertheless, both protagonists' body language—the soldier in a stance of defiance, the other suggesting subservience—may make us hear a mute conversation in which the soldier says "You think that this is yours—but it is mine."

Arab Israeli culture sees hedgerow of cactus plants as a symbol of place, used for marking town and village boundaries and for traces of destruction and ruination. Kamal Boulata explains that *sabr*, the word for cactus in Arabic means not only the plant but patience and perseverance.[30] He also claims that in Arabic the word *sabr* rhymes with *kabr*, grave, that the two concepts in Abu Shakra's works produced an image of a cactus plant, planted in a household pot, an allusion to Palestinian suffering as a people uprooted from its soil and

29 Tali Tamir (curator), *Motivin Tanachiyim baOmanut haYisraelit* (Biblical Motifs in Israeli Art), Tel Aviv: Artists House, 3.
30 Kamal Boulata, *Palestinian Art 1850–2005*, London: Saqui, 2009, 185.

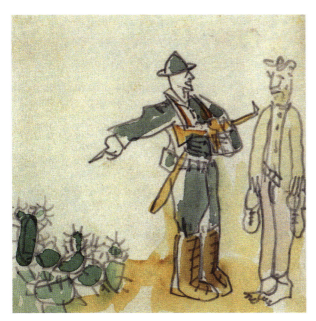

FIGURE 11.37 Assim Abu Shakra, *Untitled*, 1988, pencil and watercolor on paper

planted within a foreign one. Abu Shakra painted a series of images of potted, household cultured cactus plants. His cactus in a pot motif became his trademark.

Most scholars' commentaries of the artist's potted cactus motif present it in its Israeli context, both for its personal aspect, as well for an Arab artist' living within Jewish society in Israel and for the Palestinian national plight aspect hinted in his works.[31] Their words indirectly attest to a concealed struggle for the right to use the cactus plant as a symbol for either Jewish-Israeli society or that of Palestinians, hinted in Abu Shakra's drawing. Jewish-Israeli culture's refusal to pass its *sabra*-cactus symbolism into the hands of Israeli-Palestinian culture, was clearly expressed in a retrospective show, organized by Tel Aviv Museum after Abu Shakra's death. Curators of the exhibition decided to add to its elaborate, comprehensive catalog a supplement, containing a short article entitled *haTzabarim Halalu* (These Sabres) in which Gideon Ofrat traces

31 For various interpretations and commentaries on Abu Shakra's works see: Elen Ginton, "haPasion shel Assim Abu Shakra" (The Passion According to Assim Abu Shakra), in *Assim Abu Shakra* (exh. cat.), Tel Aviv: Tel Aviv Museum of Art, 1994, 10–12; Tali Tamir, "Tzel haZarut: al Tziyurav shel Assim Abu Shakra" (The Shadow of Strangeness in Abu Shakra's Paintings), Tel Aviv: Tel Aviv Museum of Art, 1994, 13–16.

FIGURE 11.38 Micha Kirschner, *Abba Eban*, 1996, from the series *The Israelis*, published in the daily newspaper *Ma'ariv*

the history of the *sabre*-cactus motif in the works of *Jewish* Israeli artists. It is only in his conclusion that he mentions Abu Shakra's cactuses and sees in them an exceptional, new phenomenon in the history of Israeli art treatment of the theme.

Abu Shakra's works are embraced and highly appreciated by contemporary Jewish-Israeli art lovers and connoisseurs. Two years after the retrospective exhibition held at Tel Aviv Museum, photographer Micha Kirschner (b. 1947–2017) published a photograph portrait of Israeli statesman Abba Eban (fig. 11.38), one in a series of photographs entitled *The Israelis*. Kirschner added make-up to his subjects and entrusted them with various accessories. Abba Eban, usually conceived by Israelis more like a British Lord than an average Israeli, was ordered by the photographer to wear a *kova tembel* (literally a fool's hat, a local Israeli accessory of the 1950s and 1960s) and hold a potted cactus in his hands, most probably formally quoting Abu Shakra's motif. The tiny cactus plant indicates the dying concept of the *sabre* as a symbol to the Zionist New Jew concept and its reduction, through a representation of a decorative cultured plant, into an image-icon lacking any mythical symbolic-national aspect.

Bibliography

Almog, Oz, *haTzabar Diokan*, (The Native Israeli—a Portrait), Tel Aviv: Am Oved Publishing, 1997.

Bassok, Ido, *Yofi velaNisgav Libo Er, Tchernichovsky—Chayim* (Of Beauty and Sublime Aware, Shaul Tchernichovsky—a Life), Jerusalem: Carmel Publications, 2017.

Bein, Alex, *Theodor Herzl, Biyografia* (Theodor Herzl, a Biography), Jerusalem: 1967

Boulata, Kamal, *Palestinian Art 1850–2005*, London: Saqui, 2009.

Chernick, Baruch, *Tzimchey El, Agadot veSichot al Tzimchey Eretz Israel* (God's Plants; Legends and Conversations about the Land of Israel Flora), Tel Aviv: 1930.

Ginton, Elen, "haPasion shel Assim Abu Shakra" (The Passion according to Assim Abu Shakra), in *Assim Abu Shakra* (cat. exh.), Tel Aviv: Tel Aviv Museum of Art, 1994.

Guri, Chayim, *Shirim* (poems).

Kipnis, Levin, *haBrosh vehaDegel, Zmanim, Sipurim* (The Cypress and the Flag, Times and Stories), Tel Aviv: Shmuel Zamzon Publishing, 1976.

Levinski, Yom Tov, "Sukot," in *Sefer haMoadim, Parashat Mo'adey Israel, Erkam, Giluyeyhem veHashpa'ata, beChayey Israel veSafruto, miMey Kedem ve'Ad haYom haZeh*, (Book of Jewish Festivals, Issue of Jewish Festivals, their Values, their Manifestations and their Influence on Jewish Everyday Life and Literature from Ancient Times to this Very Day), Tel Aviv: Dvir Publishing, 1957.

Shalev, Meir, *keYamim Achadim* (As a Few Days), Tel Aviv: Am Oved 1994.

Smoli, Eliezer, *Yafa at Artzenu, Sipurim al haChay vehaTzomeach* (You are Beautiful, our Country, Stories about Flora and Fauna), Tel Aviv: Yavneh Publishing, 1951.

Tamir, Tali, "Tzel haZarut: al Tziyurav shel Assim Abu Shakra" (The Shadow of Alienation in Abu Shakra's Paintings), Tel Aviv: Tel Aviv Museum of Art, 1994.

Tchernichovsky, Shaul, *Shirim* (Poems), Tel Aviv: Schocken Publishing, 1959.

CHAPTER 12

Ancient Magic and Modern Transformation: the Unique Hebrew Alphabet

A legend in the *Zohar* tells that when God created the world, he spoke Hebrew with his angels. The twenty-two letters of the Hebrew alphabet, engraved on his crown, descended from on top of it and gathered around him. One after another they tried to convince God that the creation of the world should be done through them. From the letter *tav*, last in the Hebrew alphabet, to the letter *gimel*, its third, every letter tried to persuade the Creator that it is worthy of that honor—to no avail. Two remained: the letter *bet*, second in the alphabet, and *aleph*, the first. *Bet* claimed that she[1] merits God's choosing since all creatures on earth bless God with the word *baruch*, blessed, beginning with it". "Amen" God answered. "So be it." He created the world, as it is written *Bereshit* ... (In the beginning ...) Then God turned to the letter *aleph* and said: "Why didn't you introduce yourself as all other letters did?" *aleph* answered: "It is not for me to ask the creator of the world to change his mind after he bestowed honor on another letter that obeys his orders." God answered: "Oh *aleph*, in spite of the fact that I chose the letter *bet* to assist me in creating the world, you too would be blessed with honor." Because of its modesty, *aleph* became the opening letter of the Ten Commandments.[2]

The most significant expression of the Israeli-Jewish locality is the Hebrew language. Before it became the spoken language of its Jewish population, it had highly sacred connotations and was treated a holy language, God's language. Yosef Dan described this perfectly:

> One of the major results of the Zionist revolution in Jewish culture is turning the Hebrew language from a divine into a human language, just like any other language. The revival of the Hebrew language in the Land of Israel in recent generations made Hebrew a language that lost all its divine characteristics with their endless layers of meaning and acquired the characteristics of a human language.[3]

1 "Letter" in Hebrew is *ot*, is a feminine word.
2 *Introduction, The Zohar*, Jerusalem: Rabbi Kook Institution, 1984.
3 Joseph Dan, "Lashon Elohit, Lashon Enoshit ve'Haba'ah Omanutit" [Divine Language, Human Language and Artistic Expression], in *Neustein, Tzaig veGrossman beMartefei haSifriya haLeumit* (Neustein, Tzaig and Grossman in the National Library basements), The Israel Pavilion at the Venice Biennale, 1995 (ex.cat), 118.

From the beginning of the 20th-century designers had labored on developing and enhancing Hebrew typography to adapt it to secular-modern usage. As early as the 1930s Hebrew typography showed a great momentum; the typographers created new fonts for reading, advertising, and other means of mass communication.

12.1 Hebrew Calligraphy

The treatment of the Hebrew alphabet as the holy script only started after the destruction of the Temple in the 1st century CE. Before that, the Jews who lived in the Land of Israel spoke Hebrew and Aramaic, using the ancient Hebrew alphabet as their means of daily communication. The script's forms and a number of letters resembled the Phoenician script. Earlier development of the Hebrew alphabet as we know it today occurred in the 6th-century BCE; the Assyrian rule of the land at the end of that century switched to the use of Aramaic alphabet, as an international language between the Assyrian and Babylonian cultures. From the 6th to the 2nd centuries BCE ancient Hebrew script and Aramaic script were used interchangeably, and approaching the 1st century BCE Jews stopped using the ancient Hebrew script. The final shape of the Hebrew-Aramaic script was formulated at this time: its square shape became the archetype of contemporary Hebrew script.

Before the invention of the printing press, Hebrew calligraphers aspired to give their text an attractive shape and clear legibility. One way to achieve this goal was producing a practical layout for the page, where the text is aligned between two straight, vertical margins. To be precise in making the text lines straight, certain square-shaped letters were extended into rectangular shapes, thus filling the whole width of the line. Hebrew letters that permit this stretching (without deletion of their visual shape and legibility) are *tav, bet, reysh* and final *mem*. Stretched letters *reysh* [ר] (the first row left, circled). *Tav* [ת] (the third row, circled) and *mem* [ם] (the last row, left, circled) in fig. 12.2 are a few examples.

12.2 Hebrew Typography

Hebrew publishing was quick to adopt the invention of the printing press to its need. The basic forms of the letters were engraved on wooden plates and later cast in metal. Unfortunately, the process tended to freeze the natural development of the fluid hand-written text, and the letters' beauty and clarity suffered from this process.

∀	Aleph (1) א
9	Beit (2) ב
٦	Gimmel (3) ג
◁	Dalet (4) ד
⇉	Hey (5) ה
ƒ	Uau (6) ו
⊐	Zayin (7) ז
日	Chet-Heth (8) ח
⊗	Tet (9) ט
₹	Yod (10) י
ﾘ	Kaph (20) כ - ך

FIGURE 12.1
Ancient Hebrew script (left), Hebrew Aramaic script

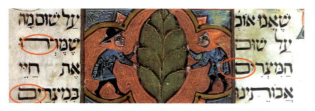

FIGURE 12.2 Hebrew letters *reysh* and *mem* extended

After the preliminary period of printmaking in Germany, the main Hebrew printing activity moved to Italy. The first to publish Hebrew books was the Soncino family. Later on, Daniel Bomberg of Venice, a Christian humanist, merited the title of "The Greatest Hebrew publisher of all times." Bomberg's letters (fig. 12.3) were shaped after the Soncino family models; his typefaces were to set the shape of the square Hebrew letters for a long period in the history of Hebrew printing.[4] A few years later, the Italian publishers were followed by Hebrew book printers in Flanders and The Netherlands.

The most significant contribution of the 16th century to Hebrew printing was made by Guillaume Le Bé (1525–1598), a letter cutting craftsman. His Hebrew letters are considered most successful due to their clarity and legibility. His follower in the tradition of Hebrew printing was Christofal van Dijk, another letter cutter, who worked at a printing establishment in Amsterdam in the 1660s. Van Dijk's letters, called Amsterdam Letters (fig. 12.4) are sharply delineated and resemble contemporary Latin letters.

18th century Hebrew printing suffered a decline in quality, due to the tendency of lowering quality to save money. Few publishers attempted to cut new letters for their publishing purposes, and most simply copied ready-made letters that were already flattened and distorted by the great pressure of the printing press during repeated use. The end of this century saw a new Hebrew typeface come into being, the Meruba (square, fig. 12.5). The Meruba letters exhibit thick horizontal lines while their vertical lines are thin in comparison.

The modern design process of Hebrew typography in the twentieth century is linked to the social, cultural and financial changes of the various Jewish communities throughout the world. The great interest shown by Hebrew typographers—Jews and non-Jews alike—is linked, primarily, to the revival of the Hebrew language and the flowering of Yiddish. The secular use, including newspapers, advertising, and other means of mass communication caused a revolutionary change in the forms and shapes of Hebrew typography.

4 *Ot tHee lee'Olam,Kovetz Ma'amarim Mukdash le'Eetzuv ha'Ot ha'Ivrit* (A letter is Forever, Compilation of Articles on the Design of Hebrew Letters), Jerusalem: Ministry of Education and Culture, Committee of Jewish Art, 1991.

FIGURE 12.3
The *Bomberg* typeface, ca. 1520

הַלְלוּ־יָהּ׀ אוֹדֶה יְהוָה בְּכָל־לֵבָב בְּסוֹד
מַעֲשֵׂי יְהוָה דְּרוּשִׁים לְכָל־חֶפְצֵיהֶם׃ ה
עֹמֶדֶת לָעַד׃ זֵכֶר עָשָׂה לְנִפְלְאֹתָיו ו
נָתַן לִירֵאָיו יִזְכֹּר לְעוֹלָם בְּרִיתוֹ׃ כֹּחַ מַ
לָהֶם נַחֲלַת גּוֹיִם׃ מַעֲשֵׂי יָדָיו

FIGURE 12.4
Christofal van Dijk, the *Amsterdam* typeface

FIGURE 12.5
The *Meruba* typeface

Berlin of the 1920s was a unique center dealing with Hebrew books publication. *Milgroim* (pomegranate) was a journal dedicated to Modern Jewish culture; it was published in several languages, including Hebrew and Yiddish (fig. 12.6) its editors discovered hidden treasures of Hebrew aesthetics from the middle ages while trying to adopt it to Modern design.

Jewish artists who resided in Berlin dedicated their work to the development and enhancement of Hebrew script for modern, secular uses. Joseph Budko (1888–1940) and Jacob Steinhardt (1888–1968) designed Hebrew letters, assisted by traditional models of Hebrew script they found in Medieval Hebrew manuscripts and Hebrew books from the 17th and 18th centuries (figs. 12.7, 12.7a).

ANCIENT MAGIC AND MODERN TRANSFORMATION 291

FIGURE 12.6A, B, C Cover of *Miqroim, the Letter aleph, the word Yayin* (wine), 1922

FIGURE 12.7
Initial Word in a Passover Haggadah, Germany, 18th century

FIGURE 12.7A
Joseph Budko, *Initial Word in a Passover Haggadah,* 1914

While the design process of modern Hebrew script took place in Germany, a major preoccupation with Hebrew calligraphy and typography was practiced at the Bezalel School of Arts and Crafts in Jerusalem. Its teachers and students dealt with enhancement of the Hebrew letters. Experiments with visual renderings of the Hebrew letters (fig. 12.8), treating the Hebrew script as a modern design for secular everyday use of the Hebrew speaking population.

Hebrew poet Levin Kipnis and designer Ze'ev Raban published *Aleph Bet*, a children's reader for learning the Hebrew alphabet (fig. 12.9). The book was published in an elaborate color edition.

The process of designing Modern Hebrew typefaces culminated in Germany at the beginning of the twentieth century with the invention of the Frank-Rühl typeface. Since its first use in print to the present, Frank-Rühl is the commonly used typeface for Hebrew texts (fig. 12.10). The designers based their model

FIGURE 12.8 Experiments with Hebrew letters by Bezalel students, published in *Ost und West*, 1904

FIGURE 12.9
Levin Kipnis and Ze'ev Raban, *Aleph Bet*, Berlin, *haSefer* Publication, 1923

FIGURE 12.9A Kipnis and Raban, *Aleph Bet*, details

on the *Ashkenazi* Hebrew letters[5] used in Hebrew manuscripts. The Frank-Rühl typeface is almost free of distortions, and its letters are well balanced; its design clearly exhibits the influence the *Art nouveau* style. One of its significant achievements is solving a common legibility problem, typical of Hebrew typefaces. Readers of Hebrew texts tend to confuse letters that almost look alike **such as ב כ** and ד–ר. Each one of these letters in the Frank-Rühl typeface is easily distinguished individually. Most newspapers, journals, and books published in Israel are printed in Frank-Rühl. As an almost perfect typeface, Frank-Rühl still poses a great challenge to contemporary Hebrew typographers who strive to design new, post-modern Hebrew typefaces, new alphabets that would be functional and at the same time would adhere to the tradition of original Hebrew letters.

At the beginning of the 20th century, only a few manufactures cast Hebrew letters in metal for use in the printing business. Perusing a catalog of 1924, published by The Berthold Letter Casting Firm in Berlin may assist us in realizing the condition of Hebrew printing and the variety of typefaces available for typographers and typesetters at that time. The Berthold catalog offers many ready-made examples of advertisements for restaurants' menus, title-pages, and more. Most significant aspect for Hebrew books designers are the samples of Hebrew typefaces in various sizes. However, the choice of Hebrew typefaces

FIGURE 12.10
The *Frank-Rühl* typeface

5 *Ashkenazi* script was discussed in chapter 5.

FIGURE 12.11
The Berthold Letter Casting Firm Catalog, 1924

included only five: *Miriam, Meruba, Magalit*,[6] Frank-Rühl, and *Rashi* (the last was not meant for secular uses). The catalog also included samples of initial letters (fig. 12.12).

For lack of other, better typefaces, the Frank Rühl typeface was the most used font during the *tishuv* years. However, most local Hebrew typographers expressed their criticism of it. Mordechai Narkis, head of the Bezalel National Museum in Jerusalem wrote in 1948:

> … One typeface, Frank-Rühl, conquered our printing enterprise: all of our newspapers and most of our books, if not all of them, even religious literature, are printed in this typeface. To make a long story short: Frank-Rühl became our essential typeface … its matrixes are inscribed in every type-setting machine, and its letters fill every printer's box … every book in Hebrew and in Yiddish are printed in these letters …[7]

In spite of its popularity and its excellent qualities, Frank-Rühl does show a few deficiencies, and designer Pesach Eer-Shay mentioned them in an article he published in 1948. He also referred to a common phenomenon concerning Hebrew printing establishments: their adherence to tradition and refusal to accept new, innovative typefaces:

6 *Magalit* is the correct name of this typeface; it is erroneously called *Margalit*.
7 Mordechai Narkis, "Ot Eevrit Chadasha" ("A New Hebrew Thpe face"), *Hed haDfus*, December 1949, 12–13.

FIGURE 12.12 Hebrew initial letters in the *Berthold* catalog, 1924

I would like to mention here that when the block letters I designed a few years ago for the logo of *Hamachar* newspaper, I was attacked in the press for allegedly insulting tradition. Yet a certain person who encouraged and supported me, explained that not everything we inherited from our forefathers is held as a traditional must. The *talit* is tradition; the *shtreimel* (fur hat worn by ultra-orthodox Jews), for example, is not part of Jewish tradition. It was Bialik [Hebrew poet laureate Chayim Nachman Bialik] who told me so ... every innovation, in the beginning, is "hard on the eye." However, what we are concerned with here is a conscious new arrangement in the form of [Hebrew] letters.[8]

Israeli designers-typographers Rothchild and Lifman explained the need for a larger variety of Hebrew typefaces for solving common issues faced by their colleagues:

> Letter shapes in various styles can convey various states of mind. Experienced graphic designers, calligraphers and printers know how to choose a serious typeface for obituaries, grotesque typefaces for *Purim* balls advertisements, light and delicate, elegant rhythms for fashion apparel and cosmetics ... upon our people's return to its land and the resurrection of Hebrew as an everyday language a need is felt for new Hebrew scripts ... new ways of expression pose a serious issue: suitability of Hebrew to non-Hebrew typefaces....[9]

8 Pesakh Eer-Shay, "Likrat Ktav-text Chadish" (Towards a New Text-Script), *Hed haDfus*, volume 5–6, December 1949, 12–13.
9 Rohchild and Lifman, "Mashma'uta shel ha'Ot keVituy" (Letters' Meaning as an Expression), *Hed haDfus*, 1959, 36–40.

Shortly after the end of the First World War, two Hebrew typefaces were published, both in the spirit of new, contemporary design: the first was *Chayin*, designed by Jacob Levitt (fig. 12.13). It is a geometric-angled typeface; the thickness of its letters' lines is equal (horizontally and vertically). The *Chayim* typeface is used mainly in advertisements and newspaper headlines. The other typeface, *Aharoni* (fig. 12.14), named after its creator, is less aggressive, more refined, and shapely.[10]

An announcement dropped from Egyptian airplanes on Israeli soil in 1948 compared with an announcement printed in the *Chaim* and *Aharoni* typefaces will show the latter's modern and secular nature (fig. 12.15). The Egyptian announcement's typeface was that of an antiquated traditional Jewish sacred texts. Its layout was poorly done, and spaces between words were inconsistent. Probably, no Egyptian printing enterprise had in its stock any Hebrew letters except for those used for religious publication such as the Bible or Jewish commentaries written by religious figures. The Egyptian announcement is a prime example of the hidden force imbued in the visual aspect of modern Hebrew letters; their shape is suffused with social and historical aspects that endow them with a suggestive nature. The announcement does not convey decisiveness, force, and might of texts printed in the *Chaim* or *Aharoni* typefaces.

David,[11] a new Hebrew typeface published in 1954, was named after its designer, Ismar David[12] (fig. 12.16). Upon its publication, it was referred to in *Hed haDfus* (Echo of Printing), a contemporary Israeli professional journal for the art of printing:

> We were just informed that ... Intertype firm released to market a new Hebrew typeface—*David*... On a preliminary observation, it is visually pleasing for its elegance and its sharp, as well as solid lines. This typeface has distinguished, in the new way, the letters' recognition elements—such as the similar forms of letters like ג and נ, ה and ח, ד and ר, ב ... and כ.[13]

10 Moshe Spitzer, "Ha'ot haMeruba'at beHitpatchuta" (The Square Letter and its Development), in *Ot Hee le'Olam* ... 42.
11 The David typeface was adapted as a digital typeface; it is the most commonly used font by Israelis on their personal computers.
12 Ismar David was mentioned as one of the designers of Israel's national emblem proposals in chapter 6.
13 M. Weiss, "Ot Eevrit Chadasha baMisderet" (New Hebrew typeface in the Typesetting Machine), *Hed haDfus*, September 1955, 47.

ANCIENT MAGIC AND MODERN TRANSFORMATION 297

FIGURE 12.13 The *Chaim* typeface

FIGURE 12.14 The *Aharoni* typeface

FIGURE 12.15A An Israeli announcement, 1948
FIGURE 12.15B (RIGHT) An Egyptian announcement, 1948

A few years later, typographer Henry Friedlander (1904–1996) published a new Hebrew typeface: *Hadassah* (fig. 12.17). The story of the *Hadassah* typeface design process is fascinating: it spreads over three countries, lasting 27 years. Friedlander mentions that the beginnings of the *Hadassah* typeface took place at the time when typography design, in general, was related to the Bauhaus activities. The designer left Germany in 1932 and moved to the Netherlands, proceeding there with his work on this typeface, a process in which he reached a significant conclusion to the typeface modulation: "When you look on two parallel lines, equal

FIGURE 12.16
Ismar avid, the *David* typeface, 1954

in width, one upper, the other lower, the latter looks thicker." Friedlander corrected the optical distortion and obtained visual harmony in his *Hadassah* font by making the lower horizontal lines thinner than the upper ones.[14]

In 1942 Friedlander was forced to go into hiding for three years. The typeface sketches were concealed as well. By the end of WWII he returned to work on them, this time in Israel, and after many corrections, the casting of the *Hadassah* letters took place in 1958. The lines ending Friedlander's memoirs point to his fascination, with the Hebrew letter *aleph* (א): "it is a wonder that throughout my research I found, in most cases, so I believe, a suitable shape [for the entire Hebrew alphabet] except for one letter that to this day I am at

14 Henry Friedlander, "Eych Yatzarti et ha'Ot Hadassah" (How I Designed the *Hadassah* Typeface) as quoted in *Ot hee le'Olam* ... 70. The Hadassah typeface was the first to be used by IBM electric typewriters in the 1960s.

ANCIENT MAGIC AND MODERN TRANSFORMATION

אבגדהוזחטיכך
למסנןסעפףצץ
קרשת(;:")!?/,[:]
1234567890

אבגדהוזחטיכךלמם
נןסעפףצץקרשת
1234567890 [:/?!":;]()

אבגדהוזחטיכךלמסנןסעפףצץ
קרשת(;:")!?/,[:] 1234567890
אבגדהוזחטיכךלמסנןסעפףצץקרשת(;:")!?/,[:] 1234567890

FIGURE 12.17
Henry Friedlander, the *Hadassah* typeface, 1958

FIGURE 12.17A From right to left: *aleph* in *Frank Rühl*, in *Hadassah*, in *Haaretz* newspaper logo, in *David* typeface

a loss: the letter *aleph*, first in the Hebrew alphabet, the first letter in the word *Elohim* (God) (fig. 12.17a).[15]

Indeed, the letter *aleph* possesses unique qualities; its axis (diagonal line) makes a base for two shapes that turn in opposite directions: the upper is directed to the right, the lower usually turns to the left. Turning left gives an impression of walking forward because Hebrew is read from right to left. This seemingly insignificant characteristic of *aleph* makes Hebrew calligraphers and typographers devote lengthy work hours. There are those who make the lower part of *aleph* turn to the left, i.e., the Frank Rühl typeface (right in fig. 12.17a) and *Hadassah* (second from the right in fig. 12.17a). Others turn it to the right, as in the *David* typeface, as well as in the contemporary internet logo of the *Haaretz* newspaper (left and second from the left in fig. 12.17a).

Israeli designer David Tartakover was also fascinated with the letter *aleph*. In a poster, designed for the film *Shoah* (Holocaust) (fig. 12.18), the artist adapted a typeface by designer-typographer Pesach Eer-Shai. He devised a different expression for *aleph*; by rotating it counterclockwise, he makes viewers associate it immediately with the Nazi Swastika, even though it is not exactly the same shape. Tartakover's formal reconstruction yields a poster with a strong, direct, associative message, easily understood by all Hebrew readers.

15 Ibid. 82.

12.3 Hebrew Typography in Israeli Design

Every typeface possesses unique formal characteristic; they convey different traits and indirectly various messages. Each one is used for a different purpose. They also point to a specific historical period in which they were widely used. Tartakover's logo for *Shalom Achshav* (Peace now), is a prime example (fig. 12.19). Peace Now organization came to power following Israel's 1982 invasion of Lebanon and in particular after the massacre of Palestinian refugees by Christian Lebanese Phalangists at the Israeli controlled Sabra and Shatila refugee camp. In 1982, Peace Now held a mass protest demonstration attended by 400,000 people, approximately ten percent of Israel's population at the time. In the wake of the massacre, Peace Now held a march in Jerusalem on February 10,

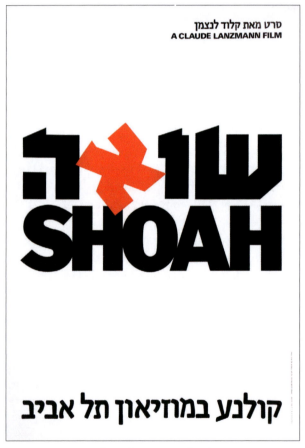

FIGURE 12.18 David Tartakover, *Poster for Claude Lantzman's film Shoah*, 1986

ANCIENT MAGIC AND MODERN TRANSFORMATION 301

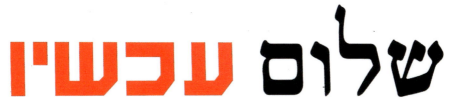

FIGURE 12.19 David Tartakover, *Logo for Shalom Achshav* (Peace Now) movement, 1978

1983, during which demonstrators encountered a group of right-wing activists. A hand grenade was thrown into the crowd, killing Emil Grunzweig, a prominent Peace Now activist, and injuring several others

Tartakover used the *Chaim* typeface for the word *achshav* (now) in the logo. This font is widely used for newspaper announcements, large-scale captions, and posters exhibited in public spaces. He chose this typeface for its decisive, energetic, and harsh qualities. Through their modulation (the uniform width of their horizontal and vertical lines), the *Chaim* letters convey strength. In perfect contrast with the poster-like trait of the *Chaim* typeface, the artist designed the word *shalom* (Peace) in the *Koren* typeface (fig. 12.20). It is a classical, modern, Hebrew typeface, created by artist typographer Tzvi Koren (1907–2001) for the *Koren Bible*, the official Israeli printed Bible. The *Koren* font is exceptionally legible, realizing a harmony between traditional shapes of Hebrew letters with modern design principles. In juxtaposing the two typefaces in the *Shalom Achshav* logo, Tartakover succeeded in evoking the message for a noble yearning for peace through the *Koren* typeface and the decisiveness of demanding its immediate necessity through the *Chaim* font.

Modern, secular Hebrew typefaces, used in Israel as a powerful means of communication, are shunned by Israeli orthodox popular publications. Although the orthodox digital media does use modern Hebrew typefaces, popular items such as posters and Jewish holiday decorations ignore them, turning back to hand-written calligraphic scripts, purporting to endow their publications with old and traditional aspects that are the complete negation of modernity and secularism (fig. 12.21).

12.4 Uses of the Hebrew Alphabet in Non-textual Israeli Visual Media

Many Jewish-Israeli artists attempt to express the essence of the Hebrew language through objects. Most of these Israeli artifacts are impossible to understand in depth without some knowledge of their cultural, social, economic, religious-ceremonial, and psychological contexts. These visual images, taken

FIGURE 12.20
Eliyahu Koren (Korngold), The *Koren* typeface

for granted and automatically understood by Israelis, are not necessarily so clear to non-Israelis.

Jewish Israeli artists make direct references to the Hebrew language; some of them deal with its meta-linguistic aspects. Certain definitions of meta-language, even though they refer to the verbal medium—are especially relevant to the expression of Hebrew meta-language in the visual arts:

a. The use of lexical or grammatical terms in observations about a language, or in a dialog with a lexical topic.
b. The use of lexical or grammatical terms in order to express a different saying that is not necessarily lexical.[16]

To point out some of Hebrew's meta-linguistic manifestations, Maya Fruchtman analyzes poems by poet David Avidan. She also relates to linguistic innovations in Hebrew literature created for figurative or humoristic purposes.

16 Maya Fruchtman, *Lomar zot Aheret: Eeyuney Signon veLashon baShirah ha'Eevrit Bat Yameynu* [Stylistic Studies in Contemporary Hebrew Poetry], Be'er Sheva, Ben Gurion University Press, 2000, pp. 78–79.

FIGURE 12.21 "A wife of noble character who can find?"
(Proverbs 31, 10), 1995, poster

These include fusing words in a unique way—the new word, *himlula*, created from the words *hamula* (bustle, clatter) and *hilula* (celebration), or duplicating consonants—changing *lehitpanek* (to be spoiled), to *lehitpankek* "to be spoiled by eating pancakes." The creators of such linguistic innovations do not intend to turn them into lexical assets.[17]

Israeli artist Michael Sgan-Cohen (1944–1999) was fascinated with Hebrew meta-language expressions, double meanings, and puns. The diacritical vowel points in Hebrew were on his mind when he used their names to label his work *Kamatz Patach* (fig. 12.22). In this work, he depicts the literal meaning of the names of the vowel points: *kamatz* (equivalent of the vowel a, as in father) also means "he made a fist" and *patach* (the vowel "a" as well) means "he opened," thus expressing the double meaning of the terms. Sgan-Cohen's sharp sense of humor is evident in this work. Every Hebrew speaker is familiar with the concepts and terms that the artist depicts visually, but accepts them as obvious, without pausing to consider their complexity.

17 Ibid., pp. 80–81.

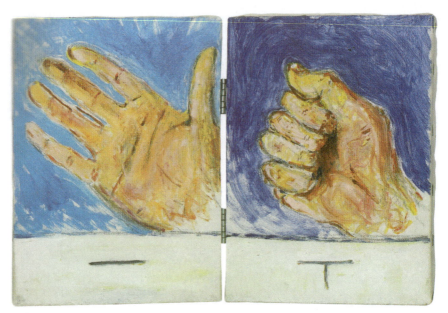

FIGURE 12.22 Michael Sgan-Cohen, *Kamatz Patach*, 1982, acrylic on canvas (diptych), 46 × 30 cm

In another work, *Yod He Vav He* [Y, H, W, H] (fig. 12.23), Sgan-Cohen shows the different shapes of the human mouth when pronouncing the Hebrew letters *Yod, He, Vav, He* which together spell YaHaVeH, the Hebrew name of God. This group of paintings resembles the meticulous illustrations in old phonetics books used to explain the shape of the lips, teeth, and tongue needed to enunciate each sound. These paintings by Sgan-Cohen speak to us in Hebrew. His work is silent, of course. Nevertheless, when viewers come across its title, they might put its letters together and thus would be pronouncing the name of God, a forbidden act according to orthodox Jewish beliefs.

A more abstract treatment of meta-language is found in Drora Dominey (b. 1950)'s work (fig. 12.24). The artist's sculpted objects are punched with vowel points without consonants—*kamatz* and *patach* ['a' as in father], *tzere* ['ey' as in they], *chirik* ['i' as in machine], *cholam* ['o' as in alone], *segol* ['e', as in met], *kubutz* and *shuruk* ['oo' as in moon]. In one of her exhibitions, the objects on display ceaselessly and silently voiced five or six syllables: eh-eh-oh-ai-eh, eh-eh-oo-ai-eh, and eh-eh-ee-oh-ai-eh. The syllables emanating from each work had a different rhythm. Naturally, the audience tried to attach different consonants to them, since the vowel points are imprinted in Hebrew readers' minds. The artist caused spectators to become engrossed with the sculpted object even before they grasped it in its entirety; at first glance, they counted, sorted out, and made some order out of its components. Dominey's objects are

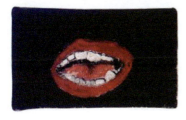

FIGURE 12.23
Michael Sgan-Cohen, *Yod He Vav He* [Y, H, W, H], 1980, acrylic on canvas, 4 units, 7 × 12.5 cm each

meticulously planned and give the audience a variety of visual items, which are meaningful symbols, but indirect, not limited in their suggestive potential, and thus open to any private association by spectators who share her culture.[18]

The engagement with Hebrew meta-language is taken a step further in the work of artist Hila Lulu Lin (b. 1964), who uses a personal typographic design to emphasize morphological expressions in the language. In *Ptzatza Metaktekteket* (Tick-ticking Bomb) (12.25), Lulu Lin added an extra syllable, *tek*, in the word *metakteket* and eliminated the space between the two words, creating one word that reads *ptzatzametaktekteket* (Ticktickingbomb). This invention of a

18 Alec Mishory, "Ah-eh-oh-ai-eh, Drora Dominey Psalim 1990–1993, Tel Aviv Museum of Art," [Drora Dominey Sculptures], *Haaretz*, 17.7.1993.

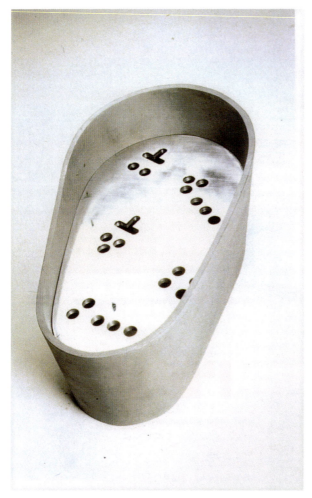

FIGURE 12.24 Drora Dominey, *Tub with Diacritical Vowels*, 1993
aluminum cast, 30 × 35 × 80 cm

non-existent Hebrew word, which widens its onomatopoeic dimension, is similar to nuance-filled words and expressions in some of David Avidan's poems, such as *veaniyodea* [Andiknow, the compression of and I know] or *mikamoniyodea* [who knows better than me compressed into whoknowsbetterthanme].[19]

19 These words appear in *Shirim Tachat Lahatz* (Songs Under Pressure). See Maya Fruchtman, *Lomar Zot Aaheret* ... 80–81. In this context, we can add *Titsaki Besheket* (Scream [and vomit] quietly), the title the artist gave to yet another of her works. Lulu Lin added the letter *alef* to *ki*, the last syllable of the word *titsaki* thus, the incorrect spelling alludes to the word *ki*, "vomit" in Hebrew.

FIGURE 12.25 Hila Lulu Lin, *Ptzatza Metaktekteket* (Tick-ticking Bomb), 2002, painted wooden box, silk-screen print, mirror

In *PtzatzaMetaktekteket*, Lulu Lin designed a new font for Hebrew letters; it is distinctive in the handling of the vertical lines in the letters ה [*he*], ק [*kof*] and ת [*tav*] and the horizontal lines in the letters פ [*pe*], צ [*tzadi*] and מ [*mem*]. The standard vertical line of the letter ק [*kof*], which ends on the baseline of the letters is lengthened in Lulu Lin's font; it crosses the baseline so that it looks like a very long ה [*he*]. Hebrew letters are traditionally proportionately sized; in her work, Lulu Lin violates this rule and completely distorts the letters by widening them, as is evident in the letters פ [*pe*], צ [*tzadi*] and מ [*mem*]. The ticking of the bomb gains an unusual visual dimension that reinforces the feeling of nervous ticking, disorganized and perhaps even threatening.

Other experiments with the Hebrew alphabet turn the wheel backward and focus on the sacred aspects of Hebrew letters allotted them in Jewish culture. Artist David Rakia (1928–2013) created a series of paintings entitled *Letters Hovering in the Air* (fig. 12.26).[20] The source for the series' caption is a sentence uttered by Rabbi Chanina ben Tardion, head of a *yeshiva* (Talmudic school) in the Galilee, in the second century CE. It is told that during the Bar Kochba revolt, Roman rule forbade studying the Torah. Ben Tardion refused to follow this restriction, taught his pupils, was caught and executed most cruelly. Wrapped in Torah parchments and tree branches, he was burnt at the stake. To lengthen his torture, the Romans placed pieces of wool soaked in water on his chest, resulting in a slow and painful death.

20 There are other Israeli artists who focus on the sacred aspects of Hebrew letters, Michael Sgan Cohen is one of them. Chapter 16 discusses such treatment of traditional Jewish aspects in his art.

FIGURE 12.26　David Rakia, *Letters Hovering in the air,* oil on canvas

She [probably Bruryah, one of his female students]: father, do I have to see you like this? He said to her: If I were to be burnt by myself, it would have been difficult for me; now that I am burnt with a Torah scroll, whoever seeks to amend offenses of the Torah is the one who would amend my offense. She said to him: what do you see? He told her: burning parchments and flying letters.[21]

The interest Israeli-Jewish typographers and designers show in Hebrew script includes the chronology of its design processes since ancient times. Designer Sharon Shrem combined principles of ancient Hebrew script with up-to-date computer technologies. As a graduate student at an art school in Israel, Shrem devoted his final project to researching the ancient Hebrew script (fig. 12.27). In the course of his research, he discovered the beauty of the old sign system and learned its rules and structures. In order to understand the nature of the script, its modulation, axes, and serifs he experimented with ancient writing tools and the way they were used on the bedding. In his thesis, Shrem re-designed the ancient Hebrew script as a font in six sizes and adapted it to computer use.

Shrem's work brings us back to the beginning of this chapter; the interest shown in ancient Hebrew script in the twenty-first century is a direct extension of basic Zionist concepts, which try to link the past period of glory of the

21　Babylonian Talmud, *Avodah zarah* tractate, page 18, column 1.

ANCIENT MAGIC AND MODERN TRANSFORMATION 309

FIGURE 12.27 Sharon Shrem, *Ancient Hebrew Script Font for Use on the Computer*, 2001, brochures

People of Israel in the Land of Israel, and the today's State of Israel who speak an ancient-new language. They succeed in conveying its unique magic and charm to audiences who are well acquainted with its syntax and the verbal and visual nuances that characterize it.

Bibliography

Amishai-Maisels, Ziva, "Chagall's Jewish Jokes" *Journal of Jewish Art* Volume 5, 1978.

Apter Gabriel, Ruth, "In Ans-sky's spirit, Popular Jewish Motifs in Russian Jewish Art" in *Back to the shtetl, An-sky and the Jewish Ethnographic Delegations 1912–1914, from the Collections of the National Ethnographic Museum on St. Petersburg*, Jerusalem: The Israel Museum, 1994.

Dan, Yosef, "Lashon Eloheet Lashon Enoshit veHaba'ah Omanutit" (Godly Language and Human Language and Artistic Expression) in *Neustein, Zayag and Grossman, beMartefey haSufriya haLe'umit haBiennale beVenetzya, 1995, haBitan haIsraeli* (Neustein, Zatag and Grossman, in the National Library Cellars, the Venice Biennale, 1995, the Israeli Pavilion) (exh. cat.), 1995.

Davidovitch, David, "ha'Ot ha'Eevreet ke'Element Kishuti beVeyt haKkneset" (The Hebrew Letter as a Decorative Element in Synagogues), *Hed hadfus*, September 1950, 1952, 1954.

Davidovitch, David, "Yosef Budko, Oman ha-ex-libris haYehudi" (Joseph Budko, ex'libris' Jewish Artist), *Hed hadfus*, September 1955.

Davidovitch, David, "Ze'ev Raban," *Hed hadfus*, August 1961.

Eer-Shay, Pesach, "Likrat Katv-Text Chadash" (Towards a New Text-Script), *Hed hadfus*, October 1948.

Friedlander, Henry, *Al Otioyot uSfarot* (On Letters and Numerals), Jerusalem: Brandeis Center, Hadassah Enterprises for professional education, 1960.

Friedlander, Henry, "Eych Eetzavti et ha'Ot Hadassah" (How I Designed the Hadassah font), in *Ot Hee le'Olam, Kovetz Ma'amarim Mukdashim le'Eetzuv ha'Ot ha'Eevrit* (The Letter is Forever, a Compilation of Articles Dedicated to the Hebrew Letter), Jerusalem: Ministry of Education and Culture, Association for Jewish Art, 1981.

Friedlander, Henry, "Kavey Yesod baHitpatchut shel haKtav ha'Eevri vehaKtav haLatini" (Basics in the Development of the Hebrew and Latin Scripts), *Hed haDfus*, September 1955.

Fruchtman, Maya, *Lomar Zot Acheret, Eeyuney Signon veLashon baShira ha'Eevrit Bat Yameynu* (To say it Differently, Studies of Style and Language in Contemporary Hebrew Poetry), Beer Sheva: Ben Gurion University Publications, 2000.

Levi, Ya'akov, "haNikud, ha'Ot haMeruba'at veTur haKri'ah" (Punctuation, the Square Letter and the Reading Column), *Hed hadfus*, November 1947.

Narkis, Mordechai, "Oot Eevrit Chadasha" (A New Hebrew Letter), *Hed haDfus*, December 1949.

Ofrat, Gideon, *Bezalel haChadash 1935–1955* (The New Bezalel, 1935–1955), Jerusalem: Art Academy Bezalel, 1987.

Ot Hee le'Olam, Kovetz Ma'amarim Mukdashim le'Eetzuv ha'Ot ha'Eevreet (The Letter is Forever, a Compilation of Articles Dedicated to the Hebrew Letter), Jerusalem: Ministry of Education and Culture, Association for Jewish Art, 1981.

Rothchild, G., Lifman, Z., "Mashma'uta shel ha'Ot Kevituy" (The Meaning of Letters as a Means of Expression), *Hed haDfus*, 1959.

Sgan-Cohen, Michael, "Ve'Ani Chozer laPshat, al Ha ve'al Da, Sefer haShirim shel Zali Gurewutz" (Ad I am Returning to Simple Commentaries, on This and That in Zali Gurevitz's Book of Poems), *Studio*, 92, April 1998.

Shpitzer, Moshe, "Al ha'Otiyot Shelanu" (Concerning our Script), *Hed haDfus*, September 1955.

Shpitzer, Moshe, "Ha'ot haMeruba'at beHitpatchuta" (The Development of the Square Letter), in *Ot Hhee le'Olam....* 1981.

Shrem, Sharon, *Eevrit* (Hebrew), final project for the Vital school of Design, June 2000.

Tamari, Itay, *Ot Eevrit Chadasha* (A New Hebrew Letter) (exh. cat), Tel Aviv: University Gallery, Faculty of the Arts, Tel Aviv University, 1985.

Tschichold, Jan, *The New Typography, a Handbook for Modern Designers* (translated from the German by Ruari McLean), Berkeley, Los Angeles, London: University of California Press, 1995, 2006.

PART 3

Sculptural Commemoration within the Israeli Public Space

∴

Since its inception, Zionism regarded itself as a collective enterprise. Its commemoration projects, consequently, were dedicated to groups of people, ideas, and historical, cultural and social events. Only in exceptional cases it chose an individual figure to represent the collective; in most cases, it was a tragic figure, perhaps a martyr, who had devoted his or her life to the collective idea. Israeli official commissions for commemoration refrained from creating realistic visual images of human figures, due to political considerations which adhered to Israeli clerical political parties. The few exceptions dedicated to individual commemorations erected in Israel were conceived and financed by private sectors—*kibbutzim*—not by formal commissions issued by the Israeli political establishment. The Zionist concept of commemoration is, therefore, the complete opposite of Western humanistic concepts which usually memorialize individual figures' contribution to society through the art of portraiture.

An example of this Zionist concept is Yosef Trumpeldor, the individual who was not granted a personal commemoration. The creator of *The Roaring Lion Memorial* (mentioned in chapter 2), which was erected in memory of Trumpeldor and his colleagues in Tel Chai, used the lion, an animal, to collectively symbolize heroism and strength.

The next three chapters trace the culture war waged between two polar design approaches of memorials: the sculptural-figurative, depicting realistic human figures, and the architectural-geometric-abstract approach embracing minimalistic concepts, according to which most Israeli official memorials were erected. The two tendencies point to the linkage—or to the lack of—to Jewish culture and tradition. Two significant figures mentioned in the following chapters—the architect Yosef Klarwein and the sculptor Nathan Rapoport make poignant examples of the two opposing tendencies.

The basic ideas that guided the designers and public dignitaries show the linkage of Israeli memorials to political parties' agendas as well as to an international context playing a major role in their design. All Israeli memorials—with no exceptions—were made possible by specially elected committees; their members included political figures such as municipal officials, public servants, and government ministers, all of whom voiced their ideas concerning the symbolic contents of the proposed memorials. Some ideas were fruitful, while others were mostly dilettante, showing no knowledge of artistic-design principles.

CHAPTER 13

From Pilgrimage Site to Military Marching Grounds: Theodor Herzl's Gravesite in Jerusalem

Theodor Herzl, the renowned leader of the Zionist Movement, died at the age of 44. His early death shocked Jewish communities throughout the world. He was buried in Vienna on July 7, 1904; author Stefan Zweig, who knew him well, wrote about his funeral:

> Suddenly, in every train station of the city, at night and during the day, people from all countries and all corners of the world continued to arrive, Jews from the west and Jews from the east, Russian Jews, Turkish Jews, from every region and every small town … Suddenly Vienna realized that it was not only a poet or author who died but one of those creators of ideas who appear only in rare moments in the history of nations and countries…. the cemetery was in commotion … any sight of order was broken by a kind of huge ecstatic grief, such as I have never witnessed since. Great pain that rose from the depth of an entire people made it possible for me to fathom, for the first time, what fervor and hope this special man gave the world through the power of his ideas.[1]

Herzl requested to be buried in an iron coffin next to his father until the Jewish People would transfer his remains to the Land of Israel. Bringing Herzl's remains to be re-buried was Zionism's wish ever since his early death, and it was realized a few months after the establishment of the State of Israel. The newly formed Israeli parliament voted for a new law: "Bringing Herzl's bones to Israel, 1949."[2]

1 Stefan Zweig's text is quoted by Reuven Hecht, Adam Zmora (editors), *biTko'ah haShofar, Herzl, Dmuto uMivchar Ktavav* (When the Shofar is Blown: Herzl, his Image and Writings), Haifa: Moledet, 1999.
2 A detailed discussion of the various committees nominated for the execution of Herzl's tomb project was published by Michal Naor-Vernik and Doron Bar, "haTacharut leTichnun Kever Herzl ve'Eetzuv Har Herzl, 1949–1960" (The Competition for the Desing if Herzl's Tomb and the Design of Mount Herzl, 1949–1960), *Cathedra* 144, 2002, 108–136. Naor-Vernik and Bar document the chain of events from 1949 to 1960, led by civil servants who were responsible for the Herzl tomb project, until it was inaugurated in 1960. Two proposals for the Herzl grave site won prizes in 1950. Naor-Vernik and Bar's article does not discuss their formal as well as symbolic carrying messages, that are the subject of this chapter.

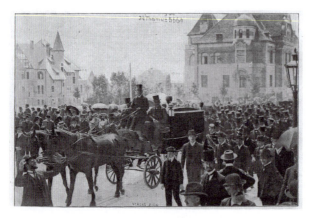

FIGURE 13.1 Herzl's Funeral. Photo in *Ost und West*, 1904

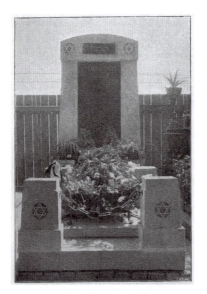

FIGURE 13.2 Herzl's tomb in Vienna

FIGURE 13.3 Herzl's tomb in Jerusalem

In a project that lasted more than ten years, Theodor Herzl's gravesite took shape on a Jerusalem mountain site, later named Mount Herzl. The monument represents a prime example of the complex system of creating Israeli symbolism during the early years of the state. As one of the first public enterprises of the sovereign state of Israel, it played an essential and significant role in establishing a visual platform expressing Israel's sovereignty. In the process, the several public committees involved had to define a new term: Israeli tradition.

The work began by attempts to endow it with concrete visual aspects of Herzl's spiritual-political-social vision. It endeavored to link it to symbolic

international and historical precedents, such as the transference of Napoleon's remains from his exile at Saint Helena to the *Invalides* in Paris and installment in the Pantheon of the French Nation. It also had to incorporate aspects taken from Jewish tradition. This combination was expected to create a new Israeli tradition.

13.1 Herzl's Coffin Brought to Tel Aviv

On August 8, 1949, Prime Minister David Ben Gurion and Berl Locker, head of the Jewish Agency, sent a letter to the Jewish Community of Vienna, asking their permission to transfer Herzl's remains to Jerusalem. Eight days later, Herzl's coffin was flown to Israel and placed at the Israeli Parliament plaza in Tel Aviv. The parliament held a meeting, at the end of which its members went out to the plaza to meet Herzl's coffin.

The ceremonial space at Parliament Plaza was designed by architect-artist Arieh El-Chanani[3] (figs. 13.4a, b). El-Chanani based his design on numerical as well as on traditional Jewish symbolism: seven columns surmounted by burning torches, which echo the seven golden stars from Herzl's proposal for the future Jewish state's flag in the shape of a modern *menorah*.

The temporary site of the Israeli Parliament next to the seashore in Tel Aviv imbued the ceremony with every conceivable impressive elements that the symbolic installment of Herzl's coffin could wish for: the silent street leading to the sea, where the only sound heard was that of waves, the blue sea, and sky whose hues adapted themselves to an Israeli backdrop in blue and white. The public passed by the coffin, which was wrapped in a gold-embroidered white cloth, until the early hours of the morning

13.2 Herzl's Burial Ceremony in Jerusalem

On August 17, 1949, the funeral procession began its way to Jerusalem. The coffin was brought to the yard of the Jewish Agency building for public view. The re-burial ceremony of Herzl's remains took place on August 18. It was staged

3 Among El-Chanani's designs are the Weitzman Institute in Rehovot and Yad Vashem. El-Chanani contributed many designs for Israeli theater sets, designed the Palestine Pavillion in the International Fair held in Paris in 1931 and the one in New York in 1939. See: Carmela Rubin, *Arieh El-Canani Rav Omanuyot* (Arieh El-Chanani, Multi Media Artist), Tel-Aviv: Beyt Reuven, 1993 (unpaged).

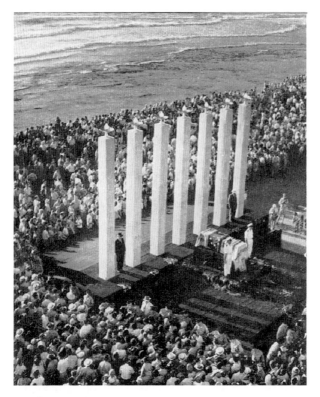

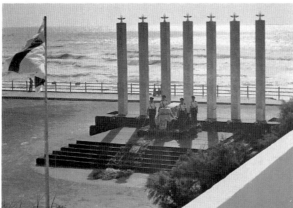

FIGURES 13.4A, B Herzl's coffin on a platform, Parliament Plaza, Tel Aviv, 1949

by actor-director Zvi Friedland (1898–1967), and the architect Yosef Klarwein (1893–1970) was assigned to its visual design.

A temporary canopy was supported by blue and white columns, wrapped in black and gold stripes intertwined with greenery. The canopy was decorated

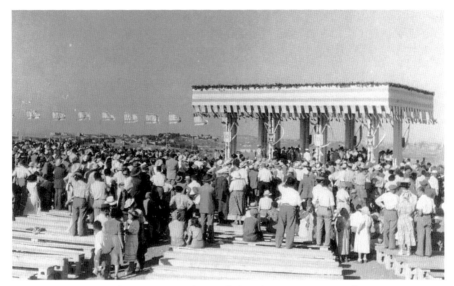

FIGURE 13.5 Yosef Klarwein's design for Herzl's burial ceremony in Jerusalem, 1949

with the state's national emblem and its flag. Forty-four poles with Israeli flags hoisted on top of them surrounded the gravesite. A unique rite performed during the re-burial ceremony engaged delegates from specially chosen Jewish settlements, towns, and villages throughout Israel who were assigned the role of Earth Bag Carriers. They were chosen to empty the contents of their bags into the freshly dug grave[4] (fig. 13.6).

In the Diaspora, a traditional Jewish ritual associated with death and burial consisted of placing Earth from the Holy Land in graves in order to grant the deceased a bond with the Land of Israel, as if they were buried there. According to Talmudic tradition, burial in the ground of the Land of Israel has greater merit than burial elsewhere, since the Land of Israel is believed to atone for sins and its dead would be the first to resurrect when the Messiah comes. Jewish sages claimed that *mechillot*, subterranean tunnels, would open from all Jewish graves outside The Land of Israel after the Coming of the Messiah. Bodies would undergo *gilgul* (literally rolling) through these tunnels until they reach the Land of Israel.[5]

The symbolic ritual enacted at Herzl's re-burial ceremony was assigned a different context. Since in Israel it is not necessary to import Earth from the Holy Land, the newly invented ritual transformed the custom from religious/traditional

4 *Protocols of 'The Committee for Herzl's Tomb'*, Central Zionist Archive, Jerusalem, file S5.10.429, files S5.10.433–435.
5 See: Ilil Arbel *The Afterlife*, *Encylopedia Mythica* at www.pantheon.org.

FIGURE 13.6 Earth-bag carriers at Theodor Herzl's re-burial ceremony in Jerusalem, 1949

to secular/Zionist. The soil, brought from various settlements throughout Israel, symbolized national mourning and veneration of the country's entire Jewish population of their secular spiritual leader, completely annulling the Messianic context. In his will, Theodor Herzl expressed a wish to withdraw any form of clericalism from his tomb and suggested being buried in Haifa, a town in Israel with no attribution of sacredness and entirely free of any traditional or religious associations.[6] Consequently, the Israeli parliament's decision to bury him in Jerusalem, the most sacred of all urban settlements in Israel, wholly contradicted his wish; the secular earth bag carriers ceremony only partially fulfilled his request.

13.3 International Competition for Herzl's Burial Site Design

A temporary gravestone was erected on Herzl's gravesite not long after the burial ceremony, and six months later, the Zionist Organization formed a special committee to start the construction of a permanent burial site. The committee's first meeting, chaired by Shimshon Kreutner[7] took place on

6 The city of Haifa is mentioned in detail in Herzl's utopian book *Alteneuland* (Old-New Land) in which he describes his vision of the future Jewish State in the Land of Israel.
7 Shimshon Kreutner was mentioned in chapter 8.

March 30, 1950.[8] Its members decided to declare an international competition, seeking an architectural design for Herzl's future burial site. One of the members, the architect Matrikin, contemplated the possibility of opening the competition to non-Jews, but at the end of the meeting, he suggested turning to representatives of the Jewish Agency abroad and by doing so to restrict participation in the competition for Jews only. His odd proposal was accepted unanimously; the committee then decided to address bureaus of the Jewish Agency around the world and request that they prepare lists of Jewish architects as potential participants in the competition. The committee members nominated themselves as the future jury for the competition.[9]

A notice announcing the competition for the design of Herzl's burial site was published in the Israeli press as well as in Jewish papers in Europe and in the United States (June 1950). Meanwhile, the committee received several conflicting reactions to its decision to restrict the participation in the competition to Jews only.[10] The members disregarded the protests; chairman Kreutner explained the restriction, claiming that it was based on a potential objection from "... Certain sections within the Jewish public who would be offended if the design and execution of the [burial] site would be carried out by non-Jews."[11]

Kreutner's explanation referred indirectly to potential protests by Israel's clerical political parties, but he did not base his view on precedents or opinions voiced by experts. He had no reason to worry about the opinion of sections of the Jewish public either. Memorials and gravestones, not to mention Synagogue buildings, were designed and built throughout Jewish history, in every part of the Jewish Diaspora, by non-Jewish architects and artists. An architect's religious beliefs had never hindered any Jewish community or its spiritual leaders from employing a skillful professional. Nevertheless, Matrikin's restriction, backed by the committee chairman's explanation, opened the competition solely to Jewish competitors.

8 The participating members were architect Pinkerfeld from Tel-Aviv, architect Rau, architect Matrikin of the Technical department of the Jewish Agency in Jerusalem and architect Professor Ratner from the *Technion* in Haifa. *Minutes of the Jury for Herzl's Tomb Competition*, 29.3.1950, Central Zionist Archive, file S5.10.429.
9 Ibid.
10 Mr. Atlan, a British architect and a future jury member of the committee, addressed it and wrote that The Royal Institute of British Architects was not opposing the fact that the architects who would participate in the competition would be solely by Jews; another message expressing bewilderment as to the committee decision was sent from the United States, claiming that "... For a long time there are architects who are not Jewish and that in spite of this fact they are dedicating a great part of their time to Zionist matters and that they are sympathetic to the State of Israel." Ibid.
11 Ibid.

On 6 September 1949, the committee announced the rules of the competition. Its main points stated:

> ... The goal of the competition is to receive proposals and suitable architectonic designs for the tomb of the founder of the Zionist Organization, the visionary of the State of Israel and for the design of the park surrounding the edifice.... Competitors should base their design for Herzl's tomb according to these guidelines:
>
> a. Their design should express the People of Israel's admiration and respect for Benyamin Ze'ev Herzl.
> b. Their design should be integrated into the Jerusalem landscape and its historical background.
> c. The tomb should be designed as a flat tombstone placed on top of the gravesite of the coffin.
> d. Though competitors are free to execute the design of the tomb in any architectural style possible, they are restricted by the following basic rules:
> 1. All formal aspects of their design should take into consideration the *restrictions of the Israeli tradition* [my emphasis. A. M.].
> 2. Designers should always use materials from Israeli quarries.[12]

The competition rules strongly reflect the committee's pre-conceived notion of the project, especially its laconic definition of restrictions of the Israeli tradition. When the competition for the design of Herzl's tomb was announced, the State of Israel was barely two years old. Consequently, the committee was showered with a torrent of questions from future competitors. They requested a clearer definition of the Israeli Tradition clause. To simplify the procedure, and due to the great number of questions, the committee sent the participants an official form in which it clearly defined its views on the matter:

> The Zionist Organization
> The Competition for the design of Herzl's tomb
> S. Y. Kreutner's Answers to Questions posed by competitors:
> 5. [Herzl's tomb]
>
> a. What does 'Israeli Tradition' mean?
> b. Is it possible for the monument to contain portraits and is it possible to include realistic or symbolic reliefs and sculptures depicting the lives

12 Central Zionist Archive, file S5.10.433.

of Zionist public figures or significant events in the history of the movement?

c. Is it permissible to create figural sculptures or is only a portrait of Herzl acceptable?

d. Please clarify what you mean by the traditional restrictions as to the inclusion of plastic forms.

e. Is it permissible to create reliefs depicting significant events from the history of the Jewish People made (in copper) or is any depiction of the human figure forbidden?

Answer:
The Israeli Tradition should be understood as follows:
It is forbidden to create sculptures depicting human form; it is permissible to depict animal figures as well as plants and symbolic depictions in reliefs, mosaics or any other medium. Herzl's portrait should not be shown.[13]

Kreutner's answer established a significant precedent. From the day it was announced in 1950, it turned into a semi-official model for Israel's official policy regarding what is permitted and what is forbidden in designs for public monuments and sculptures.[14] This dilettante directive was made without consulting experts; the essence of Kreutner's and the other committee members' interpretation show that they were not familiar with two thousand years of Jewish visual traditions. They had hastily imposed an absolute iconoclastic prohibition, bordering on the absurd, in claiming that "Herzl's portrait should not be shown."

By July 1951, The Committee received sixty-three proposals.[15] The jury's decisions were announced on July 19 of that year:[16] proposal number 54 was

13 Answers were worded at the Jury's meeting, 6.2.1951, *Central Zionist Archive, file S5.10.433*.
14 About a year after the committee announced its answer (1951), Kreutner was asked to share his experience in regard to reliefs that were to appear on the *Knesset Menorah* by Benno Ellkan. See: chapter 8.
15 These arrived from contestants from Israel, Australia, Great Britain, Argentina, United States, Belgium, South Africa, Holland, France and Switzerland. 21 entries were made by Israeli participants, 42 from abroad. *Central Zionist Archive, file S5,10.434*.
16 The jury members were: Berl Loker from the Zionist Organization and the Jewish Agency in Jerusalem, Mr. Yosef Weitz, Dr. A. Loiterbach, secretary of the Zionist Organization, Y. Matrikin of the technical department of the Jewish Agency of Israel, architect Pinkerfeld from Tel-Aviv, architect Rau from Jerusalem, Prof. Ratner from the Technion, Haifa, S. Kreutner, secretary of the competition from the Organizational department of the Zionist Organization, Jerusalem. The names of the two guest architects from abroad are not mentioned in the jury's protocol. *Central Zionist Archive, file S5.10.435*.

awarded the first prize of 1200 Israeli pounds. The winner was architect Yossef Klarwein from Jerusalem. The second prize of 900 Israeli pounds was awarded to proposal number 22 by Israeli sculptor Yitzhak Danziger (1916–1977) and architect Shalgi.

13.4 Winner of the Competition: Yosef Klarwein's Design

Klarwein's winning proposal (figs. 13.7a, b, c) was conceived as a site-specific work, carefully relating to Mount Herzl landscape. It included a burial edifice, an entrance building, and a plaza, designed for public gathering. Visitors were to arrive at Herzl's burial site through the entrance gates. A walk along a pathway would have led them to a trapezoid-shaped plaza. Its horizontal, wide side, intersected with an approaching pathway. At its end, it is crossed by a rectangular area and a circular plaza, raised on one of its ends.

The most significant part of Klarwein's design was a spectacular, enormous dome (fig. 13.7c). It was aimed to reveal itself gradually in all its magnificence to potential visitors, as they would approach it from the trapezoid plaza. Klarwein's dome was meant to cover Herzl's tomb. It was to be crowned by a round opening and supported by forty-four ribs. The floor level under the dome was meant to descend gradually at the center in five concentric circles. Klarwein placed the coffin on a high, rectangular base, at the center of the innermost circle. The role of the architectural dome was to bestow an intimate feeling of togetherness on those who stood in its inner space and evoke awe and respect.

A vertical beam of light would penetrate the dome's round opening and dramatically illuminate the coffin underneath it with theatrical-mystical splendor and majesty. Klarwein's dome meant to contain small groups of visitors. He meant to install it in the center of a vast round-shaped plaza, suitable for the gathering of large groups. Consequently, only small groups of visitors, one group at a time, were meant to enter the interior of the dome. Klarwein's design—in a word—was minimalistic, focusing on the visitors' emotional reaction while hardly alluding to any Jewish symbolism.[17]

17 The only verbal description of Klarwein's design (except mine) is given a concise formulation on the Jury's reasons. The design itself, as well as any other documents pertaining to it, are not to be found. They were untraceable in Klarwein's file neither at the Central Zionist Archive in Jerusalem or at that of the Jewish National Fund Archive.

FROM PILGRIMAGE SITE TO MILITARY MARCHING GROUNDS 325

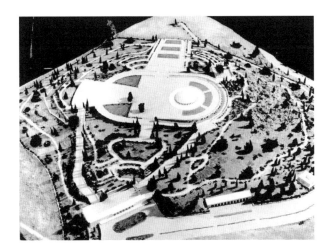

FIGURES 13.7A, B Yosef Klarwein, *Proposal for Theodor Herzl's Burial Site*, 1949

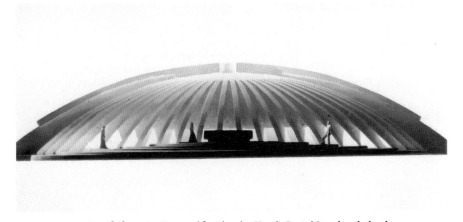

FIGURE 13.7C Yosef Klarwein, *Proposal for Theodor Herzl's Burial Site*, detail, the dome

13.5 Runner-up Prize: Danziger and Shalgi's Design

In contrast, Itzhak Danziger and architect Shalgi's proposal (fig. 13.8a, b) included many symbolic elements. Another aspect that sets it apart from Klarwein's design is its overall sculptural, rather than architectural conception. Its designers planned for it to be a site that would induce introspection and a feeling of spiritual elevation, thus trying to realize in stone Herzl's utopian vision.[18]

Visitors to Danziger and Shalgi's proposed site were to begin their walk in the direction of Herzl's tomb through an entrance building. It was to be comprised of four rectangular units crowned by domes. Three large openings would point to a terraced pathway leading to the burial site. The path would wind its way around the local terraces of the mountain. At the path's end, large steps lead to a circular flat area, a circular rift in its center. The path was meant to direct the movement of the visitors in the direction of the tomb in a spiral rhythm that was meant to engulf and close on its center.

At the ends of the circular flat area, the designers placed two horn-shaped sculptural elements with large openings. The base of Herzl's tomb, located at the center of the round crater, was to be supported by two sculptural objects in the shape of eagles. Both sculpted objects—horns and eagles—are visual metaphors relating to a Messianic concept of the ingathering of Jewish exiles. They are based on verses from Exodus and Isaiah:

> And it shall come to pass in that day, *that* the great trumpet shall be blown, and they shall come which were ready to perish in the land of Assyria, and the outcasts in the land of Egypt, and shall worship the LORD in the holy mount at Jerusalem (Isaiah, 27, 13).
>
> Ye have seen what I did unto the Egyptians, and *how* I bare you on eagles' wings, and brought you unto myself. (Exodus, 19, 4)

In Hebrew, the Great Trumpet in the quotation above is actually a *shofar*, an ancient musical instrument made from a ram's horn. This metaphoric blowing of a ram's horn is also mentioned in the Jewish *Amidah* prayer;[19] the image of *shofar* blowing reminds God of his promises to gather the People of Israel from

18 Mordechai Ommer, *Yitzhak Danziger* (exh. cat.), Tel Aviv: Tel Aviv Museum of Art, The Open Museum Tefen, 1996, 40.
19 The *Amidah* prayer is the central prayer of Jewish liturgy. Observant Jews recite it three times a day: in the morning, afternoon, and evening.

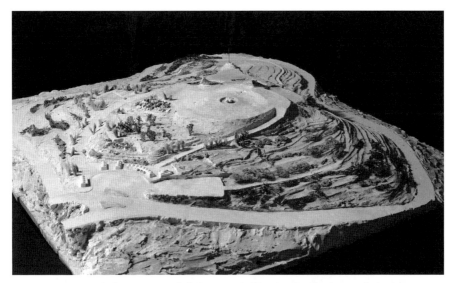

FIGURE 13.8A Yitzhak Danziger and Shalgi, *Proposal for Theodor Herzl's Burial Site*, 1949

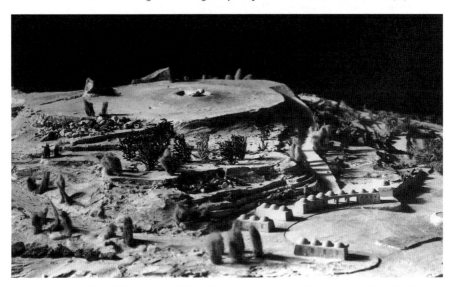

FIGURE 13.8B Yitzhak Danziger and Shalgi, *Proposal for Theodor Herzl's Burial Site*, detail

its exile and bring it back to its homeland. Shalgi and Danziger's burial site for Herzl, the secular Zionist prophet who was one of the first to express the idea of the Jewish People's return to Zion at the beginning of the twentieth century, was based on biblical symbolism, witnessing a modern, secular realization of the prophet's vision.

13.6 The Committee for Herzl's Burial Site Doubts Its Own Decisions

Nine years have passed since the first prize was awarded to Klarwein's proposal. Throughout those years members of the committee met many times, formed sub-committees and turned to advisors for professional advice. Several times they felt that they do not trust their own decision about Klarwein's competence as an architect. Consequently, they came out with alterations and additions to his original design. One of their constant debates was concerned with whether to construct the proposed dome or discard the idea altogether.[20]

The committee met on Mount Herzl (14 January 1959) in an attempt to solve the issue. At the end of their visit to the site, they decided against the implementation of the construction of the dome, because "... Even in the case of an affirmative decision [to construct the dome] it would be impossible to complete the work by the centenary birthday of Theodore Herzl and it would be impossible to inaugurate the centenary celebration on Mount Herzl during the construction [of the dome]." The committee then approached Klarwein and requested that he submit an alternative plan; Klarwein agreed. After nine years of wavering, Klarwein's design for the Herzl monument was finally disposed of. The architect agreed to put away his original plan completely and submit to the committee an entirely new project. He was expected to come forth with a new design in less than five months (December 1959 to May 1960).

At the last minute, a new protagonist voiced his opinion concerning the Herzl monument: B. Yesha'ayahu, the Jerusalem Region Deputy. He sent a letter to chairman Kreutner in which he stated his observations and suggestions. His words contained so many alterations that they merit to be quoted in full:

> Klarwein's [new] design was shown to me; I studied it carefully and talked about it with some of my friends. Well, we all believe that the present design, excluding a high tombstone, would be very distinguished and adequate. [However] I do not recommend to approve Klarwein's proposal for a high tombstone ... A low layer [for the tombstone] would be more suitable. This way, while standing next to the tomb, visitors would be forced to lower their heads (and not lift them up in front of a high tombstone); this would add to the respect [we all feel for] the leader.

20 One such decision taken by the committee members was to include a mosaic decoration within Klarwein's overall design for the Herzl monument, "... A mosaic to be covered by water, the height of which would be ten centimeters." was generally accepted through the coordination with Klarwein and Israeli authors.

Minutes of the Committee for the Implementation of Herzl's Tomb, 29.1.1958, Central Zionist Archive, file S5 11.335.

Another aspect [in Klarwein's proposal] did not satisfy me: the paving around the tombstone in the shape of a *Magen David* (the six-pointed star). The base itself is satisfactory; however, its form should rather be a large circle, befitting the existing circle around the tombstone. It would be advisory to keep the raised circle around the tomb and to re-work the new base in such a way that it would be lower so that it would be approached by two to three steps. If, after all, the committee decides to have the paving in the shape of a *Magen David* (as suggested by the architect), its inner angles should be more blunt, in order to make the passages wider between the *Magen David's* inner angles.[21]

The Jerusalem Region Deputy's letter was, indeed, an *ekphrasis*, a verbal proposal for a sculptural project containing detailed explanations for each of its components. According to Yesha'ayahu's plan, Klarwein's proposal was to undergo a complete metamorphosis. The Jerusalem Region Deputy proposals were accepted unanimously by all members of the committee during a meeting that took place on 16 February 1959.[22] Although they consulted with Klarwein, the committee's final decision was to request the architect for yet another new design for the tomb.[23] At this stage of the preparation for Herzl's centenary celebration, the architect must have given up.

13.7 Herzl's Tomb Final Design and Unveiling

Oddly enough, after ten years of long trials and tribulations, consultations, an international competition, prizes awarded to various architects from Israel and against all professional advice, the Committee for the Erection of Herzl's Tomb appointed the Haifa based *Even vaSid* (Stone and Lime) Industry Ltd.—a company that supplies gravel, building materials, lime, cut marble and concrete products—with the execution of Theodore Herzl's tombstone. It was finally inaugurated on 23 June 1960. Israeli newspapers reports were based on a press release, issued by the *Even vaSid* company:

21 *Letter to Yossef Weitz, Chairman of the Committee for the Planning of Mount Herzl, 1.12.1957* from B. Yeshaya, Deputy of the Jerusalem Region, 15.2.1960, Central Zionist Archive, file S5 11.337.
22 *Minutes of a joint meeting of the Committee for the Implementation of Herzl's Tomb and the Committee of the Zionist Management, 16.2.1960*, Central Zionist Archive, file S5 11.337.
23 Ibid.

... The implementation of the tombstone for the State's Visionary, Binyamin Ze'ev Herzl in Jerusalem throughout all its stages, from the search for a suitable stone to its erection on Mount Herzl, was entrusted with *Even vaSid* Company. The tombstone is made of black basalt rock from the Jordan valley. The unique quality of this black-hard rock is that it never crumbles or splits ... The stone's polishing is made solely in Israel since *Even vaSid* Company devised the perfect polishing techniques intended for this hard stone ... Special *Even vaSid* inspectors have patrolled the areas in which the stone is found, in order to find basalt stone blocks whose size before polishing would be three meters long by one meter thick. Difficulties encountered during the cutting procedure are significant. The following numbers would shed light on the gigantic effort [involved in the process] and the many difficulties it entailed [in cutting the blocks]. The maximum cutting speed of basalt rocks is four millimeters an hour. Consequently, the cutting of the tombstone's basalt blocks necessitated three months work in three shifts. The size of the basalt blocks necessitated a change in the cutting machines ... Another aspect that made the work so difficult was our precautious planning in preventing a potential shape of a *cross* on the marble panels.[24]

Even vaSid's bulletin is written in such pathos as to remind one of the grandiose propaganda that promoted the construction of the Lenin Mausoleum in Moscow. Its construction used 10,000 tons of black and red granite stones, brought to Moscow from seven Soviet republics. In order to transport them from the Ukraine to Moscow, a special train was manufactured, weighing 16 tons, motorized by 18 wheels. The pathos accompanying the quarrying process of the granite stones for Lenin's tomb served as a model for the stone cutting Israeli company from Haifa.

24 In *Maariv*, (24.6.1960) the bulletin was quoted almost verbatim: "Herzl's memorial made of basalt stone will be inaugurated today. Black basalt stone, quarried through significant difficult conditions at the Hukuk brook region, will be erected today as a permanent monument on Herzl's tomb. The workers of "Even vaSid" company have worked for three solid months, in three shifts, on polishing and hewing the big basalt stone. In order for the monument to be ready before the 20th of the month Tamuz. [...] The size of the monument is 2 meters by 2 meters. A single word inscribed on it: Herzl. The tombstone is resting on a basalt stone basis that is 3 meters by 3 meters. It was designed by architect Klarwein who is responsible for the design of the *Knesset* building as well."

Lamerchav (24.6.1960): "A monument was placed on Herzl's grave. It is made of black polished basalt stone that weighs about 10 tons. The word Herzl is inscribed on the tombstone; it took 200 hours to incise it on the stone." *Central Zionist Archive, file S5 n.337*.

On the centenary of Theodor Herzl's birthday (1960), Klarwein's proposal for a majestic, awe-inspiring burial site was replaced by a rectangular geometrical object made of black, finely polished basalt stones (fig. 13.9). On its front, in bold Hebrew characters, a single word: Herzl.

Most designers who participated in the international competition (including the two Israeli winners) aspired to create a pilgrimage site that would enable visitors an intimate communion with Herzl's memory as well as a vast square intended for large crowds. Klarwein's dome was meant to be an intimate gathering edifice that enables such a communion. A similar approach was taken by Shalgi and Danziger's design. Intimacy, a sensation of awe, and mourning are human feelings that every individual may experience while visiting a well-designed architectural edifice, fit for its purpose. Such feelings are bound to cause individuals to reflect upon the memory and deeds of a personality such as Herzl, whose vision brought forth the establishment of the State of Israel. The fact that Klarwein's dome was never built made any intimate communion with the memory of Herzl—an experience generally associated with a pilgrimage site as such—completely impossible.

The original plan to transfer Herzl's remains from the Diaspora with the approval of his native community members, bury them in Israeli soil, and create a new monument for him was meant "to express the respect and admiration that the People of Israel feels for Binyamin Ze'ev Herzl." Klarwein's agreement to give up most of the significant components of his original design, as well to assign the implementation of the monument to a commercial contracting firm points less to the fickle and strange nature of the architect as an individual than to the omnipotent control of members of the Zionist establishment and to their conviction that they were solely responsible for the artistic design of such a significant monument for the citizens of Israel. Klarwein was a perfect pawn in the hands of the committee members. For ten years they made his life miserable, changing his various architectural designs incessantly, adding to them, subtracting from them, and finally discarding them. The Israeli political establishment of the 1950s shunned individual values and espoused the emphasis of the Collective as the ultimate expression of Israeli nature. Therefore, the primal idea that aspired at endowing visitors to the Herzl monument with the possibility of an intimate, individual communion was utterly abandoned. Except for the grand plaza that was a part of Klarwein's original design, Herzl's burial site today looks like a typical, mundane Jewish tombstone.

The Israeli political establishment had other plans for the large public square next to Herzl's tomb. It turned the square into a site dedicated to state military ceremonies, marking the national Memorial Day for the Fallen in Israel's wars

and the opening of Independence Day celebrations. During the ceremony of Torch lighting,[25] conducted next to Herzl's tombstone every year, the tomb itself, though situated in front of the event podium, is completely overshadowed and dwarfed by burning torches and multi-colored floodlights. The thunder of drums and the sound of marching soldiers on the gravel paths around it make a perfect antithesis to the initial concept that required a respectful stillness. The designated intimate, communion pilgrimage site became military parade grounds. In addition, a few years ago a new structure was raised behind Herzl's tomb: a semi-circular dome made of aluminum planks (figs. 13.9a, b). It serves the ceremonies' chiefs, the choir that sings at the Independence Day ceremony, and the torch lighters.

The political establishment did not hesitate to appropriate its own share of the privilege. As early on as the first year of statehood, Israeli politicians and high officials awarded themselves free reign in expressing their unfounded opinions in making crucial decisions that had fateful repercussions on the character of the monuments later built in the state's public spaces. They sentenced them to a severe form of austere iconoclasm, without bothering to check with clerical experts whether these public monuments should be subject to any system of prohibitions in the first place. The political establishment foisted in the public art created during the early years of the state of Israel a new, so-called Jewish Israeli idiom; their dilettante considerations and ignorant interpretations of imagined Jewish prohibitions supposedly relevant to public memorials, have since become entrenched in the Israeli public sphere as unchallenged conventions. The austerity and paucity of Israeli public spaces have since grown to become Israeli tradition of its own.

Confronted by a black rectangular box-like object, we stand bewildered, wondering and trying to fathom whether it succeeds in expressing the aforementioned symbolical ingredients, conceived by the committee as the embodiment of Israeli Tradition. Its alleged simplicity and modesty may cause those in favor to attach to Herzl's black basalt stones tombstone the famous saying by architect Mies van de Rohe—*Less is more*. Those of us who disagree would prefer the witty retort of Robert Venturi: *Less is bore*.

25 The celebrations of Israel's Independence Dat begin with lighting 12 torches, symbolizing the biblical twelve Tribes of Israel. Candidates for the ceremony are chosen for their contributions—in many fields and professions—to Israeli society in that year.

FROM PILGRIMAGE SITE TO MILITARY MARCHING GROUNDS 333

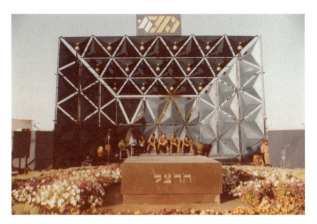

FIGURE 13.9A A plaza in front of Herzl's Tomb. Jerusalem, Mount Herzl, 1978

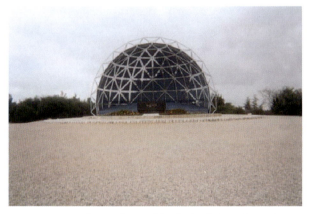

FIGURE 13.9B Plaza in front of Herzl's Tomb. Jerusalem, Mount Herzl, 2011

Bibliography

Arbel, Ilil, *The Afterlife*, Encylopedia Mythica at www.pantheon.org.

Doner, Batya, "Shkifut haKoach haNir'eh" (Transparency of the Seen Power) in *Hod veHadar, Tiksey haRibonit haIsraelit 1949–1958* (Splendor and Glory, Ceremonies of Israeli Sovereignty) (exh. cat.), Tel Aviv: Ha'aretz Museum, 2000.

Hecht, Reuven, Zmora, Ehud (editors), *Bitko'ah haShofar, Herzl, Dmuto, Po'alo uMivchar Ktavav* (When the Shofar Blows, Herzl, his Image, his Works and a Selection of his Writings), Haifa: Moledet, 1949.

Lamm, Maurice, *The Jewish Way in Death and Mourning*, New York: Jonathan David Publications, 1969.

M. G., "BeMa'arbolet haYamim" (Within Turbulent Days), *Gazit*, September 1949.

Naor-Vernik, Michal, Bar, Doron, "HaTacharut leTichnun Kever Herzl ve'eEtzuv Har Herzl 1949–1960" (The Competition for the Design of Herzl's Tomb and Herzl Mount 1949–1960), *Cathedra*, 144, 2002.

Omer, Mordechai, *Itzchak Danziger*, Tel Aviv: Tel Aviv Museum of Art, The Open Museum, Tefen, 1996.

Patai, Yosef, *Herzl*, Tel Aviv: Omanut Publication, 1936.

Unterman, Alan, *Dictionary of Jewish Lore and Legend*, London: Thames and Hudson, 1991.

CHAPTER 14

Natan Rapoport's Soviet Style of the Yad Mordechai and Negba Memorials

14.1 Ghetto Heroism and Israeli Valor

The very same year of the Herzl gravesite competition, art critic Eugen Kolb met Russian-Jewish sculptor Natan Rapoport (mentioned in chapter 8) in Tel-Aviv. The meeting resulted in an article in which he shared basic, primary ideas about the nature of future Israeli memorials:

> At a time that many among us begin to design memorials for our War of Independence … Kibbutz Yad Mordechai did well in taking upon itself the initiative to entrust Natan Rapoport with the mission of erecting the suitable memorial for the *Kibbutz* Fallen and to the hero of the Warsaw Ghetto, whose name was adopted by that *kibbutz*—Mordechai Anilewizc.[1]

Connecting the Warsaw Ghetto fighters with those of Israel's Independence War was a popular contemporary Zionist concept. Idit Zartal explains it as wishing to integrate the Ghetto uprisings into the narrative of Israel's Independence War, one link in a chain of battles for the Land of Israel. It would show that the Diaspora Jews participated in the fight for a Jewish State and that the Zionist struggle for the Jewish state meant life or death. It associated the destiny of European Jewry with the right for the establishment of a Jewish state after World War II.[2]

Kolb's great admiration for Natan Rapoport is quite understandable in this context; The Russian sculptor arrived in Israel a few days after the unveiling of his memorial to the Warsaw ghetto uprising in Warsaw (April 19, 1949). The monument was made known in Israel through photographs and newspaper

1 Eugen Kolb, "ha'Andarta, Sicha eem Natan Rapoport" (The Memorial, a Conversation with Natan Rapoport), *Al haMishmar*, April 18, 1949. For a complete discussion of Natan Rapoport's *oeuvre* see: Batya Doner *Natan Rapoport Oman Yehudi* (Natan Rapoport, Jewish artist), Givat Haviva and Yad Itzchak Ben Zvi, 2015.
2 Idit Zartal, *Ha'uma vehaMavet, Historiya, Zikaron* (The Nation and Death, History, Memory), Tel Aviv: Dvir Publication, 2002.

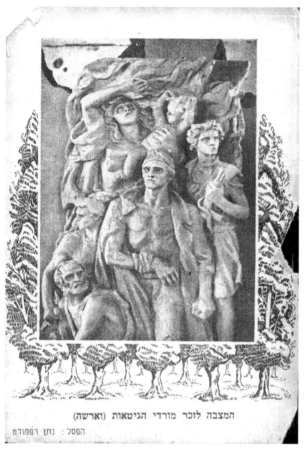

FIGURE 14.1 Natan Rapoport's *Memorial for the Warsaw Ghetto Fighters,* ca. 1950, postcard issued by The Jewish National Fund

articles. The *Warsaw Memorial* became the primary element in Rapoport's exceptional reputation among political activists in Israel.

The sculptor himself best described his sculptural style by labeling it Heroic Realism, which prevailed in Soviet Russia. His bronze heroes, presented to the public as if emerging from a massive stone wall into the spacious square, are based on 19th century sculptural concepts such as those of French sculptor Francois Rude's French Revolution heroes on the Arch of Triumph in Paris.

"Settlements, *kibbutzim,* public institutions and army units, etc. are now dealing with future plans for the erection of memorials to the Fallen." Kolb wrote

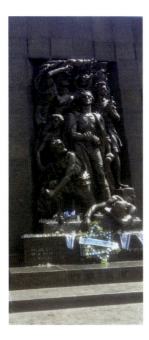

FIGURE 14.2
Natan Rapoport, *Memorial for the Warsaw Ghetto Heroes*, 1949, bronze sculpture, Warsaw

Have we learned a lesson? … A dangerous phenomenon may occur if the country would be flooded with memorials, that both their contents as well as their look would not convey the idea they are purported to express; distressing signs already appeared on the horizon…. The problem of public memorials is in the public's foremost interest.

Another possible danger would occur if instead of inducing a festive spirit, certain memorials would make the environment ugly … there is a chance that such memorials would give birth to a conjuncture for dilettantes and protectionism … the lines [of this article] are devoted to such a discussion.[3]

Kolb asked three Israeli sculptors to voice their opinions about the subject of future memorials.[4] Sculptor Dov Feigin (1907–2000) maintained that memorials should constitute a collective rather than an individual commemoration.

3 Eugen Kolb, "haDerech sheba Ye'utzvu Andrata'ot haShuchrur Shelanu, De'ot mipi haPasalim Z. Ben Zvi, Dov Feigin and N. Rapoport" (The Way our Independence War Memorials would Be Designed, Opinions Voiced by Sculptors Z. Ben-Zvi, Dov Feigin and N. Rapoport), *Al Hamishmar*, June 2, 1948.
4 Kolb, Ibid.

He demanded that they should not be gloomy and that their design would not stress the tragic or the theatrical-pathetic. He suggested that future memorials be installed within a populated public space and that their design should be entrusted with artists. Feigin foresaw the future: he recommended that religious considerations should not hamper the design process of future Israeli memorials.[5]

Adoption of the Zionist concept binding the Ghetto fighters with fighters of Israel's Independence War were the reasons for the important status Rapoport acquired in the Zionist establishment, far beyond other contemporary Israeli sculptors. Thanks to this high esteem, he was commissioned to produce two large memorials: one for *kibbutz* Yad Mordechai, the other *for kibbutz* Negba. These two completely negated the minimalist style of memorials preferred by contemporary Israeli competition as voiced by the competition for Herzl's burial site.

The giant bronze sculptures in Yad Mordechai and Negba pose some curious questions as to the circumstances that brought about their commission: Who were their patrons? Who were the persons or institutions responsible for raising the enormous sums needed for their creation? Where were the statues cast in bronze? How were they received by kibbutz members?

What must be considered is Rapoport's memorials' enormous size. In 1949, there wasn't a single foundry in Israel who could cast them. The statues had to be cast in Europe and then shipped to Israel, a task involving large sums of money. At that time the state of Israel experienced severe austerity; the entire population was living under economic restrictions and food shortages.

14.2 The Yad Mordechai Memorial

The first commission for a grand bronze memorial came from Kibbutz Yad Mordechai. A special committee was formed, named The Honorary Committee for the Commemoration of Mordechai Anilewizc, commander of the Warsaw Ghetto and the Yad Mordechai Fallen.[6] It announced its purposes in a letter sent to potential donors stating: "... The sublime idea of erecting memorials symbolizing the status of our people's heroism in the Diaspora and in Israel."

5 Ibid.
6 Among the committee members were the following: President Chaim Weitzman, Prime Minister David Ben Gurion, Knesset Chairman Josef Shprintzak, Berl Locker of the Jewish Agency, Ya'akov Dory, Chief of the Israeli Armed Forces and the two consuls of Poland in Jerusalem and in Tel-Aviv.

It also informed the potential donors of the sums needed: twenty thousand pounds[7] and did not bother with any public competition; from the beginning, the monument was commissioned solely from Rapoport.

The first concept for the memorial in Yad Mordechai was intended to create two memorials. One would show the hero of the Warsaw Ghetto Uprising (the Diaspora) facing the other, which would show fighters of Israel's Independence War. A contemporary Israeli paper reported:

> ... Rappoport plans to erect *two* memorials ... The memorial to the Fallen would comprise of a group of fighters as if rising from their grave. The other would show Mordechai Anilewicz rising from burning flames. The latter is, lighting the fire of love in the hearts of Jewish fighters, who cling tightly, with their nails, to the soil of their collective settlements in this land....[8]

The artist was busy preparing models for the two memorials. In April 1950 *Al Hamishmar* daily newspaper informed its readers that

> ... Rapoport's first memorial will be cast in bronze, and the other will be sculpted in stone. The models are made of plaster ... When the models would be finally approved, the artist would begin working so that he would be able to finish the sculptures for the next assembly in 1951 during which—so he hopes—the unveiling will take place.[9]

On April 19, 1950, the sculptor exhibited various models hoping that the kibbutz members would choose two—one for the Anilewizc memorial and the other for the Independence War fallen.

The model for the *Anilewizc Memorial* (fig. 14.3) shows the Ghetto commander as a dynamic warrior frozen in the dramatic gesture of throwing a hand grenade held in his right hand. The hero lifts his left hand and stabilizes his body in order to achieve the right balance during which, when the grenade is cocked, he would put all his energy and strength into the throwing gesture.

7 *Letter from "The Honorary Committee for the Commemoration of Mordechai Anilewitch (Commander of the Warsaw Ghetto) and the Yad Mordechai Fallen", 1949*, Yad Mordechai archive, Natan Rapoport file.

8 Gershon, "Sha'a eem haPasal Natan Rapoport" (An Hour with Sculptor Natan Rapoport), *baSha'ar* (a newspaper clip, undated), Yad Mordechai Archive, Natan Rapoport File.

9 Shabtai Kaplan, "The memory of the Ghetto Uprising will be presented in Yad Mordechai, the models for the Anilewizc memorial and the fighters memorial will be exhibited there". *Al Hamishmar*, April 17, 1950.

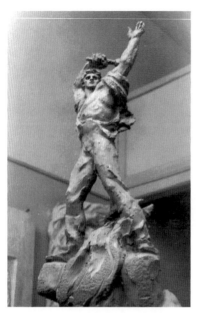 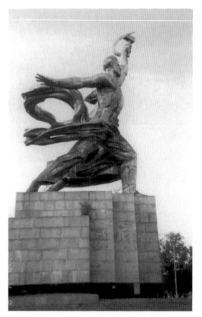

FIGURE 14.3 Natan Rapoport, *First model for the Anilewizc Memorial* in Yad Mordechai 1949 (first version)

FIGURE 14.4 Vera Muchina, *Factory and Kolchoz Workers*, 1937, stainless-steel plates on an iron skeleton, Moscow

Flames appear on the small hill to the left of his left foot. Rapoport's brave fighter is a *Phoenix* rising and renewing itself from the burning flames.[10]

The dynamic aspect of Rapoport's model is taken from Communist sculptural tradition. The most significant model which served him in the design of the *Anilewizc Memorial* must have been Soviet sculptor Vera Muchina's (1889–1953)s *Factory and Kolchoz Worker* (fig. 14.4).[11] Muchina's symbolic heroes' gestures suggest momentum, progress, breakthrough, and marching—all

10 An interesting element in this primal model is the hand grenade held by Anilewizc; its shape is that of a cylindrical container. This kind of hand grenade was used during WW2. In the final version for the Anilewizc memorial Rapoport changed the shape of the grenade and updated it to fit the typical form of hand grenades used during Israel's Independence War: an elongated ball with protrusions.
11 Originally, this statue was placed on top of Soviet Russia's pavilion in the International Fair held in Paris in 1937. Later on it was moved to the site of the Agricultural Exhibition Grounds in Moscow. Muchina's sculpture turned into a Communist icon; every Soviet citizen (including Rapoport) was very familiar with it.

directed towards a better tomorrow and an idyllic future. The two figures are visual personifications of Industry (the worker with the hammer in his hand) and Agriculture (scythe in the hand of the kolkhoz worker). The drapery in Muchina's statue, fluttering in an imaginary wind, was added to the sculpted pair in order to stress their dynamism and the dramatic flow of their marching against an imaginary storming wind representing the anti-revolutionary powers of darkness against which the progressive spirit of Communism marches on. Rapoport borrowed the drapery motif for Anilewizc's waving shirt, exposing his muscular chest.

The strange combination of realism and theatrical-pathetic exaggeration apparently was not appreciated by members of Kibbutz Yad Mordechai. They rejected this model and voted for another, showing the hero in a much more restrained way (fig. 14.6).

According to Rapoport's plan, the counterpart to the Anilewizc memorial was a memorial for the Yad Mordechai Fallen. The sculptor prepared two models: the first (fig. 14.5) was comprised of five figures: three men and two women. The theatrical juxtaposition of the protagonists shows them as farmers and warriors; the women's role is that of assistants. The female figure on the left carries a dead soldier in her arms in the familiar *Pieta* gesture. The reclining female figure (extreme right) acts as a personification of Temperance: she sends her right hand backward, thus signaling the soldier that stands behind her to wait before he throws his grenade. The general concept in the *Yad Mordechai Memorial* was a group of fighters rising from their graves; the heroes of Israel's

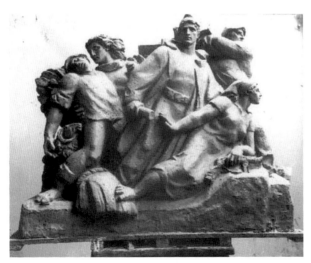

FIGURE 14.5 Natan Rapoport, *Plaster model for the Memorial of the Fallen in Kibbutz Yad Mordechai*, 1949

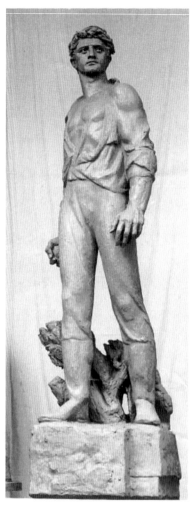
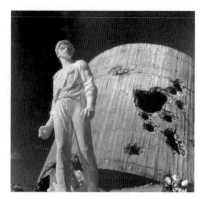

FIGURES 14.6A, B Natan Rapoport, *Second model for the Anilewizc Memorial* in Yad Mordechai

Independence War as well as the commander of the Warsaw Ghetto shown as resurrecting dead.

Both proposed sculptures express a dichotomous rendering of certain aspects of realism next to schematization. Anilewizc's exposed chest and arm muscles are rendered in extreme realism next to costumes that lack any possible contemporaneous or local characteristics. The clothes are represented schematically, separated from any periodical context as worn by the female kibbutz comrade dress or Anilewizc's pants and shirt (figs. 14.5, 14.6). Looking

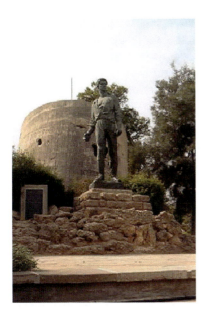

FIGURE 14.7
Natan Rapoport, *Memorial for Mordechai Anilewizc*, 1949–1951, bronze, Kibbutz Yad Mordechai

at the bronze statue of Anilewizc (fig. 14.7) one is vexed by the blurred placement of the figure's waistline and the omission of a belt. The hero's shirt is buttoned above his waist, unbuttoned on the chest. This costume is anything but authentic clothes worn by the commander of the Ghetto uprising in the middle of a battle with the German army.

In August 1950 a contract was signed with the sculptor. He was promised the sum of 3000 Israeli Pounds as well as casting expenses and the installment of the sculpture in place. It is worth mentioning that this sum is 30 times greater than that spent by the State of Israel for the preparations of the hall at the Tel-Aviv museum for the proclamation of Statehood ceremony in 1948; that sum consisted of only 102 Israeli pounds.

After completing the plaster models for the memorial, Rapoport took his family to Paris there to oversee the bronze casting process.[12] The unveiling ceremony for the *Mordechai Anilewizc Memorial* took place, as planned, on April 19, 1951. One of the speakers during the assembly was Mordechai Bilori from kibbutz Beyt Zera, who summed up the mythical aspect attributed to Rapoport's giant statue, still covered by a cloth, before the unveiling:

12 *Letter from Natan Rapoport to Monyo* (a Yad Mordechai kibbutz member), February 19, 1951, Kibbutz Yad Mordechai Archive, Natan Rapoport file.

Commander Mordechai!

We come to announce to you that on this day we renewed our covenant, the covenant between Life and Death that you made with your people and your Motherland during your fight in the Ghetto. Today we redeemed you from a foreign body in the outskirts of the Diaspora and planted you into our landscape with which you would merge.... Today we redeemed you from solitude, silence, and forgetfulness.... We were not able to gather your remains and those of your friends to bring them forth to the land and pay them the respect they deserve as commander and leader. We simply did not find them....

... Mordechai, do you know that today only you would receive a clear, convincing answer to your call 'where is rescue?' heard through the burning Ghetto walls. Lift up your eyes and behold: northwards and southwards, eastwards and westwards—Israel—a free Motherland for the People of Israel.... This is rescue![13]

In the giant bronze image of Mordechai Anilewizc, (fig. 14.7) Bilori envisioned a substitute to the hero's corporeal remains. The critic Eugen Kolb who participated at the unveiling ceremony of the *Anilewizc Memorial* published his impression in an article entitled "The Will of the Collective Manifested in an Artist's Vision":

> ... Something primeval was erected at Yad Mordechai, something that was born out of the collective will and expressing itself through the artist's vision who drew his inspiration from the creative forces of that same collective. We are confronted by a work in which site, time and environment, Nature and art, past and present, idea and matter, plastic values and educational values come together to form a common denominator.[14]

Kolb sees Rapoport's work—although he does not say it directly—a perfect expression of Social-Realist style reflection of the collective. He then continues with a minute observation of the memorial:

13 Mordechai Bilori, "Tzror Machshavot al Kivro shel Mordechai Anilewizc" (Thoughts on the Tomb of Mordechai Anilewizc), published in *Basha'ar*, quoted by Vered Bar Semech (ed.), *Arba'eem Shana leHasarat haLot shel Andartat Mordechai Anilewizc beYad Mordechai April 1851–2001* (Fifty Years for the Unveiling of the Memorial at Yad Mordechai, April 1951–April 2001), Kibbutz Yad Mordechai, 2001.
14 Eugen Kolb, "Retzono shel Kolektiv Mitgashem beChazono shel Oman" (The Will of the Collective Manifested in an Artist's Vision), *Al Hamishmar*, May 4, 1951.

FIGURE 14.8 Natan Rapoport, *Plaster model for Mordechai Anilewizc*, detail of fig. 14.5b

FIGURE 14.9 Mordechai Anilewizc (1919–1943), (photograph)

This is a realistic work ... a beautiful masculine idea; in it, the love for the people and the hate for Fascism are combined ... But the memorial is much more than just a familiar realist depiction of a human figure. It does not depict the portrait of Mordechai Anilewizc himself (though it does have something of his facial features). The memorial is elevated from the individual, unique aspects and enters a higher sphere: that of a type.[15]

Kolb was right in his comment about Mordechai Anilewizc's facial features. Rapoport did not see it as essential to realistically stress the model's individual features and they do not resemble his real-life features at all (fig. 14.9b). The missing resemblance reveals the enormous gap separating the accepted definition in Western art for realism and that of Communist Social-Realism. The latter demands of its artists an oxymoronic creation, based on two contradictory aspirations: on the one hand the need to create art for the Collective, easily understood by it and therefore a mimetic art. On the other hand, it must deprive private persons of their individualistic characteristics and endow them with the sublime aspects of an anonymous *type* that represents an entire collective. Kolb explains the models used by Rapoport when creating Anilewizc's image:

15 Ibid.

> At this point, the artist had before him the French school to which he is tied culturally ... Through realistic means, Rapoport renders Anilewizc's image into a symbol. This figure is not itself alone—it rises from the ground, it ascends. The face is a summation of concentration and determination of a commander—but it doesn't allow us to forget that in front of us stands a *boy* (my emphasis. A. M.) out of a crowd, in all his simplicity.... Those who see in this memorial an idealization of reality are wrong, in my opinion. It would be correct to say: in front of us rises a realization of an ideal.[16]

In this passage Kolb makes a perfect example of the common phenomenon of human observation: he stands in front of a monumental sculpture and sees in it all the characteristics which he expects it to represent, not what is really in front of him. The face and the body of Rapoport's statue are those of a grown-up man and not those of a boy or a youth. Rapoport did not create a thoroughly realist rendering of Mordechai Anilewizc who was twenty-four years old when he died. Due to his adherence to a theatrical-pathetic style, he had to depict the Ghetto commander as a stocky man.

Standing in front of the statue, made the art critic write the following conclusion:

> ... I, myself, don't think that Rapoport's work should set an example to every monumental sculpture in our country—but I am convinced that this special site [kibbutz Yad Mordechai] in which this memorial is of special significance, any other solution would not be right. Even if there was no prohibition from the religious front, we should be careful, for artistic reasons to avoid giant bronze figures looking at us atop high pedestals in our streets and our public squares. In such places, more abstract memorials would catch the eye of beholders and induce the right atmosphere through their plastic beauty. Here, within the bosom of nature and the content of kibbutz reality, with its different atmosphere—here, the right artistic impression is conveyed through a human figure ... The style loses its 'foreign' nature by the fact that it is integrated harmoniously with its environment.[17]

16 Ibid.
17 Ibid.

Rapoport's stone group sculpture of the Independence War heroes was never realized. The symbolic combination of Holocaust and Resurrection, the tie between ghetto fighters and their spiritual offspring who continue their mission was forgotten. The explanation for the missing memorial for the Fallen was made in an official declaration that bestowed symbolic values to the bombed water-tower next to which Rapoport situated his statue of Mordechai Anilewizc (fig. 14.6b).

At the end of the 1920s and especially during the 1930s water-towers were an essential element in the iconography of the Zionist settlement landscape. During the British mandate, the water-tower's symbolic value was drawn from its specific function and its situation within the Jewish settlement's topography. During the 1948 war, water-towers were metamorphosed into icons, symbolizing destruction, caused by the enemy bombardments on the home front as well as a symbol for the mythical-heroic activities of the settlers themselves. Two water-towers—one in kibbutz Negba and another in Yad Mordechai became memorial icons because the two southern *kibbutzim* played a significant role in the war against the Egyptian army. During the fights, the water-towers served as look-out points and were targeted by the Egyptian artillery. As a result of the damage they suffered, they stopped to function as water reservoirs and became ruins. From there on end, they joined a large group of ruined edifices caused by the war. Later on, they were conceived as relics, functioning as memorials.[18]

Artist Nachum Gutman (1898–1980) expressed the symbolism alluded to water-towers in a drawing he made during the Independence War. *Man of Kibbutz Gat* (fig. 14.10) focuses on the scars, etched on the water-tower by bombardment, placed in a distant plane. In the background, Gutman's *kibbutz* member stands erect, in a gesture that conveys self-confidence and firmness, traits that are completely opposed to the ruins and vulnerability of the water-tower behind him.

It is entirely possible that both Rapoport and the members of kibbutz Yad Mordechai were familiar with Gutman's drawing. It is included in *Chayot haNegev* (the Desert Beasts) book of drawings that was very popular upon its publication (1949) and for quite some time after the end of Israel's Independence War. The drawing could assist the decision to install Anilewizc's statue next

18 Maoz Azaryahu, "Migdeley Mayim beNof haZikaron: Negba veYad Mordechai" (Water-Towers in the Landscape of Memory: Negba and Yad Mordechai) in Mordechai Omer (editor), *Migdeley Mayim beIsrael 1891–1993* (Water-Towers in Israel 1891–1993) (exh. cat.), Tel Aviv University Art Gallery, 1993, 37.

FIGURE 14.10 Nachum Gutman, *Man of Kibbutz Gat*, 1949, pen and ink drawing, from the artist's book *Chayot haNegev* (The Negev Beasts)

to the *kibbutz* water tower. The contrast of a proud man standing next to a ruin—the man of Gat in the drawing and the bronze statue of Anilewizc both juxtaposed with a scarred water-tower—expresses visually the central Zionist theme that binds destruction and resurrection.

The leadership of the kibbutz movement was extremely satisfied with the Yad Mordechai giant bronze sculpture; less than two years after its unveiling, it was responsible for yet another creation by Natan Rapoport, a memorial *for Kibbutz* Negba. The memorial was dedicated solely to the Israeli Fallen in the Independence War with no connection to the heroes of the Jewish Ghetto Uprising.

14.3 The Negba Memorial

The committee dedicated to the commemoration of the *kibbutz* fallen was formed in 1951. It published a notice in various daily newspapers asking for potential contributors for financing the erection of the memorial.[19]

Rapoport's first schematic relief model was made of clay, and later on, it was cast in plaster (figs. 14.11, 14.12). The three women and three men on the relief echo the group he made for *The Warsaw Ghetto Memorial* (fig. 14.2). Four figures are fighters, identified by the weapons they hold in their hands. The second from the left figure is a mother, embracing her infant; she is also a copy from the Warsaw memorial.

In a reductive process probably influenced by low funds, Rapoport reduced the number of figures from six to three. He attempted to give the three figures appropriate gestures in his next model (fig. 14.13a). The hand grenade held by the woman in the first model was discarded; in the second model, a rifle hangs from her shoulder. To vary the figures' erect poses, Rapoport chose to differentiate the way they hold their weapons. The left figure holds it parallels with her waistline, the middle figure rests the barrel of the gun on the ground, and the third figure's weapon is hung on her shoulder. None of these gestures indicates a fighting activity, as they turn their gazes in different directions.

FIGURE 14.11 Natan Rapoport, *Model for the Negba Memorial*, clay relief, Kibbutz Negba

19 *Yad leMem Daled Chalaley haMa'aracha al Negba uMvo'oteha* (Memorial to the 44 Fallen in Negba and its Environment), Publication of the Committee for the Commemoration of the Fallen in the Negev War, Tel Aviv, 1950s (unpaged).

FIGURE 14.12 Natan Rapoport, *Model for the Negba Memorial*, plaster relief

Each is self-absorbed and has no connection with the others. The artist apparently decided to convey the concepts of fighting and mutual help through the physical contact between the three figures. In the next version of the proposed memorial, the figures connect by holding hands (fig. 14.3b).

We don't know how the sculptor came up with the idea of putting his protagonists' hands together. It may had something to do with the heroic and comradely traits of being jointly dedicated to a right aim, of fighting with dark forces, expressed through monumental, theatrical ways penetrated with eroticism like the sculptural style admired by the Nazi regime. Hitler's favorite sculptor Joseph Torak's *Fraternity* (fig. 14.14) probably made all of Rapoport's secret wishes come true. It shows a pair of nude men marching forward, realizing ideals of superhuman, immaculate race, sportive, healthy, determined—everything theatrical and pathetic which could be achieved in a work of art bordering on ludicrous realism.

It is of interest to note the resemblance of Rapoport's grouping of figures to an illustration published in an Israeli newspaper three years before the sculptor began working on the *Negba Memorial*. Figures of *The Execution Committee* by Yosef Friedman (fig. 14.15) include a male farmer (holding a hoe), a male

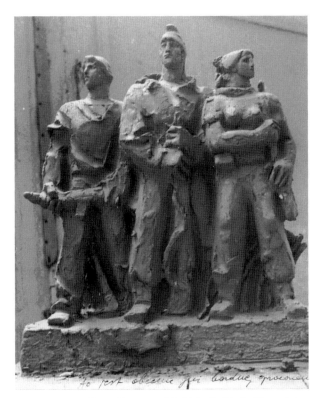

FIGURE 14.13A Natan Rapoport, *Model for the Negba Memorial*, clay

soldier (carrying a machine gun) and a female nurse (wearing a first aid kit on her shoulder). We will never know if Rapoport or any other *kibbutz* member were familiar with this illustration; nevertheless, it would be more than a coincidence that both works show not only identical protagonists: a farmer, a soldier, and a nurse but specific accessories as well.

The hands held together motif did the job; *kibbutz* Negba members were impressed by it and approved its execution. The sculptor traveled again to Paris for the process of casting the work in bronze. On November 4, 1953, the memorial was inaugurated in Negba (figs. 14.6a, b).

At the inauguration of the *Negba Memorial kibbutz* member Yoel Iglinski referred to the figures' gestures:

> The central figure is that of a *kibbutz* member, pressing strongly, hand in hand with a young soldier and a fighting woman His strong and cumbersome hands ... [are] locked together, in order to pass this strength,

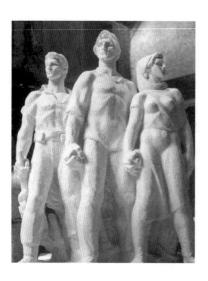

FIGURE 14.13B Natan Rapoport, *Model for the Negba Memorial*, clay

FIGURE 14.14 Joseph Torak, *Fraternity*, 1937, bronze, sculpture for the German Pavilion in the Paris International Exhibition

that comes from a man rooted and planted in his ground, to those standing on his sides—a collective fate in the fateful war.

The girl-woman symbolizes the new woman who plays an equal part in the entire system of our nation's resurrection … … the small impression of elegance conveyed by her image does not fit the overall event conveyed by the monument. The upper part of her body, from her waist up, suffers and is not convincing enough.[20]

Art critic Eugen Kolb disagreed with Iglinski's impression of the female protagonist:

It is a pity that he [Iglinski] used the expression 'elegance.' Rapoport could have blurred the image of the woman so as to resemble those of

20 Yoel Iglinski, in *Kol Negba Bama leBituy veInformatzya* (The Voice of Negba, for Expression and Information), No. 5 (103), 20.11.1953.

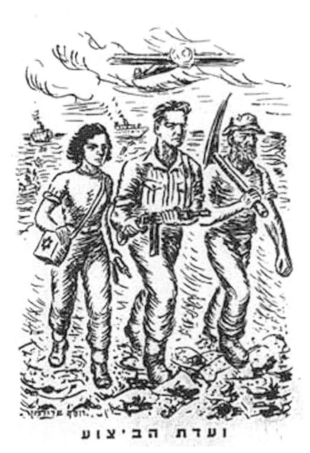

FIGURE 14.15 Yosef Friedman, *The Execution Committee*, illustration in a daily newspaper, 1948

the men next to her. Indeed, he did well in emphasizing her uniqueness. The artist imbued her with grace. She is a beautiful girl.[21]

Both Iglinski and Kolb's impressions reveal that they noticed Rapoport's female heroine's erect breasts. The sculpted cloth covering her body looks wet, stuck to her belly and buttocks, imbuing her with hidden eroticism, as best following of Soviet precedents.

21 Ibid.

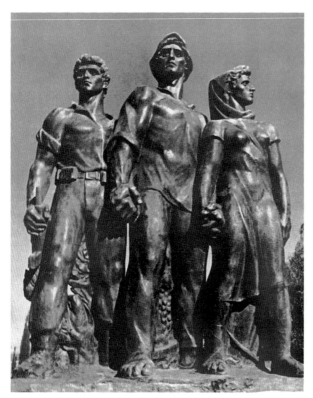

FIGURE 14.16 Natan Rapoport, *The Negba Memorial*, 1953, bronze, Kibbutz Negba

• • •

Both of Rapoport's memorials were installed on private grounds of *kibbutzim*. Since the two memorials were made for private institutions and were not commissioned by formal Israeli ones, their erection did not cause any objections by the Israeli clerical establishment. The memorials express the victory of one ideological-political agenda over another: socialist ideology, followed by the *Mapam* (United Workers Party) over *Mapay* (Workers of the Land of Israel Party). Both were Socialist parties, but they had their differences. During Israel's Independence War ties both party members tried to minimize any conflicts, but at other times *Mapam* took definite oppositional stands to contemporary Israeli government headed by the *Mapay* party. While the *Mapay* party, who had formed the government in those days, had to take into consideration pressures put on it by the religious parties that formed the coalition, the population of *kibbutzim*, mostly belonging to the *Mapam* party, did

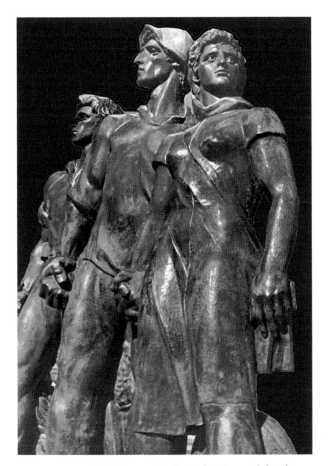

FIGURE 14.16A Natan Rapoport, *The Negba Memorial*, detail

not have to heed any restrictions or religious laws. Moreover, they apparently were proud to adopt the Soviet Social Realism style, through which they could boast an equal status to other members of the Socialist International. *Kol Negba* (Negba Voice), the *kibbutz* official paper, referred to Rapoport's memorials' symbolic ideological victory of *Mapam* over *Mapay*:

> With the unveiling of the memorial, the event satisfied all members; before everyone left for home ... people were saying that] there were no controversies with *Mapay*, nobody talked about the revenge on the government and its coalition.[22]

22 *Kol Negba*, 20.11.53.

Both Rapoport's memorials depict large-scale human figures. As such, they disregard the declaration of the Herzl Tomb Committee announcements that "Herzl's portrait should not be shown." The Israeli religious parties' potential claim that depiction of human figures was not allowed was of no interest to Rapoport or to the Yad Mordechai and Negba officials.

Kolb's prophetic assumptions concerning the erection of public monuments in the Israeli public space came true: only a few monuments depicting human figures were erected in Israel, most of which commissioned and installed in *kibbutzim*; most others, as he foretold, are abstract.

Bibliography

Azaryahu, Maoz, "Migdeley Mayim beNof haZikaron: Negba veYad Mordechai" (Water-Towers in the Landscape of Memory) in Mordechai Omer (editor), *Migdeley Mayim beIsrael 1891–1993* (Water-Towers in Israel 1891–1993) (exh. cat.), Tel Aviv University Art Gallery, 1993.

Bar Semech, Vered, (ed.), *Arba'eem Shana leHasarat haLot shel Andartat Mordechai Anilewizc beYad Mordechai April 1851–2001* (Fifty Years for the Unveiling of the Memorial at Yad Mordechai, April 1951–April 2001, Kibbutz Yad Mordechai, 2001.

Bilori, Mordechai, "Zer Machshavot al Kivro shel Mordechai Anilewizc" (Some Thoughts on the Tomb of Mordechai Anilewizc"), published in *baSha'ar*, as quoted by Vered Bar Semech (ed.), *Arba'eem Shana leHasarat haLot shel Andartaa Mordechai Anilewizc beYad Mordechai April 1851–2001* (Fifty Years for the Unveiling of the Memorial at Yad Mordechai, April 1951–April 2001, Kibbutz Yad Mordechai, 2001.

Doner, Batya, *Natan Rapoport Oman Yehudi* (Natan Rapoport, Jewish Artist), Givat Haviva and Yad Itzchak Ben Zvi, 2015.

Iglinski, Yoel, in *Kol Negba Bama leBituy veInformatzya* (The Voice of Negba, for Expression and Information), No. 5 (103), 20.11.1953.

Kaplan, Shabtai, "The Memory of the Ghetto Uprising will be Presented in Yad Mordechai, the Models for the Anilewizc Memorial and the Fighters' Memorial will be Exhibited There" *Al haMishmar*, April 17, 1950.

Kol Negnba, Bama leVituy ve'Eenfornatzya (The voice of Negba, for Expression and Information), 1953.

Kolb, Eugen, "Keytzad Te'utzav Dmutan shel Matzvvot haZikaron leMilchemet Shichrureynu, Chavat Da'at haPasalim Z. Ben Zvi, D. Feygin, N. Rapaport)" (How would the Image of Memorials for our War of Independence be Designed, Opinions Voiced by Sculptors Z. Ben Zvi, D. Feygin, N. Rapaport), *Al haMishmar*, 1948.

Kolb, Eugen, "Matzevet haZikaron, Sicha eem Natan Rapoport" (The War Memorial, a Conversation with Natan Rapoport), *Al haMishmar*, 18.4.1949.

Kolb, Eugen, "Retzono shel Kolektiv sheNitgalem beChazon Oman" (The will of the Collective as Realized in an Artist's Vision), *Al hamishmar*, 1951.

Yad leMem Daled Chaleley haMa'aracha al Negba uMvo'oteha (Memorial to the 44 Fallen in the War on Negba and its Environment), Published by the Committee for the Commemoration of the Negba Fallen, Tel Aviv, 1950.

Yad Mordechai Archive, *Natan Rapoport file*.

Zartal, Idit, *ha'Uuma vehaMavet, Historiya, Zikaron, Politika* (Nation and Death, History, Memory, Politics), Tel Aviv: Dvir Publishing, 2002.

CHAPTER 15

Holocaust and Resurrection in Yigal Tumarkin's Memorial in Tel Aviv

The Zionist ideas linking the concepts of Holocaust and Jewish heroism, expressed in Natan Rapoport' *Anielewicz Memorial* in Yad Mordechai, were given different forms in the 1960s by many Israeli municipal authorities' decisions to erect memorials to the Holocaust.[1] Rapoport's heroic style was shunned by both Israeli artistic circles and political establishments and was never pursued in Israel's urban public spaces. Memorials to the Holocaust victims erected throughout Israel are mostly minimalistic-abstract-architectonic in style, following contemporary European and American models.

New laws dedicated to the conservation and commemoration of the Holocaust, one of the most sensitive subjects in Israeli culture, were declared a few years after the founding of the state. The general public's conception of the Holocaust changed throughout the years and influenced artistic approaches to the subject. Moshe Zukerman wrote about the Israeli attitude towards the Holocaust during the state's early years:

> It seems that there isn't anything more natural since who if not 'The Jewish State' would seek primogeniture of Jewish Holocaust remembrance? Nevertheless, the matter is not so simple: since the fact that Zionist ideology relies on a complete negation of the Diaspora, Holocaust victims, as an expression of Diasporic subjects, must be negatively integrated in Zionist ideology, or, more precisely as ones that must be categorically demanded to do away with their Diasporic identity. One could not approach those who perished with such a demand—they quickly turned into an enormous mass of anonymous objects ('six million'), the subject of self-righteousness blame/grievance.[2]

The attitude towards Holocaust survivors was repressed in Israeli thought during the early years of the state. It is no wonder that Israeli artists ignored the

1 Many Israeli towns such as Ashkelon, Eilat, Beer Sheva, Givatayim, Zichron Ya'akov, Jerusalem, Kfar Saba and Afula erected memorials to the Holocaust; this is merely a partial list.
2 Moshe Zukerman, *Charoshet haIsraeliyut, Mitossim veEedi'ologyot beChevra Mesuchsechet* (Israeli Industry, Myths Ideologies in a Perplexed Society), Resling Publishing, 2001, 80.

subject in those years as well. Zukerman quotes Theodor Adorno (1903–1969) and claims that due to the sublimity of the Holocaust subject, it is quite impossible to be visually depicted. He quotes Adorno's controversial statement, published in 1949: "Writing poetry after Auschwitz is barbaric." Later on, Adorno acknowledged that suffering is entitled to be represented as those who were tortured are entitled to scream, therefore "it is a mistake to claim that after Auschwitz it is impossible to write poetry."[3]

15.1 Is It Possible to Render the Holocaust Visually?

Adorno's statement serves as the background when discussing how it is possible to render the Holocaust visually. Zukerman explains:

> The issue of representing the Holocaust is principally not different than any issue of representing a historical past. Nevertheless, the issue of representing the Holocaust seems different from other events and processes, because of its binding with the scale and monstrous character of this unique historical event.... A question raised as to how can one say something that is unsayable. Conceptualizing the Holocaust that is impossible to be conceived and while doing so to be precise in creating an appropriate attitude just because of its tension between the need for presentation (negatively) and the awareness of that which is forbidden to go near it because it is too threatening.[4]

The difficulty of representing the Holocaust visually, especially in memorials installed in public spaces, was shared by artists throughout the world. At the time Natan Rapoport was busy with his memorial at Yad Mordechai many European artists were concerned with ideas for modern designs for Holocaust memorials. Towards the end of World War II, the Nazis bombarded the most significant edifices in most concentration camps. However, gates, huts, and sentries' towers remained intact at Auschwitz-Birkenau. Prisoners' clothes, suitcases, and other personal belongings, bespeaking the memory of the Death Factory camp were collected and put on display at the site's museum. At the

3 Quotes from Adorno's book *Negative Dialektik* (1982) published in Ronit Fisher, *miMerchavey haZikaron, Yetzirot Bney haDor haSheni vehaShlishi shel Nitzoley Shoah* (From Spaces of Memory, Works by Second and Third Generation Offspring of Holocaust Survivors), Emek Izrael Acvademic College, 2008.
4 Zukerman, Ibid.

same time, a need was felt to erect a memorial for those murdered in the camp. The *Auschwitz-Birkenau Memorial* is significant since it served as a model for later designs for Holocaust memorials throughout the world, including Israel.

The International Committee, Auschwitz was formed in Switzerland in 1952. Its main aim was to formulate careful guidelines for the future memorial designs. The committee announced an international competition, open to all sculptors and architects except for those who were known as collaborators with the Nazi regime. Participation was enormous, and at the end of 1948, six-hundred and eighteen proposals were submitted to the committee from thirty-one countries in Western and Eastern Europe. The jury was comprised of seven representatives from Italy, France, Holland, and Poland[5] and headed by the eminent British sculptor, Henry Moore.[6] The committee deliberated whether it was at all possible to create a work of art that would convey the feelings rooted in the term "Auschwitz." Henry Moore was quoted saying that "Perhaps a very great sculptor—a new Michelangelo or a new Rodin—might have achieved this."[7]

Indeed, all those who tried to delineate various visual forms for the atrocities of the Holocaust were faced with the impossibility of expressing the magnitude of the horror by artistic means. At an early stage several attempts were made to represent the subject through figurative memorials, and very quickly the designers concluded that such memorials could not express the victims' horrific fate and that it is impossible to visually condense human suffering into sculpted human figures. Instead, they started looking for abstract, concise symbols that would express—merely by hinting—the atrocities carried out in the concentration camps.[8]

15.2 The International Committee, Auschwitz

The International Committee, Auschwitz recommended creating a large stage, made of several levels and connected by stairs, from which one could see the crematoria and the whole camp (fig. 15.1a). A vertical component, in the shape of a tower made of stone slabs and looking like a gravestone, rises on top of

[5] Adolph Rieth, *Monuments to the Victims of Tyranny*, New York: Frederick A, Praeger Publishers, 1969, 17.
[6] Henry Moore was the most renowned Modern sculptor before the rise of American Minimalist sculpture.
[7] Jan Zachwatowicz, "The International Memorial Competition in Auschwitz" *Poland*, No. 11, 1964, 11.
[8] Ibid., 22.

FIGURE 15.1A
P. Casella, J. Jarnuskiewicz, J. Falka, F. Simoncini,
Final Plan for the Auschwitz Memorial, 1964, model

 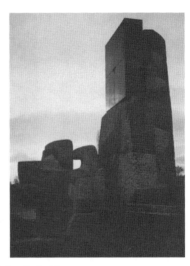

FIGURES 15.1B, C *The Auschwitz Memorial*, 1967, height: 7 meters

constructions, whose heavy and cumbersome forms remind one of coffins (fig. 15.1C).

Holocaust memorials erected in Western Europe aspire to formal restraint and a conscious choice of minimalistic architectural components. The *Memorial for the Victims of Bergen Belsen Concentration Camp* (fig. 15.2) is a prime example; it is made of an obelisk, signifying constancy that overpowers time.

15.3 Israeli Holocaust Memorials at Yad Vashem

Israel's formal institution dedicated to the memory of the Holocaust is Yad Vashem (literally memorial and name) in Jerusalem. Its compound comprises

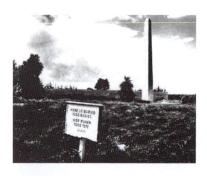

FIGURE 15.2
Bergen Belzen Memorial

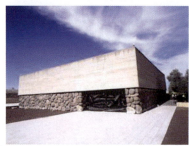 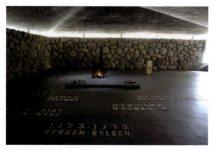

FIGURES 15.3A, B Arieh Elchanani, Arieh Sharon, Binyamin Idelsohn, *Ohel Izkor* (Memorial Tent), 1961, Jerusalem, Yad Vashem compound

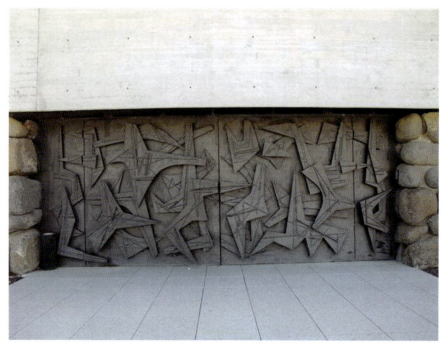

FIGURE 15.3C Bezalel Schatz, *Entrance Gate to Ohel Yizkor*, 1961, iron, Jerusalem, Yad Vashem compound

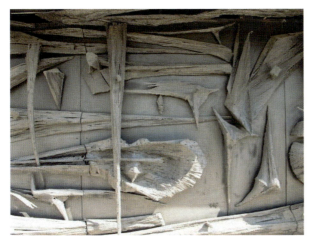

FIGURE 15.3D David Polombo, *Entrance Gate to Ohel Yizkor*, 1961, iron, Jerusalem, Yad Vashem compound

several memorials commemorating European Jewish communities destroyed by the Nazis. *Ohel Yizkor* (Memorial Tent) is one of the compound's most significant edifices (figs. 15.3a, b). Its walls are made of giant basalt rocks, brought to the site from the upper Galilee region. They are surmounted by a horizontal bare concrete band. The ceiling of the edifice is shaped like a cropped pyramid. A sculptural motif of burnt tree trunks appears on two entrance doors, one designed by artist David Polombo (1920–1966), (fig. 15.3d), the other by Bezalel Schatz (1912–1978) (fig. 15.3c). The modern meaning in Hebrew of the traditional Jewish concept *ud mutzal me'esh* (a branch that survived a fire), refers metaphorically to refugees, people who survived pogroms and destruction, and particularly Jewish survivors of the Holocaust. Polombo's tree trunks look like burnt branches; Schatz's are stylized, their surface engraved with narrow stripes, possibly evoking images of dead bodies in piles before being sent to the crematorium.

Names of concentration camps mark the floor inside *Ohel Yizkor* (fig. 15.3b). Visitors walk on a ramp which raises from the floor. From an aperture on the ceiling, a beam of light penetrates the inner space, shedding light on a stone slab covering the ashes of victims, brought to the site from various concentration camps. The Memorial Tent is a large-scale, covered inner space. It endows visitors with a dramatic atmosphere of terrible silence, meant for communing with the memory of the victims. *Ohel Yizkor* does not intend to convey *tkumah*, resurrection, a concept linked by Israeli culture to the Holocaust. Consequently, the Yad Vashem edifice is no different in its conception from Holocaust memorials erected elsewhere in the world. The idea of Resurrection as an answer to the Holocaust is solely Israeli.

15.4 The *Memorial to the Holocaust and the Resurrection of Israel*

The combined concept of the Holocaust and Israel's Resurrection is significantly conveyed by *The Memorial to the Holocaust and the Resurrection of Israel* designed by Israeli sculptor Yigal Tumarkin (b. 1933), inaugurated in 1975 at *Kikar Malchey Israel* (Kings of Israel Square) in Tel Aviv.[9] The process of its erection is a fascinating narrative of all the possible imaginative ideas linked to the complex, charged subject of the Holocaust and their transformation into visual language terms, assigned to the Israeli public space.

Maoz Azaryahu's published a detailed article about Tumarkin's memorial[10] in which he traces the chain of events that preceded the construction of the monument. The title he gave to his article already contains his conclusion that the memorial designed by Tumarkin failed in its attempt to be favored by the public as well as that it did not succeed in creating a link to the function of commemoration and to its meaning. Thanks to historical perspective, the following interpretation of this memorial regards it rather as a success, both in its power to convey a symbolic aspect of the Holocaust, as well as its merit in functioning as a public memorial.

Tel Aviv Municipal Council decided to erect *The Memorial to the Holocaust and the Resurrection of Israel* in 1951. The Municipal Committee for the Erection of the Memorial intended it to commemorate the idea that the mere existence of the State of Israel is the answer to the atrocities of the Holocaust. In a letter to Tel Aviv mayor, poet Aba Kovner (1918–1987), himself, a Holocaust survivor, who was a member of the municipal committee and very much in favor of the erection of the memorial, explained his own ideas regarding the proper visual representation of the Holocaust:

> Main transportation roads surround The Kings of Israel Square … We intend to add to this site a pause for memory in the throbbing heart of the city…. We do not suggest to change the nature of the square; rather [we suggest] creating a visual focus, drawing its strength in transforming passers-by, even for a moment, beyond the mundane into something that would endow the bustling life here and all around with good taste and meaning. European Jewry was wiped out during 1940–1945. The State of Israel was founded in 1948. By a simple way of thinking, one allegedly suggests that

9 After the murder of Israel's Prime Minister Yitzhak Rabin on this very site (1995), it was renamed *Kikar Rabin* (Rabin Square).
10 "Public Controversy and Commemorative Failure: Tel-Aviv's Monument to the Holocaust and National Revival", *Israel Studies*, Vol. 16, Number 1, Spring 2011, 129–148.

[Israeli] Resurrection is an answer to the Holocaust. Auschwitz did not, and cannot be served by an answer. Whatever happened there during the Holocaust and Ghetto rebellion is a feeling of despair, Israel's sovereignty was made possible to carry this horrible memory without despair, but not without anxiety. If the nation has a heart, indeed, it is cut in two; we wish to make a fitting designated expression to this twofold memory, impressed in all our deeds and struggles nowadays and in the future.[11]

A significant matter referred to in Kovner's letter is the meditative nature he foresaw as suitable for the future memorial. He searched for "a pause for memory;" the same idea that guided designers in their original conception of the Herzl gravesite (Chapter 13).

Tel Aviv municipality public servants were impressed by Kovner's thoughts. However, they simplistically decided to separate the Holocaust from Resurrection physically in the future monument:

... We noted two basic issues: one, the polarity of content and meaning of 'Holocaust' and 'Resurrection,' second, the creation of pause and commune with memory within an open, bustling city square. Indeed, we offer a solution for both issues: [we suggest] to physically cut off the two parts of the memorial, Holocaust here and Resurrection there. At the same time [we suggest] to create a substantial visual connection between the two parts of the memorial.[12]

At this early stage of the process, the committee members were already sure of the visual connection between the two parts of the future memorial would look like. Their thoughts constitute yet another *ekphrasis*, resembling the one conceived by the Jerusalem Deputy for the Herzl monument (chapter 13). Their thoughts included so many components that they also merit to be quoted in full:

The memorial for Resurrection would grow from a pit and would rise above the square. In contrast, the part that belongs to the Holocaust would be erected within a deep funnel, carved in the square. North

11 Letter from Aba Kovner to Yehoshua Rabinovitch, mayor of Tel Aviv, undated (ca. 1961), Tel Aviv Municipal Archive, *File 25/1347*.
12 Minutes of the ideas concerning the *Holocaust and the Resurrection of Israel Memorial* voiced by members of the Municipal Committee, Tel Aviv Municipal Archive, *File 25/1347*.

stairs would catch passers-by in the square and would make them descend to see what is going on down there.[13]

While descending to the lower level, you would begin to feel and actively be a part of the memorial experience. On the left visitors would encounter piles of sand and rubble, suggesting a ditch and the Valley of Death. A light colored stone wall would rise on the right, cut off from the square. When he descends [the visitor] would behold in front of him a darkened niche, its round walls covered by black basalt rocks, invoking a feeling that the darkness has no end. The grotto contains a memorial candle. Here, downstairs, he is given an opportunity for communing as he is completely cut off both by sight and by the sounds of all that takes place upstairs, in the bustling square. On ascending and coming out by the southern stairs, he would be facing the memorial for Resurrection and Hope as if it grows in front of him from the abyss.

The Resurrection memorial is a three-trunked tree, rising and growing from the square, creating a sort of a Jewish Star, spreading out upwards in the shape of both a candelabrum and [a pair of] hands. The coming together of the three separate, identical columns would create the illusion of oneness, the candelabrum and a Jewish Star protruding from every side and angle. The memorial would be made of metal (steel or stainless steel); its final shape is open to development during the design process. The simplicity of its lines would be emphasized on the bustling environment background. A Jewish Star as a symbol of the Jewish People, the candelabrum as a symbol for Israel's Resurrection, hands and candelabrum that come together as one, as a twofold convincing nature of grief and hope, a cry and resurrection.[14]

The committee's verbal description of their vision of the future monument shows that they firmly believed that these various objects are bound to arouse excitement and identification in the potential visitors to the future monument. There is no doubt that a few of the committee members visited the *Memorial Tent* at Yad Vashem in Jerusalem. It is also feasible that the architect Sharon, one of its designers and member of the Tel Aviv municipal committee, brought to their attention the idea for complete darkness and the placing of a

13 The text in the minutes of the municipal committee meeting is full of mistakes in Hebrew, most common the erroneous use of masculine and feminine adjectives that cannot be translated into English.

14 Minutes of the ideas concerning the *Holocaust and the Resurrection of Israel Memorial* voiced by members of the Municipal Committee, Tel Aviv Municipal Archive, *File 25/1347*.

memorial candle. Apparently, members of the committee saw in Yad Vashem a vital model and precedent for any future Holocaust memorial.

Such an exaggerated conglomeration of symbolic elements as tree trunks, hands, candelabrum, Jewish Star and basalt rocks, sand, and rubble was bound to become a visual catastrophe. An unnamed official at the Tel Aviv Municipality was probably surprised by the committee members' fantasies and was well aware that if they were to be materialized, the monument would be a prime example of *kitsch*. The official, therefore, suggested that such an endeavor should be given to professional artists.

Following lengthy debates, they finally decided to declare a closed competition, by invitation only, of proposals for the design of the future monument. Ten Israeli sculptors were asked to submit their proposals. The jury for the competition consisted of seven civil servants of the Tel Aviv Municipality, three architects, the head of the Bezalel School of Art, two persons associated with the Holocaust subject—but not a single sculptor. The members of the jury quickly realized that they lacked the professional tools needed for judgment, and decided to consult an expert, choosing the head of the Tel Aviv Museum, Chayim Gamzu. Later on, they summoned an art collector, the lawyer Michael Caspi, the architect Ya'akov Rechter, and the artist Mordechai Ardon. The decision to consult experts was apparently made merely for protocol since the experts were denied the right to vote. After voicing their professional opinion, they were asked to leave the meeting, and the voting was carried out by the jury members. The proposal chosen by the committee members was submitted by the distinguished sculptor Yigal Tumarkin.[15]

The committee was impressed by the artist's ideas, expressed in a letter attached to his preliminary sketches:

> There is no reason to treat the subject of the memorial, nor is it possible to render it by a literary-illustrative approach. It is too great for me to try and 'describe' it [the Holocaust] or even some of its fragments without falling to banality and unnecessary sentimentality ... Indeed, the outer, black frame of the memorial [fig. 15.4] indicates the Holocaust as well as to all powers and events that threatened our existence. From within this frame, an organic elliptical form grows and breaks through. It is made of

15 Minutes of the jury for the competition for the design of *The Holocaust and the Resurrection of Israel Memorial* at The Kings pf Israel Square in Tel Aviv, June 28, 1972, Tel Aviv Municipal Archive, *File 25/1374*. Members of the jury were A. Sharon, architect, head of the committee mayor Rabinovitch, D. Hofner, head of the Bezalel School of Art, Y. Arad, representative of Yad Vashem, A. Yaski, architect, Sh. Borstein, Ch. Bassok, Ch. Levanon, M. Namir, M. Savidor and Aba Kovner.

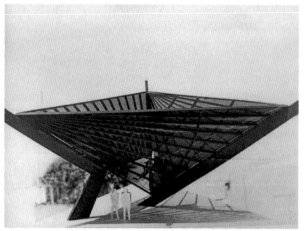

FIGURE 15.4 Yigal Tumarkin, *Sketch for The Holocaust and Resurrection of Israel Memorial*

flowing lines, a form whose color sense excels in optimism and lightness. It will draw sunshine, thus creating a feeling of a glowing body floating in midair ... [the memorial's] strong part is its inner opening and the feeling of floating created by the stainless steel inserted into the black metal net. This effect will not be diminished even if buildings in the square would rise upwards.[16]

... My intention is to build an architectonic sculpture that would become, next to its function as a memorial, an identifying symbol of Tel Aviv, a site that draws to it many visitors and tourists. A site that with time, would be associated with Tel Aviv just like the Statue of Liberty is identified with New York or the Eifel Tower with Paris.

The memorial, as a social function: I assume that in order to draw the citizens of Tel Aviv to it, the social function is extremely important. Consequently, I designed an architectural space in the memorial, 20 meters above ground. This space can be made into a documentary museum ... at the same time, it can be assigned to other purposes.[17]

Tumarkin's organic ellipse and black net, meant to symbolize the Resurrection of Israel were omitted in the final construction of the memorial, but the geometrical body was executed. It is an inverted pyramid, its upper part cropped, supported by diagonal-triangular shaped columns (figs. 15.5). The pyramid is

16 Yigal Tumarkin, *Explanatory Letter concerning the memorial*, Tel Aviv Municipal Archive, File 25/1374.
17 Ibid.

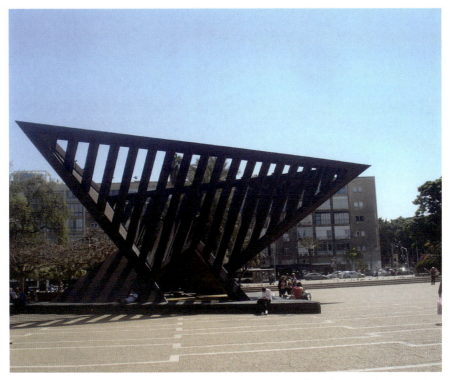

FIGURE 15.5 Yigal Tumarkin, *The Holocaust and Resurrection of Israel Memorial*, 1975, steel, painted concrete, bronze relief, Tel Aviv, Rabin Square

made of rusted metal, its upper part open to the sky. Tumarkin's metal beams were originally covered by smoked glass panels. A few years after its construction, the glass panels were removed since they were considered hazardous to public safety.

The memorial's supporting columns stand on top of a raised, triangular concrete base, painted black, its inner range is painted yellow. The psychological effect aimed at is experienced only by actually entering the structure. On top of a triangular-shaped bronze relief, Tumarkin engraved the word *zachor*, (remember), topped by three Jewish Star shapes, an arrow and a few additional grooves (figs. 15.5b, c). Avigdor Poseq tells us that beneath the bronze relief the sculptor meant to include a constant flow of water; its base was meant to symbolize a Weeping Stone, which brings to mind the Wailing Wall.[18]

18 Avigdor, W., H. Poseq. *Igael Tumarkin, a Study of his Imagery*, Jerusalem: 2010. 122. Such an image of a weeping stone was mentioned in the context of the Weeping Daughter of Zion in chapter 9.

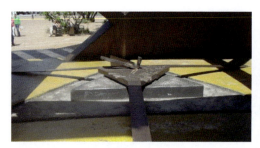

FIGURES 15.5A, B Yigal Tumarkin, *The Holocaust and Resurrection of Israel Memorial*, details

Besides the obvious use of the color symbolism of black and yellow, one wonders what brought Tumarkin to choose an inverted pyramid form for his memorial. The artist used this geometrical body in some other public sculptures since, as he was quoted to say:

> Pyramids are conceived as witnessing elements for the gap separating ideologies and the enslavement results that they produce. What did we learn since the construction of the great pyramids of more than 4000 years ago? Do forced labor and death set one free?[19]

His words link two occurrences: the construction of pyramids in ancient Egypt, traditionally viewed as done by Hebrew slaves before the Exodus, with the infamous quote *Arbeit Macht Frei* (Work Sets You Free) engraved on the entrance gate to Auschwitz. Poseq convincingly sums up the message conveyed by Tumarkin's monument:

> By building his cage-like memorial from industrial materials rather than stone, Tumarkin transformed the token of ancient slavery into a modern prison, and by inverting the pyramid structure, he suggested a reversal of the former order. The message is complemented in the interior by the tears of the weeping stone that become a life-giving stream.[20]

Public reaction to the monument was negative; Poseq claims that "Perhaps because the symbolism of the monument could not be immediately grasped, it was criticized as being divorced from human experience, incomprehensible and what seemed most relevant, totally unable to stir emotional response or

19 Tumarkin, *Explanatory Letter concerning the memorial*, Tel Aviv Municipal Archive, *File 25/1374.*
20 Ibid. 124.

FIGURE 15.5C Yigal Tumarkin, *The Ecological Pool* next to the *Holocaust and Resurrection of Israel Memorial*

teach a moral lesson."[21] Tumarkin kept aloof from the debate but published a short statement in which he refers neither to his personal feelings about the Holocaust nor to his own traumatic childhood experiences, which he often recalls in other public projects.[22]

From a high vantage point (as seen from the roof of the Tel Aviv Municipality building), the two triangular shapes—the wide upper part of the inverted metal-made pyramid and the concrete base—blend together to form a large image of a Jewish Star. The black and yellow colors allude directly to the badge of shame which Jews were forced to wear.

Next to the inverted pyramid in his original plan for the memorial, as well as next to the one finally inaugurated in 1975, the artist included a rectangular water basin, filled with water by a system of fountains, attached to one of its side walls. Water, especially flowing water, is a universal symbol of life.

Not long after its inauguration, the Tel Aviv Municipality emptied the water basin; the empty pool became a health hazard, dangerous due to its depth and the rusted metal fountain pipes. A fence was constructed around the basin, and it was left lacking any function for many years. The municipal neglect caused people to stay away from Tumarkin's monument. A few years ago, the

21 Ibid. 123.
22 Tumarkin's father was a German who in compliance with the Nazi laws divorced his Jewish wife. She immigrated with her son to Palestine. Though his mother remarried Tumarkin felt he had lost a father and continued to evoke his traumatic injury in numerous works.

Tel Aviv Municipality decided to renovate the site and turn the basin into an ecological pool. Following the renovation, the pool draws its water from a fountain in its middle, and exotic fish swim among beautiful water lilies and lotus flowers growing in it. Easy chairs surround the pool, turning it into an inviting area meant for relaxation and recreation (fig. 15.5d).

American Minimalist artist, Walter de Maria (1935–2013) summed up the nature of his own minimalist style as "The invisible is real," or in other words, whatever is hidden behind things is the real thing. Applied to Tumarkin's *Memorial for the Holocaust and the Resurrection of Israel*, De Maria's wording may explain that visual images are not necessarily linked directly to the Holocaust to evoke associations with it. Holocaust memorial designers see this characteristic as the only means available to them when they try to document and express that which is impossible for representation.

These days, Tumarkin's Holocaust memorial and the flourishing water pool next to it constitute an enjoyable, popular meeting place for the citizens of Tel Aviv. Children play in the inner part of the inverted pyramid, while adults sit nearby and relax next to the delightful water lilies and goldfish. This, no doubt, must be a realization of Israel's Resurrection.

Bibliography

Azaryahu, Maoz, "Public Controversy and Commemorative Failure: Tel-Aviv's Monument to the Holocaust and National Revival," *Israel Studies*, Vol. 16, Number 1, Spring 2011, 129–148.

Fisher, Ronit, *miMerchavey haZikaron, Yetzirot Bney haDor haSheni vehaShlishi shel Nitzoley Shoah* (from Spaces of Memory, Works by Second and Third Generation Offspring of Holocaust Survivors), Emek Izrael Academic College, 2008.

Poseq, Avigdor W. G., *Igael Tumarkin, a Study of his Imagery*, Jerusalem: 2010.

Rieth, Adolph, *Monuments to the Victims of Tyranny*, New York: Frederick A, Praeger Publishers, 1969.

Tel Aviv Municipal Archive, *File 25/1347*.

Zachwatowicz, Jan, "The International Memorial Competition in Auschwitz" *Poland*, No. 11, 1964.

Zukerman, Moshe, *Charoshet haIsraeliyut, Mitossim veEedi'ologyot beChevra Mesuchsechet* (Israeli Industry, Myths and Ideologies in a Perplexed Society), Tel Aviv: Resling Publishing, 2001.

CHAPTER 16

In Conclusion: Secularizing the Sacred, Israeli Art, and Jewish Orthodox Laws

Israeli artists dynamically adopted, responded to and adapted significant Diaspora influences for Jewish Israeli purposes, as well as Jewish sacred themes for secular goals all in the name of creating new art with unique iconography and style. They followed Western artistic principles and adapted them to the creation of contemporary, modern secular commentaries of biblical narratives, while at the same time referring and examining Jewish Orthodox laws and rituals through modern secular eyes.

"Neo-paganism" is the name David Sperber gave a phenomenon which he perceived, in recent years, in the work of some Israeli artists. He defines it as the reclamation of a plethora of notions, which he presents alongside one another: "A world in which the material, the body, desire, sin, pornography, and erotica serve as a liberating and challenging bolt."[1] "In recent years," he alleges, "The combination between Judaism, body and sexuality has become *bon ton* amongst researchers, many of whom argue that as Our Sages of Blessed Memory saw it, it was the body rather than the soul that was accorded centrality." Sperber designates those who do not belong to the Israeli religious order as fresh voyeurs; he claims that "It sometimes seems that their astonishment is tainted with a smidgen of ignorance." In the visual references of certain Israeli artists to the texts of the Mishnah and the Talmud he sees "Clichés that rise to the surface with one who, having only just become acquainted with Jewish lore, is stricken with wonder."[2]

Sperber's words bear witness not so much to Israeli artists as to the way in which the Israeli clerical establishment perceives itself as the sole titleholder to Jewish lore. His remarks, confirm that Israeli orthodoxy appropriates the entirety of Jewish thought to itself and its disciples while boycotting any extraneous Jewish element that does not belong to their order (including Conservative and Reform Judaism) on the grounds of its being ignorant, a new immigrant who has yet to penetrate the depths of Jewish tradition secrets which only members of the order know. Artists who decline to walk in the light

[1] David Sperber, "*Letargem et haTorah llvanit*" (Translating the Torah into Greek), "Sabbath" Thought, Literature & Art Supplement, *Makor Rishon*, November 8, 2010.
[2] Ibid.

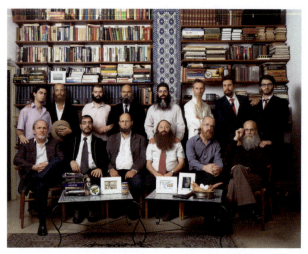

FIGURE 16.1 Ro'ee Rosen, *Gvarim beTarbut Israel (Mezukanim)* (Men in Israeli Culture [Bearded]), 2004, photograph

of the interpretations and disputations of Jewish intellectuals who preceded them over the past thousand years, and who would rather go straight to the source without reciting the prevalent orthodox doctrine, are deemed, at best, to be ignoramuses, or worse, to be desecrators of all that is holy. It is a concept not far removed from the attributes of any religious cult.

Israeli artist Ro'ee Rosen refers ironically to the shaved beard, an external signifier in Jewish-Israeli male secularism, in a staged photograph entitled *Men of Israeli Culture (Bearded)* (fig. 16.1). Staged in his studio, he covered the faces of several of his colleagues—Israeli men of letters—with fake beards. The artist arranged their seating to resemble that of a rabbinical gathering. Attaching beards to secular Israelis is an act of defiance against the prevailing concept of some Israeli rabbis who condemn Zionism as non-Jewish and strive to establish a more Jewish culture for the sovereign state of Israel. Rosen ironically mourns the status of contemporary Jewish-Israeli intellectuals and suggests, cynically, that the only way they can be recognized as such is to don a beard. Doing so may help them join the company of those who had crowned themselves as the sovereign state's spiritual leaders.

Ruth Calderon voiced her opinion concerning contemporary Israeli, Modern commentaries on the Bible. She writes:

> The Bible is the most well-known text of Jewish tradition. It is taught [in Israel] beginning with kindergarten Bible stories all the way up to the

final years of high school; it penetrates Israeli learning by heart. We recognize in it [the Bible] names, similar to ours, and sites described in it are the actual landscape in which we grew up.

Midrash is an act that expresses freedom. It is only a free person who is able to face a classical text, no matter which, whether it is the Bible, the writings of Marx or a familiar landscape and find in it new meanings, close to its [the text's] obvious meaning, a commentary that stems from the issues one is preoccupied with, at the time and place in which one exists.

Where would creators of new commentaries come from? Powerful venues of game and creativity, recklessness, the courage to walk on thin ground, to protest the familiar-accepted interpretation, to destroy familiar worlds. Many communities lack all of the above; [they are] groups that became estranged of awareness of cultural defensive. Generations of erudite persons grew up in Israel who are close to the Bible ... instead of fighting existing schools one must establish competitive schools who would renew the acts of commentaries, who would contribute varied materials ... with healthy competition and political respectability the good ones would drop out and the worthy would remain. The handful chosen who are capable of commenting should be cultivated by the public as assets.[3]

16.1 The Hebrew Bible: a Spring Abundant with Narratives and Allegorical Figures

As if answering Calderon's wishes, Israeli artists approach the Bible and make visual commentaries to its narratives and major figures. Artist Michael Sgan Cohen expressed his admiring, straight, direct approach to the Bible in an interview he held with himself:

'The Bible, I take it, is important to you?' ... of course. The Bible is an Israeli form of communication ... Secular context is important from an Israeli/Zionist vantage point but don't misunderstand me. I, for instance, am not against the Talmud. I wish I could know the whole Talmud, nevertheless, the Bible retains its proper, respected place ... the

3 Ruth Calderon, "Kol Anot" in Tali Tamir (curator), *Kol Anot, Motivim Tanachi'yim baOmanut haIsraelit* ("The Sound of Singing" in The Sound of Singing, Biblical Motifs in Israeli Art) (exh. cat.), Tel Aviv: Agudat haTzayarin vehaPasalim, 1998, 3–4.

> Bible represents an entire, ambitious view of the world, including views on history, [I mean] what is happening with ideas etc. it is not a matter for the religious who do not read the Bible this way.[4]

Artist Chaim Maor's view concentrates on the unique aspect of biblical language:

> ... The biblical language is economical, enigmatic and opaque on the one hand, open, creative and free on the other. It allows me to take a sentence from the source, to break it down to units, to examine them with a fresh eye and to compose with them new compositions and meanings, or to uncover from within them concealed messages.[5]

Examination of some exemplary Israeli works of art will show unique secular approaches to the Bible, producing fresh, modern commentaries. Artist Shalom Seba (mentioned in chapter 10) is known for his interpretations of biblical narratives. He begins his projects by reading relevant verses from the Bible and then trying to visually express the figures' reactions to situations in which they participate in the biblical narrative, expressing their inner feelings.

Seba's *Moses About to Break the Tablets of the Law* (fig. 16.2) shows the protagonist in an exaggerated foreshortening that guides spectators to see him from a lower vantage point, looking upwards. Moses' body, arched backward, rendered like a spring about to be released. Next to him and nearer to us the artist placed a youth. In this dramatic moment, Moses is angry after witnessing the Israelites dancing around the Golden Calf. He is about to break the tablets, but someone is in his way. Hundreds of artistic renderings of this moment in Moses' life were made throughout the history of art in which artists show the protagonist in a heroic pose, a disappointed prophet, a tragic figure, spiritual, and almost godly. Seba's view is different. He presents a thoroughly mundane moment, lacking any sign of heroism or spirituality. Moses seems to be bothered and unable to tolerate anybody stopping his action. He gets rid of the perpetrator by kicking him out of his way with his right foot.

4 Micha'el Sgan Cohen, "Chur ve'Aharon, Ra'ayon Atzmi al Hashkafot be'Eenyaney Omanut, Dat veYisraeliyut" (Hur and Aaron, an Interview with Myself on matters of Art, Religion and Israeliness), *Studio*, 17, December 1990, 23.

5 Chaim Ma'or as quoted in Sarah Breitberg (curator), *Oman—Chevra—Oman, Omanut al Chevra beYisrarl 1948–1978*, (Artist—Socirety—Artist, Art about Society in Israel 1948–1978) (unpaged), Tel Aviv: Tel Aviv Museum, 1978.

IN CONCLUSION 377

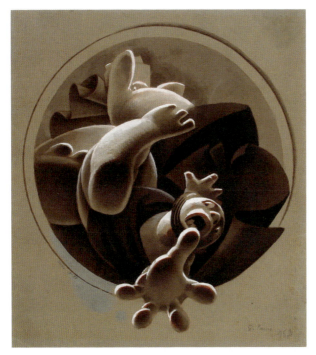

FIGURE 16.2 Shalom (Siegfried) Seba, *Moses about to Break the Tablets of the Law*, 1947–1953, tempera and gouache on paper

A biblical narrative served artist Chaim Maor as well (fig. 16.3). He saw a parallel between a mythical biblical event and Israeli reality. The Bible tells us of Joseph's brothers fearing their father's wrath; they decide to take advantage of his poor eyesight and make him believe that Joseph was murdered:

> And they took Joseph's coat, and killed a kid of the goats, and dipped the coat in the blood; And they sent the coat of many colours, and they brought it to their father; and said, This have we found: know now whether it *be* thy son's coat or no. And he knew it, and said, It is my son's coat; an evil beast hath devoured him; Joseph is without doubt rent in pieces. (Genesis 37, 31–33)

Maor wrote about his work:

> This text led me to ponder the issue of identification and the message of bereavement, beginning with the original narrative of Joseph's garment

FIGURE 16.3
Chaim Ma'or, *haKtonet Bincha Hee?* (Know now whether it be thy son's coat or no), 1978, photograph, text and shirt on plywood

and its identification by Jacob ... up to actual contemporary Israeli reality ... the biblical murder never took place, nevertheless, the dynamic authority of jealousy and hatred between the brothers encouraged a process that indicated a chronical of preconceived death. The biblical definition of *Is this your Son's Robe?* set against a criminal-police drawing denotes for me that it is impossible to cut the knot that ties social and religious offences in our far away past with our Israeli present.[6]

The body posture of the little girl by Vered Aharonovitch's *Untitled* (fig. 16.4) conveys a furious expression, the look of suffering. The sculpture radiates a sense of isolation, self-destruction, and vengefulness. The girl's face radiates anger and vulnerability. Her eyes look down, indicating contemplation rather than defiance of victory over the giant man who, so we are led to believe by the small dagger stashed in her belt, that she cut his head off. She is a 'good girl'; her head is bowed down, as she is sunk in her innermost musings, and possibly

6 Chaim Ma'or, as quoted in *Oman—Chevra—Oman* (Artist—Society—Artist) (exh. cat.), Tel Aviv, Tel Aviv Museum of Art, 1978 (unpaged).

FIGURE 16.4 Vered Aharonovitch, *Untitled,* 2011, polyester and marble dust, 40 × 50 × 90 cm

embarrassed by her victory, as if not sure of her deed, ashamed, reluctant to share her feelings with us, the spectators.

The severed head held by the little girl's outstretched hand leads us to biblical narratives of two heroes. The first is the victorious David, holding Goliath's severed head; the second is Judith, holding the severed head of Holofernes. The artist intentionally draws us to think of these familiar biblical heroes. Her sculpted girl, gender-wise, may evoke our association with Judith; however, the sculpture is not of a mature woman overpowering a virile man. When children are under attack, they adopt a defensive pose, keeping guard, but even then they can only be submissive to their attackers. Through a familiar and powerful gesture of a biblical figure, Aharonovitch seeks to raise difficult questions in which black humor and fantasy definitely coexist when referring to the contemporary issue of child abuse.

16.2 A Visual Discourse with Jewish Artists from the Past

After years of adhering to the Zionist dogma of negation of Jewish Diasporic tradition, some Israeli artists of the 1960s and especially of the 1970s showed interest in precedents of Jewish art commentaries of the Bible.

Artist Michael Sgan Cohen was intimately acquainted with the illustrations of the *Bird's Head Haggadah*,[7] whose title is so named because the Israelites in some of its illustrations are hybrids: their bodies are human, their heads are birds' heads. Art historians assume that through the idd cross-breeding, Jewish artists bypassed the Second Commandment's restriction of depicting human figure. The illustrated figures with birds' heads were not considered proper humans, and therefore they do not transgress the commandment.

Sgan-Cogen's *haYehudi haNoded* (The Wandering Jew) (fig. 16.6) is a self-portrait.[8] The artist delineated his body by a thick black contour, showing

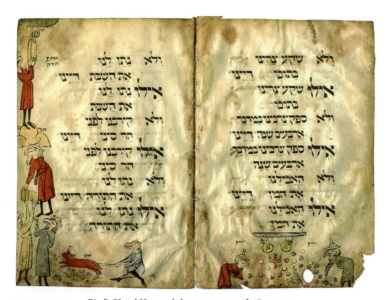

FIGURE 16.5 *Bird's Head Haggadah*, ca. 1330, south Germany

7 The artist probably saw reproductions of the *Bird's Head Haggadah* in Bezalel Narkiss (with a foreword by Cecil Roth), *Hebrew Illuminated Manuscripts,* Jerusalem: Keter Publishing, 1969. The book offers reproductions of illustrations and illuminations included in Hebrew manuscripts from Europe and Islamic countries with a commentary concerned with the original commissioners and owners of the manuscripts and their contemporary provenance.

8 Amitai Mendelson (curator), *Chazon Muchael—Yrtzirato shel Michael Sgan Cogen* (Michael's Vision—the Works of Michael Sgan Cohen) (exh. cat.), Jerusalem: The Israel Museum, 2004. On the Wandering Jew morif see Ziva Amishai Meisels, "*Menashe ben Isral vehaYehudi handed*" (Manasseh ben Israel and the Wondering Jew), in Bracha Yaniv (editor), *Timora*, Ramat Gan: Jewish Art Department, The Faculty of Jewish Studies, Bar Ilan University, 2006, 87–110.

IN CONCLUSION

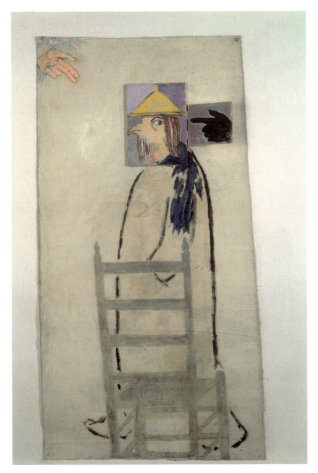

FIGURE 16.6 Michael Sgan-Cohen, *The Wandering Jew*, 1983, acrylic and pencil on cloth diptych. 108 × 212 cm

himself as walking towards the painting's left, his left hand in his coat pocket. His head resembles that of a bird with its beak. He wears a pointed three-cornered hat, which was used to identify Jews as a group in the middle ages, the same hat worn by the Israelites in the *Bird's Head Haggadah* illustrations. To his odd-looking face, the artist added personal attributes: long hair and a beard.

On the upper right edge of the painting, he drew a human hand in a commanding gesture. This is a visual quote of another famous Jewish artwork depicted on a 5th-century floor mosaic of the Beyt Alfa Synagogue, as part of the biblical narrative of The Sacrifice of Isaac, as God commands Abraham not to harm his son. By quoting the image of God's hand, Sgan Cohen probably meant it as a command to set on wandering. He repeats the symbolic image of

a hand, this time in black, pointing to the direction of wandering as well. The artist must have identified himself with the image of the Diasporic Wandering Jew, with a negative image of Judaism, comprised of no small number of anti-Semitic components. Sgan Cohen, a born Israeli citizen, returned and settled in his ancestral land and new sovereign state, is still wandering in search of his Jewish identity.

16.3 Israeli "Graven Images"

The Bible contains the original base for Jewish laws. They are mentioned in various chapters, with the Ten Commandments as their most precise and concise expression. The Second Commandment, as referred to in this chapter, is the most straightforward and relevant to any discussion on Judaism's approach to the visual arts. "Thou shalt not make unto thee any graven image, or any likeness of anything that is in heaven above, or that is in the earth beneath, or that is in the water under the earth." The work of secular Jewish artists, living in a state that defines itself as a Jewish-democratic state, must be viewed in the context of, and with an affinity or non-affinity to the Second Commandment.

The attitude of Israeli artists toward the Second Commandment, be it deliberate or inadvertent, has to do with numerous commentaries that were created in the course of the history of Jewish culture concerning the Second Commandment as a prohibition on the visual representation of the human figure. As the background of the current discussion, the Second Commandment reprises its role as a presence-absence or, sometimes as a positive presence, in the creative processes of Israeli artists engaging in various representations of the nude human form. This constituted a topic for numerous forays into various fields of research such as the history of art, sociology, anthropology, culture, and gender.

16.4 Hybrids

A hybrid is a mythical amalgam arrived at by crossing two different components. In a subgroup of hybrids in Greco-Roman mythology, a man is crossed with a beast. Its dichotomy finds expression not only in its appearance but also in the crossing of two parts that are suspended between two worlds—the bestial versus the human—and correspondingly also the instinctive versus the rational and the savage versus the civilized. As a rule, crossbreeds constitute

an allegory for human life, since they are founded on the basic recognition that such totally contrasting forces operate within our soul.[9]

One of the modes of finding expression in contemporary art is creating visual images based on Ovid's *Metamorphoses*.[10] Some figures in Ovid's work mutate due to offenses or sins they committed. When they become hybrids, they are fated to bear the nature of their offenses in their outward appearance. Contemporary works of art that are based on Ovid's *Metamorphoses* take the presentation of inner change to the point of a ridiculous or bizarre form of the personality.[11] The classical concept of Greece and Rome radically diverges from the principle of body-soul unity enshrined in the Jewish and Christian tradition. Consequently, mutations in shape that involve a different outward appearance of the particular entity sometimes suggest it was the work of the Devil.

The particular restriction of the Second Commandment is completely ignored by certain Israeli artists, particularly regarding creatures that belong in the realm of heaven, the vast expanses of air, and that live in water.

Artist David Morris (b. 1936) is a sculptor who works in fired clay. Throughout history potters aspired to create useful vessels of impressive shapes; the construction of simple terracotta containers was refined over the course of time and yielded sculpted receptacles. These were sometimes modeled on the human body or on the bodies of animals. The earthenware vessels connected with food and used for storing grain, wine or oil, were often symbolically related to life. The similarly-shaped burial urns were related to death. David Morris preserves this combination in his clay figurines, even though they no longer fulfill any functional uses. The artist knowingly refers to ancient civilizations but reshuffles their broader cultural contexts while creating a new whole which lends his hybrid sculptures a cryptic universal dimension.

The lid of the *Chicago Bulls Kettle* (fig. 16.7) consists of the lower part of a woman's body, while its abdomen is made of a man's head. The eyes are expressionless, while the tongue is tucked into the oral cavity. The human head ends

[9] For a discussion on hybrids in Israeli art see: Meital Oman, "Man-Beast Hybrid, the Two in the One," in *"Man-Beast Hybrid, the Two in the One,"* (exh. cat.), Tel Aviv: The University Art Gallery, 2004, 9.

[10] Publius Ovidius, 43 BCE–18 CE. A Roman poet, who wrote a history of the world from its creation to the days of Julius Caesar, interspersed with figures from classical mythology. His most famous works include: *Metamorphoses* and *Festivals*. Ovid's *Metamorphoses* is known as one of the most widely read books in the world.

[11] Marina Warner, "Satyrs, Spiders, Jellyfish, and Mutants: Ovidian Metamorphosis in Contemporary Art," in Cornine Saunders, Ulrika Maude, Jane McNaughton, *The Body and the Arts*, Palgrave Macmillan, 2009, 191.

FIGURE 16.7
David Morris, *Chicago Bulls Kettle*, 1993, wood-fired clay, 47 × 14 × 10 cm

in a cross with the head of what might be a bird, possibly a penguin, with a long beak. The human lid is not supposed to open; the receptacle is impotent and is quite incapable of fulfilling the function it is ostensibly designed for.

Morris's work thus undermines and distorts the classical symbolism of life and death. His figures express their feelings with a deafening silence, and their strange appearance is shrouded in mystery. It is not possible to determine unambiguously whether they are screaming with pain, happy, tranquil, or are caught in a moment of ecstasy fraught with erotic sensations and musings. They come together in a unique creation of an Israeli graven image.

16.5 Jewish Angels and Israeli Cherubs

One of the most famous and familiar hybrids in Jewish mythology, and which we take for granted, is that of angels. The likeness of these mysterious beings is familiar to us from their biblical descriptions, Talmudic literature and later Bible commentaries, which describe them as possessing human features with

IN CONCLUSION 385

wings.¹² Angels are assigned a number of roles, including standing guard, judging human deeds, bearing glad or ill tidings, and possessing healing. Their main function is serving as mediators between the earthly mortals and the Divine. Some of them have individual, specific names, while others are defined by their function, such as the well-known couple of the Temple cherubs.¹³

According to various Jewish commentaries, statues¹⁴ of two cherubs stood above the Ark of the Covenant first in the Tabernacle in the wilderness and later on in Solomon's Temple. They were an embarrassment to Jews throughout history because their mere existence in the Holy of Holies constitute a breach of the Second Commandment because they may easily be interpreted as graven images. Maimonides was troubled by their existence in the Holy of Holies. He saw the cherubim as representing angels and explains that there are two of them and not one because only God is "One" and the angels have no divinity. He reasons that if there had been only one figure of a cherub, people would be misled and would mistake it for God's image. Consequently, they might assume tat the angel (represented by the figure) was also a deity, and would thus adopt a dualism.¹⁵ Despite the apparent contradiction between the ban of the Second Commandment and the presence of cherubs in the Holy of Holies, visual depictions of them are known from a centuries-old tradition in Jewish art. They figure in illuminated medieval manuscripts and on the opening pages of volumes of the Pentateuch.¹⁶

A vast abyss of difference yawns between Jewish intellectuals of the second and fifth centuries, whose arguments are included in the Mishnah and the Talmud, and Jewish scholars who interpreted them during the Middle Ages and to this very day. Since the biblical verbal description of the cherubs is highly abstract, the only thing that is accepted as fact concerning them is that they are winged. The Bible describes them as they were to be made by artist Bezalel ben Uri:

12 It is interesting to note that wherever angels' wings are referred to in the Bible, there is no mention of what kind of wings they have. Foul wings? Insect wings? Bat wings?
13 See: Gustav Davidson, *A Dictionary of Angels, Including Fallen Angels*, New York and London: The Free Press, 1967.
14 Here, too, it is interesting that no commentary on cherubs expressly mentions that they were three dimensional figures, or, in other words, statues, despite the fact that the substance from which they are made is expressly stated, as also is their gold overlay.
15 Maimonides, *Guide to the Perplexed*, 3:45.
16 'Cherub, cherubim' in Alan Unterman, *Dictionary of Jewish Lore and Legend*, London: Thames and Hudson, 1991, 50.

> And thou shalt make two cherubims *of* gold, *of* beaten work shalt thou make them, in the two ends of the mercy seat ... And the cherubims shall stretch forth *their* wings on high, covering the mercy seat ... and their faces *shall look* one to another ... And there I will meet with thee, and I will commune with thee from above the mercy seat, from between the two cherubims which *are* upon the ark of the testimony ... (Exodus, 25, 17–22).

And in Solomon's Temple:

> And within the oracle he made two cherubims ... And he set the cherubims within the inner house: and they stretched forth the wings of the cherubims, so that the wing of the one touched the *one* wall, and the wing of the other cherub touched the other wall; and their wings touched one another in the midst of the house ... (1 Kings, 6, 23–29).

The debates among Jewish intellectuals from the 2nd and 3rd centuries CE, documented in writing and summarized in the books of the Babylonian and Jerusalem Talmud, indicate that they were of the opinion that the cherubs above the ark symbolized God's love of the Israelite people and that this may be likened to the love between male and female. They fantasized on the way the cherubs were exposed to the general Israelite public:

> Rabbi Ktina said: Whenever [the People of] Israel came up to the Festival, the curtain would be removed for them and the cherubim were shown to them, whose bodies were intertwisted with one another, and they would be thus addressed: Behold! You are beloved before God as the love between man and woman.[17]

A thousand years later, Rashi (Rabbi Shlomo Ben Yitzhak, 1040–1105) the 11th-century Jewish intellectual, reiterated the text of the Talmud and argued that the cherubs "Cleaved to one another, holding and embracing each other as the male embraces the female."

Verbal descriptions such as those published by Jewish scholars of the ancient world as well as by Medieval Jewish intellectuals is one thing; a *visual* description is another. There is a tremendous gap between the two modes of description; the former is ambivalent, more abstract and leaves readers to

17 The Babylonian Talmud, Yoma Tractate, Chapter 5, p. 54.

conjure up the likeness of the creatures in their imagination. But if artists were to try to represent them visually, basing their interpretation on a description such as the one written by Rashi or rabbi Ktina, their efforts would be deemed sacrilegious.

The first chapter of this book discussed a modern approach to the imagery of angels in general in Lilien's graphic works. Almost a hundred years later, Israeli artist Miriam Gamburd (b. 1947) reverted to them and included drawings of their likeness in an artist book that she published at the end of a long and comprehensive study. *Yetzer haRa Tov Me'od—Ahava veTo'eva baTalmud uvaMidrashim* (The Evil Inclination is very Good—Love and Abomination in the Talmud and Bible Commentaries) includes eighty drawings and five essays.[18] Regarding the process of the creation of the book and the drawings in it, and concerning the reason why drawing constitutes for her an appropriate tool in the dialogues she conducts with past interpretations of the Torah, Gamburd writes:

> Conversations and consultations with great figures of the past in the art of drawing [...] that I regularly conduct, and which hold such great significance for me, help me understand the nature of a phenomenon which is one of the most unique in Talmudic-Rabbinic practice: live discourse with extolled colleagues from the past. Participants in the colloquy lightly exchange sayings, converse through the generations, and issue declarations in the name of sages of previous centuries ... As a draftswoman, my choice falls on excerpts that can be seen. These are scenes that may be staged by a director or a choreographer. The language of pantomime and dance: gesticulation, movement, plasticity, costume, choice of types, lighting, composition—the placement of the characters on the stage (the page)—all these components form part of my arsenal.[19]

Jewish tradition holds that those who inscribed the Word of God in the biblical text were faithful to the verbal original and wrote the Torah "in the language of men." If so, then in their description of the cherubs, the scribes of the biblical text dedicated a detailed discussion to the shape of their wings, the substance from which they were fashioned, and its overlay, but said nothing about their clothing. Gamburd dared to impart a visual aspect to verbal interpretations

18 Miriam Gamburd, *Yetzer haRa Tov Me'od—Ahava veToeva baTalmud uvaMidrashim* (Evil Inclination is Very Good—Love and Abomination in the Talmud and Bible Commentaries) Beit Berl: 2009.
19 Ibid.

FIGURE 16.8 Miriam Gamburd, *Kruvim Me'urim Ze baZeh* (Cherubs Intertwined), 2002, pastel chalks on paper

by the great Jewish intellectuals, almost all of whom would be alarmed at her visual concretization of the cherubs as they themselves envisioned them.

How can one visually express a phrase stating that the cherubs were intertwined or "cleaved to one another?" Gamburd's visual interpretation shows the physical proximity between the cherubic pair in a series of studies, in which she sketches how this proximity could occur in the Holy of Holies in the Tabernacle or in Solomon's Temple. Her drawings show first that she adhered to scholars' interpretations of them as female and male, in a diverse range of couplings. In one drawing, the male cherub sits on the lap of the female cherub, while each has its arms around the other. In another drawing (fig. 16.8), their bodies form an X; their legs and back are turned away, while their loin area alone is united. In a third drawing, the male cherub stands on his tiptoes holding the female cherub in his arms, while they join each other at the loins.

Gamburd states that her study sketches, dedicated to cherub-related erotica, are "… But an attempt to translate it into Greek—a charged and dangerous task." When it comes to contemporary Jewish stance regarding such daring, unusual commentaries, Levoussove, Lilien's biographer, gave exactly that explanation for Lilien's work of a century beforehand. He would by no means regard Gamburd's works as "a charged and dangerous task" and rather would probably applaud them and see them as a natural continuation of Lilien's legacy. More than a hundred years after his observation the Israeli clerical establishment regards Gamburd's works as pure blasphemy.

16.6 Taharah and Tum'ah (Purity and Impurity)

According to Jewish rabbinical laws, Impurity is defined as a state in which human beings or objects are forbidden to come near anything that is holy. It is caused by acts that are generally connected with the death of human beings or animals, or with human secretions that may be transferred to other humans, to objects, or to food. Purity is the lack of impurity that can be ridden off by various acts and rituals.[20]

Israeli Artist Assi Meshullam engaged in multidisciplinary creative work dedicated to what he designates as the Order of Impurity, a virtual contemporary religious order, based essentially on a book of a prophet-emissary called *Ro'achem* and on a *Lexicon of Principles*, a book of commentary on his doctrines. The name of the prophet-emissary and the book hold a threefold meaning consisting of a play on Hebrew words: *Ro'achem* in Hebrew means your shepherd as well as your evil. Read backwards, the word spells *mecho'ar*, ugly.

Meshulam published his book in 2005.[21] It recounts the life story and the outlook that the prophet-emissary communicates as a philosophy to eight students. The book constitutes a song of praise to the notion of hybridism as it crossbreeds linguistic expressions, creates plays on words and infuses familiar biblical quotations with new meanings which the author distorts into new, hybrid configurations. The book reverberates with biblical language. Meshullam's text abounds in quotations and additional references from various sources such as fairy tales, adventure and travel books and Modern Hebrew poetry. The book is divided into chapters numbered by Hebrew letters. It is paginated and printed in a font resembling as closely as possible the traditional, antiquated font with which the Bible is printed—the *Drogolin*, or as it was known at the beginning of the twentieth century, the *Meruba* font.[22] The appearance of the book's graphic's formats manages to convince readers that they are reading a familiar religious canonical book (fig. 16.9).

Prophet-emissary *Ro'achem* is a hybrid that was born when its father, a human, mated with a canine bitch: "I am your reflection, a creature of this world: let my name be for you Your Shepherd son of a bitch and son of a man … I am your hybrid shepherd upon this earth, more hairy than any man, none has yet been created like me, I am God's horror" (*Ro'achem*, 76).

20 See: "*nida*", in Unterman, *Dictionaey of Jewish Lore and Legend*, 147.
21 Assi Meshullam, *Ro'achem*, published as part of the *Rok* (Saliva) exhibition at the Julie M. Gallery, Tel Aviv, 2005.
22 The *Merubah* font was mentioned in chapter 12.

ב׳
וַיְהִי בָּעִיר הַהִיא לִפְנֵי שָׁנִים יֶלֶד וּשְׁמוֹ אַשְׁמָת: וַיְהִי אַשְׁמָת יֶלֶד יְפֵה תֹאַר טָהוֹר הוּא לְמַרְאֵה פָּנָיו סִימְטְרִיִים מִן הָאַף יְמִינָה וּמִן הָאַף שְׂמֹאלָה אוֹתוֹ הַדָּבָר: וַיִּהְיוּ לַיֶּלֶד הַלְּתָלִים לוֹ חוּטִים בְּצֶבַע הַתֶּמֶר וְהוּא בֶּן חָמֵשׁ בְּפַעַם הַהִיא אֲשֶׁר בָּה הִתְקוֹטְטוּ הוֹרָיו לָרִאשׁוֹנָה כִּי גִלָּה הָאָב אֶת אִשְׁתּוֹ אֲשֶׁר בְּנִדָּה בּוֹ: וַיֵּדַע הַבַּעַל בְּאִשְׁתּוֹ וַתֵּדַע אֶת אָנְרוּפוֹ בְּפַרְצוּפָהּ מֵאֵיפֹה בָּא לָהּ: וַיִּשָּׁבֵר אֶת לִסְתוֹתֶיהָ כִּי בְּעַצְמָהּ הִכָּה בָּהּ: וַתֹּאמֶר הָאֵם לְבֵן אָבִיהָ רְאֵה מָה זֶה עָשָׂה לִי בַּעֲלִי וַאֹמֶר לָהּ מַדּוּעַ זֶה עָשָׂה בָּךְ כַּדָּבָר הַזֶּה וַתֹּאמֶר כִּי גִלִּיתִי אֶת עֲלָל כְּשֵׁלֹּא הָיִיתִי: וַיֹּאמֶר לָהּ הָאֵם מָה זֶה הַדָּבָר אֲשֶׁר גְּלִית וְהִסְפֵּר לוֹ כִּי יָדַע בַּעֲלִי אֶת הַשְּׁכֵנָה בְּתוֹךְ חֲבִית וְאַתְפָּס אוֹתוֹ עַל חַם: וַיַּקְשֵׁב הָאָח לַעֲלִילָה וַיַּאֲמֵן בָּהּ כִּי אֲחוֹתוֹ הִיא וּמִפִּיהָ בָּאָה: וַתְּהִי הַמְּצִיאוּת אֲשֶׁר בָּנְתָה לוֹ לֶאֱמֶת צְרוּפָה בִּגְבוּרוֹ וַיֵּעוֹר בּוֹ יֶצֶר הַנְּקָמָה כַּתְּשׁוּקָה הַמִּין וַיִּתְרַגֵּשׁ וְהוּא אַלִּים מְאֹד: וַיֵּלֶךְ אֶל בֵּיתוֹ אֲשֶׁר שָׁם מֵעֵבֶר לַכְּבִישׁ וַיָּבֹא מִשָּׁם פַּטִּישׁ וְגַרְזֶן וַיַּחֲצֶה בַּחֲזָרָה אֶת הָרְחוֹב: וַתְּכַנֵּס אוֹתוֹ אֲחוֹתוֹ

FIGURE 16.9
Printed page in Assi Meshulam's *Ro'achem*

The character of *Ro'achem* is passionate and violent, but also wise, possessing a unique outlook that derives from his familiarity with the human condition and with the bestial nature of man.[23] The hero develops a philosophy that includes commandments and prohibitions, all concealed within the text both as an echo of the commandments and prohibitions mentioned in the Bible and also in the style of parables, sermons and short stories that carry an encoded moral message like those given by Jesus in the New Testament.

Like the individual commandments set forth in the Bible, which an observant Jew must perform, so does *Ro'achem* impose his commands on the body of his male followers. One command inverts the Bible directive concerning the facial hair of the male believer: the beard and sidelocks adorning the face of the believing Jew, which the Torah forbids him to shave, are prohibited for men who are believers of the Order of Impurity—they must shave.[24]

Ro'achem serves Meshullam as a formative text in the creation of a series of paintings, drawings, and sculptures. The latter are figures of youths; their images may take two forms: a human body and a goat's face and a human face and a goat's body. The captions given them by the artist reflect his irony: *Isaac, Jacob, David* (figs. 16.10, 11).

Jacob's head (fig. 16.10) is partly concealed under the white mask-head of a billy goat with horns and peeps through it. The spread legs indicate a walk momentarily frozen; in his hands, he holds scraps of white fabric which he seems to be peeling off his body. The horned *David* (fig. 16.11) stands in a posture recalling that of the Michelangelo's famous sculpture. The artist suggests his virility by the huge horns on his head and his exposed erect male member.

23 Assi Meshullam, *The Order of Impurity, Lexicon of Principles*, private publication, 2009, 336.
24 Ibid. 351–352.

IN CONCLUSION 391

 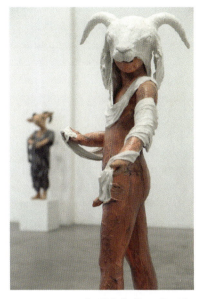

FIGURE 16.10 Assi Meshullam, *Ya'akov* (Jacob), 2011, mixed media

FIGURE 16.11 Assi Meshullam, *David,* 2011, mixed media

At first glance, it is impossible not to perceive these bits of fabric as shrouds. Thus, one may assume that Meshullam's hybrids express a resurrection; the figures are presented in the moment of their coming back to life, and the garments of death still envelop them. The change is clearly reflected in the principle of the overt and the covert in the *Jacob* sculpture; through the white head of the billy goat pokes a new human head, already in the process of creation.

Meshullam's sculptures restore the traditional notion of the statue, the ritualistic dimension with which it was vested in the ancient world. His sculptures are meant to serve the Order of Impurity as a bridging object between believers of a religious order and an abstract entity. By serving such a function, the ancient world's function of sculptures as visual representations of gods, the very issue that the biblical Second Commandment advocates Jews to avoid. It is obvious that all of Meshullam's sculptural works, not to mention his texts, are an abomination. They are sacrilegious graven images, blaspheming Judaism's very restrictions against their creation.

One of the rituals linked with the concepts of purity and impurity is the *Nida* ritual. Jewish rabbinical law considers women to be impure during their menstrual period. The law maintains that women should check themselves regularly during the *nida* period to see if they have stopped bleeding. To do so, they are advised to insert a piece of cloth into their body and check for

stains. If the woman is not sure that her period is over, she must wait seven days called clean and then, after a ritual bath at the *mikveh*, ritual bathhouse, she is declared pure to resume sexual intercourse with her husband.[25]

During the late 1960s and especially throughout the 1970s Israeli artists followed international artistic trends by choosing performance, a new artistic medium. Combining elements from the theater, music, and the visual arts, the performance acts were extremely prevalent in Israel at that time. The medium enabled artists to convey political, ritualistic and at times, violent messages, side by side with psychodramas or subjects that were considered taboo in contemporary Israeli society, including even striptease.[26]

Artist Yocheved Weinfeld (b. 1947) turned the individual and private nature of the *nida* ritual into a public artistic performance (fig. 16.12). She began her act by entering the gallery space, wearing black clothes. She sat on a stool and read aloud texts from Jewish rabbinical law on women's abstention from being touched by their partners during the period of *nida*. Water bowls were laid at her feet. The artist proceeded to tear her clothes in a ritual of quasi-mourning. Other women participants in the performance acted as traditional *balaniyot*, ritual bathhouse attendants, whose function is to help women in their immersion in a ritual bath. They wiped her feet with a wet piece of cloth which the artist then moved between her legs, alluding to the purity test. The attendants took the cloth and stuffed it into the artist's mouth, then sealed it with adhesive bandages, as if to silence her. After removing the cloth from her mouth, they painted it and the artist's cheeks in red. Then, they put dark colored socks on her feet and placed a wine goblet, set on a tray, in her hands. The performance concluded as the artist approached the audience holding the goblet and offered them a drink of its liquid.

The audience's reactions to the *nida* performance were a mixture of embarrassment and revulsion as they attended the private turned into public before their eyes. Weinfeld's protest against rabbinic laws was aimed at representing the ritual's degrading aspects and its view of women as mere vehicles for men's sexual needs.

Artist Michael Druks[27] reconstructed a Jewish male ritual. "It is possible that I am a religious man," the artist said in an interview, "Nevertheless I oppose coerced rituals (putting on phylacteries) and concentrate on my own rituals;

25 Unterman, *Dictionary of Jewish Lore and Legend*, 147. It is worthwhile mentioning that impurity is not only concerned with women; Jewish men suffering from venereal disease are considered impure as well.
26 Leah Orgad, "Meytzag 76" (Performance 76), *Mussag*, 1976, 98–99.
27 Druks' work was discussed in chapter 8.

IN CONCLUSION

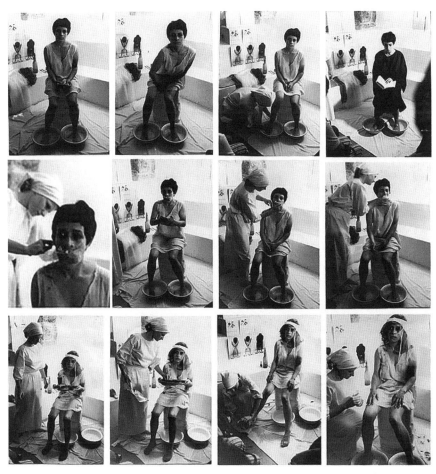

FIGURE 16.12 Yocheved Weinfeld, *Nida*, 1976, 8 photographs documenting a performance enacted at the Debel Gallery, Eyn Karem

my ritual utensil is a camera."[28] In *Looking towards the East* he photographed himself standing at his room's doorstep, holding a book, and wearing head and hand phylacteries. Jewish custom demands that phylacteries should be put on one's weak hand; a right-handed man would then wrap them on his left hand, a left-handed person would tie them on his right. If Druks is a left-handed person, indeed he tied the phylacteries on his weak [right] hand and thus enacted the Jewish ritual properly. If he is right-handed, he put them on the wrong hand. The angle from which he is seen in the photograph does not show whether he wears a skull cap while performing the ritual.

28 Druks is quoted in Galia Bar Or, *Michael Druks, Massa'ot beDruksland* (Michael Druks, Voyages in Druksland), Ein Charod: Mishkan le'Omanut Ein Charod, 2007, 115.

FIGURE 16.13 Michael Druks, *Hitbonenut laMizrach* (Looking towards the East), 1977, staged photograph

The artist wound the phylacteries straps seven times around his arm, as is customary. The ritual of wrapping the phylacteries is said to provide a chance for Jewish males to cut themselves from the actual world and concentrate in an internal contemplation, full of modesty in which they express their devotion to God. As the phylacteries are put close to their essentiality centers—the brain (mind), a tiny black box, tied by leather stripes around the forehead and heart (two protruding leather stripes coming down on both sides of a man's neck, reaching his chest). Druks replaced the black box of the head phylacteries with a camera, attached to his forehead, and put on an additional camera on his hand phylacteries. This attachment of cameras, which are optical fixtures that function as conveyers of outer rather than inner observation, suggest that instead of a spiritual act, Druks' style of putting on phylacteries is, in fact, an act of blasphemy.

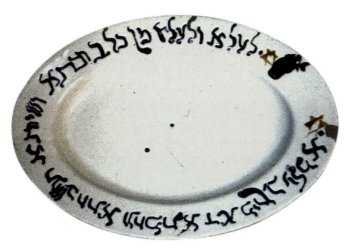

FIGURE 16.14 Moshe Gershuni, *Le'Eyla ule'Eyla Min Kol Birkata*
(Beyond any Blessing and Song), 1988, china plate
decorated with ceramic glazing inscriptions and stains

Artist Moshe Gershuni alluded to purity and impurity in a series of ready-made ceramic vessels. His creative process involved personal abandoning his religious upbringing as a youth.[29] Through a personal experience suffused by memories linked to objects, the artist conveyed a sad, tragic message in a one-person exhibition at Tel Aviv Museum of Art (1990). He decorated ready-made ceramic utensils and included inscriptions, written by hand. The utensils include old china for everyday use by anonymous people. Gershuni arranged them in such order that gave the impression that they were laid on a table, ready for a meal. His inscriptions comprise of sentences and verses taken from the Bible and Jewish traditional blessings and prayers.

Vessels like bowls or pitchers that are meant to contain water are used in purification ceremonies for washing the deceased body before entombment. Traditional Jewish vessels serving this ritual are inscribed with verses from the Bible: "Then will I sprinkle clean water upon you, and ye shall be clean: from all your filthiness, and from all your idols, will I cleanse you." (Ezekiel 36, 25), "Treasures of wickedness profit nothing: but righteousness delivereth from death" (Proverbs 10, 2). Jewish purification ceremonies are geared to purify people of their greatest sins and cure them of the impurities that stuck to them through the use of water, a liquid suffused with symbolic aspects of purity, stored in sanctified vessels.

29 Gershuni's religious upbringing was mentioned in chapter 11.

Gershuni made his vessels-containers impotent by removing their original functions. He replaced verses (in Aramaic), traditionally inscribed on purification vessels, with others, all of which linked to death and entombment. On a flat serving plate he quoted in handwriting parts of verses from the *Kadish* prayer: *"Le'eyla ule'eyla min kol birkata veshirata tushbechatah venechematah, da'aameeran be'almah, ve'eemru"* (Beyond any blessing and song, praise and consolation that are uttered in the world. Now say ...)—the word Amen is missing, leaving the prayer un-sanctified by the reciter. The unfinished wording renders it powerless, and it is no longer able to function in a purification ritual for which it was traditionally intended.

The impotent aspect of Gershuni's vessel is joined by yet another symbolic aspect: the artist affixed the plate with images of stains, the reverse of cleanliness and purity. The ceramic glazing seals the painted stains, acting as a form of dirt that cannot be removed. As it is impossible to get rid of it, the stain makes sure that there is no chance for getting rid of impurity or fulfill the vessel's function of purification. Gershuni's handwriting of the letter *aleph* (א) intentionally resembles the Nazi swastika. The yellow stain consequently reminds one of the yellow badge of shame.[30]

This plate is a confusing mixture of symbolic, message-carrying verses from sections of Jewish prayers stuck in the artist's mind since childhood. They move in a senseless action and land, affixing to his vessels, at times in preconceived planning, at others inadvertently. The results are vessels deprived of their function, made by the artist in a creative process that extorted enormous emotional energy that probably left him in a state of purified emptiness, accompanied by a feeling of heavy guilt, pain, grief, and disappointment. Gershuni touched the sanctified with the hands of a person who forsook his religious belief, hands that are impure. No wonder that the beauty of the purifying ritual turned in his works into blasphemy, probably attesting to the sensation of helplessness which is often typical of an apostate. A conflict between the inner nostalgia towards the Jewish sources which continue to haunt him and won't let him go, and the reluctance, or inability to willingly return to them.

Geshuni's vessels evoke an association with destruction. He purchased his ceramic dishes at a flea market and then discovered that they were marked by the date of production (1936) next to which was a swastika. The dishes were probably owned by German Jews who immigrated to Palestine after the Nazis

30 Such use of the letter *aleph* was made by David Tartakover, as described in chapter 12.

came to power. They served them in their homes and apparently, after they passed away, the content of their home was sold to scrap vendors and then found their way to the flea market. The artist displayed a few of them upside down so that their date of production and the swastika were exposed to viewers. By displaying his vessels on top of tables he brought back their original function as dishes. Indirectly, it alluded to a virtual meal; the dishes display created shocking associations of pogroms and deportations, engraved on viewers' memories of orphaned meal dishes standing for people who were snatched from their homes in the middle of a meal.

Last, and probably most painful message conveyed by Gershuni's vessels and their unique display points at the disconnection typical between secular Jewish Israelis with anything that has to do with Jewish religious customs. A disconnection that for years was cultivated by Zionism's negation of the Diaspora and its secular educational efforts to cultivate the Israeli melting pot, which left the beauty of Jewish traditions solely in the hands of the orthodox establishment. To fathom the changes put by Gershuni in his ready-made vessels, secular Jewish Israeli viewers are in need of basic knowledge of Jewish iconography. The secular art public in Israel is more acquainted with classical and Christian iconography; when it comes to Jewish iconography such acquaintance is most often very limited. Consequently, the secular audience that frequents exhibitions such as Gershuni's lacks the ability to fathom the concealed messages conveyed by the works on exhibit, since if one wishes to fathom blasphemy, one has first to be familiar with the sacred.

A similar sad message is conveyed in a work by artist Arnon ben David's (b. 1950), *Jewish Art* (fig. 16.15). It is made of a plywood board which serves as bedding to a toy *Uzi*, the Israeli-manufactured machine gun. Ben David's critical stance is a reversal of concepts: it conveys a forceful Jewish-Israeli identity, secular and modern, whose faith is given to military might. His cynical approach may seem like an embodiment of local Jewishness relating to the question "Is there Jewish art?" Ben David's work is an ironic positive answer to this question, as if it is accompanied by another question, Harold Rosenberg's quoted: "What do you mean by Jewish art?"

Bibliography

Amishai Meisels, Ziva, *Menashe ben Israel vehaYehudi hanoded* (Manasseh ben Israel and the Wandering Jew), in Bracha Yaniv (editor), *Timora*, Ramat Gan: Jewish Art Department, The Faculty of Jewish Studies, Bar Ilan University, 2006.

FIGURE 16.15 Arnon ben David, *Jewish Art*, 1988, plastic toy gun, anti-rust paint, cloth and ink on plywood

Bar Or, Galia, *Michael Druks, Massa'ot beDruksland* (Michael Druks, Voyages in Druksland), Ein Charod: Mishkan le'Omanut Ein Charod, 2007.

Gamburd, Miriam, *Yetzer haRa Tov Me'od—Ahava veTo'eva baTalmud uvaMidrashim* (Evil Inclination is Very Good—Love and Abomination in the Talmud and Bible Commentaries) Beit Berl: 2009.

Kalderon, Ruth, "Kol Anot" (The Sound of Singing), in *Kol Anot, Motivim Tanachi'yim baOmanut haIsraelit* (The Sound of Singing, Biblical motifs in Israeli art) (exh. cat.), Tel Aviv: Agudat haTzayarim vehaPasalim, 1998.

Meshullam, Assi, *Misdar haTum'ah Lexicon ha'Eekarim* (The Order of Impurity, Lexicon of Principles), private publication, 2009.

Meshullam, Assi, *Ro'achem*, published as part of the *Rok* (Saliva) exhibition at the Julie M. Gallery, Tel Aviv, 2005.

Mishory, Alec, "Kelim Shvurim: Motiv haTahara bItzirot haKeramika shel Moshe Gershuni" (Broken vessels, the Purity Motif in Moshe Gershuni's Ceramic Works), *Studio*, 17, December 1990.

Narkiss, Bezalel, (with a foreword by Cecil Roth), *Hebrew Illuminated Manuscripts*, Jerusalem: Keter Publishing, 1969.

Nochlin, Linda, *The Body in Pieces, The Fragment as a Metaphor of Modernity*, London: Thames and Hudson, 1994.

Ofrat, Gideon, "Beyn Bereshit leVeyn Acharit, 1944–1946" (Bwtween Beginning and End, 1944–1946) in *Shalom Seba, Monograhy* Ein Chard and Tefen: Ein Charod Museum of Art and the Open Museum in Tefen, 1994.

Oman, Meytal, *Hybrid Adam veChaya, haShnayim shba'Echad* (Hybrid Man and Beast, the Two in One) (exh. cat), Tel Aviv: University Gallery, Faculty of the Arts, Tel Aviv University, 2004.

Sgan Cohen, Michael, "Chur ve'Aharon' Ra'ayon Atzmi al Hashkafot be'Eenyaney Omanut, Dat veIsraeliyut" (Hur and Aaron, an Interview with Myself on Matters of Art, Religion and Israeliness), *Studio*, 17, December 1990.

Sperber, David, "Letargem et haTorah lIvanit" (Translating the Torah into Greek), "Sabbath" Thought, Literature & Art Supplement, *Makor Rishon*, November 8, 2010.

Tamir, Tali (curator), *Kol Anot, Motivim Tanachi'yim baOmanut haIsraelit* (The Sound of Singing, Biblical Motifs in Israeli art (exh. cat.), Tel Aviv: Agudat haTzayarin ve-haPasalim, 1998.

Unterman, Alan, *Dictionary of Jewish Lore and Legend*, London: Thames and Hudson, 1991.

Warner, Marina, "Satyrs, Spiders, Jellyfish, and Mutants: Ovidian Metamorphosis in Contemporary Art," in Cornine Saunders, Ulrika Maude, Jane Macnaughton, *The Body and the Arts*, Palgrave Macmillan, 2009.

General Index

Abramson, Larry *see* [Israeli] artists
Abu Shakra, Assim *see* [Israeli] artists
Ademollo, Luigi 161, [8.1, 8.2]
Achad ha'Am 22, 22 n.12, 23 n.13, 51 n.10
Adler, Freidrich 227–229, [10.20]
Aharonovitch, Vered *see* [Israeli] artists
[Hebrew] alphabet *see also* calligraphy, typography
 aleph 286, 289, 291, 298, 299, 396, [12.9, 12.17a]
 capital word 106, 107
Alterman, Natan 1, 68, 268, [2.15b]
Alweil, Arieh *see* [Israeli] artists
Amichai, Yehuda 270–272
Amsterdam letters *see* typography
An-Sky 8 n.14, 18
angel, angels 26, 28, 29, 35, 40, 56, 113, 149, 213, 286, 384, 385, 387
 cherubs 56, 384, 385–386, 388, [16.8]
Anilewizc, Mordechai 335, 339, 340, 341, 342, 343, 344, 345, 346, 347, 348, [14.3, 14.6 a, b, 14.7, 14.8, 14.9] *see also* memorials
animals
 donkey 74, 216
 dove 145, 154, 156, 217, [7.8]
 eagle 326
 gazelle 73, 74
 lion 73, 74, 76, 313
 of Judah 139, 145, 196, 216, 228, 234, [7.9]
 White 74, 74 n.11
 snake 216, 239
 wolf 218, 220, 241, [10.10]
Arch of Titus 10, 138, 140, 145, 148, 153, 156, 159, 160, 164, 165, 167, 168, 176, 178, 183, 184, 185, 190, [8.4]
Archaeology 140, 154
Art
 art nouveau 21, 71, 293
 Greek 11, 21, 22, 23, 24, 41, 50, 191, 236, 266, 388
[Israeli] artists
 Abramson, Larry 280–281, [11.36]
 Abu Shakra, Assim 282–283, [11.37]

Aharonovitch, Vered 397–398, [16.4]
Allweil, Arieh 167, [8.5]
Averbuch, Ilan 279–280, [11.35]
Baruch, Francisca 140
Ben Dov, Ya'akov 197, [9.8]
Ben David, Arnon 397, [16.15]
Ben David, Shmuel 52, [2.7]
Danziger, Yitzhak 13, 326–327, 331, [13.8a,b]
David, Ismar 140, 296, 298, [7.4a, 12.16]
Dominey, Drora 304–305, [12.24]
Druks, Michael 186, 392–394, [8.15, 16.13]
Eer-Shay, Pesach 112, 294, 299, 394
El-Chanani, Arieh 317–318, [13.4a, b]
Feigin, Dov 337, 338
Fenichel, Aba 168, [8.6]
Friedlander, Henry 297, [12.17]
Gamburd, Miriam 387–388, [16.8]
Gershuni, Moshe 273–274, 276, 395–397, [11.29, 16.14]
Gershuni, Uri 276, [11.32]
Glieksberg, Chayim 52
Gros, Michael 270–273, [11.28]
Gumbel, David 108, 109 n.5, 110, [5.7 a, b]
Gutman, Nachum 347, [14.10]
Kirschner, Michah 284, [11.38]
Livni, Zvi 264, [11.21, 11.24]
Lulu Lin, Hila 305, 307, [12.25]
Maor, Chayim 376, 377, [16.3]
Melnikov, Avraham 59, 60, [2.11]
Meshulam Assi 389–391, [16.9, 16.10, 16.11]
Molcho, Ilan 206–207, [9.17]
Morris, David 383–384, [16.7]
Nimtza-Bi, Mordechai 126, 127, [6.13]
Raban, Ze'ev 11, 45, 67, 71, 71 n.10, 72, 73, 74, 75, 76, 77, 79, 80, 81, 89, 90, 163, 164, 198, 291, [2.2, 3.1, 3.2, 3.3–3.9, 4.6, 4.7, 8.3, 9.9, 12.9]
Rakia, David 307–308, [12.26]
Reeb, David 276, [11.31]
Reisinger, Dan 134
Rosen, Ro'ee 374, [16.1]
Seba, Shalom 232–236, [10.24, 10.24a, b, c]

[Israeli] artists (*cont.*)
- Sgan-Cohen, Michael 303–304, 305, 375, 376 n.4, 380, 382, [12.22, 12.23, 16.6]
- Shaltiel, Ohad 132, [6.16]
- Shamir Brothers Studio 146–149, 151, 152, 156, [2.12a, b, c, 7.12, 7.12a, 7.13, 7.15]
- Shamir, Eli 277–278, [11.33]
- Shamir, Michal 279, [11.34]
- Schatz, Bezalel 363, [5.3c]
- Schatz, Boris 5, 5 n.6, 11, 41, 43, 44, 44 n.1, 46, 48, 50, 52, 53, 54 n.13, 54, 57, 58, 59, 61, 64, 65, 67, 68, 69, 70, 71, 72, 75–76, 80, 83, 83 n.2, 84, 192, 194, 198, [2.1, 2.6, 2.8, 2.9, 2.10]
 - Garden of Love 68, 69, 70, 72, 77
 - *Jerusalem Rebuilt—a Day Dream* 11, 44, 46, 67, 68, 71, 84, [2.2]
- Schechter, Yerachniel 140, 141, 142, [7.4a, b]
- Shur, Aharon, Shaul 259, [11.17]
- Steinhardt, Ya'akov 290
- Studio Roli (Rothchild and Lifman) 204, 296, [9.16]
- Tartakover, David 111, 114–115, 274, [5.8, 5.9, 11.30]
- Tumarkin, Yigal 364, 367, 368, 369, 370, 372, [15.15a, b, c]
- Ur, Baruch 264, [11.22, 11.23]
- Walisch, Oteh 103, 105, 106, 107, 108, 112, 128, 129, 138, 140, 203–204, 206, 236, 251, [5.5, 6.14, 7.2, 9.5, 9.15, 10.25, 11.25, 11.26]
- Weinfeld, Yocheved 391–392, [16.12]

Ashkenazi script *see* calligraphy
Averbuch, Ilan *see* [Israeli] artists

Badge of shame 130, 131, 134, [6.5]
Bamidbar Rabbah 210, 210 n.4, 211
[Israeli] Bank notes [2.12a, 2.12b, 2.12c, 2.13a, 2.13b, 2.13c, 2.14a, 2.14b, 2.15a, 2.15b]
Baruch, Franciska *see* [Israeli] artists
Beardsley, Aubrey 21 n.1, 29, 30
Ben David, Arnon *see* [Israeli] artists
Ben David, Shmuel *see* [Israeli] artists
Ben Dov, Ya'akov *see* [Israeli] artists
Ben-Gurion, David 1, 61, 103, 104, 114, 116, 139, 317, [2.13b]
Ben Sh'ealtiel, Zerubabbel 150
Ben Yehida, Baruch 246
Ben Yehuda, Eliezer 55–56, [2.8]
Ben Uri, Bezalel 47, 48, 56, 176, 385
Ben Jehozadak, Yehoshua 151
Ben Zvi, Yitzhak 61, 62, 231, 236, [2.13a, 2.14a, b]
Benjamin *see* Twelve Tribes of Israel
Bezalel School of Arts and Crafts 4, 5, 11, 43, 44 n.1, 46, 49, 52, 54, 58, 72, 83, 87, 103, 198, 258, 291, 367
Bialik, Chaim, Nachman 5, 62, 74, 199, 252, 293, 295
Bible 9, 49, 57, 72, 82, 87, 94, 101, 103, 110, 122, 123, 151, 178, 189, 210, 211, 213, 215 n.9, 218, 222, 229, 239, 245, 251, 256, 259, 260, 262, 281, 282, 296, 301, 374, 375, 376, 377, 380, 384, 389, 390, 395, 396
blasphemy 13, 21, 81, 115, 391, 394, 396, 397
Bomberg, Daniel 289, [12.3]
Book of Legends 74
[high priest's] breastplate 209, 213, 215, 215 n.9, 228
Bride 81
Brunelleschi, Filippo 47, 48
Buber, Martin 17, 18, 20, 23
Budko, Joseph 290, [12.7]

[Hebrew] calligraphy 11, 103, 105, 112, 206, 287, 291
- Ashkenazi script 105, 185, [5.3]
- Sephardic script 105, 106, [5.3]

Chayim typeface *see* typography
clerical parties 1, 111, 115, 170, 171, 172, 173, 180, 181, 182, 246, 313, 321, 332, 346, 354, 356
ceramic tiles 48, 83, 84, 87, 88, 91, 93, 96, 198, 252, 254
cherubs *see* angels
classical mythology 35, 36, 266–267, 277, 383 n.10
colors 117, 117 n.1, 118, 124, 227
- blue and white 124, 126, 132, 134, 145, 226, 230, 248, 317, 318
- light blue 114, 118, 122, 123, 124, 125, 126, 129, 131, 138, 227
Commemoration *see* memorials
Churban *see* Memorial to the Destruction of the Temple
Crane, Walter 229, 230, 230 n.25, [1.7, 1.8]

GENERAL INDEX 403

cypress *see* plants

Danziger, Yitzhak *see* [Israeli] artists
[King] David 48, 178, 194, 379, [2.5, 6.11]
 shield *see* Jewish Star
David, Ismar *see* [Israeli] artists
David typeface *see* typography
Daughter of Zion 12, 32, 33, 74, 189, 190,
 193, 194, 196, 198, 200, 201, 206, 207,
 280, 369 n.19, [4.4, 9.5, 9.9, 9.10a, b,
 9.11, 9.13a, b, 9.15, 9.16a, b]
Destruction of the Jerusalem Temple 12, 25,
 86, 87, 151, 160, 161, 163, 169, 178, 192, 195
Diaspora 3, 6, 8, 11, 17, 23, 33, 40, 41, 57, 59,
 67, 85, 87, 89, 96, 102, 127, 137, 167, 168,
 181, 197, 209, 229, 245, 246, 247, 250,
 256, 282, 319, 321, 331, 338, 339, 344
 Jew 17, 23, 36, 40, 41, 67, 254, 335, [1.16]
 negation of 6, 358, 397
Dominey, Drora *see* [Israeli] artists
dove *see* animals
Druks, Michael *see* [Israeli] artists

Eer-Shay, Pesach *see* [Israeli] artists
eagle *see* animals
earth from the Holy Land *see* Land of Israel
Elijah *see* prophets
Elkan, Benno 170, 170 n.13, 172, 174, 175, 176,
 178, 179, 180, 182, 183, 184, 185, [8.7, 8.8,
 8.9, 8.10, 8.12]
El-Chanani, Arieh *see* [Israeli] artists
Ephraim *see* Twelve Tribes of Israel
eroticism 30, 75, 77–78
Exile 38, 44, 85, 112, 153, 159, 161, 163, 167, 185,
 192, 193, 317, 326, *see also*
 personifications

Fallen 9, 173, 268, 272, 274, 276, 331, 335, 338,
 339, 341, 347, 348, 349, [14.5, 14.11]
Feigin, Dov *see* [Israeli] artists
Fenichel, Aba *see* [Israeli] artists
flag, flags 132
 Herzl's 118, 126, 138, 147, 317, [6.11]
 Israeli 117, 126, 127, 131, 133, [6.2, 6.10, 6.11,
 6.12, 6.13, 6.14, 6.16, 6.17]
 Palestinian 275
 Zionist 115, 117, 117 n.1, 118 n.4, 124, 127,
 129, 130, 131, [6.9]

Flavius, Josephus 101, 151, 159–160
Florsheim Haggadah 211, [10.1]
flower, flowers
 and death 248, 249, 260, 261–267,
 268–274, 276
Four Holy cities 88, 89, 92, 96
Four Species *see* plants
Frank Rühl *see* typography
Frankl, Ludwig, August 124
Friedberg, Avraham, Shalom 194
Friedlander, David 86–87, 86 n.7, [4.3]
Friedlander, Henry *see* [Israeli] artists

Gamburd, Miriam *see* [Israeli] artists
Garden of Eden 40, 93, [1.3]
Garden of Love *see* Schatz, Boris
gazelle *see* animals
Gershuni, Moshe *see* [Israeli] artists
Gershuni, Uri *see* [Israeli] artists
Grunberg, Avraham 218, 219, [10.7, 10.9,
 10.10]
Ge'ula 25
Glieksberg, Chayim *see* [Israeli] artists
Gothic 31, 46, 58
 Revival 46, 46 n.2
grapevine *see* plants
graven image 5, 13, 52, 146, 156, 171, 382, 384,
 385, 391
Gros, Michael *see* [Israeli] artists
Gumbel, David *see* [Israeli] artists
Gutman, Nachum *see* [Israeli] artists
Guri, Chayim 268, 272, 273, 274

Haifa 88, 89, 92, 93, 93 n.14, 95, [4.9]
HaTzarfati, Yosef 151, 252, [7.14]
Hebron 88, 89, 93, 95, , 113, 114, [4.10]
heraldry *see* Twelve Tribes of Israel
Herzl, Theodor 13, 35, 36, 38, 50, 51, 55, 56,
 57, 83, 116, 117, 118, 126, 138, 142, 144, 145,
 146, 165, 196, 315, [1.14, 1.15, 2.10, 6.11, 13.1]
 burial ceremony 317, 320, [13.5, 13.6]
 burial site 182
 burial site competition 321–324
 Danziger's design 326–328,
 [13.8a, b]
 Klarwein's design 324–325,
 [13.7a, b]
 tomb 182, 328–333, [13.9a, b]

Herzog, Isaac 153, 153 n.20, 172, 172 n.16
Holocaust 134, *see also* memorials
hybrid 380, 382, 383, 383 n.9, 384, 389, 391

Ideal Woman 71
Imber, Naphtali 194
impurity 389, 390, 391, 395
Isaiah *see* prophets

Jacob 210, 216, 378, 391, [16.10]
 blessing his sons 210, 216, 218, 232
 blessing his grandchildren 210
Jaffa 88, 89, 90, 94–95, [4.6, 4.11]
Jerusalem 48, 49, 54, 72, 76, 80, 85, 86, 88, 109, 113, 125, 138, 150, 151, 159, 160, 163, 165, 167, 168, 169, 170, 173, 174, 175, 183, 189, 193, 194, 195, 198, 204, 213, 222, 229, 239, 244, 247, 254, 256, 258, 259, 291, 294, 300, 316, 317, 321, 326, 328, 329, 330, 361, 386, [4.2, 10.28]
Jerusalem Rebuilt—a Day Dream *see* Schatz, Boris
Jesus 33, 153 n.4, 161, 169, 176, 178, 179, 210, 213, 390
Jew
 diasporic 67
 New 17, 40, 41, 44, 58, 71, 245
 tiller of the soil 254, 282, 284, [1.20, 10.10, 11.11]
Jewish
 Agency 317, 321, 338 n.6
 Brigade 165–166, 198, [9.9]
 identity 17, 25, 67, 102, 209, 227, 382, 397
 martyrdom 180, 183
 Nation 31, 32, 165, 179, 196, 197, 206, 222
 National Fund 165, 222, 223, 246, 247, 248, 256
 Renaissance 7, 8, 17, 22, 30, 41
 Star 10, 25, 32, 33, 40, 118, 119–121, 125, 126, 129, 130, 131, 132, 133, 134, 138, 140, 144, 145, 196, 231, 239, 366, 367, 369, 371
Judah *see* Twelve Tribes of Israel
Judea *see* personifications
Judea capta coin 189–190, 193, 196, 199, 201, 203, 206, [9.2]

Kadish prayer 274, 396
Kipnis, Levin 264, 265, 266, 273

Kirschner, Michah *see* [Israeli] artists
Kishinev pogrom 28, 28 n.22, [1.6]
Klarwein, Yosef 318, 324, 324 n.17, 328, 329, 331, *see also* Theodor Herzl, burial site
Kolb, Eugen 334, 335, 337, 345, 346, 352, 353, 356
Kook, Yitzchak haKohen 53, 54, 54 n.13, 54 n.16
Koren typeface *see* typography
Kovner, Aba 364, 365
Kreutner, Shimshon 181, 181 n.33, 182, 320, 321, 322, 323, 328

Land of Israel 18, 25, 41, 44, 45, 47, 48, 58, 67, 69, 84, 85, 87, 89, 93, 94, 107, 122, 153, 167, 196, 197, 209, 223, 226, 236, 239, 244, 245, 246, 247, 252, 254, 256, 259, 262, 279, 280, 287, 309, 315, 319, 335, 354
 earth 318–329, [13.6]
 landscape 80, 93, 276, 324, 347
 maps 223
landscape *see* Land of Israel
Levoussove, M. S. 22, 22 n.11, 388
Lilien, Ephraim Mose 19, 21, 23, 24, 25, 26, 28, 30, 33, 192, 196, 222, 227, 238, 386, 388, [1.2–1.6, 1.9–1.11, 1.13, 1.15–1.20]
Lion *see* animals
Livni, Zvi *see* [Israeli] artists
Lulu Lin, Hila *see* [Israeli] artists

Magen David *see* Jewish Star
mandrake *see* plants
Manasse *see* Twelve Tribes of Israel
Maor, Chyim *see* [Israeli] artists
Marti, Raymond 211
Matathias 50, [2.6]
Maimonides 61, 64, 109, 110, 173, 211, 385
martyrdom *see* Jewish
Meir the Miracle Maker 90–91, 90 n.13, [4.3]
Melnikov, Avraham *see* [Israeli] artists
Men of renown 11, 52, 58, 60
menorah 9–10, 12, 18, 84, 118, 138, 138 n.1, 139, 140, 141, 143, 145–151, 152, 153, 154, 155, 159, 161, 163, 164, 165, 167, 168, 169, 171, 172, 173, 174, 175, 176, 177, 178, 179, 180, 181, 182, 183, 184, 185, 186, 187, 188, 227, 236, 237, 238, 323, [0.5, 7.3, 7.4a, b, 7.5, 7.12, 7.13, 7.14, 7.15, 8.1, 8.5, 8.7, 8.8, 8.12,

8.13, 8.14, 8.15, 10.25] *see also* Seven Branched Candelabrum
memorials 50, 54, 56, 57, 59, 60, 64, 86, 87, 173, 174, 183, 313, 321, 332, 335, 336, 337, 338, 339, 345, 347, 348, 354
 Mordechai Anilewizc 339–340, 343–348, [14.6a, b, 14.8]
 Auschwitz 360–361, [15.1a, b, c]
 [to the] Fallen 336, 339, 341, 347, 348–354, [14.5, 14.11, 14.12, 14.13a, 14.13b, 14.16a, 14.16b]
 [to the] Holocaust 361–363, [15.3a, b, c, d]
 [to the] Holocaust and the Resurrection of Israel 364–372, [15.4, 15.5a, b, c]
 [to the] Warsaw Ghetto Heroes 336–337, [14.2]
Memorial to the Destruction of the Temple 85, 86, 87, [1.18, 4.3]
Meruba typeface *see* typography
Meshulam Assi *see* [Israeli] artists
Messiah 38, 151, 159, 163, 167, 169, 178, 179, 319
mezuzah 109, 110, 115
midrash (commentary) 74, 210, 211, 375, 387
Milgroim 8, 290, [12.6a, b, c]
Molcho, Ilan *see* [Israeli] artists
moon 211, 216
Morris, David *see* [Israeli] artists
Morris, William 29, 44, 46, [2.3]
 News from Nowhere [2.3]
Muscle Judaism *see* Nordau, Max
Moses 35, 36, 57, 68, 113, 122, 179, 210, 212, 213, 215, 217, 280, 281, 282, 376, [1.15, 2.10, 16.2]
Moshe haDarshan 211

Narkis, Mordechai 294, 294 n.7
Nassi (tribe's Patriarch) 93, 211, 213, 215, 229, 230, 245
New Jew *see* Jew, New
nida 391–392, [16.12]
Nimtza-Bi, Mordechai *see* [Israeli] artists
Niobe 190–191
Nordau, Max 17, 38, 67, 91, 92, [1.17, 4.8a]
 Muscle Judaism 67

Orientalism 79, 81
Ost und West 20, 30, 194 n.6, 196, [1.9]

Pasternak, Leonid 24, 25, 25 n.18
[tribe's] Patriarch *see nassi*
Personifications
 Daughter of Zion 33, 193, 194, 196, 197, 199, 200, 206, 207, 280, [1.9, 4.4]
 Exile 95
 Freedom 24, 35, 36, 189, 192, 196, 197, [1.13, 9.3]
 Israeli 206–207, [9.17]
 Judea
 Captive 190, 191, 192, 194, 196, 205, 206, [9.1, 9.5]
 Fighting 201, [9.12]
 freed 196, 197–198, 200, 201, 204, [9.6]
 reinstated 201, [9.13a, b]
plants 12, 182, 210, 245, 246, 247, 251, 259, 260, 262, 264, 274, 278, 280, 282, 323
 Amnon veTamar 261, 261 n.11, 262
 anemone 244, 262, 264, 266, 267, 268, 269, 274, 275, 276, [11.20, 11.25, 11.27, 11.30, 11.31]
 cedar of Lebanon 74, 150, 206, 244, 255, 256, 268
 cyclamen 264, 266, 268, 270–274, [11.21, 11.22, 11.28, 11.29]
 cypress 70, 254–259, [11.13, 11.14, 11.15, 11.17]
 corn 143, 206, 229
 fig 76, 245, 251, 261, [11.14]
 Four Species 244, 245 n.2, 247–250
 grapevine 73, 251, 279, 280
 mandrake 215
 narcissus 264, 267, 269, 277, [11.23, 11.24, 11.27]
 olive 10, 12, 31, 52, 145, 146, 147, 148, 149, 150, 151, 152, 153, 154, 156, 203, 217, 241, 245, 248, [7.11, 7.12, 7.13, 7.14, 7.15]
 palm 70, 140, 141, 143, 149, 141, 189, 191, 196, 199, 204, 206, 244, 245, 247, 248, 252, [9.1, 9.2, 11.17]
 pomegranate 72, 73, 84, 245–248, 252, 254, 277–278, 279, 290, [11.33, 12.6b]
 rose of Jericho 33, 33 n.27, 280, 281, [1.9, 11.36]
 Seven Kinds 246, 247, 248, 249, 250, 251, 277
pomegranate *see* plants

poseq, Avigdor 369, 370
prayer shawl 40, 118, 121, 122, 123, 124, 125, 129
precious stones 213, 215, 215 n.9, 217
Prophets
 Elijah 49, [2.5]
 Isaiah 33, 34, 49, 110, 111, 176, 178, 178 n.27, 256, 279, 326, [1.11]
 Jeremiah 49, 87, 178, [2.5]
 Jonah 88, 89, 90 n.11, [4.6]
 Zechariah 148–150, 152, 180, [7.14]
public space 8, 13, 57, 181, 182, 301, 331, 332, 338, 356, 358, 359, 364
Pugin, Augustus 46, 46 n.3
purity 389, 390, 391, 395

Raban, Ze'ev see [Israeli] artists
Rakia, David see [Israeli] artists
Rapoport, Natan 183–186, 313, 335, 336, 338, 339, 340, 341, 343, 345, 347, 348, 349, 350, 353, 354, 356, 358, 359
Rapoport, Shlomo Zanwil see An-sky
Rebirth, revival, renewal 95, 198, 267, 268
Reeb, David 17, 22, 33, 40, see also [Israeli] artists
Reform Judaism 209, 211, 220, 221, 222, 373
Reisinger, Dan 134, see [Israeli] artists
religious coercion 143
Remez, David 201, 231
Renaissance 7, 8, 17, 33, 43, 46, 47, 48, 49, 50, 51, 52, 54, 55, 56, 59, 191
Return to Zion 87, 94, 150, 152, 159, 179, 195, 209, 254, 265, 327
Reuben see Twelve Tribes of Israel
Rivers of Babylon see Memorial to the Destruction of the Temple
Rosen, Ro'ee see [Israeli] artists

Sabbath 28, 52, 81, 110, 114, [1.5]
Sacred Heart 33, [1.12]
Saint-Gaudens, Augustus 47, 50
Samuel, Lord 170, 171, 172, 180
scales of justice 145
Schocken, Gershon 152–153, 153 n.19
Scroll of Independence container 109–111, [5.7]
Sculpture, sculptural 24, 47, 48, 50, 53, 54, 68, 118, 122, 172, 174, 182, 183, 191, 279, 313, 322, 323, 326, 329, 336, 339, 342,
346, 348, 350, 363, 368, 370, 378, 379, 390, 391
seal 142, [7.6]
Seba, shalom see [Israeli] artists
secular, secularism 12, 13, 17, 18, 30, 51, 52, 55, 57, 81–82, 85, 86, 87, 92, 105, 107, 115, 129, 139, 140, 142, 143, 159, 167, 180, 181, 209, 219, 229, 236, 246, 247, 274, 287, 289, 290, 291, 294, 296, 301, 320, 327, 373, 374, 375, 376, 382, 397
Sephardic script see calligraphy
Seven Branched Candelabrum see menorah
sexuality 67, 68, 71, 73, 113, 373, 392
Sgan-Cohen, Michael see [Israeli] artists
Shaltiel, Ohad see [Israeli] artists
Shamir Brothers Studio see [Israeli] artists
Shamir, Eli see [Israeli] artists
Shamir, Michal see [Israeli] artists
Schatz, Bezalel see [Israeli] artists
Schatz, Boris see [Israeli] artists
Schechter, Yerachniel see [Israeli] artists
Sharet, Moshe 61, 125, 127, 128, 129, 138
Shield of David see Jewish Star
ship 216
Shofar 9, 140–141, 142, 143, 196, 326
Sholem, Gershom 119, 119 n.6, 120, 121, 130
Shprintzak, Yosef 144, 172, 174, 182
Shulamite 68, 70, 73, 74, 77
Shur, Aharon Shaul see [Israeli] artists
Simeon see Twelve Tribes of Israel
six pointed star 10, 25, 118–121, [6.3, 6.4, 6.5, 6.6, 6.7, 6.8] see also Jewish Star
Smoli, Eliezer 264, 266
[King] Solomon 57, 73, 74, 75, 76, 77, 118, 176, 178, 244, 385, 386, 388
Song of Songs 57, 67, 74
 Illustrations 72–74, 80, 81
 Pavilion 57, 70–71, 72, 75–76
spies motif 252–253, 279, [11.8, 11.9, 11.35]
Star of David see Jewish Star
Steinhardt, Ya'akov see [Israeli] artists
Studio Roli (Rothvhild and Lifman) see [Israeli] artists
Sukenik, Lipa 140, 144
sun 40, 55, 56, 110, 216, 239, 266
Synagogue 18, 25, 32, 81, 86, 87, 120, 121, 140, 141, 165, 173, 210, 218–222, 229, 246, 249, 321, 381

GENERAL INDEX

Tabernacle 9, 47, 115, 124, 176, 211, 211, 212, 229, 236, 247, [10.2]
tahara see purity
tallit see prayer shawl
Talpir, Gavriel 153–154
Tartakover, David see [Israeli] artists
tchelet see colors, light blue
Tchernichovsky, Shaul 11, 260–262
Tel Aviv 48, 83, 86, 87, 87 n.9, 95, 96, 110, 112, 199, 252, 254, 317, 364, [4.5]
Temple 57, 58, 86, 118, 138, 141, 149, 150, 151, 156, 159, 163, 167, 176, 178, 245, 247, 266, 385–386
 curtain 161, 162
tent 216
Tiberias 88, 89, 90–91, 92, 95, [4.7, 4.8]
Titus 138, 140, 148, 153, 156, 159, 160, 161, 163, 165, 166–167, 168, 169, 176, 177, 183, 184, 185, 189, 193, 196, 271, [8.1, 8.2]
Trumpeldor, Yosef 313
Tumarkin, Yigal see [Israeli] artists
Twelve Tribes of Israel 25, 84, 85, 145, 209, 210, 211, 212, 213, 218, 220, 222, 224, 227, 229, 231, 232, 236, 239, 241, 250, 259
 Asher 217, [10.20]
 Benjamin 218, [10.20]
 Dan 216, [10.20]
 Ephraim 210, 218, [10.20]
 estates 224, 236, 239, 241
 Gad 216, [10.20]
 heraldry 209, 211, 212, 213–218, [10.10, 10.12, 10.12a, 10.13, 10.14, 10.15, 10.17, 10.18, 10.25, 10.26]
 Issachar 216, [10.20]
 Judah 215, [10.8, 10.9, 10.20, 10.24a]
 Levi 215, [10.20]
 Manasseh 210, 218, [10.20]
 Naphtali 217, [10.20]
 Reuben 215, [10.20]
 Simeon 215, [10.20]
 Zebulun 216, [10.20]

tum'ah see impurity
[Hebrew] typography 103, 112, 153, 154, 287–299
 Aharoni typeface 296, [12.14]
 Amsterdam letters 290, [12.4]
 Chaim typeface 296, [12.13]
 David typeface 296, [12.16]
 Frank Rühl typeface 293, 294, 299, [12.10]
 Hadassah typeface 297–298, [12.7]
 Koren typeface 301, [12.20]
 Merubah typeface 289, [12.5]

Ur, Baruch see [Israeli] artists

verbal and visual description 3, 5, 12, 72, 77, 201, 210, 211, 213, 218, 222, 232, 302, 309, 324, 329, 366, 386, 387
Virgin of Israel see Daughter of Zion

Walisch, Oteh see [Israeli] artists
War of the Languages 92
Warburg, Otto 56, [2.9]
Warhaftig, Zerach 143, 152
water tower 347
Weinfeld, Yocheved see [Israeli] artists
wolf see animals
Wolfsohn, David 2, 54, 117–118, 118 n.2

Yitzhak, Yitzhak 166

Zebulun see Twelve Tribes of Israel
Zechariah see prophets
Zukerman, Moshe 358, 359
Zionist Congress
 First 118
 Fifth 17 n.1, 20, 40, [1.20]
 enterprises 61, 84, 87, 95, 96, 143, 206, 243, 244, 316
 Organization 117, 129, 130, 131, 322
Zweig, Stefan 164, 315